Painted With Words

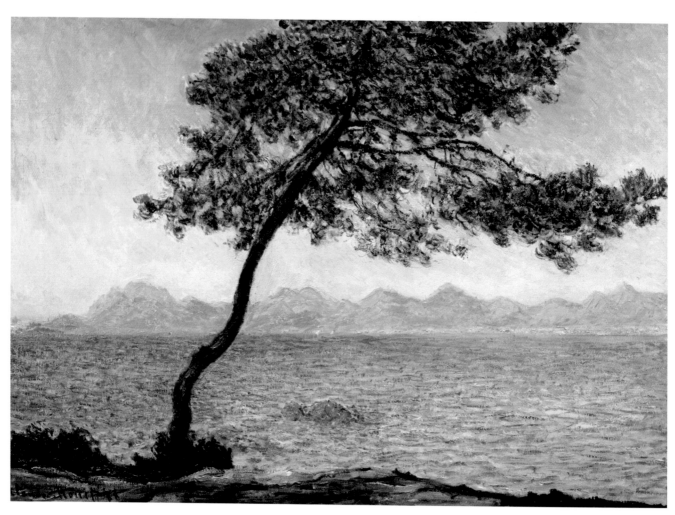

Painted With Words

Lara Marlowe

LIBERTIES

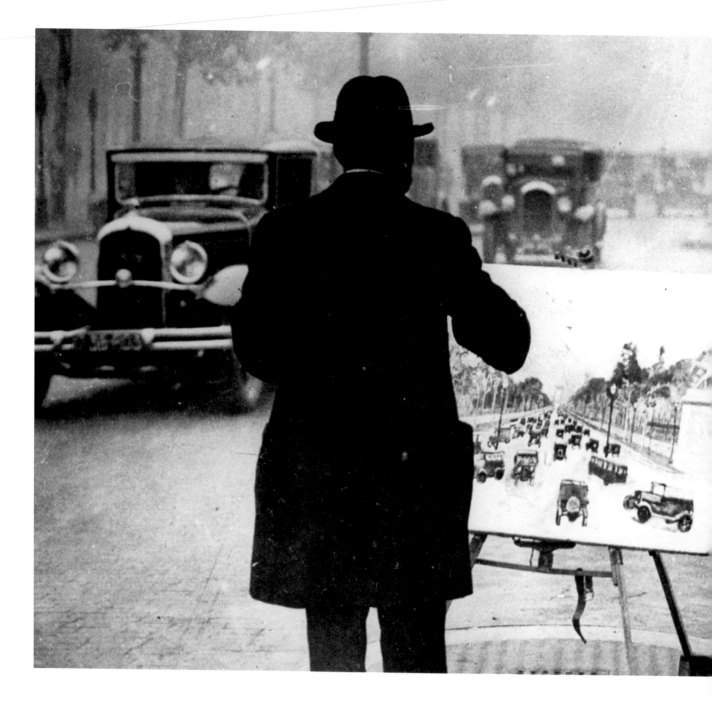

Painter on the Champs-Elysées, Paris © Imagno/Hulton Archive/Getty Images.

First published in 2011 by
Liberties Press
Guinness Enterprise Centre | Taylor's Lane | Dublin 8
Tel: +353 (1) 415 1224
www.libertiespress.com | info@libertiespress.com

Distributed in the United States by
Dufour Editions | PO Box 7 | Chester Springs | Pennsylvania 19425

Trade enquiries to Gill & Macmillan Distribution
Hume Avenue | Park West | Dublin 12
T: +353 (1) 500 9534 | F: +353 (1) 500 9595 | E: sales@gillmacmillan.ie

Distributed in the UK by
Turnaround Publisher Services
Unit 3 | Olympia Trading Estate | Coburg Road | London N22 6TZ
T: +44 (0) 20 8829 3000 | E: orders@turnaround-uk.com

ISBN: 978-1-907593-36-9
2 4 6 8 10 9 7 5 3 1
A CIP record for this title is available from the British Library.

Cover design by Graham Thew
Internal design by www.sinedesign.net

Printed by Cambrian Printers Ltd, Aberystwyth

Unless otherwise stated, all articles which appear in this collection were
originally published in *The Irish Times*.

'Painting is silent poetry; poetry is eloquent painting.
 – Simonides in Plutarch's *Moralia*

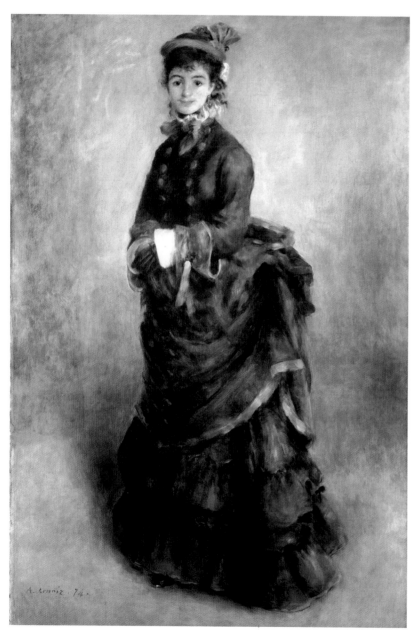

La Parisienne, Pierre-Auguste Renoir (1874), National Museum of Wales;
Miss Gwendoline E Davies Bequest, 1931.

For Margo Rietbergen and Henk Werner,
who will drive across Europe to see a painting

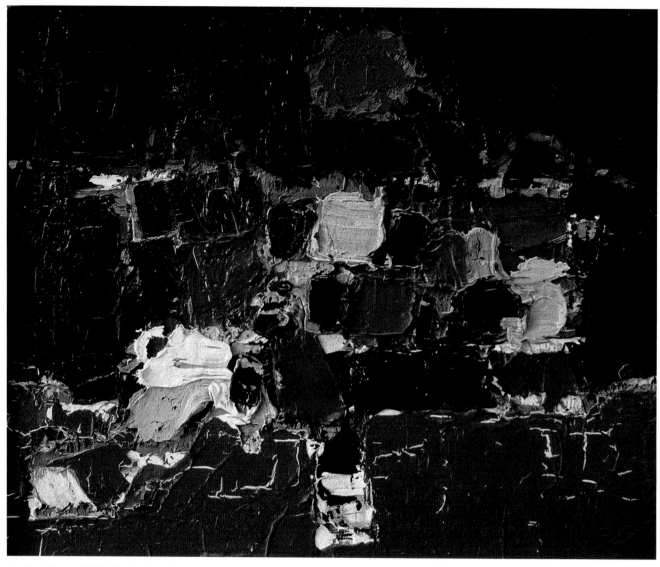

Les Footballeurs, 1952 © Nicolas de Staël / IVARO 2011.
Photo: © BI, ADAGP, Paris/Scala, Florence.

Contents

Foreword

I suspect that anyone with even a passing interest in art has had an experience such as mine when I first went to see Claude Monet's water lilies in the Orangerie in Paris. It embarrasses me to admit it, but my expectations were low. I had seen the greetings cards, the calendars and the coasters, but instead of showing me in advance what I was going to see, they misled me.

It's difficult to describe the effect of standing before those vast curved canvases for the first time without falling into hyperbole or cliché. It wasn't like looking at paintings: it was like being underwater. I could hardly believe that what I was seeing was paint and canvas. Those blues and greens, the sheer beauty of it all was overwhelming; and I came away electrified.

It's not the only time something like this has happened to me. A retrospective of Mark Rothko's paintings also confounded me, as did a casual reading of Gerard Manley Hopkins's 'Spring and Fall' on a poster on a train in the London Underground. And, as I said at the start, most anyone with even a passing interest in art will understand what I'm talking about here, and have had similar experiences.

Because this is what art does.

Emily Dickinson said that if something she read made her feel physically as if the top of her head had been taken off, she knew it to be poetry, which seems to me as good a definition as any. But how can this happen? Why does art have this mysterious power over us? There's no definitive answer, but here are some ideas to think about.

It has to do with energy. If a work of art is any good at all, it will be a storehouse of energy. This is often particularly apparent in paintings, where the energy can almost seem to pull you across the room towards the work in question. It can make a painting look as if it's lit up from within, as if it's literally full of electricity. It's also particularly apparent if an outstanding painting is displayed amongst more mediocre works. Sometimes the energy contained is no more than the energy of the moment, of society as it was at the time when the work of art was created. It speaks to people then, perhaps even quite forcefully, but over time the energy drains out of it, it empties itself, and what remains is a period piece that is no longer engaging or powerful. But a real work of art can hold its energy for years, even for centuries. Which brings me conveniently to the second idea.

It has something to do with time. The relationship between art and time is peculiar, to say the least. It's pretty well impossible for a work of art to escape the period in which it was created. Joyce may be the arch-Modernist, but there's also something quintessentially Edwardian about *Ulysses*. A painting or a poem may be simultaneously of its time and ahead of its time. Indeed, it may be so far ahead of its time that it takes society quite a bit of time to catch up with it. The artist may be saying something that the world isn't quite ready to hear. The usual reactions in

this case are anger, ridicule and bewilderment directed towards both the art and the artist. (Think of Samuel Beckett. Think of van Gogh.) Also, a work of art exists in time but somehow stands outside it. We can perhaps see this most clearly in the theatre. As Tennessee Williams said in relation to Arthur Miller's *Death of a Salesman*, we can feel compassion and understanding for Willie Loman because we are observing him from a different time dimension. If he were not at such a remove, in the timeless world of the stage, but there before us, sharing the same time continuum, we too might find him weak and tiresome, and wish to get him out of our office, and our life, as fast as possible. This strange relationship art has with time is also why very old things can seem fresh and new.

It has something to do with reality. Just because something is imaginary, it doesn't mean that it isn't real. We live in a world full of unreal things that would have us believe that they are real: advertising, for example, or political rhetoric. In fact, so surrounded are we by empty imagery and language that when we encounter something real, like a performance of *Krapp's Last Tape* or a still life by Chardin, it can be like a blow to the head, a shock, a revelation. Sometimes only the imaginary is capable of expressing the real, which is why mythology exists.

Lara Marlowe lived in Paris for many years and most, although not all, of the essays in this book date from that time. While living in France she was also working as a foreign correspondent, covering wars and violent conflict in places such as Algeria, Iraq and Afghanistan. A collection of these writings, *The Things I've Seen*, was published by Liberties Press in 2010.

In September 2004, one of the most shocking crimes against humanity of modern times took place in Beslan, North Ossetia, when over a thousand parents and children were held hostage in a school without food or water for over two days. Over three hundred people, most of them children, were killed in the end of the siege. It was deeply disturbing, the kind of thing that can make you lose all hope in humanity. It so happened that a short while later I visited Chartres Cathedral. The whole time I was there I was thinking about those children. While humanity is capable of what happened in Beslan, it is also capable of conceiving and building Chartres Cathedral.

It is wholly fitting that having reported with such integrity and compassion on some of the most barbaric and cruel acts of our time, Lara Marlowe has now given us this exquisite collection of essays on some of the most sublime art ever produced.

Deirdre Madden
Dublin, September 2011

Deirdre Madden teaches in Trinity College Dublin. She has published seven novels, most recently Molly Fox's Birthday.

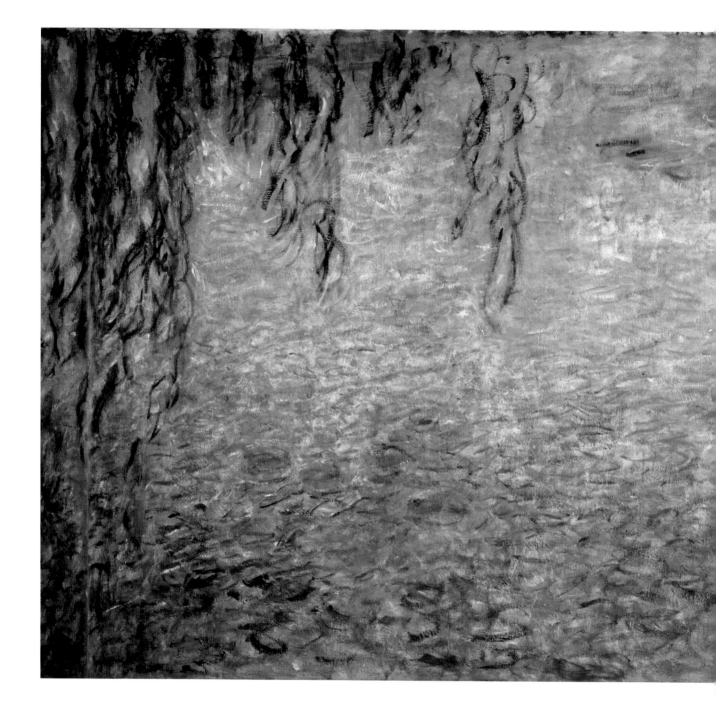

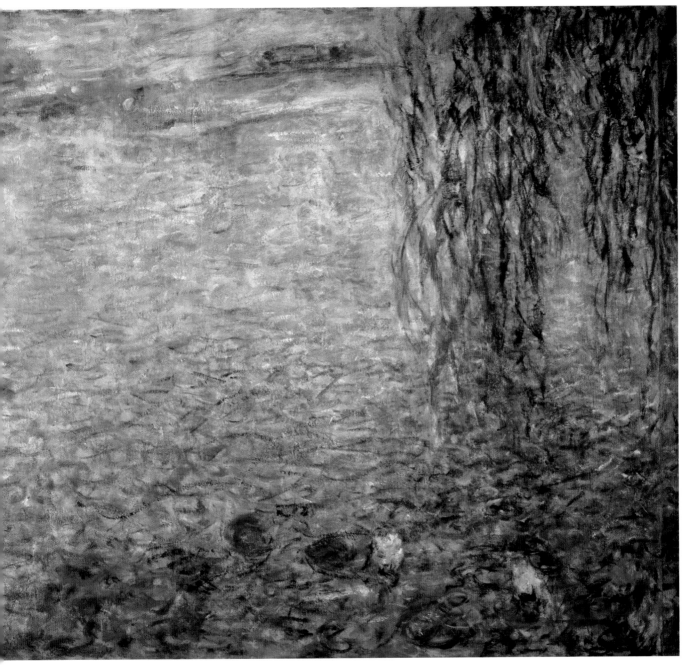

Les nymphéas, le matin clair aux saules. Triptyque partie centrale,
1914-26, Claude Monet © White Images /Scala, Florence.

Prologue

Bonnie Blue Campbell was tall and skinny with wavy red hair. Miss Bonnie, as we called her, hung her paintings on the bright yellow walls of her classroom. Her large canvases were semi-abstract, in monochromatic shades of blue and orange. One showed the voluminous curves of a nude woman. It was all rather risqué for our conservative corner of southern California.

Miss Bonnie was my first true eccentric. She wanted to be a painter, but appeared doomed to teach French to middle class teenagers for the rest of her life. Because of her, painting and the French language have always been inextricably linked in my mind.

Though only in her mid-twenties, and despite allusions to an absent boyfriend named Douglas, Miss Bonnie had the air of a confirmed spinster. Her stylish clothes seemed out of place. She drove an orange Porsche 914 convertible with a detachable black roof. The car was her pride and joy, her bauble. It must have cost most of her teacher's salary to maintain it, so she lived in a tiny garage converted into a studio apartment, with the car parked outside.

I took French I and II from Miss Bonnie. When I reached my third year of high school, I told her that I wanted to continue. Miss Bonnie sacrificed her free period to teach me French III, a class she invented for me. There was only one rule: we spoke to each other in French only.

Together, we would zoom up the mountainside in Miss Bonnie's Porsche. Over pancakes and coffee, she talked about her year abroad in France. She drove me to the chic department stores in Pasadena where she bought her clothes. I began to imitate her, wearing platform shoes and palazzo trousers with tight tops in bright colours, because Miss Bonnie wore them.

Miss Bonnie introduced me to the poems of Jacques Prévert, and the medieval Lady and the Unicorn tapestries. On weekends we'd drive to the art cinema in Westwood to see French movies. We liked *Madame Rosa* with Simone Signoret so much that we sat through two successive showings. Claude Lelouch's *And Now My Love*, with Marthe Keller and André Dusollier, was another favourite.

The hours with Miss Bonnie were the happiest of my adolescence. But the day she took me to the Los Angeles County Museum of Art was particularly special. I had of course looked at paintings in books, but as Deirdre Madden describes in her foreword, nothing compares with the almost electrical jolt of seeing the real thing.

Ambroise Vollard, the collector and art dealer who 'discovered' Cézanne, van Gogh, Matisse and Picasso, said that seeing his first Cézanne was like a blow to the stomach. Seeing Picasso's *Woman with a Blue Veil* and Renoir's *Two Girls Reading* for the first time gave me that breathless, euphoric feeling one has on falling in love.

The *Irish Times*'s Science Editor Dick Ahlstrom wrote last summer about research indicating that beauty provokes activity in the medial orbito-frontal cortex, the

'pleasure and reward centre' of our brains. But beauty also activates the nearby 'caudate nucleus' which is associated with romantic love. Nearly forty years after I stood transfixed before my first Picasso and my first Renoir, Dick provided a scientific explanation for the spell they cast on me.

My upbringing amid the fast food outlets and shopping malls of southern California must have left me parched for beauty. Miss Bonnie laughed and told me I looked as if I were drinking the paintings with my eyes. I was determined to remember them always.

To this day, I play a little game in museums, by myself or with friends. In each room, I choose the painting I would most like to take home, then an overall favourite for the exhibition. It is a way of imprinting them on the brain, of not forgetting.

Sadly, I lost track of Miss Bonnie soon after I left for university. But the writers and artists she introduced me to — Prévert and Picasso, Ronsard and Renoir — accompany me through life. Had it not been for Miss Bonnie, I probably would not have moved to Paris at the age of nineteen and spent a third of my life there. It was she who planted a seed in my brain, the idea that Paris was the centre of the civilised world, the place where, from the Renaissance until the Second World War, everything of importance in art and literature happened.

On my last holiday in Paris, I wandered late one evening past 47 rue des Écoles, where I studied for a year at the Sorbonne. I had all but forgotten the statue of Michel de Montaigne in the little park across the street. 'Paris has my heart since childhood,' said the quote from Montaigne. 'I am French but through this great city. Great and incomparable in variety. The glory of France and one of the most noble ornaments of the world.' Reworking the essays in this book, almost all of which were written for *The Irish Times*, filled me with nostalgia for events I have experienced only through books or

conversation. I wish I could have attended George Sand's *soirées* at Nohant, where Chopin and Liszt took turns playing the piano in the dark, then asked guests to divine which one of them was playing. I would have liked to have dined with Proust and his friends after midnight at the Ritz, frequented the cafés of Montparnasse between the wars, or Saint-Germain-des-Prés in the 1950s.

One of my favourite scenes in French literature comes from *The Silence of the Sea* by Vercors, the pen name for the Resistance figure Jean Bruller. A German officer was billeted in the home of an old Frenchman and his niece during the war. They refuse to speak to him, so the German engages in long monologues in their presence.

One night the German officer runs his finger over the bindings in the old Frenchman's library. The British have Shakespeare, he says; the Italians Dante; the Spanish Cervantes; Germany Goethe. But France . . . how to chose between Molière, Racine, Hugo, Voltaire, Rabelais . . . 'They're like a crowd at the entrance of a theatre; one doesn't know who to let in first,' he says.

This embarrassment of literary riches, the endless delight in the possibilities of language, is something that France shares with Ireland, and it was one of the things that drew me to Ireland in adulthood. The French poet Stéphane Mallarmé wrote that France was the country where everything ended up in a book. The same is true of Ireland. Irish writers too are a crowd at the theatre door: Yeats, Wilde, Joyce, Beckett, Heaney And how does one explain the contemporary flowering of Irish poetry and fiction, whose energy and expanse are, to my mind, unparalleled in Europe?

A friend in Washington introduced me to the term 'ekphrasis', the use of one medium of art to describe another. I savoured the word and the concept, and was delighted to come across Truman Capote's advice to aspiring writers after I'd chosen the title *Painted With Words* (with the help of Deirdre Madden). 'Writing has

laws of perspective, of light and shade, just as painting does, or music,' Capote said.

Explaining his own spare style, the Russian-born French painter Nicolas de Staël said he was 'trying to say what I have to say with as few words as possible'. Picasso said of his *347 Suite*, the raucous and erotic series of intaglio prints he produced at the age of eighty-seven: 'Bascially, it's my way of writing fiction.'

Remembered scraps of poetry and prose occasionally impose themselves on my newspaper reporting. Likewise, I recall interviewing a Bosnian Serb official in the early 1990s who was a dead ringer for Jean Clouet's *François I*. It's a game I learned from Proust, whose Swann 'found a peculiar fascination in tracing in the paintings of the old masters not merely the general characteristics of the people whom he encountered in his daily life, but rather what seems least susceptible of generalisation, the individual features of men and women whom he knew . . .'

This use of one's meagre knowledge is not just amusing. It's a way of fighting the onslaught of time, of attaching words and images to people and experiences, of freezing them in memory.

André Malraux said that art was 'anti-destiny', a form of salvation that enabled man to transcend his own mortality. I suspect there are many reasons why painters paint and writers write. Some create because it is joyous. Others say it is torment. Perhaps it is always a joyous torment. Most seem to feel a compulsion; they do it because they have to.

A few years ago, during a period of transition in my own life, I spent weeks asking myself what gave life meaning, only to conclude that it was truth and beauty. Then John Keats's 'Ode on a Grecian Urn' popped into my head to remind me that I'd invented nothing.

Yet the more I thought about it, the more I felt Keats got it wrong. Beauty is not truth, and truth is most certainly not beauty. For me, the exquisite colours and light in an Impressionist masterpiece are a world apart, a rare and privileged place that is denied to most of us most of the time. Truth is the gritty reality of war and torture and assassination, the greed of bankers and the failure of politics. Beauty is an escape from truth.

'The human soul needs actual beauty more than bread,' D. H. Lawrence wrote. We *need* beauty, and we need self-expression. Why else would Paleolithic men have adorned the caves of Lascaux? Why else did the Brazilian Indians with whom the French anthropologist Claude Lévi-Strauss lived spend up to three-quarters of their time decorating themselves?

When I interviewed the French businessman and patron of the arts Pierre Bergé before the auction of the art collection he'd shared with Yves Saint Laurent, Bergé told me the collection 'was all about the quest for beauty'. He was fortunate to have 'lived [his] life surrounded by beauty.'

Beauty fortifies us. A character in the Franco-Russian writer Andreï Makine's novel *A Hero's Daughter* heard birdsong after a horrific battle. Makine told me of a prisoner in the Gulag who hatched a bird's egg by sheltering it for days in his armpit. 'Finding beauty in the midst of hell was the only thing that enabled people to survive,' Makine said. 'A lot of people who did not have the capacity to see beauty sank into alcoholism or crime or committed suicide.'

Should art have a purpose? When I interviewed John Banville before an audience at the Irish College in Paris in April 2006, on the eve of the centenary of Beckett's birth, I asked him whether writers should be *engagés*. Banville vehemently answered that they should not; that art and literature are about craftsmanship — about creating beauty — and should having nothing to do with politics.

Yet others — Victor Hugo, Zola, the French existentialists, for a start — have insisted that the writer/ artist must fight injustice. From Goya's painting of the

execution of the Spanish defenders of Madrid to Picasso's *Guernica*, political engagement has produced some great art.

I was struck by the determination of the Irish painter Brian Maguire to remind the world of political evils, be it the assassinations of Allende and Lumumba, the treatment of prisoners in the US or gang warfare in north Dublin. Yet there's a kind of beauty to Maguire's painting. 'If you say something with passion, if you are angry, in itself the thing is optimistic,' Maguire told me.

As I wrote about these painters and writers, yet another question nagged me: are the life and character of an artist relevant, or should his or her art stand on its own merit?

I've had this argument with the French academician Michel Déon. Michel maintains we've become so obsessed with artists' lives that we neglect their works.

Perhaps. But somehow the bright colours of Gauguin's South Pacific paradise tarnished for me when I learned that the painter repeatedly 'married' thirteen- and fourteen-year-old girls whom he impregnated and infected with syphilis. Jean-Paul Sartre and Simone de Beauvoir seemed less admirable when one considered how they treated their lovers. On the other hand, I grew more fond of Pissarro's Impressionist paintings when I read of his wisdom and generosity.

I've learned that there is no such thing as an artistic temperament, that painters and writers run the gamut from happy to sad, from arrogant to humble. The bourgeois Magritte walked out on ill-mannered Surrealists telling his wife, 'Come on, Georgette. We're going home to Brussels.' Poor Nicolas de Staël threw himself from his roof in Antibes, but Kandinsky wanted to live 110 years 'to delve into art ever more deeply.'

Picasso thought an artist's character was paramount — not because of its effect on those around him, but because of the way it determined his art. 'It's not what the artist does that counts, but what he *is*,' Picasso said. 'What interests us is the disquiet of Cézanne, what Cézanne teaches, the torment of van Gogh, the tragedy of the man. Everything else is false.'

Lara Marlowe
Washington DC, October 2011

Acknowledgements

For the fifteen years I've worked for *The Irish Times*, my editors have periodically indulged — and at times encouraged — my desire to write about cultural matters. I remain an amateur, in the English sense of a dilettante, but also in the French sense of someone who loves.

This book is the result of my forays into the world of art and literature, mostly during my years as Paris correspondent. Since I've moved to Washington, museums and the occasional concert or poetry reading are a happy distraction from my real job, which is to focus on the brutal politics of the United States.

The cultural bond between Ireland and the US is so powerful that I could not resist including the last two pieces, about the Chicago police chief Francis O'Neill, who did so much to save Irish traditional music, and Stella O'Leary's annual gathering to commemorate James Joyce's 'The Dead'.

I've been proudest of my reporting from war zones, from Lebanon, Algeria, Iraq and Gaza. But I may not be the best judge. Ingres — no comparison with myself intended — thought his large religious murals, now forgotten, were his best work, and disliked painting portraits.

I did many of these pieces for Patsey Murphy and Gerry Smyth, both of whom I was sorry to see retire this year. Caroline Walsh, the *Irish Times*'s superb literary editor, sent me to Balzac's house in Passy, and to Normandy to interview Alain Robbe-Grillet in his château. Deirdre Falvey found space on her pages for many a piece on an exhibition. Reggie Dwyer has been a cheerful and efficient presence in the features department for as long as I can remember. Enda O'Doherty, of the *Irish Times* foreign desk, and the editor of the *Dublin Review of Books*, shares my preference for Camus over Sartre and de Beauvoir.

Without Seán O'Keeffe, the director of Liberties Press, this book would not have happened. Dan Bolger, Alice Dawson, Caroline Lambe and Clara Phelan at Liberties have been a delight to work with. I thank my agent, Jonathan Williams, for his unerring eye and impeccable advice.

During my years in Paris, the Irish College was a haven and a source of inspiration. I am grateful for the help and friendship of its directors, Helen Carey and especially Sheila Pratschke.

Through their writings, and over not a few meals and glasses of wine, Harry Clifton, Paul Durcan and Deirdre Madden have shared their reflections on aesthetics.

I must also thank Aine Adès and Pierre Joannon of the Ireland Fund of France, and Ambassador Emmanuelle d'Achon and cultural counsellor Hadrien Laroche of the French Embassy in Dublin for their generous support.

As I put this book together, I was saddened by the fact that at least six of the people I interviewed have since passed away.

Jean Baudrillard, the rebellious intellectual, died in 2007.

Alain Robbe-Grillet, the father of the *nouveau roman* who taught me at UCLA, and whom I interviewed twice for newspaper articles, died in 2008.

In her youth, the art collector and museum director Dina Vierny modelled for Maillol, Matisse and Bonnard. She told wonderful stories, including how she stood lookout for Bonnard at the *Salon d'Automne* while he touched up paintings that no longer belonged to him. Vierny died in 2009.

Jean Martin and Pierre Chabert, close friends of Samuel Beckett who gave me insights into Beckett's character, died in 2009 and 2010 respectively.

Françoise Cachin, a founder of the Musée d'Orsay, the longtime director of the Museums of France and the grand-daughter of the pointillist painter Paul Signac, told me how she tired of posing for the many painters in her family as a child. Cachin put together the wonderful *Méditerranée* exhibition at the Grand Palais in 2000-01. She died in 2011.

Other friends provide a precious bridge to twentieth century writers and artists whom I could not have known. Olivier Todd, the novelist and biographer of Camus, Malraux and Jacques Brel, pointed out to me the windows of the apartment on the rue Bonaparte where he used to visit Jean-Paul Sartre, about whom he wrote *Un fils rebelle*.

I've spent many hours discussing books and painting with Michel Déon. Michel gave me a new appreciation for Poussin, and regaled me with his recollections of Salvador Dalí, Coco Chanel and Françoise Sagan.

I am grateful to all these people for accompanying me on the cultural journey that began decades ago with my high school French teacher, Bonnie Blue Campbell. This book is for them too.

I Twentieth Century Painters

*'Painting is not done to decorate apartments.
It is an instrument of war against brutality
and darkness.'*

Pablo Picasso

Picasso

The Egocentric 'I' of Genius

If one artist embodied the twentieth century, it was the 5 foot 3 inch Spanish titan who moved to Paris in 1900, at the age of nineteen, and spent the rest of his long life in France. Pablo Picasso was in the forefront of every artistic movement, yet defied emulation. He pillaged the themes of earlier centuries, twisting and distorting them until he had forged something new. His erotically charged art was the visual expression of Sigmund Freud's discovery of the sexual impulses that underlie human behaviour. Picasso crashed through three-quarters of the twentieth century with the recklessness and power of the bulls he painted, accumulating fame and wealth, pulverising the lives of the women he possessed and then discarded.

Picasso's first teacher was his father, José Ruiz-Blasco, a professor at the fine arts academy and director of the local museum in Málaga. The boy started painting at the age of seven, knew he wanted to be a painter by eleven, and was admitted to the academy at fourteen. At eighteen, he dropped his father's name, and used only his mother's surname of Picasso thereafter.

Picasso was such a prodigy that his father allegedly gave up painting when he saw the boy's talent. At the 'Picasso and the Masters' exhibition at the Grand Palais in 2008-09, a portrait of Ruiz-Blasco, painted by a colleague in 1895, hung in the same room with Picasso's 1901 self-portrait, *Yo, Picasso (I, Picasso)*. Picasso's first-person pronoun, his *'Yo'*, was the egocentric 'I' of genius.

Though the two portraits were painted only six years apart, father and son personified different epochs. The pale Ruiz-Blasco wore conventional clothing, and harboured a beaten look in his eyes. Picasso stared boldly from the canvas, raffish in his artist's smock with a bright orange scarf at his throat and palette in hand. Ruiz-Blasco's expression spoke of sensitive, suffering artists. In Picasso's face one reads the fearlessness of a man determined to dictate the terms of modernity.

Picasso held his first solo exhibition in the Els Quatre Gats tavern in Barcelona that same year he moved to Paris. The small paintings are simple, cartoonish portraits of the nineteen-year-old and his friends. All are signed 'P Ruiz Picasso', except for the self-portrait, *'Yo'*. Picasso would paint himself countless times; as Harlequin, the seducer from the *commedia dell'arte*, as a lascivious minotaur, and later as a diminutive musketeer frolicking with voluptuous women.

Picasso's loves and losses often inspired his paintings. The first tragedy of his life appears to have been the death of Carles Casagemas, the son of the US consul general in Barcelona, and Picasso's closest friend. The young men had travelled to the World's Fair in Paris in 1900. Casagemas became obsessed with a woman he met there, Laure Gargallo, known as Germaine. When Germaine

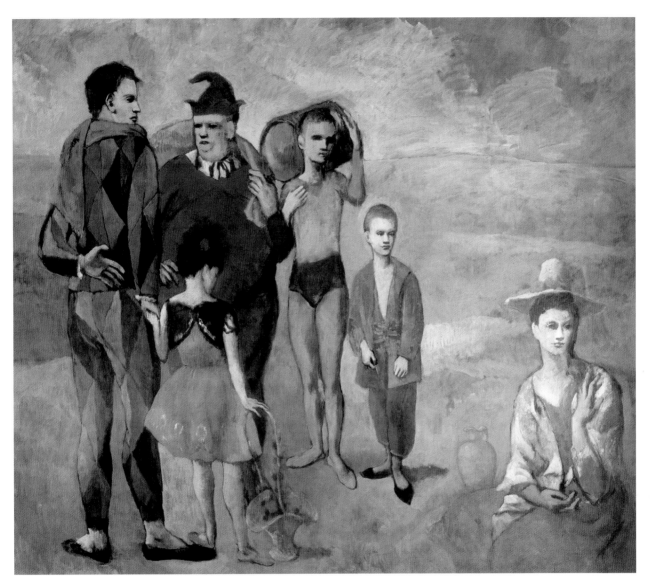

refused to leave her husband for him, Casagemas tried
to shoot her in a Paris café. She dived to the floor.
Thinking he had killed her, Casagemas turned the
gun on himself and died a few hours later.

Picasso painted Casagemas's funeral in the style of El Greco, and insisted that his friend's suicide precipitated his Blue period. El Greco inspired the colours and elongated figures of many of Picasso's early paintings. In *Boy Leading a Horse*, he transposed the horse and servant in El Greco's *Saint Martin Sharing His Coat with a Poor Man*. Saint Martin disappeared from Picasso's canvas, which was totally different, yet somehow traceable to El Greco.

Casagemas's death continued to haunt Picasso. More than a decade later, when Picasso and Georges Braque glued newspaper clippings onto canvases as part of their experiment in 'synthetic Cubism', Picasso constructed a collage with an article about a Parisian salesman who stabbed his fickle lover, a singer, in the arm, then shot himself in the head. It was Casagemas's story all over again.

In the autumn of 1901, Picasso painted *Seated Harlequin*, regarded as his first masterpiece. Art historians believe it was a tribute to Casagemas. Picasso gave Harlequin the whiteface and ruffled collar and sleeves of Pierrot, the sad clown who always loses Columbine. When New York's Metropolitan Museum of Art exhibited its entire Picasso collection at once, for the first time, in 2010, *Seated Harlequin* was the signature painting of the exhibition.

Picasso returned to the Harlequin theme in *At the Lapin Agile* (1905), which he painted for the owner of the famed Montmartre café in exchange for meals. This time, Harlequin is Picasso's self-portrait, seated beside Germaine, the woman who drove his best friend to suicide. Picasso had a brief affair with Germaine and later sent her money when she fell on hard times.

Picasso's work was in many ways a catalogue of the people he encountered. Over his long career, bordello madams, landladies, art dealers, poet friends, his children, and especially his lovers became Picasso's models. Although he is also known for sculptures, still lifes and large murals like the Spanish civil war *Guernica* and the revolutionary *Demoiselles d'Avignon*, the portrait was Picasso's favourite genre.

Picasso's Women

Madeleine was one of Picasso's first mistresses in Paris. Art historians no longer know the family name of this slender woman, whom he painted in his blue and pink periods. Her angular face was always solemn and strangely poetic. In a 1905 oil portrait, a seated, nude Madeleine sits staring into space, her body melting into planes of pale yellow and burnt sienna. As he often did, Picasso left the background unfinished.

The more voluptuous Fernande Olivier supplanted Madeleine. The influence of African art can be seen in one of Picasso's first Cubist paintings, a geometric rendition of Fernande holding a fan, in earth colours, from 1908.

The American writer and art collector Gertrude Stein believed Picasso was the greatest living artist, and it was largely through her salon in the rue de Fleurus that he became known. Stein wrote that Picasso's portrait of her (1906) marked his passage from the Blue and Rose periods to Cubism.

Picasso aspired to be the twentieth-century Ingres, and there is a hint of Ingres's portrait of the newspaper editor Louis-François Bertin in Stein's hulking figure as painted by Picasso. With her dark eyes and long nose, Stein's face looks strangely like Picasso's, and like the African masques that Picasso sought out in museums and antiquarian shops.

When she died in 1947, Stein bequeathed Picasso's portrait of her to the Metropolitan Museum of Art. It was the first Picasso acquired by this prestigious but conservative museum, and remains the Met's most celebrated Picasso.

Picasso's Cubist drawing *Standing Female Nude* was included in his first show in the US in 1911. The painter

said it was one of the most beautiful things he ever created, but a critic referred to the zig-zagging vertical figure as a 'fire escape, and not a good fire escape at that'. Picasso never crossed the line into pure abstraction. His Cubist paintings may be difficult to decipher, but they always purport to represent something.

In 1917, Picasso met his first wife, the Russian dancer Olga Kokhlova, while working on a ballet with Sergei Diaghilev in Rome. The Renaissance art he saw in Italy, and Olga's classic features, prompted Picasso's neo-classical period, which lasted until 1925. *Woman in White* (1923) is a particularly lovely neo-classical Picasso. Historians are not sure whether this pensive woman in a diaphanous dress is Olga or Sara Murphy, the wife of a wealthy expatriate American painter. Like Harlequin/Pierrot, she may be a hybrid.

Picasso and Olga's son Paulo was born in 1921. His portraits of Olga and Paulo are perhaps the most beautiful of all Picasso's paintings. Photographs show Olga was a rather ordinary, slavic-looking woman. But his paintings romanticised her, giving her either the sculptural weight of classic Greek and Roman art or, with a floral shawl, the exoticism of a Spanish lady.

The Grand Palais in Paris chose two portraits of Olga as the theme paintings for its exhibition on 'Picasso and the Portrait' in 1998-99. In one, a large, luminous pastel-and-charcoal portrait done in 1921, Olga is radiant, serene. In *The Seated Bather*, painted nine years later, Olga has become a disjointed, abstracted assemblage of body parts on a cliff above the sea. One can't help wondering what she felt when her husband began painting her face as a tiny triangle with two dots for eyes, and vertical, nearly interlocking, zig-zags in lieu of a jaw. Yet the painting, in blue, beige and grey, has a kind of gracefulness. Olga's arm clutches one knee while her other leg curls beneath her.

The phases of Picasso's love life, like the periods of his artistic style, often overlapped. Picasso's women were his models and inspiration, but he repeatedly drained lovers of their life force before discarding them. Olga became mentally unstable when Picasso left her for Marie-Thérèse Walter, an innocent seventeen-year-old whom he approached one morning in 1926 outside the Galeries Lafayette department store, saying, 'Mademoiselle, you have an interesting face. I would like to make your portrait. I am Picasso.'

When his marriage to Olga soured, Picasso painted her as an amoeba-like creature with a gaping mouth filled with teeth. He wanted to divorce Olga, but was reluctant to sacrifice half his property in a settlement. At the Grand Palais's 2008-09 exhibition on 'Picasso et les Maîtres', Picasso's *Grand nu au fauteuil rouge* hung beside Ingres's masterpiece, *Madame Moitessier*, on which it was allegedly based. Both paintings show a woman seated on a red armchair with one hand lifted to the face. Ingres's subject, with her flowered dress, ribbons, jewels and milk-white shoulders, exudes luxury and calm. Picasso's dislocated figure, with her octopus limbs, lopsided breasts and the open jaws of a shark, is in fact a portrait of his disintegrating marriage.

Picasso usually painted the blonde and curvaceous Marie-Thérèse with a small head, sleeping or dreaming, with seeming cheery tenderness. From 1936 until the Second World War, Marie-Thérèse's arch-rival, the Franco-Croatian photographer Dora Maar, who chronicled the painting of Picasso's Spanish civil war masterpiece *Guernica*, was his public mistress, while Marie-Thérèse and their daughter Maya remained his hidden family.

Nineteen thirty-five marked Picasso's divorce from Olga, the birth of Maya, and his first meeting with Dora. She was the antithesis of the sweet, submissive Marie-Thérèse, whom Picasso continued to see throughout their liaison.

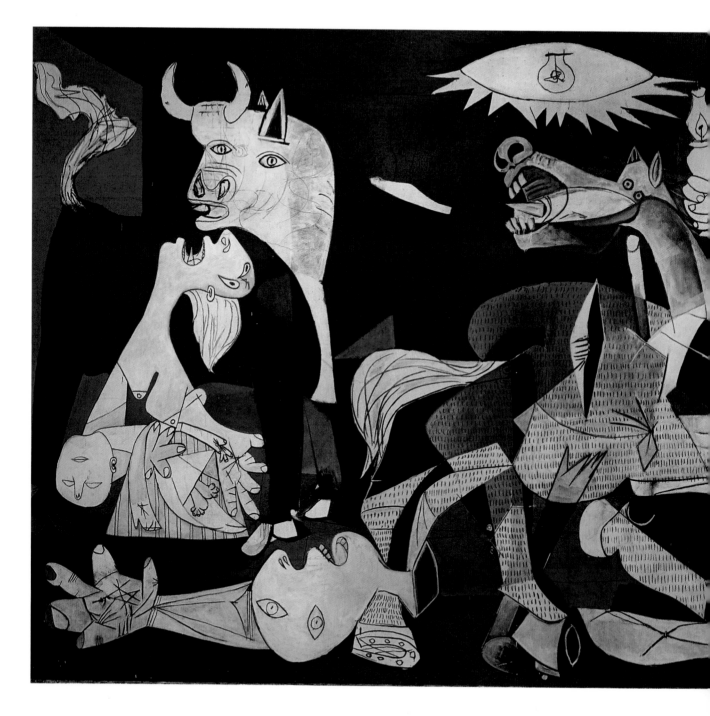

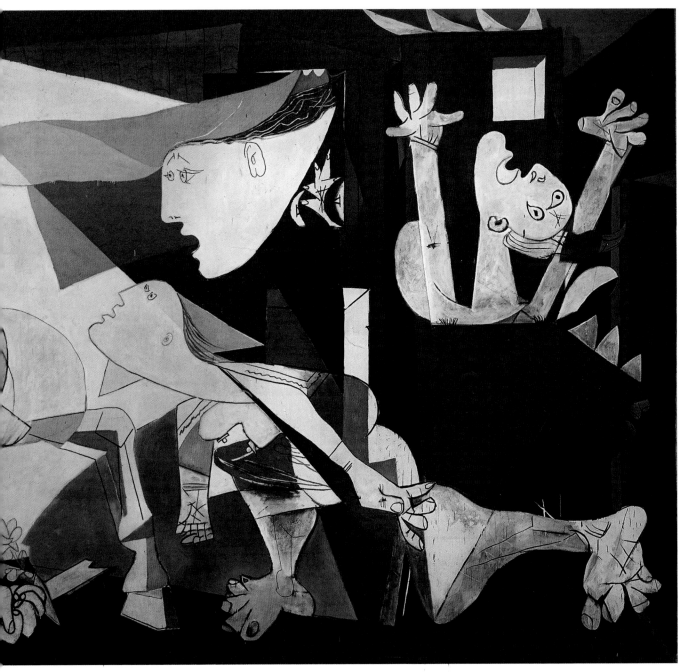

Guernica, 1937, Pablo Picasso ©Succession Picasso 2011.
Photo: © Art Resource/Scala, Florence/John Bigelow Taylor.

Portraits of the two women contrast sharply. In paintings done on the same day, with his models lying on the same sofa and bearing the same title – *Woman Lying Down with a Book* – Picasso divulged his bigamous life with Marie-Thérèse and Dora. Marie-Thérèse is soft and passive. Dora, the reflection of Picasso's anxieties, is jagged, violent, almost reptilian.

Picasso met Dora at the Café de Flore, where the beautiful young woman caught his eye by sitting a few tables away and carrying out a theatrical stunt which she may have devised to entrap him.

'She wore black gloves embroidered with little pink flowers,' wrote Françoise Gilot, the younger woman who would later supplant Dora in Picasso's affections. 'She had taken off her gloves and took a long pointed knife which she jabbed into the table, between her spread fingers. From time to time, she missed by a fraction of a millimetre and her hand was covered with blood. Picasso was fascinated . . . He asked Dora to give him her gloves, which he kept in a glass case.'

That same year, Picasso recalled Dora's bizarre performance in a poem he published in *Cahiers d'Art*: 'young girl handsome carpenter who nails boards with the thorns of roses don't cry a tear to see the wood bleed'.

Dora Maar was born Henriette Theodora Markovitch. Her father was a Croatian architect, her mother French. She spent her childhood in Buenos Aires and spoke fluent Spanish, which strengthened Picasso's attraction to her. She was twenty-eight when she met the fifty-three-year-old Picasso.

Dora was already a successful fashion and portrait photographer, and an active member of the Surrealist movement. She was more politicised than Picasso, participating in the far left-wing groups *Octobre*, *Masses* and *Contre-attaque*.

Picasso identified something of himself in Dora's high-strung intelligence. 'Picasso is a man and a woman deeply entwined,' wrote the poet Jean Cocteau. 'Like in his paintings. He's a living ménage. The Picasso ménage. Dora is a concubine with whom he is unfaithful to himself. From this ménage marvellous monsters are born.'

Anne Baldassari, the director of the Musée Picasso in Paris and the curator of the 'Dora Maar-Picasso 1935-1945' exhibition in 2006, insisted that when Picasso painted Dora repeatedly as a weeping woman, he was in fact painting himself, grieving for the barbarity of mankind.

This is borne out by a study for *Guernica*, entitled *The Pleading Man*. The man wears Picasso's signature striped fisherman's jersey, raises his hands to the sky and, like Dora Maar, sobs. Picasso's best-known portrait of Dora, *The Woman Crying* (1937), is a powerful representation of a hysterical sobbing fit.

The decade through which Picasso and Dora loved each other was the worst in a terrible century; in Picasso's words, an age 'of brutality and darkness'. In a poem he dedicated to Dora, Picasso wrote, 'It was so dark at noon that one saw the stars.'

Baldassari said Picasso saw Dora as 'a true artistic and intellectual partner, probably the only woman he ever considered an equal'. Images of her taken by the American photographer Man Ray show her to have had the beauty of a film star. Man Ray, like Picasso, was fascinated by Dora's hands. Her habit of polishing her fingernails with red, green or black varnish, and her fondness for flamboyant hats, are in evidence in many of Picasso's portraits of her.

Soon after they met, Dora shot a series of portraits of Picasso in his studio in the rue d'Astorg. She never printed this first photographic encounter, which Baldassari exhibited as negatives in 2008. They give one the impression of watching Dora take possession of the painter through the lens of her Rolleiflex. At the beginning of the session, he is reserved, in jacket and tie; by the end, he has abandoned both, and all formality.

As an illustration for a poem by Paul Éluard, Picasso first depicted Dora as a nude female Minotaur with hairy chest and horns – further evidence that he saw her as a sort of alter ego. Picasso often portrayed himself as a Minotaur, with a bull's head on a man's body, or the other way around, as a centaur. These mythological creatures represented sexual potency and the brutality of politics. But they were also objects of pity. As Picasso's fascination with bullfighting showed, they were doomed beasts.

Picasso's myriad portraits of Dora were anything but an attempt to understand his subject. 'They're the opposite of the psychological profile,' Anne Baldassari said. 'Picasso uses a face to impose a style.' He several times painted Dora with the body of a bird. 'She was anything you wanted,' Picasso said of Dora: 'a dog, a mouse, a bird, an idea, a thunderstorm. That's a great advantage when falling in love.'

Though Picasso and Dora created countless images of each other, relatively little is known of their actual relationship. That is what made a small room in the 2008 exhibition holding the momentos of their love so precious.

On a blue sheet of paper, Picasso wrote his mistress's name dozens of times. On another scrap he quoted Verlaine, 'And here is my heart which beats only for you'. There were tiny pressed bouquets with the brown envelope that held them, marked, in Picasso's writing: 'Dora Maar, first day of spring 1937.' She kept a brown-stained piece of paper marked 'Picasso's blood'.

This tenderness was overshadowed by the Spanish Civil War. On 26 April 1937, the Luftwaffe bombed a Basque village, killing more than two thousand people. Picasso was enraged by the news.

'He ordered a large canvas and began to paint his version of *Guernica*,' Man Ray recalled. 'He worked feverishly, every day, using only black, grey and white:

he was too angry to worry about subtleties of colour or problems of harmony and composition.'

Not only did Dora Maar inspire the central figure in *Guernica*, a woman holding an oil lamp, she also photographed the work in progress – the first time the creation of a masterpiece has been chronicled in this way. Picasso studied her photographs to help him advance through those months of May and June 1937. In July, the painting represented Spain at the World's Fair in Paris.

A perhaps apocryphal anecdote says that during the occupation, a German officer showed up at Picasso's studio in the rue des Grands-Augustins, clutching a photograph of *Guernica*.

'Did you do this?' the German asked. (Picasso's art was considered 'degenerate' by the fascists.)

'No. You did,' Picasso replied.

Spain no longer loans *Guernica*, considered a national treasure too priceless to travel. But the Musée Picasso exhibited a series of eighteen of Dora's photographs of *Guernica* in the making, plus several of Picasso at work on the canvas.

The New York Museum of Modern Art owns *The Mass Grave*, painted in a similar monochrome style eight years after *Guernica*. Picasso said he painted *Mass Grave* by intuition, before learning of the full horror of the Nazi death camps. Dora said it was inspired by a Spanish film of a family massacred in their kitchen.

When Picasso met a tall, slender, twenty-two-year-old painter named Françoise Gilot in May 1943, he told her she had 'the spirit of a plant in springtime'. He became obsessed with the theme and often painted Françoise like a flowering plant, her body a long stem, her breasts and abundant hair like petals.

Françoise gave birth to Claude in 1947 and Paloma in 1949. As with Paulo and Maya, Picasso expressed love for his children by painting their portraits.

When Picasso met Françoise, Dora, like Olga before her, became literally mad with jealousy, spending a brief period in a psychiatric hospital. She grew increasingly reclusive and religious until her death in 1997, saying 'After Picasso, only God.'

Picasso's affair with Dora drew to a long, agonising close. They ran into each other one day in the Café de Flore and he insisted on bringing Françoise to Dora's studio to see her paintings. He then bullied Dora into reassuring Françoise that it was all over between them.

'Dora Maar looked over at me briefly and witheringly,' Gilot wrote. 'It was true; there was no longer anything between Pablo and her, she said, and I certainly shouldn't worry about being the cause of their break-up.'

Dora then predicted that Françoise would be 'out on the ash-heap before three months had passed'. Turning to Picasso, she added: 'You've never loved anyone in your life. You don't know how to love.'

If love can be measured by longevity, Picasso's last love was his best. He began living with Jacqueline Roque, who was forty-five years his junior, in 1955. They married six years later, and Jacqueline stayed with him until his death in 1973. Picasso painted the dark-haired, high-cheekboned Jacqueline hundreds of times, usually in modern, Cubist style, as if from several angles at the same time. But Picasso's occasional reversion to his early realism produced exquisite portraits.

Picasso's output was always prodigious. In just six months, at the age of eighty-seven, he produced 347 intaglio prints, owned by the Metropolitan Museum. 'I spend hour after hour while I draw . . . observing my creatures and thinking about the mad things they're up to,' Picasso said of the *347 Suite*. 'Basically, it's my way of writing fiction.'

The prints are salacious, humorous and erudite. Throughout his life, Picasso remained an erotic and artistic powerhouse, but the brooding young Spaniard evolved into a happy and fulfilled old man.

Picasso as Artistic Cannibal and Vandal

As a young man, Picasso knew the Prado and Louvre museums by heart. He described himself as the heir of Rembrandt, Velázquez, Cézanne and Matisse, saying, 'A painter doesn't come from a void'. Goya and van Gogh were his 'best friends', Cézanne his 'father'.

But Picasso had a rebellious streak. 'I paint against the paintings that count for me,' he said. He was creating his own imaginary museum, adding what he found lacking in real-life collections. 'One must do what is not there, what has never been done,' he said.

Critics decried the Grand Palais's blockbuster exhibition of 'Picasso et les Maîtres' as a circus or 'best of' compilation without intellectual cohesion. But seeing Picasso's canvases alongside masterpieces by Titian, Velázquez, El Greco, Zurbarán, Rembrandt, Poussin, Ingres and Manet provided a unique lesson in the continuity of Western art while showing how irreverently Picasso cannibalised and vandalised his own artistic heritage.

Picasso's early charcoal drawings of statues from Greek and Roman antiquity show him to have been a fine draughtsman. As a young man, he said, he 'could draw better than Raphael . . . But it took me a lifetime to learn to draw like a child'. Once the classical beauty of his Blue and Rose periods passed, Picasso painted slowly and carefully only occasionally, in a style reminiscent of Ingres, as in the exquisite portraits of his Russian wife Olga.

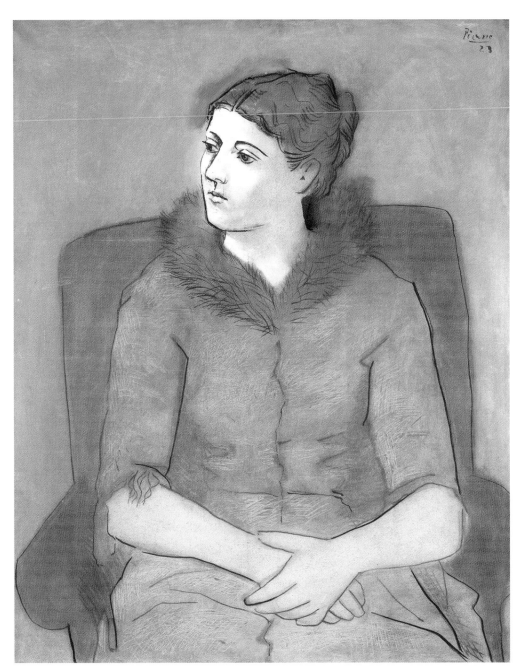

Madame Picasso,
1923, Pablo
Picasso
© Succession
Picasso 2011.

But in the age of photography, Picasso understood that there was no point in painting lifelike images. 'It's not what the artist does that counts, but what he is,' he said. 'What interests us is the disquiet of Cézanne, what Cézanne teaches, the torment of van Gogh, the tragedy of the man. Everything else is false.'

The paradox of Picasso is that this most original painter stole others' work throughout his career, always transforming it into something else. Picasso liked to quote van Gogh: 'In life and in painting, I can do without God. But I cannot, suffering, do without something that is greater than me, that is my life — the power of creating.'

Van Gogh was right, Picasso told André Malraux: 'The need to create; it's a drug. You must invent; you must paint.' Four of the world's most famous nudes — Titian's *Venus and Cupid and an Organist* (1548), Goya's *The Nude Maja* (1797-1800), Ingres's *Odalisque in Grisaille* (1823-34) and Manet's *Olympia* (1863) were exhibited alongside Picasso's *Nude Reclining with a Cat* and *Reclining Nude with a Man Playing the Guitar* in the Grand Palais. Picasso painted the latter canvas in one day. In his variation on Titian's masterpiece, Venus's genitalia, anus and breasts are lined up in a row, as if served on a platter. Judging from the conversations I overheard, museum-goers preferred the masters to Picasso.

But art isn't meant to be pretty, Picasso seemed to answer. 'Art is not chaste,' he said. 'It should be forbidden to ignorant innocents. It should never be put in contact with the insufficiently prepared. Yes, art is dangerous. Or if it is chaste, then it is not art.'

Picasso's interpretation of the masters reached fever pitch in the late 1950s and early 1960s. Working intensely on series for concentrated periods of time, he produced fifteen variations of Delacroix's *Women of Algiers in their Apartment* in two months in the winter of 1955-56, then fifty-eight paintings inspired by Velázquez's *Las Meninas* between August and December 1957. For his *Rape of the Sabine Women* series in early 1963, Picasso combined elements of paintings by Poussin, David and Delacroix, all of whom had painted the eighth-century war crime. Picasso was allegedly inspired by the Cuban missile crisis, but his images of women and children being trampled by sword-brandishing horsemen seem to evoke the massacre of civilians in every conflict of the last half-century, from Vietnam to Latin America, Yugoslavia, the Middle East and Africa.

Through the seven decades he spent dismantling what he scornfully called the 'canon of beauty', Picasso never lost his sense of humour. To celebrate his ninetieth birthday in 1971, the Louvre temporarily exhibited a selection of Picasso's work – an honour never before accorded to a living artist. 'Speak to me with respect!' he teased friends. 'I'm going to be hung in the Louvre!' Surveying works by Goya, Velázquez and Zurbarán in the Louvre's Grande Galerie, where his works were about to be shown, the ageing painter joked: 'You see, it's the same thing! It's the same thing!'

This chapter is based on five major Picasso exhibitions over a fourteen-year period: Museum of Modern Art, New York, and Grand Palais, 'Picasso and Portraiture', April 1996 to January 1997; Grand Palais, Paris, 'Chefs d'oeuvres du Metropolitan Museum of Art, New York', October 1998-January 1999; Musée Picasso, Paris, 'Picasso-Dora Maar', February-May 2006; Grand Palais, Paris, 'Picasso et les Maîtres', 2008-2009; the Metropolitan Museum of Art, New York, 'Picasso in the Metropolitan Museum of Art', April-August 2010.

De Staël

The Border of Abstraction

Though he painted for only sixteen years before his suicide in 1955, Nicolas de Staël created an oeuvre of unparalleled intensity, changing style several times.

Staël is best known for straddling the border between figurative and abstract painting. He refused to be drawn into theoretical quarrels, but nonetheless thanked a museum curator for not classifying him with what he called 'the abstraction gang'.

'I do not oppose abstract painting to figurative painting,' Staël wrote in 1952. 'A painting should be both abstract and figurative at the same time: abstract as a wall, figurative as a representation of a space.' At a time when contemporaries such as Pierre Soulages, Hans Hartung and Jackson Pollock were experimenting with 'action painting' and *tachisme*, Staël horrified advocates of abstract art by returning to an almost figurative style in the early 1950s, allowing the grey and white upper canvas of *Les Toits* to suggest the sky above the roofs of Paris. His compositions continued to allude to the real world, in paintings inspired by football players, music and dance concerts and the landscapes of France and Italy.

Ironically, the painter's success contributed to his suicide. His reputation as a tormented, van Gogh-like, doomed artist prone to drink and depression has since made him more famous, said Jean-Paul Ameline, the director of the Musée National d'Art Moderne in Paris and the curator of the landmark retrospective of Staël's work at the Pompidou Centre in 2003.

Staël's legend was, Ameline said, 'perhaps the only cliché he fell into, despite himself. It has sometimes prevented people from seeing his painting'.

Nicolas de Staël was born in St Petersburg in 1914. His father, Vladimir, was the vice-governor of the Fortress of Peter and Paul, the Czar's prison. After the Russian Revolution, the aristocratic family fled to Poland with the family jewels sewn into the lining of their nanny's clothing. The de Staël parents died in Poland. A Belgian couple adopted Nicolas and his two sisters and took them to live in Brussels.

An art collector friend of Staël's adoptive parents was so impressed with Nicolas's work at the Belgian Académie des Beaux Arts that he paid the young artist's way to Morocco in 1936, on the understanding that Staël would send him paintings and drawings. For the first time, Staël knew the pressure of other people's expectations. Though he was dazzled by the light and colours of Morocco and worked for eight hours a day, Staël destroyed most of his efforts and sent nothing to his patron.

In a café in Marrakech, Staël met Jeannine Guillou, a French painter. She left her husband, also a painter, to live in poverty with Staël in Nice and Paris through the

Second World War, giving birth to their daughter, Anne, in 1942.

Staël painted Jeannine in the style of El Greco, or Picasso in his blue period. 'Looking at them,' he wrote of the paintings, 'I asked myself: what did I paint there? A dead person who is alive, a living dead person? Little by little, I felt awkward painting something that resembled . . . So I tried to attain free expression.'

For most of the 1940s, Staël's 'free expression' took the form of dark, abstract paintings in autumn colours. Staël spread thick slabs of paint with a putty knife and trowel. The impression they convey is best summarised by a title, *La Vie dure*, painted in 1946, the year Jeannine died.

Though he called Jeannine 'a being who gave me everything and who still gives to me each day', Staël married Françoise Chapouton, a law student who had taught Jeannine's son English, a few months after her death. As Staël's life improved, his painting became less gloomy. In the appropriately named *Calme* (1949), he used broad planes of colour for the first time – the beginning of what has been called Staël's 'abstract apogee'. Henceforward, his canvases are luminous.

Staël cared little for titles, sometimes simply numbering his paintings for gallery showings. He often compared the canvas to a wall. An exhibition of Ravenna mosaics in 1951 inspired him to transform his assemblages of large, irregular forms into variegated, mosaic-like squares that appear to decorate a wall.

Staël broke more than a decade of fidelity to abstraction when he painted *Les Toits*. Like the landscapes and seascapes which followed, the painting is more suggestive than representational. 'I am trying to say what I have to say with as few words as possible,' Staël explained.

In 1952, Staël attended a football match at the Parc des Princes in Paris and was thrilled by the shapes, colours and movement of the players. He completed twenty-four small oil studies on the theme, then distilled all he had learned in a huge mural-like painting from which explicit references to sport have vanished.

That same year, Staël rented a house in the south of France, and like Matisse and the Fauves before him, revelled in the violence of its colours, as in *Figures au bord de la mer*. 'After a while, the sea is red, the sky is yellow and the sands are purple,' Staël wrote to his close friend, the poet René Char. 'I'd like to soak myself in it until the day of my death.'

In 1953, Staël's first major exhibition in New York was a critical and financial triumph. 'All my life I needed to think painting, to see paintings, to do painting to help me live, to free me from all the impressions, all the worries which I found no way out of other than through painting,' he wrote while preparing the New York exhibition.

A few months later, he was smitten by Char's muse, Jeanne Mathieu, who became his mistress. She travelled with Staël, his wife and children to Sicily that summer. Staël's Sicilian canvases have been called 'a paroxysm of pure colour'. In September 1954, Staël left his wife and children to move to Antibes – alone. For the first time, his biographers say, he loved more than he was loved. His failed affair with Jeanne and the pressure of art galleries demanding ever more paintings plunged him into depression.

During those last months in Antibes, his style changed again. For the first time, Staël abandoned the thickly sculpted paint that was his hallmark, thinning his colours down to near-transparency. He painted still lifes of his studio and kitchen, seagulls and a shimmering blue and grey rendition of the ancient fort of Antibes, where he began his last, monumental, unfinished painting, inspired by a Schönberg concert.

On 16 March 1955, Staël wrote to his friend and art dealer in Paris, Jean Dubourg: 'I don't have the strength

to put the finishing touches on my paintings.' That night, at the age of forty-one, he threw himself from the roof of his building.

This chapter is based on 'Nicolas de Staël', at the Centre Pompidou in Paris, March to June 2003.

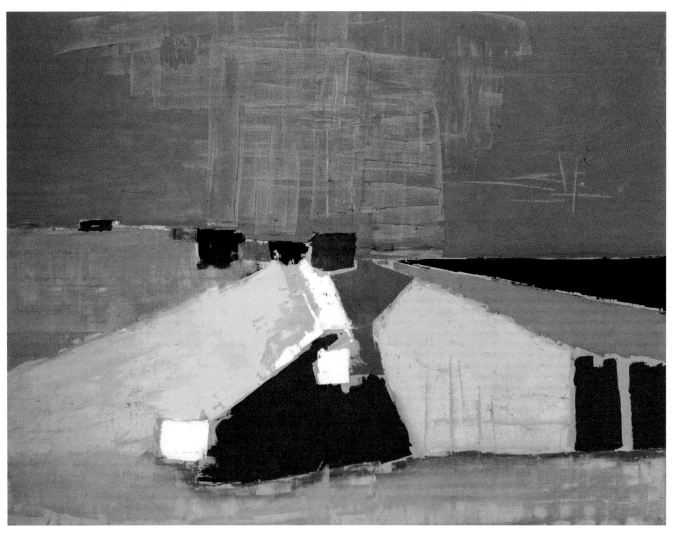

Sicile, 1955 © Nicolas de Staël / IVARO 2011.
Photo: © Grenoble, Musee de Grenoble / Scala, Florence.

Kandinsky's Colourful Life

Green, blue, yellow, pink, red, purple, black and white seem to explode from the canvas. The colours shimmer like reflections on water, resonate like the dissonant notes in Ravel's music. Could those be flowers on the lower right? The circle a human head? It's hard to resist seeking forms in abstract art, and with Kandinsky one is never certain that all figuration has been definitively banished. Kandinsky's *Painting With a Circle* (1911) is considered the world's first abstract painting, though it was several years before the painter's assistant wrote on the back of it: 'First non-objective.' The historic work, which now belongs to the National Museum of Georgia, was considered lost during the reign of the Soviet Union. It was shown in Paris, along with one hundred other Kandinsky paintings, at the Centre Pompidou in 2009.

Kandinsky told his pupil and mistress Gabriele Münter that he'd been thinking of 'painting without objects' since his youth in Moscow. Kandinsky wanted the public to strain to see what he'd hidden. As he progressed towards abstraction, the horses, archers and mountains of his early works fade to mere allusions. Later, fascinated by science, he would decorate his canvases with fantastical forms evoking microscopic creatures, cuneiform, hieroglyphs, or an astronomer's view of the heavens.

Many of Kandinsky's early compositions concentrated forms and colours at the top. 'For years, Kandinsky's canvases were hung upside down,' said Christian Derouet, curator of the exhibition at the Centre Pompidou. 'Aesthetic habits had not accustomed people to looking at top-heavy canvases.'

The show at the Pompidou Centre marked the first time that the three main collections of Kandinsky's work, from the Städtische Galerie im Lenbachhaus in Munich, the Guggenheim Museum in New York and the Centre Pompidou, were brought together, spanning the artist's entire career.

The distribution of Kandinsky's work over three museums reflects his life story. The artist's early work was kept by Münter, with whom he lived from 1904 until 1914. The American millionaire Solomon Guggenheim purchased his first Kandinsky paintings, including *Composition VIII*, when he visited the artist in Germany in 1930. Guggenheim would snap up much of what the Nazis rejected as 'degenerate art', including the finest Kandinsky paintings. The painter's widow Nina gave her collection to the Centre Pompidou in Paris.

The brilliant colours of Kandinsky's 'impressions' and 'improvisations' — of which he painted some two hundred between 1910 and 1914 — constitute the best-known period of his extremely varied oeuvre. He described his wonder at opening tubes of paint as a child: 'Those strange beings we call colours came out one after

another, living in and for themselves, autonomous, endowed with all the qualities needed for their future autonomous life and ready at any moment to mingle with one another and form new combinations, blending into each other to create an infinity of new worlds.'

Kandinsky was fascinated by theosophy, a late-nineteenth-century search for spirituality that incorporated aspects of Buddhism and Brahmanism. In his paintings, he sought to express inner meaning, as opposed to the superficial reality shown by repesentational art.

Wassily Kandinsky was born in Moscow in 1866. His father was a tea trader from eastern Siberia, his mother from a wealthy Moscow family. He studied law at Moscow University, married his cousin Ania and seemed destined for a quiet life as a professor. But at the age of thirty, he decided to become a painter. He took his wife to Munich and the couple settled in the artistic neighbourhood of Schwabing. Ania tired of the Bohemian life — and doubtless of Kandinsky's relationship with Münter. She returned to Moscow in 1904. The couple divorced in 1911.

Kandinsky's earliest paintings were marked by his love of Russian and German folklore. His *Couple on Horseback* (1906-07) is intensely romantic. *The Colourful Life* (1907), painted in the same, almost pointillist style against a dark background, contains Kandinsky's favourite themes: the onion domes of the Kremlin, a horseman, an oarsman rowing.

Kandinsky and Münter travelled for four years in Europe and north Africa. On their return, she purchased a house in the countryside at Murnau, where most of the German avant-garde congregated. It was a prolific period for Kandinsky, during which his work shows the influence of van Gogh, Gauguin and the Fauves, for example in *The Blue Mountain* (1908-09), in which trees are bright yellow and red, horsemen pink and green.

In *Lyrical* (1911), one must look closely to see the horse and rider galloping furiously across the canvas, as if pursued by the dark forms behind and above them. The spare outline of the horse evokes prehistoric cave art.

Kandinsky participated in successive artistic groups. In 1911, with his friend Franz Marc, he founded *Der Blaue Reiter* (The Blue Horseman). This brief, brilliant period in German art ended with the onset of the First World War. 'The *Blaue Reiter* was two people: Franz Marc and me,' Kandinsky wrote after Marc was killed at Verdun. 'My friend is dead. I do not want to continue alone.' The German Expressionist August Macke, a member of the *Blaue Reiter*, described Kandinsky as 'a very strange fellow, though with an exceptional talent for stimulating all the artists who came under his influence. There was something singularly mystic, or fantastic, about him, together with a certain pathos and, of course, his dogmatism.'

As a Russian citizen, Kandinsky had to return to Moscow when the war started. Conditions were difficult and he painted little. In *Moscow I* (1916), he reverts to the bright, blue-dominated palette of *The Colourful Life*. But by fragmenting and recomposing the city's houses and domes, he entered the twentieth century.

Kandinsky claimed to be able to 'hear' colours and 'see' sounds. He painted *Impression III (Konzert)* in 1911, the day after a concert of his friend Arnold Schönberg's atonal music. During his Bauhaus years (1922-33), he designed the decor and costumes for a production of Modest Mussorgsky's *Pictures at an Exhibition*.

In 1917, at the age of fifty-one, Kandinsky married Nina Andreevskaya, who was twenty-seven years his junior. 'We fell in love at first sight, and for that reason we were never apart for one day,' she wrote in her memoirs. Kandinsky worked for the Soviet government, establishing a fine arts academy and twenty-two regional museums. He and Nina went to Berlin on a semi-official mission at the end of 1921, and never returned.

The architect Walter Gropius invited Kandinsky to join the Bauhaus in Weimar. The school was a centre of modernism and experimentation in the arts. It advocated simplified forms, and harmony between function and design. But it was distrusted by conservative Germans, who drove it from Weimar to Dessau to Berlin, before it was shut down by the Nazis in 1933.

At the Bauhaus, Kandinsky formed a close friendship with the painter Paul Klee. For his sixtieth birthday in 1926, his fellow professors gave him their own works of art.

Kandinsky's *Several Circles* (1926) conveys a sort of cosmic harmony and is considered the most representative of his Bauhaus period. In a letter to an art historian friend, he wrote that the circle was '(1) the most modest form, but asserts itself unconditionally; (2) a precise but inexhaustible variable; (3) simultaneously stable and unstable; (4) simultaneously loud and soft; (5) a single tension that carries countless tensions within it'.

In 1933, the Kandinskys moved to the Paris suburb of Neuilly, where they would remain until his death from pneumonia in December 1944. Kandinsky had the rare distinction of having been a citizen of Russia, Germany and France. During the German occupation of France, he turned down an offer of asylum in the US.

In Paris, Kandinsky's friends were the Delaunays, Léger, Miró, Mondrian, Chagall, Max Ernst and Brancusi. The Surrealists acknowledged his influence, and some art critics classified Kandinsky's work as Surrealist.

Kandinsky's paintings in France were a blend of pure abstraction, Surrealism and biological and zoological motifs borrowed from natural science. The effect is enigmatic, often humorous. Kandinsky considered *Dominant Curve* (1936) one of the most important paintings of his Paris period. In photographs of his artist's studio after Kandinsky's death, two paintings were set on easels on either side of the dead painter: *Movement I* (1935) and *Mutual Agreement* (1942), the last full-size canvas he painted.

Abstract painting would flourish in the decades after Kandinsky, and the psychedelic art of the 1960s and 1970s owed much to him. At age sixty, Kandinsky said he wished to live at least another fifty years 'in order to be able to delve into art ever more deeply'. He complained that 'one is forced to give up much too soon ... But perhaps one will be able to continue in the great beyond.'

This chapter is based on 'Kandinsky,' organised jointly and exhibited by the Städtische Galerie im Lenbachhaus in Munich, the Centre Pompidou in Paris and the Guggenheim Museum in New York from October 2008 until January 2010.

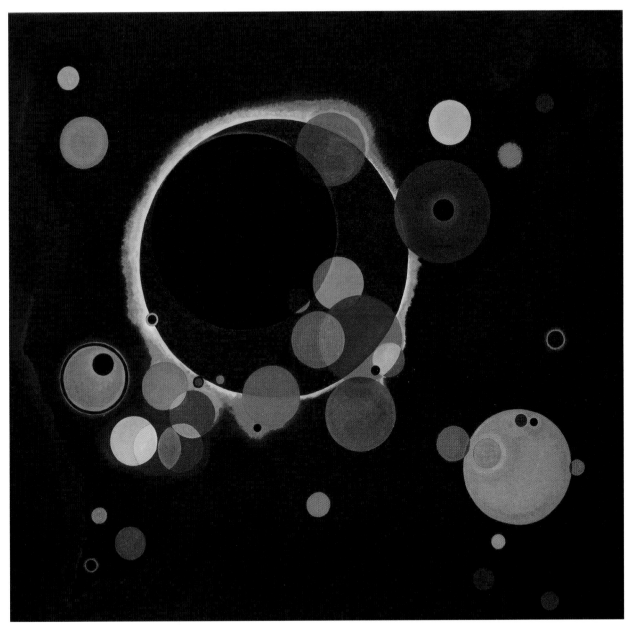

Several Circles, 1926 © Wassily Kandinsky / IVARO 2011.
Photo: © Solomon R. Guggenheim Museum, New York.

Where Would We Be Without Surrealism?

A winged insect clings to the belly of an amorphous form resembling a man's head, which grows into the bust of a beautiful woman with her eyes closed and her nose nudging a man's genitalia. Blood vessels course like the tributaries of a river over the woman's face, while a phallic Easter lily lies against her breast. Seashells suggest an ear; a swarm of ants, fecundation. A tiny male figure embraces a jagged stone. The gradated blue sky, black shadows, rocks, a hook and bleeding cuts place us in Salvador Dalí's nightmarish, erotic dreamworld. Before the Surrealists, no one would have dared to paint such a painting; no one but Dalí would have named it *The Great Masturbator*.

For three decades preceeding 'The Surrealist Revolution' at the Pompidou Centre in 2003, France had not held a major exhibition of Surrealist art. Werner Spies, the curator of the show, was particularly proud to count *The Great Masturbator*, from the Museo Nacional Centro de Arte Reina Sofia in Madrid, among the six hundred works he showed. It was, he explained, 'one of the most difficult paintings to borrow, and the most extraordinary work of the artist'.

Spies spent five years organising the exhibition, but said it was in gestation since he first met Max Ernst in 1996. The author of the *catalogue raisonné* of Ernst's work and the former director of the French national museum of modern art, Spies described Surrealism as 'the only successful revolution of the twentieth century' because it changed attitudes to art and society and our very perception of the world. 'The Surrealist Revolution' was also the title of the review which the group began publishing in 1924.

Without the Surrealists, it is impossible to imagine the subsequent history of cinema, advertising, the pop art and psychedelic movements. That the word 'surreal' so often replaces other terms – bizarre, strange, unusual, extraordinary, fantastical, absurd – in everyday vocabulary shows how completely it has permeated our thinking.

The Surrealist Manifesto, published by the 'pope of Surrealism', André Breton, in 1924, combined the two most influential thinkers of the previous century, Karl Marx and Sigmund Freud. From Marx, the Surrealists took their ambition 'to change the world'; from Freud's *Interpretation of Dreams*, their belief in the creative power of the subconscious. Most of the Surrealists joined the Communist Party, though some – like Dalí (who was fascinated by Hitler and Franco) – were expelled by the doctrinaire Breton.

Violon d'Ingres, 1924 ©
Man Ray / IVARO 2011.
Photo: © Scala, Florence.

Surrealism grew out of the post-First World War Dada movement, which called itself non-art or anti-art, but was in essence a nihilistic rejection of the civilisation that created the war. Surrealism kept the provocative, humorous approach of the Dadaists, but introduced a constructive and uninhibited determination to explore the 'more real than real world behind the real'.

A cosmopolitan mix of artists, all born around the beginning of the twentieth century, helped make Dadaism and Surrealism truly international movements, anchored in Paris, from their inception. (The term 'Surrealist' was taken from the subtitle of a play by the first great modern French poet, Guillaume Apollinaire, who died in the 1918 flu epidemic.) Max Ernst and Hans Arp were German; Francis Picabia, Cuban; Man Ray, American; René Magritte, Belgian; Roland Penrose, English; Giorgio de Chirico, Greco-Italian; Salvador Dalí and Luis Buñuel, Spanish; and Tristan Tzara, Romanian.

In 1925, Pierre Naville wrote that there was 'no such thing as Surrealist painting' because dreams and imagination could not be painted. It is a persistent prejudice, especially in France, where the literary aspects of the movement left a more lasting impression.

Yet Walter Spies's 2002 exhibition at the Pompidou Centre proved Naville was wrong; that Surrealism retains a unique and magical quality.

Two de Chirico canvases from 1914, *Premonitory Portrait of Guillaume Apollinaire* – with a dotted circle showing where the poet would be wounded in the head – and *Song of Love*, in which a pink rubber glove is thumb-tacked next to a plaster replica of the Belvedere Apollo, showed how much the Surrealists owed to the inventor of the *pittura metafisica* in modern Italian art.

Max Ernst's 1922 group portrait of *Le Rendezvous des Amis* includes the original members of the Surrealist movement against an Alpine background, and threw in Dostoyevsky and Raphael Sanzio for laughs. Ernst lived for a time in a ménage à trois with Paul and Gala Eluard, who also appear in the group portrait. (Gala later left her poet husband for Salvador Dalí.)

In 1923, Ernst painted a mural of turgid artichoke plants, ant-eaters and insects in a garden, on the wall of the house he shared with the Eluards in the Paris suburb of Eaubonne. A woman's hand with crossed index and middle fingers holds a red ball though an opening in the fresco. Forty-five years later, Ernst returned to the house, which was by then inhabited by a butcher, who had painted and papered over his mural. The mural was retrieved and cut in two, on Ernst's instructions. An art dealer sold one panel to the Dusseldörf Museum. Farah Diba, the former empress of Iran, bought the other. After the revolution, it ended up in storage in the Tehran Museum of Contemporary Art. Thirty-four years later, Spies reunited the two panels for the exhibition at the Pompidou Centre.

Doubtless the silliest criticism of 'The Surrealist Revolution' was made by *Le Monde* newspaper, which complained that there was 'a bit too much Dalí' in the exhibition. Who could fail to marvel at the originality and craftsmanship of *Partial Hallucination, Six Images of Lenin on a Piano*, or the unleashed tigers in *Dream Caused by the Flight of a Bee*? Among the Surrealists, only Magritte attained a comparable level of genius in oil paint, but his canvases are coolly calculated, intellectual games compared to Dalí's wild fantasies.

The Surrealists used an impressive number of techniques. Max Ernst invented frottage when he was inspired to rub pencil-lead over a wooden floor in a house in Brittany. He was also a master of collage, another favourite Surrealist art form. André Masson's 'automatic drawings', in which he squirted glue on canvas, threw sand on the glue and then painted in haphazard fashion, prefigure Jackson Pollock's work more than twenty years later.

The *cadavres exquis*, a group effort in which each artist added a feature, uninfluenced by what was painted before or after his contribution, grew out of a game in which words were written on a folded piece of paper. The first such experiment resulted in the eminently surreal sentence: *'le cadavre – exquis – boira – le vin – nouveau'* ('the exquisite cadaver will drink the new wine').

In their *Abridged Dictionary of Surrealism*, Breton and Eluard listed 'real and virtual, mobile and silent objects, ghost objects, interpreted objects, incorporated objects, to be objects, etc.' The playful fascination with the barrier between the imaginary and physical led to works such as Magritte's painting of a piece of cheese, under a genuine glass cheese bell, entitled *This is a Piece of Cheese*.

Man Ray's photograph of a nude woman is a joke on several levels: black curlicues show her back to have the shape of a violin. The title, *Violon d'Ingres*, means a hobby or pastime in French, and the model's Oriental turban and earring make her look like a painting by Ingres, who played the violin in his spare time.

In 1936, the Charles Ratton gallery in Paris held an 'Exhibition of Surrealist Objects' which Spies reconstructed in the Pompidou Centre. The objects included a fur-covered breakfast cup, saucer and spoon by Meret Oppenheim, Man Ray's iron with nails and Dalí's Bakelite telephone with a red lobster clutching the receiver.

Spies says that Surrealism ended in 1942, when many of the artists fled to New York. Other art historians claim it lasted until the 1960s. But as the dreary, final rooms of the exhibition at the Pompidou Centre made clear, the onset of the Second World War drained the movement of its energy and humour.

This chapter is based on 'The Surrealist Revolution', at the Centre Pompidou in Paris from March to June 2002.

Magritte

In December 1929, the writer André Breton summoned his fellow Surrealists to a meeting in his Paris apartment. 'Someone here is wearing a thing I cannot abide; I cannot continue until they remove it,' he said, indicating the gold crucifix around the neck of Georgette Magritte, the wife of the Belgian painter René.

Mrs Magritte explained that she was not a practising Catholic, but the crucifix had belonged to her grandmother and had sentimental value. Breton persisted.

René and Georgette had rented a flat in the Paris suburb of Le Perreux for the previous eighteen months, so that he could participate in the Surrealist movement. But Breton's bad manners made up René's mind.

'Come on, Georgette,' Magritte said, extending an arm to his wife: 'We're going home to Brussels.'

That break with Breton lasted for two years, and Breton, the self-declared 'pope of Surrealism', would eventually 'excommunicate' Magritte in 1947. It was in any case questionable whether a painter who calculated his images so carefully belonged in a movement allegedly based on hazard.

Magritte's talent and fame ensured his place in twentieth-century art regardless; as an inventor of images, precursor of pop art, hyper-realism and conceptual art.

The humour, cruelty and irony of Magritte's painting was belied by his bourgeois existence. He always wore a double-breasted suit and neck-tie, perhaps a tribute to his father, Léopold, a tailor. The bowler hat, a constant theme in Magritte's painting, may have something to do with the fact that his mother, Régina, was a hat-maker.

When Magritte was thirteen, his parents displayed his first painting, of two horses escaping from a stable in flames. A sense of impending doom would recur often in Magritte's work. His burning musical instruments would later be copied by Salvador Dalí.

The following year, Régina Magritte committed suicide by drowning herself in the Sambre river. Someone placed a cloth over the dead woman's face, leaving an indelible impression on her fourteen-year-old son.

In 1928, his most productive year as a painter, Magritte painted figures shrouded in cloth. In *The Invention of Life*, a woman stands next to a veiled figure who is strikingly like an Afghan woman in a burka, perhaps her double. In *The Symetrical Ruse*, two veiled forms flank the lower body of a woman, a cloth covering the waist where it seems to have been amputated.

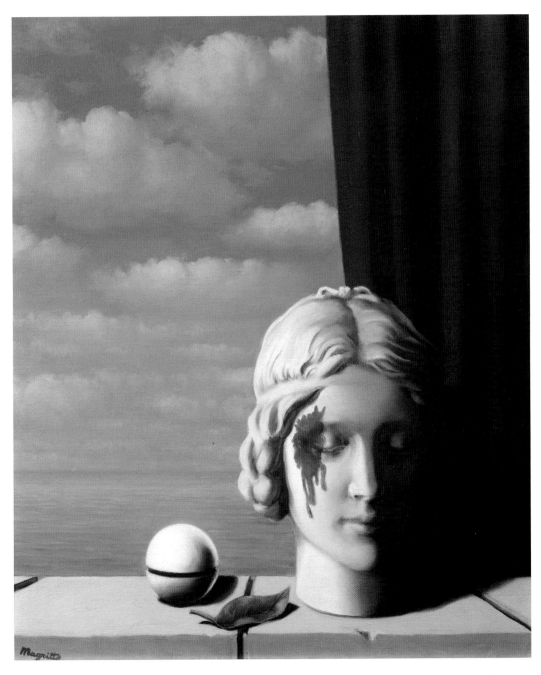

La Mémoire, 1948
© René Magritte /
IVARO 2011. Photo:
© Scala, Florence.

In two versions of *The Lovers*, Magritte painted a couple snuggling and kissing, their faces hidden by cloth. We always hide ourselves, even in love, he seemed to be saying. Magritte never talked about his own life, describing himself as 'a black box'.

Back in Brussels, René and his inseparable wife and model, Georgette, lived quietly in a semi-detached bungalow at 97 rue des Mimosas. Georgette kept the furniture and baby grand piano polished, the knick-knacks dusted. René was careful not to spill paint on the Oriental carpet in his upstairs studio. Except for rare trips abroad for exhibitions and to meet art dealers, the Magrittes rarely travelled.

René Magritte marked the Nazi occupation of Belgium with an odd 'Renoir period', during which he painted sunny Impressionist pastiches with Surrealist motifs, such as a tiny ballerina dancing in a fiddler's lap.

Immediately after the war, Magritte again broke his own style, entering his garish *Vache* (literally 'cow' but also 'rude' or 'unpleasant' in slang) period. It was a commercial failure, and Georgette urged him to return to his pre-war style of almost academic execution.

Magritte enjoyed success in the last two decades of his life. There were fifteen Magritte exhibitions in New York before the painter's death in 1967, including a major retrospective at the Museum of Modern Art in 1965.

The Magritte exhibition at the Jeu de Paume in 2003 was the first in France for twenty-three years. The curator, Daniel Abadie, excluded the painter's early works, which were inspired by the Fauves and Cubists, so the public were immediately confronted by his Surrealist paintings from the mid-1920s. These were strongly influenced by Magritte's 'discovery' of the Italian Giorgio de Chirico, of whom he said, 'His was a new vision where the viewer found again his own isolation, and heard the silence of the world.'

Although there is a dream-like quality to many of Magritte's paintings, unlike Dalí, he emphasised the importance of mystery over dreams. When choosing a subject for a painting, Magritte said, he sought 'an image that defies all attempts to explain it'. The effect is often unsettling, as in *Memory*, in which a classical statue of a woman's head sits on a parapet before the sea and sky, its closed right eye splashed with blood. A small, UFO-like sphere with a line around its circumference – a recurring theme in Magritte since the 1920s – sits beside the woman's head, and a curtain is drawn behind the right third of the painting. Other paintings – the gutted birds in *Murderous Sky* and *Young Girl Eating a Bird* – are incredibly savage.

Yet Magritte could be humorous too, when he mocked our sense of permanence by perching a small wooden chair atop a fossilised stone chair in *Legend of the Centuries*, or when he superimposed Botticelli's Flora on the back of a bowler-hatted man in *The Bouquet All Ready*.

Magritte's titles were works of art in their own right, the product of weekly brain-storming sessions with poet friends. In one canvas, a self-portrait of Magritte at his easel, the artist looks at an egg and paints a bird. The title: *Clairvoyance*.

Magritte's repetition of figures in *La Golconde*, in which bowler-hatted, overcoated men are repeated, was copied by pop-artists, especially Andy Warhol. More than a decade before Warhol, Magritte painted $100 bills.

From the late 1950s, the 'neo-Dadaists' Jasper Johns and Robert Rauschenberg also used Magritte-like methods. Johns owns Magritte's *The Key to Dreams*, in which ordinary objects – a horse, a clock and a pitcher – are mislabelled 'the door', 'the wind' and 'the bird'. The last image, a suitcase, is correctly labelled 'the valise'. Similarly, in his own painting *False Start*, Johns mis-labelled colours.

Magritte transformed the very substance of his subjects, turning a woman's flesh into grained wood, a tree's bark into bricks, birds into plants and fossils. And he toyed with natural affinities between humans and objects, painting a woman's breasts on a nightgown suspended from a hanger, or boots transmogrifying into toes. Claes Oldenburg would also play on reality, sculpting a droopy, soft toilet, and a cardboard bathtub that would become soft like his other sculptures if used for its ostensible purpose.

Since Magritte's death, at least fifty brand names have appropriated his pictorial repertoire for advertising. Imitation may be the most sincere form of flattery, but it's not certain Magritte would have appreciated the compliment. In his early years as an artist, he hated having to design wallpaper and posters to earn a living.

This article is based on 'Rétrospective Magritte' at the Jeu de Paume in Paris from February to June 2003.

De Chirico

The Enigma

Giorgio de Chirico entitled one of his first self-portraits *And what shall I love, if not the enigma?* The forefather of Surrealism would vie with Modigliani for the distinction of most famous Italian painter of the twentieth century. But decades after his death in 1978, at the age of ninety, Chirico remains an enigma. We don't know what, if anything, his haunting paintings of deserted piazzas mean. Chirico's metaphysical paintings, as he called them, convey alienation, the unease of a disturbing dream. They are a silent tribute to the incredible strangeness of being.

The intense, variegated skies, Italianate architecture, statues and shadows of Chirico's metaphysical paintings long ago entered our universal museum. Describing his first trip to Europe in *Dreams from My Father*, Barack Obama wrote: 'I crossed the Plaza Mayor at high noon, with its de Chirico shadows and sparrows swirling across cobalt skies . . . '

There is no rhyme or reason to Chirico's shadows. In *Metaphysical Interior (with Big Factory)* (1916), shadows slant in several directions. Chirico has many ways of disorienting us: incongruous juxtapositions, for example the branch of bananas next to a Venus de Milo–like sculpture in *The Poet's Uncertainty* (1913); the multiple vanishing points in *Gare Montparnasse or the Melancholy of Departure* (1914).

Nor can anyone explain why an artist of such talent seemingly lost his way in the 1930s, 1940s and 1950s, painting kitsch still lifes and garish copies of fourteenth- and fifteenth-century Italian masters. These canvases are so embarrassingly bad that museums shunned them and collectors did not want their valuable Chiricos to be shown alongside them. In 2009, the Musée d'Art moderne de la Ville de Paris held the first major Chirico exhibition in twenty-six years. Unlike previous exhibitions, it brought together paintings from Chirico's entire career — not just those works that found favour.

Chirico was born of Italian parents in Greece in 1888, and began studying art as a teenager in Athens. Allusions to Greek mythology, particularly Ariadne, the Cretan princess who helped her lover Theseus subdue the Minotaur, then married Dionysus, abound in his paintings. In *Square with Ariadne* (1913), her statue reclines parallel to a colonnade, with a train heading towards a tower on the horizon. Ariadne crooks an arm over her head, and bends one knee.

Statue or human? With Chirico, one is never sure. In *Morning Meditation* (1911-12), another reclining statue stares at the sea. Statues and humans co-exist, like the living and the dead. A cane rests against a wall. Weeds grow among broken paving stones. It is as if one had arrived in the distant aftermath of war.

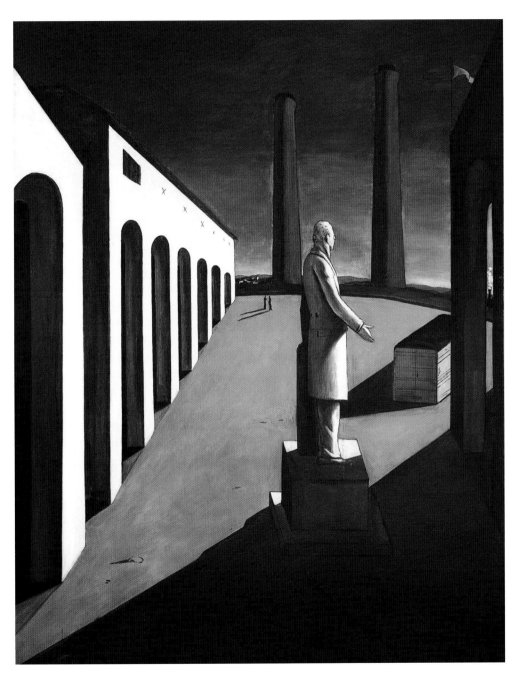

The Enigma of a Day,
1914 © Giorgio de
Chirico / IVARO 2011.
Digital Image: © The
Museum of Modern
Art / Scala, Florence.

Jacqueline Munck, the curator of the 2009 exhibition, said that in Chirico's painting, 'Time is a human affair, but it is not reality. He was strongly influenced by Nietzsche and Schopenhauer. Their philosophy inspired him to eliminate what was human, to *chosifier* everything – turn everything into objects.'

When Chirico painted himself, he never attempted to improve his weak chin and prominent nose. 'The self-portraits are about seeing oneself as someone foreign,' Munck said. In his 1922-24 self-portrait, Chirico painted a bust of himself staring at a Renaissance-like self-image, in three-quarter profile. A beautifully rendered lemon seems to sit on a windowsill before them. It was a turning point, towards realistic, classical painting.

Chirico painted dozens of self-portraits. In the 1940s and 1950s, he portrayed himself in seventeenth-century costume, with velvet breeches and plumed hats. The effect is comical, not unlike the work of the US photographer Cindy Sherman. Was Chirico humorous? Or slightly cracked? In its brutal honesty, Chirico's 1945 nude self-portrait, in which the painter sits on a chair, clothed only by a loincloth, is reminiscent of Lucian Freud. It is one of the rare Chirico canvases void of mystery. 'It is the naked portrait of a ruin who was once a genius,' Max Ernst wrote in 1946. 'A weak, totally asexual body, falling cheeks and the pallor of a man who is already almost dead. There is something very convincing in this portrait, as if a painter painted his own body after death.'

Chirico's father was an engineer who built infrastructure for the Italian national railway. We sense his unhappy grip on the painter in innumerable try-squares, T-squares and other draughtsman's paraphernalia, and in repeated paintings of prodigal sons returning. Chirico often painted his mother and brother, never his father. In *The Enigma of a Day* (1914), a statue of a father or commander, austere and inaccessible, turns its back to the viewer, gazing towards the horizon.

Chirico suffered from recurring depression and an intestinal ailment. 'He turned inward when he was suffering,' Munck said. 'It was probably in those moments of isolation that he created distance from himself, the way one distances pain when one feels badly.' More detached than tormented, Chirico said his paintings came to him in 'revelations'.

It was in Paris, where he followed his younger brother, also a painter, that Chirico began the metaphysical paintings that made him famous. In 1912, he was 'discovered' by the great poet and art critic Guillaume Apollinaire, who called Chirico 'the most surprising painter of the young generation'. Writing in *L'Intransigeant* in October 1913, Apollinaire described the contents of Chirico's atelier at 115 rue Notre-Dame-des-Champs: 'The art of this young painter is an interior, cerebral art which has nothing to do with that of painters who have revealed themselves in recent years.'

In Chirico's 1914 *Portrait of Guillaume Apollinaire*, a classical bust wears dark glasses, symbolising the blind poet of antiquity. A fish and seashell are placed incongruously beside the statue. Apollinaire's dark silhouette lurks behind these symbols. With eerie premonition, Chirico placed a circle on the poet's temple, where he would later be wounded by shrapnel in the First World War. In exchange for the painting, Chirico asked Apollinaire to dedicate a poem to him.

Through Apollinaire, Chirico met the luminaries of the pre-First World War art world: Picasso, Derain, Max Jacob, Braque . . . Apollinaire introduced Chirico to the art dealer Paul Guillaume, who contracted to buy six paintings a month, for a total of 120 French francs.

Breton, Eluard and Aragon, the future theoreticians of Surrealism, collected Chirico's works, which were admired by Magritte and Ernst. Years later, as Ernst recounted, Chirico deliberately provoked Breton, showing him and Giacometti his garish postcard-like paintings

of Venice and Naples. When Breton expressed nostalgia for Chirico's metaphysical paintings, the artist rounded on him: 'It's the easiest thing in the world to do this type of painting, even if there are people who are stupid enough to buy them.' Breton, the 'pope' of Surrealism, 'excommunicated' Chirico.

Chirico and his brother had gone home to join up when Italy entered the First World War in 1915. They were given administrative jobs in Ferrara, whose Renaissance architecture inspired more of Chirico's metaphysical paintings. Chirico became a close friend of another art dealer, Mario Broglio, who described Chirico's paintings as 'a unique example of melancholic and tragic irony'. In Chirico's hybrid paintings, faceless mannequins sometimes have feet or other human characteristics, but their bodies are, for example, comprised of ancient ruins, as in *The Archaeologists* (1927). Amputated arms are capped by barbell-like contraptions. In *Furniture in a Valley* (1927), the two empty armchairs that face each other in the open air seem to be an allegory for the impossibility of human communication. 'Learn to express the hidden voice of things, that is the path and the goal of art,' Chirico wrote in 1938.

Throughout his life, Chirico painted 'replays', copies of works from his metaphysical painting period. This duplication was interpreted as a form of self-destruction, a deliberate attempt to drive down the value of his early paintings.

The later replays, such as *Italian Square — the Great Game* (1968) have a lighter palette and humorous, cartoon-like quality not present in the original paintings. Fiery suns and crescent moons appear, linked by cables to fires or shadows.

Chirico's self-derision is evident in *The Return of Ulysses* (1968). The Greek hero, his alter ego, rows on a sea the size of a bedroom carpet, surrounded by parquet floor, chairs and a wardrobe. He has travelled the world, and ends up in a bourgeois bedroom. A Chirico painting hangs on the wall, and in the distance, outside the window, stands a Greek temple.

Chirico's Revolt

Giorgio de Chirico cast doubt on the authenticity of his own paintings by formally disowning hundreds of the copies he made of his own work.

The question arose again in 2009, when the Pompidou Centre bought Chirico's *The Ghost*, also known as *The Return of Napoleon III* or *Napoleon III and Cavour* for €11 million at the Yves Saint Laurent–Pierre Bergé sale.

Painted in Ferrara in 1917-18, *The Ghost* shows the upper part of a classical column transmogrifying into Napoleon III, alongside a headless, mannequin-like figure.

In 1972, Chirico stormed into a Surrealism exhibition at the Musée des Arts Décoratifs in Paris and announced that four paintings bearing his signature, including *Napoleon III*, were fakes and that he wanted them destroyed. Lawyers and experts argued until after Chirico's death.

Munck believed, that *The Ghost* was authentic. 'He sent drawings to Gala Eluard. He described in letters what the painting looked like ... Even the de Chirico Foundation reversed its decision and certified it as real; otherwise Christie's could not have sold it,' she said.

What motivated Chirico? 'He did it at a period when he was totally exasperated by the controversy over his metaphysical works and the "replays" he made,' Munck explained. 'He was deeply revolted by the art market.'

This chapter is based on 'Giorgio de Chirico, la fabrique des rêves' at the Musée d'Art Moderne de la Ville de Paris, February-May 2009.

Modigliani

Amedeo Modigliani's brief, tragic life resembled an early twentieth century version of *La Traviata* or *La Bohème*. The Italian Jewish painter came to Paris in 1906 at the age of twenty-two. His handsome face, fine manners and generous spirit made him popular with the Bohemian artists and writers of Montmartre and Montparnasse.

From childhood, the painter battled pleurisy, typhoid, scarlet fever and tuberculosis. In the cafés of First World War Paris, he showed a huge appetite for life, seducing women and indulging in hashish, opium and alcohol. When he drank too much, Modigliani recited Dante for hours.

In 1917, Modigliani fell in love with an art student and model fourteen years his junior, Jeanne Hébuterne. Their daughter was born the following year. Jeanne was eight months pregnant with their second child when a friend found Modigliani dying in her arms in their garret. 'I know it will soon be over,' he murmured. 'Before you take me to hospital, let me kiss my wife. We have agreed on eternal bliss.' Modigliani died three days later, at the age of thirty-six , of tubercular meningitis.

Jeanne came to the hospital room, cut a lock of her hair, which she placed on his chest, then, staring at her lover's body, walked out of the room backwards. She went to her parents' apartment at 8 rue Amyot, behind the Irish College in the Latin Quarter, and in the early hours of the morning threw herself from a fifth-floor window. The couple's surviving daughter, also called Jeanne, was raised by Modigliani's spinster sister Margherita.

The Polish poet and art dealer Leopold Zborowski took up a collection in La Rotonde and Le Dôme – brasseries still haunted by the memory of Modigliani – and a thousand people followed his flower-laden casket to Père Lachaise cemetery. For years, Modigliani had charged ten francs and a drink for a portrait. Sometimes he painted both sides of a canvas to save money. But in the last months of his life, following an exhibition organised by Zborowski in London, he was obtaining recognition. The price of his portraits rose to six hundred francs. In his funeral procession, speculators offered the painter's grieving friends up to 400,000 francs for a canvas.

Modigliani's legend was born the moment he died. It continued to flourish, perhaps to the detriment of his artistic reputation. The great French actor Gerard Philipe played the impoverished, diseased painter in a 1957 film. Most of his work was bought by private collectors, so Modigliani's story became better known than his oeuvre. Several of his paintings change hands at auction every year. Records were set in 2010, when his 1910–12 sculpture of an elongated head with almond eyes fetched €43.18 million at Christie's in Paris, and *Nude Sitting on a Divan* (1917) sold for €55.56 million at Sotheby's in New York.

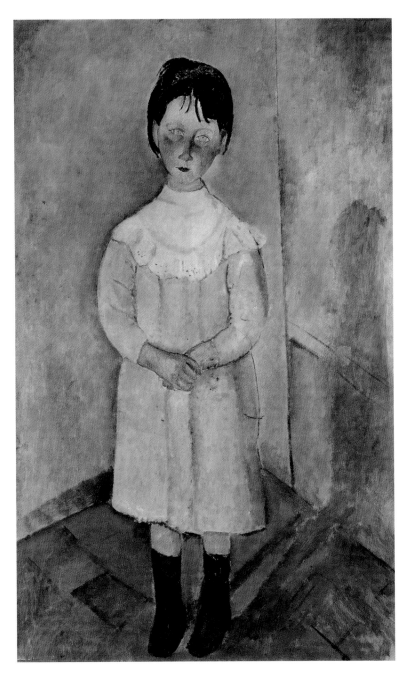

Petite Fille en Bleu, 1918, Amedeo Modigliani. Photo: © White Images / Scala, Florence.

The art historian Marc Restellini was the curator of *Modigliani, l'ange au visage grave*, the largest ever compilation of his work, at the French Senate's Musée du Luxembourg from October 2002 to March 2003. Twenty years had passed since Modigliani was shown in Paris, and this magnificent exhibition brought together 110 canvases – close to one-third of all Modigliani's paintings – thirty drawings, and one sculpture. Seventy paintings were lent by private collectors, whom Restellini coaxed into parting with their treasures temporarily. Dozens had not been seen in France, and some, such as the 1909 *Beggar of Livorno*, had never been shown in public.

During his first years in Paris, Modigliani was influenced by Cézanne, Gauguin, Toulouse-Lautrec, Fauvism, Expressionism and Cubism. But by 1916 he had developed a style all his own, belonging to no school but immediately recognisable.

Modigliani never received the academic consideration he deserves, Restellini said. 'He was one of the great painters of the twentieth century, on a par with Picasso or Braque. We must rehabilitate him. Modigliani is too popular. When that distorts the approach to the artist, it's a problem; his work is not understood.'

Forgeries have also been an obstacle to serious study of Modigliani. Some were 'authenticated' by two of the artist's friends when they fell on hard times in the 1950s: Zborowski's widow Hanka and Lunia Czechowska, both of whom modelled for him. So many fakes made their way into the market that publication of Restellini's *catalogue raisonné* of Modigliani's work had to be postponed repeatedly. Restellini nonetheless insisted that modern techniques, including infra-red, magnetic scans and chemical analysis made it possible to establish authenticity with certainty.

Modigliani wanted to be a sculptor. In his first years in Montmartre, he asked masons on building sites for leftover stone. 'The dust from chiselling irritated his throat and his lungs, and he had to stop sculpting temporarily,' his daughter Jeanne wrote. 'Then he'd resume for short periods.' Wood was easier to work with, and Modigliani stole railway ties from Paris Métro construction sites. He shared an atelier with Constantin Brancusi and completed about twenty figures, mostly elongated busts of women.

'Nearly all are in fact the same statue, constantly recommenced with a definitive form in mind, which I believe he never attained,' wrote Paul Alexandre, Modigliani's friend, doctor and benefactor.

'Happiness is an angel with a solemn face,' Modigliani wrote in a postcard to Alexandre in 1913. He signed the card *'Le Ressuscité'* — the risen one — an allusion to near-fatal bouts of tuberculosis. 'Sculpture is too hard a profession,' Modigliani admitted with resignation. 'I am beginning to paint.' His rarely seen drawings and paintings of a series of crouching women caryatids, which he intended to form the foundation for a 'temple of beauty', were shown in the 2002-03 exhibition.

From about 1910, Modigliani's artistic life shifted from Montmartre to Montparnasse, where Zborowski let him use his sitting room as a studio. 'Zbo' — who was far from wealthy — gave Modigliani a stipend and even funded a long stay in Nice with Jeanne in the hope that the climate would improve his health.

Modigliani was 'worth two Picassos', Zborowski told his wife. Modigliani painted the Polish poet several times. With his unkempt hair, short beard and hands folded confidently across his chest, 'Zbo' looks surprisingly contemporary.

Czechowska, a close friend of the Zborowskis, was one of Modigliani's favourite models. In her memoirs, she recounted their first meeting, in 1916. 'I can still see him, crossing the boulevard Montparnasse, a very handsome boy, wearing a big, black felt hat, a corduroy suit and a red scarf. There were pencils sticking out of his pockets, and

he held a huge portfolio ... I was struck by his distinction, his radiance, the beauty of his eyes. He was at the same time very simple and very noble. He was different from other people, down to the tiniest gesture – the way he shook your hand ... '

The South African-born English journalist Beatrice Hastings, correspondent for the *New Age* in Paris, was Modigliani's mistress from 1914 until 1916. Their passionate, sometimes violent, affair was marked by a shared abuse of whisky and hashish. Modigliani painted fourteen portraits of Hastings.

'It is the human being that I am interested in,' Modigliani wrote. 'The face is nature's supreme creation; I use it endlessly.' He became one of the great portraitists of all time, often taking fellow painters – Chaim Soutine, Moise Kisling, Diego Rivera, Picasso – as subjects. His many renditions of Jeanne Hébuterne, sometimes pregnant, are especially poignant in view of her fate. With their long oval faces, Modigliani's women are modern Madonnas, twentieth-century descendants of Botticelli.

Modigliani's portraits often have one eye open, one closed. When one of his sitters asked why, the painter answered: 'Because you watch the world with one eye; you look into yourself with the other.' Some of his finest masterpieces have come down through the decades anonymously, the identity of the sitters forgotten.

Victoria, a long-necked young woman with a beauty spot on her chin and straight-cut fringe, painted in 1916, could only be French, with that petulant stare. Her eyes are glassy; she has not slept well, has just had a row with her lover.

The Little Girl in Blue (1918) was the signature painting for the exhibition. The child, nearly life-size, wears black boots with the toes turned slightly inward, a white eyelet collar and a pink hair ribbon. She holds her hands shyly before her and is wistful, pensive. Perhaps because the painting is devoid of the sugary sweetness that marked Renoir's child portraits, her innocence and vulnerability are disarming.

When Modigliani held his first exhibition at Berthe Weill's gallery in 1917, he hung several nudes in the window. The local police commissioner threatened to shut down the show because, he noted with outrage: 'These nudes have pubic hair!' In the ensuing scandal, not a single painting was sold.

Modigliani's voluptuous nudes still retain what his friend Jacques Lipchitz called their 'sexual frankness'. The critic Francis Carco, writing in the 1920s, said that Modigliani 'made palpitate the headiness of mysteries, the tastes, the trembling, the stickiness, the undulations: his nudes exhale a breath – the breath of life itself'.

In 1928, Shigetaro Fukushima, Japan's ambassador to France, bought one of the most sensual nudes, painted in 1917. Today, she belongs to the Osaka City Museum of Modern Art. With her back slightly arched and one hand placed suggestively on her pubis, she crooks the other arm in a come-hither gesture.

Restellini called Modigliani's portraits 'the masque of the soul'. In the painter's last canvas, a self-portrait, he holds his palette in one hand and looks from a three-quarter angle with blank, almond-shaped eyes. He strongly resembles the death masque that would be made several weeks later. In Modigliani's own premonitory words, his was the visage of 'an angel with a solemn face'.

This chapter is based on 'Modigliani, l'ange au visage grave' at the French Senate's Musée du Luxembourg from October 2002 until March 2003.

II Impressionists and Post-Impressionists

'In life and in painting, I can do without God. But I cannot, suffering, do without something that is greater than me, that is my life – the power of creating.'

Vincent van Gogh

Sargent and Sorolla

Two Painters in Similar Light

The Spanish painter Joaquín Sorolla was born in Valencia, on the Mediterranean coast, in 1863. In the summer of 1909, he returned there to paint a series of large canvases of women and children on the beach. The artistic result was a moment of pure happiness, a seaside holiday flooded with sunshine.

There were other pleasures to be found in 'Painters of Light: Sargent and Sorolla' at the Petit Palais in 2007. John Singer Sargent's portaits of American and British gentry are stunning in their beauty and grasp of psychology. But none equals the burst of joy in a room filled with Sorolla's beach scenes.

With easy, rapid brushstrokes, Sorolla painted a little girl, poised to jump into the sea. In another canvas, a nursemaid holds a parasol over a baby while two girls frolic in ankle-deep water. In *Despues del baño* (After the Swim), Sorolla painted two adolescents who had just pulled on long sleeveless dresses after a swim. Other children can be seen in the background, still in the water. The almost Grecian, classical poses and draperies prefigure *La bata rosa* (The Pink Dress).

In *Las dos hermanas* (The Two Sisters), a grinning child clutches her small sister by one hand, and shields her sun-burned face with the other, looking towards the painter, as if in a snapsnot.

As an art student, Sorolla had met the photographer Antonio Garcia, who became his patron. In 1888, Sorolla married Garcia's daughter, Clothilde, and his paintings chronicle their happy marriage. Like Pierre-Auguste Renoir before him, Sorolla marvelled at the world of women and children, which he conveyed to perfection. He was influenced by photography, and an earlier beach painting, of Clothilde at Biarritz in 1906, shows his wife sitting on the sand, holding a camera in her gloved hands.

In the 1909 series, Sorolla's wife and daughter stroll on the strand, purple-blue waves behind them. You feel the strength of the sun in the blinding white of their dresses, and the depth of the shadows. The older woman makes a half-hearted attempt to shield herself, raising a hand to her veiled straw hat. But both women seem frozen by the sun's power. Clothilde lets her parasol lapse in the breeze. Their daughter dangles her hat.

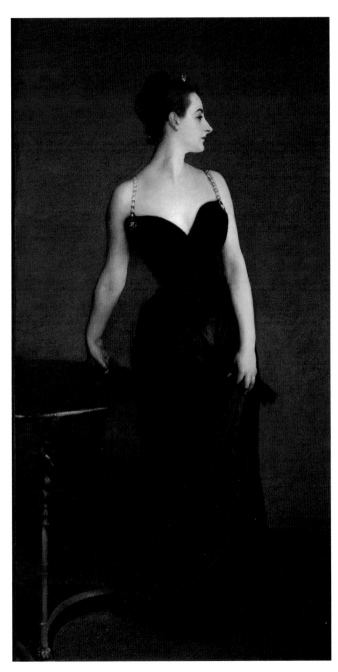

Madame X (Madame Pierre Gautreau), 1883-84, John Singer Sargent. Photo: © The Metropolitan Museum of Art / Art Resource/ Scala, Florence.

Paseo a orillas del mar (Walk by the Sea) was one of two signature paintings for the exhibition. The other was John Singer Sargent's *Lady Agnew of Lochnaw*, painted in 1892. The wife of a Scottish baron, Lady Agnew wears a white organza dress with a lilac-coloured sash at the waist and matching bows on the sleeves. She is infinitely refined, ensconced on her Louis XV armchair, against an Oriental silk backdrop. Yet there is something playful in her smile, in the way she drops one hand over the edge of the armchair.

In his day, Sargent was considered the greatest living portrait painter, a modern Van Dyck. He had to leave Paris for London in 1884 after his portrait of Madame X, in reality a banker's wife named Gautreau, created a scandal. That portrait now belongs to the Metropolitan Museum of Art in New York. Though the model wore a low-cut black sleeveless dress held in place by two jewelled straps, it is difficult to understand why it created such a fuss.

Sargent enjoyed huge success in Britain and America, where everyone who was anyone clamoured to sit for him. He painted millionaires Rockefeller and Vanderbilt, the future president Theodore Roosevelt and the writers Robert Louis Stevenson and Henry James.

Sargent often turned commissioned portraits into stylistic exercises, painting the clothing and background with rough strokes and saving the fine detail and introspection for the faces. His portrait of Arthur George Maule Ramsay, Lord Dalhousie, still belongs to the earl's family. In his white suit, striking a pose against white marble columns, the British aristocrat was 'unbearably pretentious and arrogant', said Dominique Morel, the curator of the Petit Palais. Sargent seemed to mock his sitter by painting the imprint of sunburn left by Dalhousie's hat.

Sorolla and Sargent came from very different backgrounds. The Spaniard was orphaned at the age of two and was raised by his uncle, a blacksmith. The regional government recognised the young Joaquín's talent and gave him a scholarship to study art in Italy.

Though both painters have been called post-Impressionist, Morel preferred to link them to the realist tradition of Courbet. 'They painted daily life and nature, but on a scale that enabled them to exhibit in the salons,' he said. 'They captured the truth of contemporary characters.'

Sargent was born in Florence in 1856 to American parents. His father was a doctor, his mother was from a wealthy trading family. After studying at the Academy of Fine Arts in Florence, Sargent moved to Paris in 1874 to study with the French painter Carolus-Duran, who taught him to paint instinctively and quickly, without preparatory sketches.

'Sargent was American by birth, French by his paintbrush, and totally cosmopolitan,' Morel said.

Sargent and Sorolla met at the 1900 World's Fair in Paris, where both exhibited paintings to great acclaim.

'They wrote to one another, gave each other paintings, admired each other,' Morel said. 'But their relationship was always one of fellow painters, never close friends.'

In the 1880s and 1890s, Sorolla was influenced by the social realism then in fashion in Spain. Three striking examples of this period are *La vuelta de la pesca* (Return from Fishing), in which oxen pull a fishing boat to shore, *Trata de blancas* (White Slavery), showing young prostitutes accompanied by an old women in a third-class train compartment, and *El experimento* (The Experiment), where a scientist labours in a laboratory as students look on.

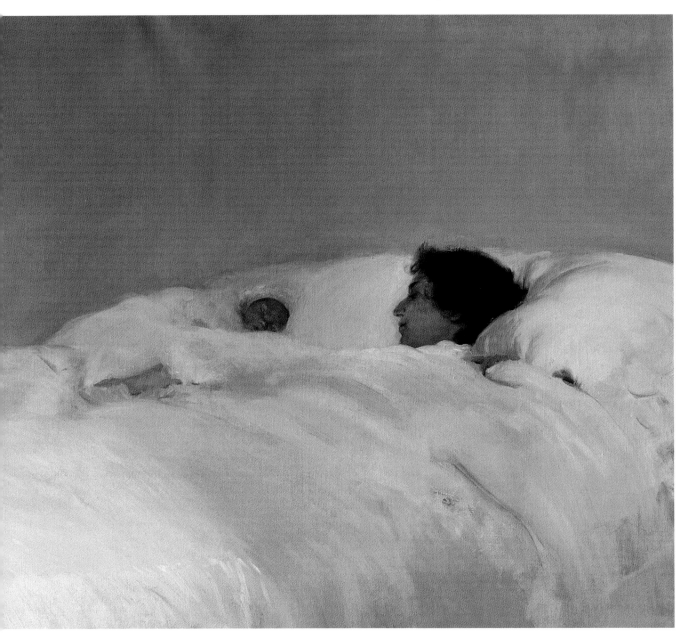

Mother, 1895, Joaquín Sorolla y Bastida. Photo: © Museo Sorolla, Madrid, Spain / Index / The Bridgeman Art Library.

Sargent, like Sorolla, was influenced by the seventeenth-century Spanish painter Velásquez. A lifelong traveller, Sargent copied Velásquez's Jester, painted Spanish dancers in Madrid and executed a haunting portrait of a gypsy in Venice.

In a room of group portraits, the similarities between Sargent and Sorolla are so strong that it is easy to confuse the two. Both had a weakness for the colour red, though Sargent's subdued Venetian tones are outdone by Sorolla's brilliant blood-red. Sorolla's painting of Rafael Errazuriz, the Chilean consul, and his family, is reminiscent of Velásquez's 1656 masterpiece, *Las Meninas*, with Errazuriz's eldest daughter strongly resembling the Spanish infanta.

Both painters enjoyed wealth and fame early in life and both exhausted themselves with major public commissions, Sargent for the Boston Public Library, Sorolla for the Hispanic Society in New York. By the end of their careers, both could afford the luxury of turning down work. Sargent declined an offer to paint the coronation of Edward VII and refused the position of president of the Royal Academy in London.

Though his depictions are often more controlled, more finely executed, nothing in Sargent rivals the warm intimacy of Sorolla's family paintings, of *My mujer y mis hijas en el jardín* (My Wife and My Daughters in the Garden) or *Madre* (Mother), in which Sorolla painted his wife Clothilde, tenderly watching her newborn third child, Elena, in a cloud-like white bed.

Sorolla spent his last years painting Spanish gardens, while Sargent kept a diary of his travels in watercolours. Curator Dominique Morel and Philippe Maffre, the museum scenographer who designed the exhibition, were thrilled to find similar paintings of women lying in the grass to close their exhibition. *Two Girls in White Dresses*, by Sargent, and Sorolla's *La Siesta* were both completed in 1911. In both, women lie like fallen blossoms on the ground. These canvases, replete with repose at the dawn of a terrible epoch, provide a feminine coda to the painters' narrative of life at the turn of the last century.

This chapter was inspired by 'Peintres de la lumière, Sargent et Sorolla' at the Petit Palais in Paris from February until May 2007.

Bonnard

The Sadness Hidden Beneath the Colours

Was Pierre Bonnard a late-blooming post-Impressionist who wandered through the first half of the twentieth century ignoring the revolutions of Fauvism, Cubism, Surrealism and Abstraction? Or was Bonnard (1867-1947) 'a great classic of the twentieth century', as claimed by Suzanne Pagé, the curator of a major retrospective of Bonnard's work? The exhibition, at the Musée d'Art Moderne de la Ville de Paris from February until May 2006, included ninety masterpieces, on loan from dozens of Russian, American, other European and French museums.

The quarrel over Bonnard's modernity – or lack thereof – started during his lifetime. 'Bonnard is the best of all of us,' his friend Matisse said. But Picasso dismissed Bonnard as 'not really a modern painter' and called him 'a pot-pourri of indecision'. What, one wonders, could be more modern than indecision? Bonnard's paintings are definitely crowd-pleasers: lush gardens, sun-flooded rooms, women meditating in bathtubs, children dancing, and small dogs frolicking, all in brilliant colours. Yet Pagé rejected the widespread perception that Bonnard was *le peintre du bonheur* (the painter of happiness).

'I find a great deal of melancholy in these paintings,' she said. 'Bonnard blurred lines. He worked in uncertainty.' Like the poet Stéphane Mallarmé, Bonnard wanted 'to suggest things, rather than name

them'. Though he was not a theoretician, Bonnard's pronouncements on art hint at what he tried to achieve. 'A painting is a little world which must be sufficient unto itself,' he said. His canvases are flat and decorative, his themes limited to the beauty of nature and the intimate world of women. 'The principal subject,' Bonnard wrote, 'is the surface, which has its colour, its laws – beyond objects.'

The son of a French civil servant, Bonnard studied law before breaking away to become a painter. 'I'd been interested in drawing and painting for a long time, but it wasn't an irresistible passion,' he wrote. 'I wanted at any cost to escape from a monotone life.'

In 1893, Bonnard met Marthe, the muse who would have a decisive influence on his life. The daughter of a provincial carpenter and a midwife, her real name was Maria Boursin. On coming to Paris in 1892, she changed it to the more aristocratic Marthe de Méligny and found work doing arrangements in an artificial flower factory.

For forty-nine years, until her death in 1942, Marthe was Bonnard's principal model. The early paintings are suffused with the young painter's discovery of sensuality: Marthe putting on black stockings; pulling her nightgown off over her head; lying naked on sofa and bed, her legs spread invitingly apart. Already, there is something aquatic in the way the bedclothes swirl around

her. In *L'Homme et la Femme* (1900), Bonnard captures the alienation that he and his mistress feel after making love. Two kittens have jumped back onto the bed that was just occupied by the lovers. Marthe seems to stare at her foot while Bonnard stands naked on the other side of a folding screen, elongated like an El Greco.

Art historians are not certain whether Marthe suffered from asthma, tuberculosis or merely hypochondria, but she bathed several times a day and the childless couple travelled often to spas, mountains and the countryside, for her health. Marthe's ablutions provided Bonnard with his best-known theme. In *Cabinet de Toilette au Canapé Rose* (1908), we see her standing nude, in black slippers, her back arched and chest thrown forward, spraying herself with perfume. A mirror – one of Bonnard's favourite devices – hangs over the wash basin.

As the years pass, eroticism ebbs from Bonnard's paintings of Marthe, though her body remains young. By the time we see her in *Baignoire* (1925), the tub looks like a sarcophagus; her flesh has the greyish tones of a cadaver.

Bonnard met Renée Monchaty, who became his model and mistress. He painted more than twenty portraits of her, including *La Cheminée* (1916), where Renée stands naked before a fireplace mirror, one hand raised behind her head. A horizontal nude painting by Bonnard's friend Maurice Denis is reflected behind Renée, whose back is in turn reflected in a smaller mirror. The brown hair in the lower right corner of the mirror is believed to be Marthe's head.

In 1925, the same year that Bonnard finally married Marthe, Renée committed suicide. Bonnard was devastated by Renée's death, and kept paintings of her with him for the rest of his life. Whatever sadness Bonnard felt, it showed only in his introspective self-portraits. There are hints of melancholy in his sunny paintings: the woman who bathes, lies in a chaise longue in the sun or sits with a pet dog or cat before a table laden with fruit, never smiles. In rare group scenes such as *Le Café au Petit Poucet, Place Clichy, Le Soir*, individuals appear solitary.

But Bonnard's paintings are about light and colour, not emotion. 'The one who sings is not always happy,' he said. He and Marthe spent winters on the Côte d'Azur, summers in Normandy. Many times, Bonnard painted the countryside through an open door or window. In *Salle à manger à la campagne* (1913), the hot oranges and pinks of the interior contrast with the cold blues and greens of the tablecloth, door, foliage and sky outside.

'Colour swept me up, and almost unconsciously, I sacrificed form to colour,' Bonnard said. Matisse also painted windows and the land or sea beyond them. But in Matisse's paintings, interior and exterior form a continuous pattern. Bonnard clearly delineates the two, and makes one long for a house in the country. When he returned to Paris after the Second World War, Bonnard was invited to the Louvre one evening. Thrilled by the view of the quais and the Seine, he pulled a young curator aside to tell him: 'The most beautiful things in museums are the windows.'

A Mediterranean Holiday for the Eyes

The Faubourg Saint-Germain is silent in August, when the limousines of government ministers and ambassadors no longer sweep through the portals of its eighteenth-century stone townhouses. Tourists teem at the edges of this central Paris neighbourhood, on the terraces of the cafés at Saint-Germain-des-Prés, and at the Orsay and Rodin museums.

In the summer of 2000, a gem of an exhibition of fifty-eight rarely shown Pierre Bonnard paintings from private collections was held, tucked away in the heart of the *septième arrondissement*, at the Fondation Dina Vierny-Musée Maillol.

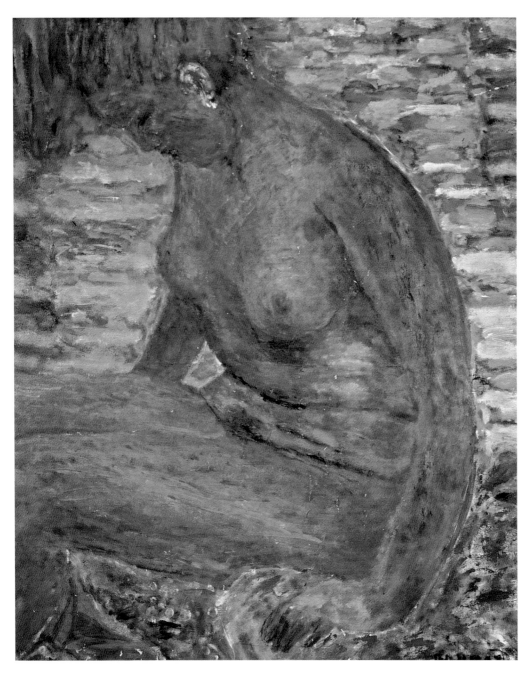

Nu Sombre, 1941
© Pierre Bonnard /
IVARO 2011. Photo:
© The Bridgeman Art
Library.

The French capital had not seen a Bonnard exhibition since 1984. Prompted in part by the success of the larger show at the Tate Gallery two years earlier, Dina Vierny, who would die in 2009 at the age of eighty-nine, dedicated a retrospective to the man she considered 'the greatest painter of the twentieth century'. Because the Maillol is relatively small and outside the state-run museum circuit, its expositions receive less fanfare than those at the Orsay or the Louvre.

But the Russian-born Vierny, who began posing nude for the sculptor Aristide Maillol when she was nineteen, had an unerring eye for art. Her permanent collection includes many of Maillol's voluptuous statues, as well as works by Duchamp, Matisse and Kandinsky. The silent, spacious rooms of the museum have the feel of a monastery or a cool cellar in summer.

The brilliantly coloured canvases of the Bonnard exhibition spread over two floors of the museum like a Mediterranean holiday for the eyes. Paintings were arranged in chronological order, so one followed Bonnard's progress from his involvement with the 'Nabis' (prophets) movement in 1889, when he and fellow students at the Académie sneaked out to see the Impressionist paintings their professors shunned. The painter Edouard Vuillard was among the friends whom Bonnard met there.

The range of greens in Bonnard's early landscapes – often compared to Corot's – is almost Irish. The Nabis wanted, as the poet Mallarmé wrote, 'to suggest rather than to say', and advocated painting in grey tones. Bonnard's friends teased him about his interest in Japanese print-makers, especially Utamaro. They called him 'the Japanese Nabi', and, indeed, in the introspective self-portraits of his later years, Bonnard *looks* Oriental. His 1892 portrait of his cousin Berthe Schaedlin – whose parents refused to let her marry him – also shows a Japanese influence.

Bonnard once wrote that he 'wanted not to paint life, but to make painting come alive'. To do so, he had to use colour, and fortunately his love of colour quickly triumphed over abstract theories. 'Colours pulled at me and I almost unconsciously sacrificed form to them,' Bonnard wrote in 1909. Gauguin was the painter he most admired, and his colours - but not his subjects from everyday life - owe a great deal to Gauguin. Bonnard made extensive use of purple, which had gone out of fashion, and liked to juxtapose related colours: yellow and orange, red and purple. The results are incredibly bright, but never violent. He carefully studied the effects of weather and light, writing in his notebook that 'in fine but cool weather, there is vermillion in the orange-toned shadows and purple in the greys'.

Perhaps the finest example of Bonnard's talent as a colourist is the almost tropical *Dark Nude*, painted between 1941 and 1946, the year before his death. The picture is warmer than the well-known, Degas-like bathing scenes of Bonnard's companion – ultimately wife – of forty-nine years, Marthe Boursin. Although the early paintings of Marthe were sensual, they were transformed by her obsession with washing and the suicide of Bonnard's mistress Renée Monchaty. In the later Marthe paintings, she appears chalky, anaemic.

Dina Vierny's Pygmalion-like mentor Maillol lent his favourite model to his old friends Matisse and Bonnard. It was Vierny who posed for *Dark Nude* around the time of Marthe Bonnard's death in 1942, and she kept the painting. Vierny recalled that for the first week he was painting her, Bonnard did not say a word. When Vierny finally asked him why he was so silent, he talked unreservedly about painting, telling her how he always returned to a canvas, sometimes over an eight-year period.

After Aristide Maillol died in 1944, Vierny and Bonnard saw one another often until Bonnard also died three years later, at the age of eighty. They went to the *Salon d'Automne* together, to admire works by Maillol and Bonnard. 'All of a sudden I saw Bonnard pull some paint and a brush from his pocket and start touching up his paintings, which no longer belonged to him,' Vierny recounted. 'I said, "Bonnard, what are you doing? We're going to be arrested!" "Be the lookout!" he told me.'

Dina Vierny and Maillol

Carving a Place in Art History

A sprightly old woman wearing a loud print dress and bedroom slippers sat on an armchair in the main room, watching the art critics with an amused eye, holding court as, one by one, they stopped to pay homage. Dina Vierny didn't have to travel far for the opening of the *Maillol Peintre* exhibition in the summer of 2001 – just a few floors down from her rooftop apartment above the museum she created. She needed to be near the splendid records of her youth: 'I wake up at night to go and see them,' she said of the paintings and sculptures she posed for sixty years earlier.

The years had made Vierny short and plump, but the dark eyes still sparkled. The long plait down her back had thinned, and Vierny dyed it black. Forgive my indiscretion, I asked, but how old are you? 'It's not indiscreet!' she hooted, her laughter breaking the church-like silence of the museum. 'I am part of the history of art!' she declared, adding that she was proud to be eighty-two years old and still organising exhibitions of her hero's work in London, Valence and São Paolo.

Aristide Maillol met Dina Vierny in 1934, when he was seventy-three and she a fifteen-year-old lycée student. She was in awe of him, because after Rodin died in 1917, Maillol was considered the greatest living French sculptor.

Struck by Vierny's resemblance to Maillol's heavy-limbed, majestic stone and bronze nudes, the architect of the Musée d'Art Moderne in Paris suggested that the ageing artist, who was going though a severe depression, contact the young model. 'Mademoiselle,' Maillol wrote to her, 'I am told you resemble a Maillol and a Renoir – I would be satisfied with a Renoir.'

Dina Vierny visited Maillol's studio at Marly. 'I meant to stay a few hours; I stayed ten years,' she told me. The sight of one of his sculptures made flesh shook Maillol out of his lethargy. Inspired by Vierny, he not only began sculpting again, but returned to his first love, painting.

Born to a family of poor wine-growers in the Mediterranean port of Banyuls, next to France's border with Spain, in 1861, Aristide Maillol wanted to be a painter from the age of thirteen. An artistic son was a catastrophe in his milieu, but when the phylloxera epidemic destroyed the family's vineyards, Maillol's Aunt Lucie relented and sent the young Aristide to art school in Perpignan. After three failed applications, Maillol was finally accepted by the École des Beaux-Arts in Paris.

Maillol was thrilled by the work of the post-Impressionists he saw at the Salon des Indépendants. His early paintings are an odd combination of styles: outright copies of Puvis de Chavannes, haystacks that could have been painted by van Gogh, his Aunt Lucie looking just like Whistler's mother, colours and models that seem borrowed from Matisse, Monet and Renoir – with a few

Botticelli faces and quattrocento portraits in profile.

But the most powerful influence was that of Paul Gauguin, whom Maillol met during the 1889 World's Fair. 'Gauguin's painting was a revelation for me,' Maillol said. 'Beaux-Arts blindfolded me instead of enlightening me.' Maillol's palette is lighter, but he adopted Gauguin's use of flat surfaces and foliage for decoration. Like Gauguin, he abandoned perspective and was attracted to symbolism and *japonisme.*

Maillol's first two successful paintings, the luminous *House in Roussillon* (1888) and *Portrait of Mademoiselle Jeanne Faraill* (1889), showed great talent. His first art teacher's daughter is a serious little girl in a red and white striped dress and black stockings, standing on an Oriental carpet. She is part doll, part adult. 'I love the rose-like freshness of very young girls,' Maillol told his biographer Judith Cladel. 'The look in their eyes shows faith in life, confidence untouched by sadness. The young girl is for me the wonder of the world and a perpetual joy.'

Maillol idealised and adored women. In this first exhibition devoted solely to his paintings, the only males are a self-portrait, the painter's infant son, Lucien, and two figures copied from Puvis de Chavannes. Otherwise, Maillol's world is inhabited solely by women.

Woman with a Parasol (1892), on loan from the Musée d'Orsay, is Maillol's best-known painting. A graceful figure in a pink wallpaper dress with fluttering ribbons raises her gloved hand to the brim of a straw hat, against horizontal swathes of sky, sea and sand.

With Gauguin's encouragement, Maillol set up a tapestry workshop in Banyuls in 1894. He fell in love with and married Clotilde Narcisse, whom he'd hired to make tapestries. In an 1894 portrait, the bride posed in a simple black dress with her hair pulled up. Large almond eyes look seductively from an angular face with an exquisite mouth.

Marriage brought the first awakening in Maillol's work. With no need to pay for nude models, he abandoned the frou-frou hats and dresses of his earlier work and joyously took up the theme that would fascinate him for the rest of his life – the female body – usually in the open air, often walking in water. He and Clotilde wandered the foothills of the eastern Pyrenees. 'I lived my most beautiful hours there,' Maillol recalled later. 'The entire mountain range saw my wife naked. She was beautiful.'

Quoted by Dina Vierny in a book on Maillol, he was grateful to Clotilde. 'She posed in the cold. At a time of great poverty, she was hungry with me, without complaining; I cannot forget that.' The nude led Maillol to sculpture, and by 1900 he all but stopped painting. For three and a half decades he was famed as a sculptor. Indeed, Maillol considered himself an inferior painter – one reason his canvases were not exhibited earlier.

The shock of meeting Dina Vierny led the old man to take up paintbrushes again – and invent a sculptural style of painting that was all his own. Vierny was studying chemistry and physics at lycée, and Maillol affectionately called her his 'laboratory rat'. Sessions were different, depending on whether he was painting or sculpting, Vierny says. 'During the sculptures, I could move a little. For a sculpture, he always started with one foot. It was extraordinary seeing the form take shape.'

Most artists' models were uneducated girls, Vierny says. But she and Maillol discussed poetry. 'He told his painter friend Maurice Denis: 'She is young, she is beautiful and she speaks like Gide', Vierny recalls proudly. Maillol was so pleased that he suggested that Vierny also pose for his friends Matisse, Bonnard and Dufy.

The nude paintings of Dina Vierny, all from the last decade of Maillol's life, are so suffused with sensuality that it is difficult to believe the painter and model were not lovers, despite the fifty-eight-year difference in ages. When I dared ask, Claude Unger, the press attaché for

the museum, quickly corrected me. 'Madame Maillol was extremely jealous,' she said. 'It was never a love relationship. When Mme Maillol died in the 1950s, she told her son to make Dina the executor – if there had been anything between them, she wouldn't have dreamed of it.'

During the Second World War, Dina Vierny, who was Jewish, joined the Resistance. The red dress she wore was a signal to refugees from the Nazis, whom she helped to reach Spain.

Maillol let her use his little farm outside Banyuls as a meeting place, and showed the *résistants* the fastest escape path through the mountains, which became known as the 'route Maillol'.

Aristide Maillol was killed in a car crash in 1944, on his way to visit his painter friend Raoul Dufy.

Among his last works were several paintings of Dina in the red dress of resistance, and a tribute to Gauguin in which Dina stands in a wheatfield, tying her scarf – like one of Gauguin's Tahitian models.

Maillol's last sculpture, *Harmony* stands out from the others. It is not meant to be a stylised, generic, nude woman, but a likeness of Dina, his muse.

Les Fauves

Wild Things

On a balmy evening in Saint-Tropez during the summer of 1904, the French artist Henri Matisse grew irritated with his dot-painting Pointillist friends and went off to work alone. The end result of his travails that night was called *Luxe, calme et volupté*, after the Baudelaire poem. Matisse had not yet freed himself from the syncopated brushstrokes of the Pointillists, but the theme and colours – pink, blue and violet nude bathers on a red beach against a brilliantly multicoloured sea – made this canvas the first Fauve painting. Appropriately, it opened the exhibition entitled 'Fauvism or Trial by Fire; The Eruption of Modernity in Europe' at the Paris Museum of Modern Art in the winter of 1999-2000.

Two hundred and twenty canvases and six years later in 1910, the exhibition closed with another painting by the chief Fauve, Matisse: *The Dance*, from St Petersburg's Hermitage museum. While Fauvism is usually deemed to have lasted only from 1905 until 1907, Matisse was faithful to its style long afterwards. His nearly three-by-four-metre *Dance* has been called 'the apogee of Fauvism', with its flat, brick-red figures forming arabesque arches as they skip across an emerald green earth and a cobalt blue sky.

Suzanne Pagé, the director of the Musée d'Art moderne de la Ville de Paris, calls Fauvism 'an eruption of colour everywhere in Europe'. Without theories, without a formal grouping of artists, the self-liberation experienced by Matisse that night in Saint-Tropez constituted a revolution in painting – the very foundation of modern art.

In the summer of 1905, Matisse consummated his break with the neo-Impressionists by moving west to the little sea port of Collioure, near the Spanish border. He enticed his friend André Derain to join him, and their paintings, along with four of their colleagues', were shown at the autumn Salon in Paris. Derain's *Boats in the Port of Collioure* shows how the painters egged one another on to greater daring. Derain left some of his canvas blank so that the whiteness of the light would burst through it. He did his best paintings in the Fauve period, as if the power of the colours he used – yellow and green skies, red-hot sand – exhausted his talent. 'We don't understand what we are doing, what we are,' he wrote, calling the experience 'trial by fire'.

In the snide comment that ensured his place in history, the critic Louis Vauxcelles remarked on an Italianate sculpture among the paintings by Matisse and his friends at the Salon. 'Donatello among the Fauves [wild beasts]!' he exclaimed. The colour revolutionaries did not like the name, but it stayed with them because it seemed to suit their youth and rebellious nature.

In 1905, Matisse was the eldest, at thirty-six, followed by Maurice Vlaminck, then twenty-nine, and Derain, twenty-five. Matisse and Derain had met on a painting course in 1899. The following year, Derain came across Vlaminck – a giant of a man who raced bicycles, rowed boats, lifted weights and wrestled – in the train from Chatou to Paris. Matisse and Derain spent hours in the Louvre, but the self-taught Vlaminck hated the very smell of museums. 'Forgetting is for me the whole secret of painting,' he said. Vlaminck had nonetheless attended a van Gogh retrospective in 1901. 'That day,' he said, 'I loved van Gogh more than my own father.' His paintings of Chatou, where he shared a studio with Derain, owe a great deal to van Gogh. Vlaminck said that painting allowed him to do things 'that would have led me to the scaffold if I'd done them in life . . . I satisfied my desire to destroy old conventions, to "disobey" so as to create a sensitive, living and liberated world.'

Derain likened paint tubes to 'cartridges of dynamite' that released light. The art dealer Ambroise Vollard sent him to London, where Derain promised to 'make something other than a colour photograph of the Thames'. Only three years had passed since Monet completed his Waterloo Bridge series, but the distance between their paintings could be a century. Derain's 1906 *Effects of Sunlight on Water* is not identifiably a painting of London. Cobalt blue clouds loom in an orange-red sky, reflected in a beam through the green foreground – probably a river.

Kees van Dongen, a Dutch painter working in Paris, was the most sensual of the Fauves. More than half of the canvas in van Dongen's *Red Dancer*, completed in 1908, is taken up by the cancan dancer's pulsating, lifted red petticoat. The painting was snapped up by the Russian collector Riabouchinsky, and made a sensation in Moscow in 1909. The Hermitage Museum in St Petersburg lent it to Paris for the Fauve exhibition.

Perhaps the most startling lesson of the show was how truly European the art world was at the beginning of the last century – European 'from the Atlantic to the Urals', as General de Gaulle used to say. The exhibition included the work of Scottish, Belgian, Swiss, German, Czech, Hungarian, Finnish and Russian artists. Before our eyes, it showed how the colour revolution mutated into Expressionism, Cubism and Abstraction. As Matisse said, Fauvism was not everything, but it was the beginning of everything.

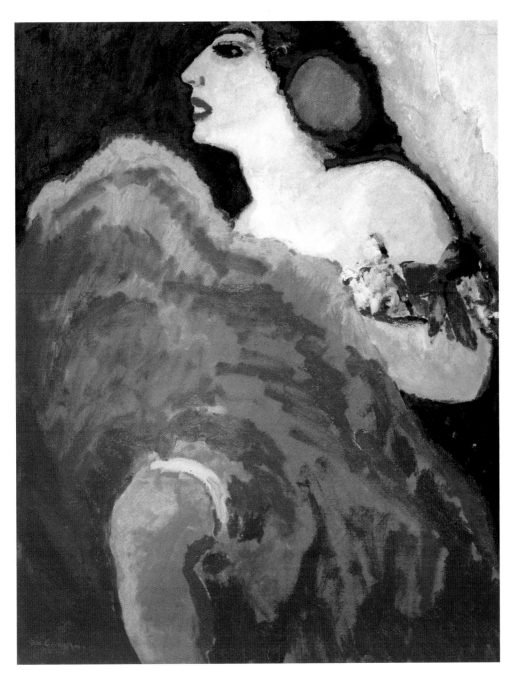

The Red Dancer, c. 1907 © Kees
van Dongen / IVARO 2011.
Photo: © Art Media/Heritage
Images/Scala, Florence.

Signac

When All the Dots Add Up

What a loss it would have been if the gruff Paul Gauguin had frightened away young Paul Signac forever. A Degas picture at the 1879 *Salon des Impressionistes* inspired the sixteen-year-old to put pencil to paper. 'We don't copy here, Monsieur,' Gauguin declared, throwing Signac out of the exhibition.

Signac was the adored only child of wealthy leather goods merchants – the Hermès of their day – who indulged his artistic leanings. The year after Signac's ill-treatment by Gauguin, the aspiring painter's father died. He and his mother moved to the Paris suburb of Asnières, next to the Seine, where Signac's life-long passion for water and sailing began. Asnières and Montmartre would provide his first subjects – suburban landscapes, river banks, boulevards in snow. Also in 1880, Signac visited a Monet exhibition. He had wavered between writing and painting, but Monet convinced him that he had to become an Impressionist.

With no formal training, Signac began painting in earnest at the age of eighteen, in the style of Manet, Degas, Monet and Caillebotte. At twenty-one he exhibited at the first *Salon des artistes indépendants*, where he met Georges Seurat, his elder by four years. The young men saw one another daily, and were excited by new 'scientific' theories of painting.

Zola and the naturalists believed that scientific principles could be applied to fiction. The *neo-impressionistes* – as they would be dubbed by the critic Félix Fénéon in 1886 – believed that the same was true of art. 'Confidence in science was a hallmark of the late nineteenth century,' explained Marina Ferretti, who was one of several curators for a major Signac retrospective which moved from the Grand Palais in Paris to the van Gogh Museum in Amsterdam and the Metropolitan Museum in New York in 2001. 'The Post-Impressionists were men of their time. They were modern. They were absolutely convinced that science equalled progress.'

Seurat invented the divisionist theory, which held that colour must be mixed by the eye of the viewer, not on the canvas. In 1885, Seurat repainted *Un dimanche à la Grande Jatte*, entirely with dots. Signac would follow Seurat's example the following winter, repainting his own *The Milliners* in dots.

The critics were merciless. 'There's nothing to see but confetti,' Georges-Albert Aurier wrote in 1890. Should the new style be called 'confettism'? he mocked. Or since there were dots, why not 'pointillism'? Although the term 'pointillist' stuck, the artists preferred the more scientific-sounding 'divisionism'. In Holland, a similar school called itself 'luminism'.

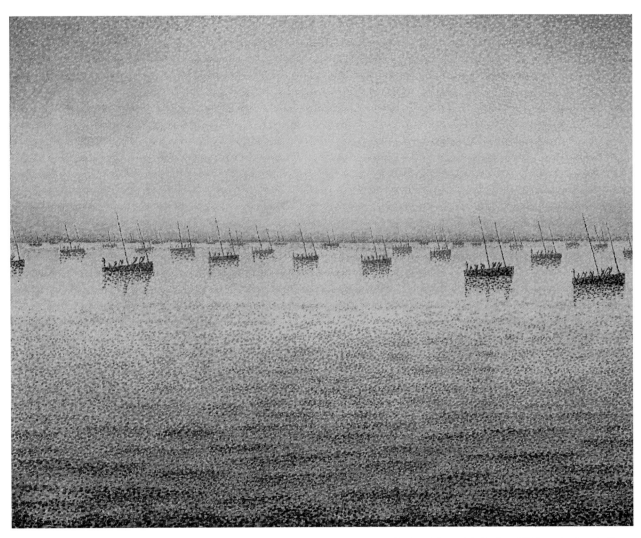

Setting Sun. Sardine Fishing. Adagio. Opus 221 from the Sea, the Boats,
Concarneau Series, 1891, Paul Signac. Digital image: © The Museum of
Modern Art, New York/Scala, Florence.

Signac rejected the term 'pointillist'. 'In his opinion it reduced a complex method to its most simple element,' Marina Ferretti said. 'The most important thing to him was the division of colours – that colours not be mixed on the canvas. The little dots were a means to maintain the purity of colour. At Saint-Tropez in 1895, he enlarged his brushstrokes to a rectangular shape. For him, the dots were a secondary, superficial aspect of it.'

In 1891, Seurat caught a fatal chest infection while organising the *Salon des Indépendants* in the Grand Palais – ironically the venue for the 2001 Signac exhibition. His grief-stricken friend Signac held exhibitions of Seurat's work in Paris and Brussels. By 1897, the critic Yvanhoe Rambosson wrote that 'fortunately' there were only two pointillist painters left, Signac and Henri-Edmond Cross, and that the former was 'a good artist spoiled by a theory'.

Nonetheless, 'Signac was faithful until the very end,' Marina Ferretti said. 'He always painted as a divisionist, until his last breath.' When applied to human figures — as in *The Dining Room, A Sunday,* or *Woman Reading* — the technique gives an impression of geometric stiffness. But from the late 1880s, in Brittany and on the Côte d'Azur, Signac painted mostly water and sky, with breathtaking luminosity.

One day in 1892, Signac anchored his yacht in a little harbour called Saint-Tropez. He was the first to 'discover' what would become the world's most fashionable port. 'I am swimming with joy,' Signac wrote to his mother. 'I could work here for the rest of my life – it is happiness that I've just discovered.'

With Berthe Robles, whom he had met nine years earlier at the 'Chat Noir' cabaret in Montmartre, Signac settled down in Saint-Tropez, buying a villa which he named 'La Hune' (The Topmast). Some of his most exquisite paintings are views of the town and its surroundings, including *Saint-Tropez, La Terrasse,* which belongs to the National Gallery of Ireland.

By the late 1890s, Signac was painting with the brilliant pinks, purples, greens and blues that would soon be adopted by the Fauves. When he began *Capo di Noli* on the Italian riviera in 1898, Signac wrote in his diary, 'I would like to attain an extreme polychromy . . . If it is loud, there will always be time to tone it down later.'

In part owing to the influence of his book, *From Eugène Delacroix to Post-Impressionism*, young artists flocked to Saint-Tropez to learn from Signac. It was at 'La Hune' that Matisse painted the first Fauvist canvas, *Luxe, calme et volupté* in 1904, which Signac purchased. In 1913, Signac gave Berthe the villa and left her to live with one of his students, Jeanne Selmersheim-Desgrange, in Antibes. They had a daughter named Ginette, also a painter, whose daughter Françoise Cachin was a museum director who helped found the Musée d'Orsay in Paris. Cachin, who would die in February 2011, loaned three of her grandfather's paintings for the 2001 exhibition.

'Everyone in the family was a painter,' Cachin recalled in an interview with the *Irish Times*. 'My grandmother, my aunts. It was very tedious because I had to pose all the time for my mother. I was bored to death.'

Signac fancied himself an anarchist; one of his biggest murals, showing a working man's seaside paradise, was initially entitled *In the Time of Anarchy*. Wasn't it ironic that the grand-daughter of an anarchist should become the highest-ranking curator in France? 'I think he would have been very happy to know his grand-daughter was looking after museums, that I created the Musée d'Orsay,' Françoise Cachin said. 'He adored museums. And an anarchist who did such orderly painting – I'm not sure what it means.'

Cachin published the *catalogue raisonné* of all Signac's work, so she was familiar with the eighty-one oil paintings and fifty-three drawings and watercolours in the 2001 exhibition. 'It was the later paintings that struck me,' she said. 'I was somewhat critical of them in the past,

but now I find them charming; his desire to link up with the great art of the seventeenth and eighteenth centuries, after starting out as a maverick, an Impressionist who never went to the École des Beaux Arts. He needed to return to images engraved in history. The big canvas of the port of Saint-Tropez was obviously a return to the tradition of Vermeer, Claude Lorrain and Turner, at a time of utter modernity.'

Gauguin

Myth-making in the South Pacific

How many men have dreamed of emulating Paul Gauguin? In the century since the French painter's death, the story of a stockbroker who abandoned the Bourse, his hectoring, spendthrift wife and five children for a Polynesian paradise has been sanitised of its more unpalatable elements.

All but forgotten are Gauguin's brawling, drinking, whoring, and penchant for bedding thirteen-year-olds, whom he impregnated and infected with syphilis while railing against the missionaries he accused of perverting the culture of Oceania.

Gauguin inherited a provocative streak from a revolutionary grandmother, and named his last abode – located between Protestant and Catholic missions in the Marquesas Islands – the House of Orgasm. Seven months before his death at the age of fifty-four, he wrote to a friend: 'You've known for a long time what I wanted to establish: the right to dare everything.'

Jacques Brel and Marlon Brando followed in Gauguin's footsteps. Like the French painter, they believed the description that Gauguin copied from a book in 1889: 'Under a winterless sky, in a land of marvellous fecundity, the Tahitian has only to raise his hand to gather food; thus he never works . . . Tahitians . . . know only the sweetness of life. For them, life is singing and loving.'

Gauguin's marriage to a masculine Danish woman, Mette Gad, was all but over by the mid-1880s, when Mette took the children to Copenhagen. Though deeply attached to his daughter Aline, Gauguin fled the contempt of his in-laws, wandering off to Martinique and Brittany to paint.

In the autumn of 1888, Gauguin finally gave in to Vincent van Gogh's insistent invitation that he join him in Arles. The unstable van Gogh hero-worshipped Gauguin and dreamed of establishing a 'Studio of the South' with him in the tropics.

Gauguin went to Arles only because he was bankrupt. Van Gogh's brother, the art dealer, Theo, offered a stipend if he would live in Vincent's house. But Gauguin's indifference to van Gogh transformed the Dutchman's adoration into fury.

Three days before Christmas, van Gogh hurled an absinthe glass at Gauguin in a café. Gauguin left of his own accord. Fifteen years later, Gauguin recorded how he went for a walk in the public gardens: 'I heard behind me a well-known step. Short, quick, irregular. I turned about the instant that Vincent rushed towards me, an open razor in his hand. My look at that moment must have had great power in it, for he stopped and, lowering his head, set off running towards home.'

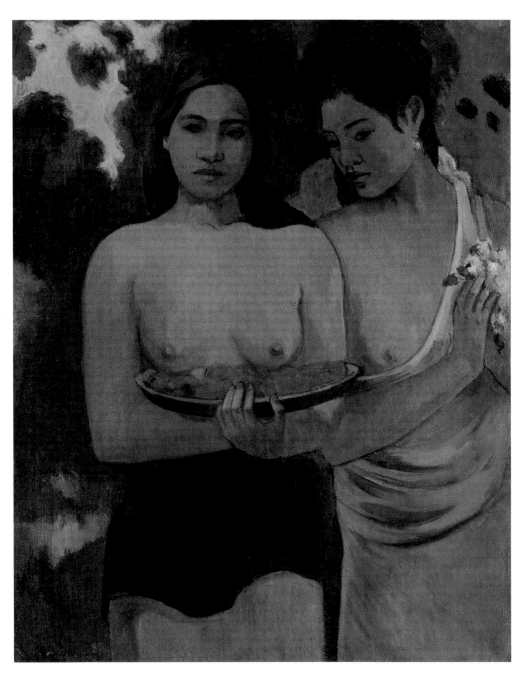

Two Tahitian Women,
1899, Paul Gauguin.
Digital Image: © The
Metropolitan Museum
of Art/Art Resource/
Scala, Florence.

The following morning, Gauguin learned that van Gogh had sliced off his left ear and delivered it to the local brothel with instructions that it be given to a shy young prostitute named Rachel. Gauguin left Arles immediately, telling a policeman: 'If he asks for me, tell him I left for Paris; the sight of me might prove fatal to him.'

In 1891, the French minister of fine arts agreed to grant Gauguin an official but unpaid mission to study the customs of Polynesia. His first Tahitian painting, *Ia orana Maria* (Hail Mary), shows a woman in a red pareo holding an infant on her shoulder. Were it not for the haloes and blue-and-yellow-winged angel in the background, the painting would be a scene from daily life.

The Paris Musée du Luxembourg rejected Gauguin's offer of *Ia orana Maria* in 1893. Today, the masterpiece belongs to the New York Metropolitan Museum of Art. No matter how many times one has seen it, the colours are still astounding. As the poet Stéphane Mallarmé wrote: 'It is extraordinary that one can put so much mystery in so much brightness.'

In Tahiti in 1891, Gauguin took his first child 'bride', a thirteen-year-old named Teha'amana, also called Tehura. She was his favourite model during his initial two-year stay. Penniless and ill, Gauguin returned to Paris two years later, where he lived with another thirteen-year-old, 'Annah la Javanaise', from Malaysia.

Gauguin moved back to Tahiti in 1895, and 'married' Pahura, aged fourteen. Their infant daughter died in 1897, the same year that Gauguin's beloved daughter Aline died in Denmark.

In 1901, Gauguin moved to the Marquesas in the belief that 'life is very easy and cheap there'. His last 'wife' was fourteen-year-old Vaeoho Marie-Rose, who rejected him after bearing their daughter. Gauguin had persuaded her father, a local chieftain, to take the girl out of convent school so she could become his *vahine* (woman).

Gauguin's paintings of a pregnant Teha'amana, wearing a Western 'mission dress' and holding a mango, or seated against a backdrop representing her Polynesian ancestry, are among his finest.

In *The Spirit of the Dead Keep Watch*, Gauguin painted his child mistress lying naked on a bed, her eyes wide open, while a *tupapau* (ghost) looks on. The painting exudes primeval fear and sensuality. When it was shown in Sweden in 1898, the director of the Academy of Arts deemed the canvas indecent and had it removed from the exhibition. But Gauguin liked *Spirit of the Dead* so much that he used it as a backdrop to his own self-portrait. The painter's South American lineage can be seen in his features; his great-grandfather was the brother of the last Spanish viceroy of Peru, and Gauguin spent six years of his childhood in Lima. He boasted that he had Inca blood.

'It's reflected in everything I do,' he wrote. 'It's the basis of my personality. I try to confront rotten civilisation with something more natural, based on savagery.'

In 1897, after suffering a heart attack, Gauguin began working on the huge canvas he considered his artistic testament.

'I wanted, before I died, to paint a big picture I had in mind, and I have worked feverishly night and day all month,' he wrote. 'It was all dashed off, directly with the top of a brush, on a piece of sacking full of knots and rough bits.'

The result, *Where Do We Come From? What Are We? Where Are We Going?*, is a right-to-left visual narrative, in which a newborn infant progresses to old age. Gauguin often painted from prints and photographs, and is believed to have mimicked Botticelli for the composition, and Rembrandt for the figure plucking a piece of fruit in the middle. The painting belongs to the Boston Museum of Fine Arts and was the centrepiece of the exhibition 'Gauguin: Tahiti; Studio of the Tropics' at the Grand

Palais in Paris from September 2003 until January 2004, and at the Boston Museum of Fine Arts from February until June 2004.

Yet despite Gauguin's – and present-day art critics' – assertions that *Where Do We Come From?* was his best work, there is something disturbing about the dark, moody painting. Just as we prefer the myth of the liberated stockbroker attaining artistic fulfilment to the reality of the drunken, syphilitic paedophile, Gauguin's prettier paintings are more pleasing.

The most beautiful must be the Metropolitan's *Two Tahitian Women*, a gentle, sensual image of two bare-breasted young women offering fruit and flowers. This is the South Pacific of our fantasies, not the dying culture that Gauguin discovered when he arrived in Papeete.

Renoir, Père et Fils

The influence of Impressionist painting on twentieth-century French cinema is not obvious, but it was the underlying assumption of 'Renoir/Renoir', the splendid exhibition which the French Cinémathèque held to celebrate its reopening in September 2005.

Pierre-Auguste Renoir was the Impressionist painter par excellence. His second son Jean, born in 1894, became one of France's greatest film-makers. Both men loved voluptuous women, sun-dappled water, foliage quivering in wind, long grass, and joyous dancers. Jean even named one of his best-known films *Déjeuner sur l'Herbe*, after a painting by Manet, one of his father's drinking buddies.

An exhibition at the Musée des Beaux-Arts in Lyons from April until July 2005, 'Impressionism and the Birth of Cinematography', showed how the Lumière brothers, who invented the motion picture camera, (perhaps unconsciously?), adopted the lexicon of Impressionist painting: a young girl with a cat, the Pont Neuf, gondolas in Venice, the approach of a steam train. Film helped to nudge painters towards Fauvism, Cubism and Abstraction, because there was no longer any point in realism.

In the exhibition at the Cinémathèque, paintings by Renoir *père* were juxtaposed with scenes from the films of Renoir *fils*. The comparison was sometimes tenuous, and the show – like their paintings and films – was dictated more by feeling than a rational structure. At times it was merely a pretext to display Auguste's magnificent paintings.

'Don't trust people who are not moved by a pretty bosom,' the painter told his son Jean. The exhibition showed Auguste's *Torse Effet de Soleil*, painted in 1876, alongside the scene from *Déjeuner sur l'Herbe* where an uptight scientist suddenly wakens to the Dionysian possibilities of life when he happens upon young Nénette bathing nude.

Renoir's 1959 film had a modern twist: Nénette pursues the scientist because she wants to have a baby through artificial insemination.

Jean Renoir filmed *Déjeuner* at Les Collettes, a Provençal farmhouse set among olive trees. His father Pierre-Auguste considered Les Collettes paradise on earth, and had died there forty years earlier, clutching his paintbrush and palette.

Father and son were most similar when joyous. 'I don't trust people who "think",' Jean Renoir said. 'I look, I listen, I touch, I sniff, and that is enough for me!' A scene in Jean's 1936 *Partie de Campagne*, where a young woman stands on a swing while her admirers look on, consciously imitates Auguste's 1876 *La Balançoire*.

The finale of Jean's *French Cancan* (1955), in which dancing girls perform splits and somersaults among the laughing clients of the Moulin Rouge, is probably the

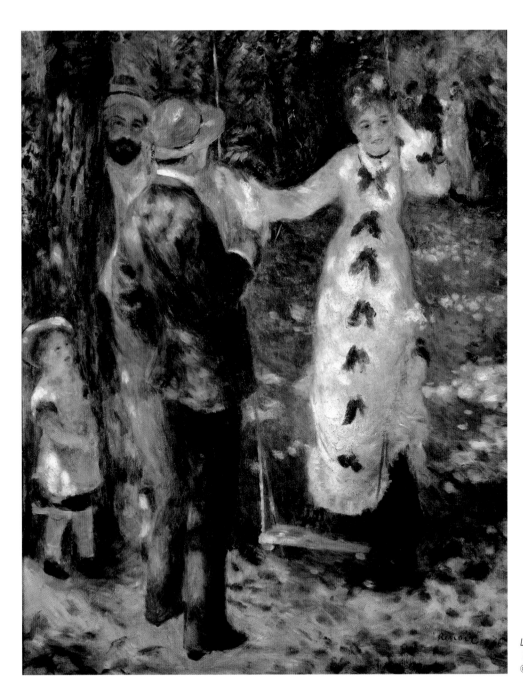

La Balançoire, 1876,
Pierre-Auguste Renoir. Photo:
© Photo Scala, Florence.

most exuberant scene in cinema history. Like the ball in *Élena et les Hommes*, it is a tribute to Auguste's *Bal du Moulin de la Galette*, *La Danse à la Campagne* and *La Danse à la Ville*, masterpieces that were loaned by the Musée d'Orsay to the Cinémathèque.

Like father, like son. Jean's mother Aline was a twenty-year-old hat-maker when Auguste spotted her in the street outside his studio and asked her to model for him. Jean fell in love with and married his father's last model, Andrée Heuschling, whom he renamed Catherine. He said he'd become a film-maker out of love, to make Catherine a star. She left him when he chose another actress for his first talking picture.

Both painter and director involved their loved ones in their oeuvre. Auguste made hundreds of paintings of his wife and sons. Two paintings of Jean as a child, with his adored nursemaid Gabrielle, are particularly tender.

Jean continued the tradition, asking his older brother Pierre to act in his films. In an excerpt from the 1937 film *La Marseillaise*, we see Pierre as Louis XVI, stuffing himself with game and wine after a hunt as the Duc de La Rochefoucauld tells him the Revolution has started.

Claude Renoir Junior, Jean's nephew, was his favourite cameraman. Claude strapped himself to the front of a locomotive for *La Bête Humaine*, the 1938 story of a train driver who commits murder.

Jean Renoir often acted in his own films. In *La Règle du Jeu*, he plays Octave, the over-size, generous friend who attempts to reconcile quarrelling lovers and unwittingly causes disaster. Renoir called *La Règle du Jeu* 'a happy tragedy'. The cynical tale of love among upper-class French people during a weekend in the country is now considered his finest. But when the film was first shown in 1939, French audiences booed it.

Renoir was so hurt that he considered leaving the cinema forever. Instead, he went to the US, where he made five films. *La Règle du Jeu* was not shown again in its original form for twenty-five years.

Renoir chose Jean Gabin, the Gérard Depardieu of his day, to play Danglard, the charming impresario who creates the Moulin Rouge in *French Cancan*. Like Renoir, Danglard goes broke financing his dreams; like Renoir, he transforms women into stars, only to move on to new conquests. Bourgeois comfort, money and morality are not important; art is the only thing that matters.

As a director, Jean Renoir was often a step ahead of evolving twentieth century cinema, embracing each new innovation, from silent pictures to talkies to the brilliance of Technicolor and the true to life style of New Wave. François Truffaut adored Renoir, and though they were of different generations, the directors became close friends.

Renoir's happy childhood left him with a sunny character. He never shouted at actors, and when a scene had to be re-shot he'd say: 'That was great! Great! What do you say we do it again, just for the pleasure?' Jean Renoir was nonetheless a lucid observer of his catastrophic century. He and his brother Pierre were both badly wounded in the First World War. The title of *La Grande Illusion* (1937), about French prisoners of war, refers to the illusion that there would be no more wars. While his father Auguste never painted a sad painting, some of Jean's films – especially *Toni* (1935) and *La Bête Humaine* – are dark.

The Cinémathèque's exhibition compared a portrait of *Jean Renoir en chasseur*, painted by his father Pierre-Auguste in 1910, to the hunting scene from *La Règle du Jeu*. Jean loved the painting and kept it with him his whole life.

As beaters advance through the underbrush, rabbits and fowl emerge, to be shot dead in rapid succession by the Marquis's weekend guests. The scene could be interpreted as an allegory for the violence of human relationships, but critics subsequently saw the slaughter of the innocent animals as a premonition of the coming war.

Mediterranean Painters

The Mediterranean was long regarded as a place where the sick and old went to die, not as a thing of beauty. Until the mid-nineteenth century, it didn't occur to French aesthetes to stare at the sea, much less paint it. That began to change when artists started working outdoors and the Paris–Lyon–Marseille train made the Côte d'Azur accessible.

Painters who had previously sought inspiration in Italy or the Orient turned instead to the Mediterranean coastline. Mostly from northern France, they were stunned by the south's blinding light and luxuriant foliage. For three-quarters of a century, the Mediterranean acted as a magnet for European painters from as far away as Scandinavia and Bohemia. They did not adhere to one philosophy or school, although Fauvism – and modern art – were born in Saint-Tropez.

In the autumn of 2000, the Grand Palais devoted its main prestige exhibition to 'The Mediterranean, from Courbet to Matisse'. It was the last show organised by Françoise Cachin, the founder of the Musée d'Orsay, long-serving director of the Museums of France and grand-daughter of the pointillist painter Paul Signac.

Some French critics derided Cachin for choosing such a vast topic, and for placing masterpieces like Claude Monet's *Antibes* alongside minor works by relatively unknown Spanish and Italian painters. The art critic for *Libération* newspaper said that the show 'resembles a painting exhibition, but in fact it's a touristic undertaking'.

Cachin, who would die in February 2011, stood by her choice. 'I imagined a visit of pleasure and delight, through a period of art history that has never been studied in this manner,' she explained. 'I wanted to show to what extent, for painters from the north, the Mediterranean was a revelation, and at the same time create surprises with paintings that had never been seen in Paris.'

Despite begrudging critics, Cachin achieved her goal of creating pleasure and delight. The show opened with Gustave Courbet's *Le Bord de mer à Palavas* in which a well-dressed gentleman waves his hat at the sea, dwarfed by its immensity. For the naturalists, the Mediterranean was still an unknown and intimidating presence, often relegated to backdrop status, as in Jean-Louis Ernest Meissonier's *Horseback Ride at Antibes* or Frédéric Montenard's *Cemetery in Provence*.

Pierre-Auguste Renoir enticed his fellow Impressionists to the southern French coast. 'It is the most beautiful country in the world, and not yet inhabited,' he wrote to a collector in 1882. 'There are only fishermen and mountains, no walls, very few buildings. Here I have the countryside at my door.'

Renoir's words, and the ninety canvases at the Grand Palais, made one angry that the modern Côte d'Azur became a tourist mecca marred by pollution and concrete high-rises. As early as 1890, Cézanne fled the first summer holiday-makers at l'Estaque, complaining of the 'invasion of bi-peds'.

Renoir took Monet on a tour of the Mediterranean coast in 1883. 'Monet, who left convinced that he wouldn't like the south, is in contemplation from morning to night,' Renoir wrote. Monet was so impressed that he returned twice for long stays on the Côte d'Azur in 1884 and 1888.

Most of us have received a winter postcard as infuriating as the one Monet sent to his companion Alice Hoschédé at their home in Giverny: 'I hate to think of you being so cold, when it's so hot here that the flowers burst out of the earth as if by enchantment.'

Looking at Monet's Mediterranean canvases, one would never guess how difficult he found it to paint these marvels of airy lightness. 'The sky is not just the colour blue,' he wrote. 'It's blue fire, and you cannot paint it.' Monet compared painting in the Mediterranean climate to a fencing match with the sun. 'Here you would need to paint with gold and precious stones!' he said.

The 1888 trip was a turning point in Monet's career, bringing both him and the south into fashion. van Gogh's brother Theo showed eleven of Monet's Antibes paintings in his Montmartre gallery, to great acclaim.

Van Gogh, Cézanne and Matisse also lamented the impossibility of capturing the Mediterranean on canvas. But the challenge led them to experiment with new ways of painting. 'The sun is so terrifying that objects seem to stand out in silhouette,' Cézanne wrote. 'Not only in black or in white, but in blue, red, brown, purple. It seems to me the very opposite of form.'

The Côte d'Azur may be the birthplace of modern art, but in many painters it also inspired a return to the origins of Western civilisation. Puvis de Chavannes and Bonnard painted the Marseille of Greek mythology. At Antibes, Picasso embarked on his neo-classical period in the 1920s. 'It is strange,' he said. 'In Paris, I never draw fauns, centaurs or mythological heroes. It's as if they only lived here.'

After the 1920s, artists continued to flock to the Mediterranean, but for other reasons. The sea and its boulders, fishing boats and views through windows, the lush vegetation that fascinated Monet and Bonnard, were no longer subject matter.

Les Iles d'Or, 1891,
Henri-Edmond
Cross. Photo: ©
White Images/Scala,
Florence.

River of Impressionist Inspiration

The English painter Joseph Mallord William Turner so loved the Thames that he bought a house in Chelsea with commanding views of the river. To satisfy his fascination, he watched its waters in the magical hours of dawn and dusk from a rowing boat or a rooftop balcony. On the day of his death in December 1851, Turner was found lying on the floor of his bedroom, trying to reach the window so as to see the river.

The River Thames was the leitmotif of 'Turner Whistler Monet', the main autumn exhibition at the Grand Palais in 2004. The three painters returned repeatedly to the river, abandoning their early realism to transform the basic elements of water, air and fiery sunsets into poetic visions.

Ironically, the soot and smoke of industrial-age London created the atmospherics the painters so loved, especially the violent sunsets. Claude Monet feared fine weather when the factories shut down on Sunday.

'On getting up, I was terrified to see there was no fog, not even a trace of mist; I was annihilated,' he wrote to his wife Alice.

Monet sometimes used the English Channel and the Seine as substitutes, but it is revealing that the canvas which gave its name to Impressionism — *Impression, Sunrise*, painted in 1872-73, was mistaken by the critic Ernest Chesneau for a 'sunrise over the Thames'.

With its zig-zagging reflection of the sun's rays on water, *Impression* so resembles Turner's *Scarlet Sunset: A Town on a River*, painted some four decades earlier, that one could be forgiven for wondering whether Monet copied Turner.

Long after the word 'impressionism' ceased to be an insult, Monet explained to *La Revue Illustrée* how the term was coined: 'I'd sent [to the 1874 exhibition] a thing done at Le Havre, from my window, of the sun in the mist . . . They asked me for the title for the catalogue. It couldn't really be called a view of Le Havre, so I said: "Put Impression." They made Impressionism out of it, and the jokes started.'

The ambitious 2004 exhibition was organised by the Musée d'Orsay, the Art Gallery of Ontario in Toronto and the Tate Gallery in London. It was meant to celebrate the centenary of the *entente cordiale* between France and Britain by showing how deeply Britain and France influenced each other. But it asked a question that makes some French curators apoplectic: was Turner, not Monet, the first Impressionist painter?

Sun Setting over a Lake, circa 1840,
Joseph Mallord William Turner. Photo: © Tate Images.

French historians point out that Turner's favourite painter, Claude Lorrain, was a seventeenth-century French landscape artist. Turner asked that his paintings be hung beside Lorrain's in the National Gallery after his death. Lorrain's influence – sky-filled canvases suffused with morning or evening sunlight – is obvious in early Turners.

Turner supporters can nonetheless point to a great deal of evidence that the English painter invented Impressionism. Monet's own biographer called him 'the French Turner'. Henri Matisse called Turner 'the link between tradition and Impressionism' and said that he 'found a great similarity of construction through colour between Turner's watercolours and the paintings of Claude Monet'. The Belgian poet Émile Verhaeren wrote in 1885 that 'the seeds of the recent techniques of the French Impressionists, of Claude Monet and his school . . . are found in Turner's oeuvre . . . A half-century before Manet, Claude Monet and Renoir, might Turner, perhaps, have created the Impressionist school?'

Monet seems to have had mixed feelings about Turner. But a letter sent by the core group of Impressionists to London's Grosvenor Gallery in the early 1880s undermines France's claim to have invented Impressionism. 'A group of French painters, united by the same aesthetic tendencies, struggling for ten years against convention and routine . . . cannot forget that it has been preceded in this path by a great master of the English school, the illustrious Turner,' the painters wrote.

The exhibition included only three of Turner's large 'Impressionist' canvases, including the magnificent *Junction of the Severn and the Wye* and *Sun Setting over a Lake*. These two oil paintings from the 1840s demonstrate how far ahead of his time Turner was.

The reaction of writer Hippolyte Taine, on visiting London in 1871, was typical of French artistic conservatism on the eve of the Impressionist revolution. Turner's later paintings 'degenerated into lunacy . . . compose an extraordinary jumble, a sort of churned foam', Taine wrote. 'Place a man in a fog, in the midst of a storm, the sun in his eyes, and his head swimming, and depict if you can his impressions on canvas; these are the gloomy visions, the vagueness, the delirium of an imagination that becomes deranged through over-straining.'

The third Turner oil painting in the exhibition at the Grand Palais, *The Burning of the Houses of Lords and Commons*, hung in a room with eleven Monets of the Houses of Parliament at sunset. Similarities in palette and composition are striking, though Turner and Monet painted the subject at thirty-year intervals.

The idea of a Turner-Monet exhibition was at least a hundred years old. In July 1904, critic Gustave Kahn wrote: 'One would understand placing certain Monets beside certain Turners . . . It would bring two dates of Impressionism together. Or rather, since the names of schools can be misleading . . . it would bring together two dates in the history of visual sensibility.'

James McNeill Whistler was an uprooted American who spent part of his childhood in Russia with his father, a civil engineer. Whistler studied painting in Paris, and moved between Paris and London throughout his adult life.

It was Whistler who introduced Monet to the London art world – and probably to the work of Turner. Though he was a teenager when Turner died, Whistler harboured boundless admiration for Turner, whose work he began copying when he was expelled from West Point at the age of twenty.

Like Turner before him, Whistler lived beside the Thames so he could paint from his window. When his wife Beatrice was dying in 1896, Whistler rented a room in the Savoy so she could watch the river while he drew it. A few years later, on Whistler's recommendation, his friend, Monet, also took a room on the sixth floor of the Savoy.

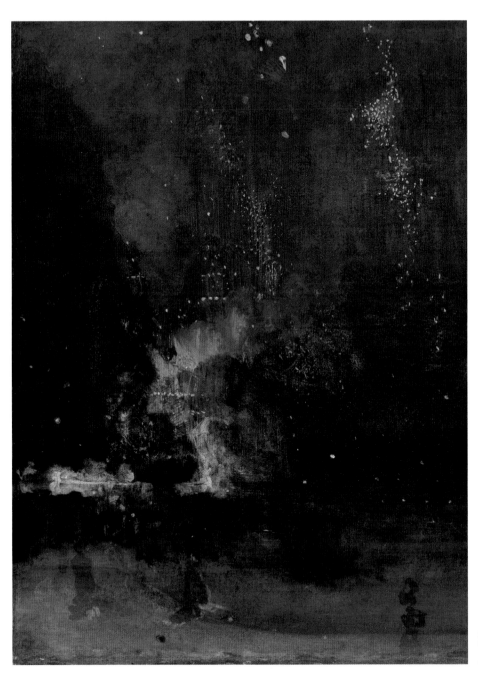

Nocturne in Black and Gold:
The Falling Rocket, 1875,
James Abbott McNeill Whistler.

Monet is believed to have met Whistler during his first trip to London in 1870. The French painter, accompanied by Pissarro, had fled Paris to escape conscription during the Franco-Prussian war. It is likely that Monet saw Whistler's *Nocturnes*, ethereal silhouettes of the Thames and the buildings of London, with a few pinpricks of light. The *Nocturnes* were influenced by the Impressionists' love of Japanese art, and were a theme Whistler returned to in Venice.

All three painters were inspired by Venice. Monet, the last to visit 'the floating city', used Turner's and Whistler's technique of painting from a gondola. But there is little beyond the obvious themes to connect Turner's watercolours, Whistler's etchings and Monet's oil paintings.

It is possible, though not certain, that Monet took his habit of doing series of paintings of the same subject from Turner. Monet's Venetian palaces recall his cathedral series; weightless, pastry-like stone suffused with purple-blue light.

In their lifetimes, Turner, Whistler and Monet were criticised for the 'unfinished' quality of their paintings. In the artistic cause célèbre of 1878, Whistler sued the art critic John Ruskin for defamation after the latter accused him of 'flinging a pot of paint in the public's face' by creating *Nocturne in Black and Gold: The Falling Rocket*. Though Whistler won a symbolic farthing in damages, his health and finances were ruined by the lawsuit.

With the Impressionists, planning fell by the wayside. 'A landscape is but an impression that the brush must seize in subtle harmonies, in its instantaneousness,' Monet wrote.

He refused to sketch, preferring to capture a moment directly on canvas with paint. The permanence conveyed by realist painters died. In its stead, the world gained the most beautiful urban landscapes in the history of art.

In Praise of Nocturnes

I have a special weakness for the John Field Room at the National Concert Hall in Dublin, not just for the intimacy of the recitals that are held there. Field was the inventor of one of my favourite art forms, the nocturne.

The Italian term *notturno* appeared in the titles of eighteenth-century compositions evoking night. But it was the Irish-born Field who first used the French form of the word for eighteen piano pieces he composed between 1813 and 1835.

Field initially called his pieces 'Romances'. Liszt wrote the preface to the first collected edition of Field's Nocturnes, published in Leipzig. 'To him we may trace the origin of pieces designed to portray subjective and profound emotion,' Liszt wrote.

Subjective and profound emotion – all romanticism is there. Chopin is believed to have heard Field's Nocturnes in Warsaw as a boy, and certainly played them in Paris before writing his own, exquisite twenty-one Nocturnes. With Chopin we are transported away from rationality, into the night-time of emotion.

Chopin.

Several decades later, the American painter James McNeill Whistler adopted the name Nocturnes for his paintings of twilight on the Thames and the lagoons of Venice. Whistler wrote to thank his patron, F. R. Leyland, for suggesting the musical term: 'You have no idea what an irritation it proves to the critics and consequent pleasure to me – besides it is really charming and does so poetically say all I want to say and *no more* than I wish.'

Music, painting and poetry all find expression in the Nocturne. William Henley, a mentor of the young W. B. Yeats in London, dedicated a poem to Whistler, for which Whistler provided a lithograph as an illustration. In one of the Thames Nocturnes, Henley heard 'the unvoiced music of my heart' – an equally apt description of the Nocturnes of Field and Chopin.

This piece was commissioned by the National Concert Hall in Dublin in 2010.

Monet's Water Lilies

In the last thirty years of his life, Claude Monet painted his beloved garden at Giverny hundreds of times, preserving 250 canvases but destroying many others.

Monet lavished the genius of his old age on the *Nymphéas* (water lilies) and *Nénuphars* (lotuses). 'These waterscapes have become an obsession,' he wrote in 1908. 'It is beyond my strength as an old man, and yet I want to manage to render what I feel. I destroy some . . . I start over . . . and I hope that from so much effort something will result.'

In the *Water Lily Ponds* of 1899 and 1900, Monet painted and repainted the arched Japanese bridge in his garden in every light, at every time of day. These canvases abound with an intense, natural energy. 'You feel the underground life at the bottom of the pools,' the Belgian poet Émile Verhaeren wrote, 'the dense growth of the roots, the tangle of stems underlying the mass of bouquets on the surface. . . .'

By 1903, Monet had narrowed his focus to the water itself, abandoning the bridge, the willow trees and the foliage on the banks. In these 'waterscapes', lilies float amid mirrored clouds, sky, sunlight and trees. The subject matter is impalpable, unreal as a reflection, yet rendered with almost photographic precision. Throughout his life, Monet reacted angrily to those who said his paintings were fanciful. He was, he protested, a realist.

Misfortune struck the ageing painter in 1910. Floods destroyed his garden at Giverny, which he redesigned and rebuilt. The following year, his wife died. Then, in 1912, he noticed 'with terror' that he could no longer see through his right eye, and learned that he was suffering from a double cataract. He nonetheless began six years of large studies for the water lily panels he would donate to the Orangerie. The precision of the 'waterscapes' disappeared. As his vision worsened, Monet's style became more blurred, sometimes approaching the abstract.

Monet's work was interrupted by depression over his failing eyesight and the slaughter of the First World War. Although he closed himself off from the world, he could not ignore the munitions trains that thundered past the bottom of his garden at Giverny.

In 1917, a government minister took Monet to Reims, to see the cathedral after German shells set fire to it. The Paris authorities hoped the old man would record this act of vandalism on canvas; but Monet took one look at the smoking ruins and returned to his water lilies.

Yet in his way, Monet wanted to participate in the victory. On 12 November 1918 he wrote to his great friend, Prime Minister Georges Clemenceau, offering to France two giant water lily panels, to be chosen by Clemenceau and installed in a specially designed museum.

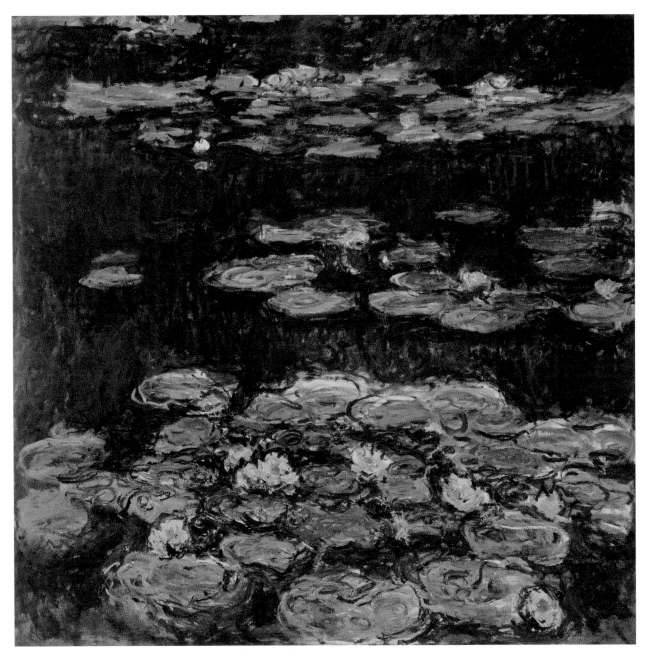

White and Yellow Water Lilies, 1915-17, Claude Monet.

To commemorate the eightieth anniversary of Monet's donation, in 1999 the French curator Pierre Georgel brought together sixty – nearly a quarter of the total – of Monet's paintings of water lilies. Eighteen paintings were loaned by US museums. Four came from Britain and others from Sweden, Germany and Japan. The Orangerie was then closed for four years. Until 2003, it was impossible to view the giant panels that Monet donated to the French state.

In the eight years between Monet's offer of the water lily panels and his death, he pleaded for more time to complete his ethereal masterpieces, quarrelled with the architects responsible for placing the canvases, and ultimately could not bring himself to part with them while he was alive.

Immediately after his death in December 1926, Monet's son gave the twenty-two panels to the Orangerie, where they were permanently attached to elliptical walls.

Today, Monet is France's most popular painter and the Orangerie is, in the words of the painter André Masson, 'the Sistine Chapel of Impressionism'.

But in the decades following his death, the painter was regarded as a slightly cracked old man who painted too many ponds. In 1935, Monet's great panels were hidden by Flemish tapestries. They were damaged in Second World War bombardments and were not fully restored until 1978.

In another sense, too, the 1999 exhibition marked the revenge of history. A few days before it opened, the French Minister of Culture handed over one of the water lily paintings to the heirs of Paul Rosenberg, a legendary French Jewish art dealer who fled the Nazis in 1940 and settled in New York. Anne Sinclair, the wife of the disgraced former director of the IMF, Dominique Strauss-Kahn, is Rosenberg's grand-daughter.

Rosenberg, who died in 1959, had hidden 160 paintings in his villa near Bordeaux and in a bank vault. Two French antique dealers denounced him to the Germans.

Rosenberg's Monet ended up in the home of Hitler's foreign minister, Joachim von Ribbentrop. It was returned to the Louvre after the war, but was not identified by the family until 1998.

American Impressionists

Soon after Claude Monet moved to Giverny in 1883, he wrote to the art dealer Théodore Duret: 'I am in ecstasy. Giverny is a splendid place for me.' The first Impressionist painter lived in Giverny until his death in 1924.

Monet's friends Pierre-Auguste Renoir, Camille Pissaro, Paul Cézanne and John Singer Sargent visited him at Giverny. The reputation of the village as a haven for artists spread, and foreign painters, three-quarters of them American, flocked there.

The Norman village had the advantage of being close to Paris, and its location in the wide Vallée de la Seine and its proximity to the sea endowed it with unparalleled light.

Katherine Bourguignon, the American-born associate curator at the Musée Américain Giverny, explained why the village drew so many of her compatriots to Normandy. 'The atmospheric conditions change quickly in Giverny,' Bourguignon said. 'A cloudy sky in the morning leads to a sudden shower, followed by sunshine. These brusque, unforeseeable interludes create infinite variations of light in the course of a single day. Some mornings, fog lies over the banks of the Seine and the Epte, and does not burn off until noon. The green fields, groves and gardens that thrive in this temperate climate inspired outdoor painters. The changing light presented a permanent challenge.'

The American painters Mary Cassat and Lilla Cabot Perry made Monet famous in the US before he was recognised in France – one reason so many of his masterpieces ended up in US museums.

In 1887, Angélina and Lucien Baudy turned their grocery store into a hotel. They built a tennis court out front, learned to make tea and Boston baked beans, sold artists' supplies, and accepted paintings in lieu of rent. By 1890, there were fifty artists living in Giverny. In all, Bourguignon determined from the hotel's records, 350 foreign artists from eighteen countries came to Giverny over three decades. A surprising number were women, including Irishwoman Katherine MacCausland, who lived at the Baudy from July until November 1898.

For English-speakers, life at the Hôtel Baudy was not unlike a US campus, with picnics, costume parties and a hand-made artists' newsletter called the *Courrier innocent*. Painters set up their easels side by side in the fields. Sometimes they even glimpsed the Great Man, though because of their invasion, Monet increasingly retreated into the walled garden of his home.

Monet befriended the early arrivals, including John Leslie Breck, considered the leader of the American Impressionists. In tribute to Monet's 1890-91 haystack series, Breck painted his own *Studies of an Autumn Day*: twelve square canvases showing exactly the same haystacks from dawn to midday to sunset and evening. The result is obviously inspired by Monet, but nonetheless original and modern.

'Breck took shortcuts,' Katherine Bourguignon explained. 'By using the same size canvas, he didn't have to think about composition. The subject didn't matter; he was only painting the light.' Breck fell in love with Monet's stepdaughter Blanche Hoschedé, also a painter. But Monet did not want his daughters to marry foreigners, and especially not artists. The rejection broke their friendship, and Breck left Giverny for good. Six years later, Blanche married Jean Monet, Claude's son by his first marriage.

When another American painter, Theodore Butler, fell in love with another Monet stepdaughter, Suzanne, Monet again opposed the union. Butler's fellow painters submitted a petition to the great painter. Gradually, his resistance wore down.

After the death of his first wife Camille in 1879, Monet began living with Alice Hoschedé, the wife of his friend and ruined former patron Ernest Hoschedé, and their six children, as well as his own two sons. Ernest died in 1891, but it took the engagement of Alice's daughter Suzanne to Butler to prompt Claude and Alice to marry on 16 July 1892, four days before the younger couple. As her legal stepfather, Monet was then able to give the bride away.

The marriage was recorded on canvas by Theodore Robinson, one of the finest American painters in Giverny. A poem in the *Courrier innocent* also commemorated the event: 'Oh haste to the wedding, and let everyman/ Drink to Butler the lucky and lovely Suzanne/ And eke to Giverny where all of us be/ And remember dear friends that the drinks are on me.' Continuing the almost incestuous tradition of the Monet family, when Suzanne died seven years later, Butler married her sister, Marthe.

Robinson was also a photographer, painting from his own photographs, returning to the open air and his model only to make finishing touches. He took a rare photograph of the middle-aged Monet, dressed like a Normandy peasant with a felt hat, cane and wooden shoes.

Claude Monet, arguably France's greatest painter, is buried in the local churchyard in a large white marble tomb, overgrown with shrubbery and flowers, with the entire Monet-Hoschedé-Butler clan. The village is well preserved, but has managed to avoid becoming a Monet Disneyworld. The Hôtel Baudy is now a restaurant, with a US flag over the door.

The artists who came to Giverny were students, not innovators. Picasso was already a Cubist when they were still painting poplar trees, haystacks and Giverny village. Yet these late, imported Impressionists enjoyed success in France as well as in the US, where they exhibited together in 1910 as 'the Giverny Group' or 'the Luminists'. Their notoriety continues to grow, with paintings often fetching more than one million dollars at auction.

The late American chemical magnate and patron of the arts Daniel Terra was so charmed by Giverny, which he first visited in the 1980s, that he sought out paintings by artists who lived there for his vast collection of American art. Terra inaugurated the Musée d'Art Américain in 1992, four years before his death. It is a discreetly designed modern building shrouded in white wisteria, just a stone's throw away from Monet's house and gardens, with their famous water lilies.

The Wedding March, 1892, Theodore Robinson.

In 2007, the Musée d'Art Américan, then the San Diego Museum of Art, exhibited 'Impressionist Giverny: A Colony of Artists, 1885-1915', which was curated by Bourguignon. About half the ninety paintings in the 2007 exhibition belonged to the Chicago-based Terra Foundation for the Arts. The other half were borrowed from museums around the world, to celebrate the museum's fifteenth anniversary.

Three Monet paintings in the exhibition showed the weakness of his followers. Monet's *Fields of Poppies at Giverny* hung alongside a similar painting by Theodore Wendel. The American's canvas was decorative, but lacked the energy and vibrancy of Monet's masterpiece.

After painting the surrounding countryside, first in the realistic style and earthy colours of the Barbizon school, then with the lighter touch of the Impressionists, the foreign artists turned to scenes of village life, a theme Monet seldom painted. The Czech painter Vaclav Radimsky was alone in painting a bleeding pig's carcass in the yard of the Hôtel Baudy. His *Old Mill at Giverny*, with its almost phosphorescent evening colours, has a distinctly central European feeling. The Czech national gallery lent the painting reluctantly, and would not allow it to move on to San Diego with the exhibition.

Gradually, the first wave of bachelor painters gave way to a more settled colony of married artists with families. Chief among them were Mary and Frederick MacMonnies, both accomplished painters, who bought an old priory in Giverny, where they raised two children. 'The MacMonnies invited friends, and created a world within Giverny,' Katherine Bourguignon said. 'It was an idyllic, refined place, with concerts in the evening. Artists were no longer drawn by Monet; they came for the other painters.'

The American artist Frederick Carl Frieseke was born in 1874 – the year after Monet painted the first Impressionist painting, *Impression, soleil levant*. A generation separated them. Frieseke launched the fashion of painting bourgeois women – clothed or unclothed – in gardens. Models in white dresses, surrounded by repetitive flower motifs, remind one of Frieske's Viennese contemporary, Gustav Klimt. Frieseke found France far freer than the US, to which he never returned.

Sophie Lévy, the curator of the Musée d'Art Américain in Giverny, said the American Impressionsists 'understood some aspects of Impressionism, but not the most radical, such as high horizons, the dissolution of the motif, to the point where you can't tell what it is . . . They were interested in brushstrokes, colours, themes. But everything to do with the reconstruction of space was too challenging for their market. Many of them needed to sell their works. They were always considering the middle ground.'

Suzanne Valadon

The illegitimate daughter of a country sewing maid, Suzanne Valadon grew up as a street urchin in Montmartre. Compared to Victorian Britain, late-nineteenth-century France was a place of incredible sexual licence. Almost miraculously, the impoverished Valadon evaded the pimps of Montmartre to become a circus acrobat, until she injured her back in a fall. At the age of fifteen, she modelled for Pierre Puvis de Chavannes, then one of France's most respected painters.

Valadon's story, from her late teens until she died at her easel in 1938, paralleled the history of French art. In the 1998 biography *Mistress of Montmartre: A Life of Suzanne Valadon*, June Rose skilfully wove together the life of this extraordinary woman and a portrait of her time. In Montmartre's Café Guerbois, the eccentric Paul Cézanne spurned the dandy Édouard Manet. 'Cézanne reserved his particular scorn for Manet, who always appeared impeccably dressed with silver-topped cane, doeskin gloves and a silk topper,' Rose wrote. 'On one occasion, after shaking hands all round, Cézanne refused to offer his hand to the man-about-town: "I haven't washed for a week, Monsieur Manet," he growled, "so I am not going to offer you my hand!"'

This was the world that Suzanne Valadon lived in. She posed for some of Pierre-Auguste Renoir's greatest masterpieces, including *Dance at Bougival* and *The Bathers*. Known then as Maria, Valadon had sex with most of her painter employers, and Renoir's fiancée was so jealous that she rubbed Valadon's face out of *Dance in the Country*, insisting that Renoir replace it with her own, less attractive, features.

While the painters around her fought the dictatorship of the Salon, the official art exhibition, Valadon gave birth to an illegitimate son, Maurice Utrillo – father unknown – in 1883.

She modelled in the daytime and spent evenings at the Chat Noir and Lapin Agile cabarets, while her ageing mother Madeleine looked after baby Maurice. Somehow she found time to draw in secret.

It was Henri de Toulouse-Lautrec, another of Valadon's employers and lovers, who encouraged her to take her firm-lined drawings of Maurice and Madeleine to the great master, Edgar Degas. 'You are one of us,' the reclusive Degas told her at their first meeting, which started a long friendship. He bought one of her drawings, and Valadon recorded: 'That day I had wings.' She would know virtually every great painter of the late nineteenth and early twentieth centuries. Modigliani called her 'the only woman in Paris who understands me'. Picasso attended her funeral.

Valadon enchanted the composer Erik Satie, who wrote her a tender love note in 1893: 'Impossible to stop thinking about your whole being; you are inside me completely; everywhere I see only your exquisite eyes, your gentle hands and your little child's feet.' Satie was devastated when Valadon left him for a wealthy stockbroker, Paul Mousis, whom she married in 1896.

But bourgeois existence did not suit Valadon. Her inspiration dried up, and in 1909, at the age of forty-four, she left the security of life with Mousis for her lover André Utter, an acquaintance of her son's who was twenty-one years her junior. Utter encouraged her to paint, and her passion for him inspired some of her best work.

In later life, Utter became jealous of Suzanne – whom he married during the First World War – and her son Maurice. Utrillo was debilitated by alcoholism, but his paintings of Montmartre street scenes supported the 'unholy family' of three, with Utter acting as business manager. Eclipsed by the success of Utrillo, Suzanne Valadon received only a small measure of the recognition she deserved in her lifetime.

Dance at Bougival, 1883, Pierre-Auguste Renoir. Photo: © The Bridgeman Art Library.

Cézanne and Pissarro

Brothers of the Brush

Their self-portraits might have been painted by cousins, even brothers. Both are bearded and balding; both look at the viewer with the intense, dark-eyed stare they inherited from Creole mothers.

If these two great artists of the late nineteenth century were spiritual brothers, Camille Pissarro (1830-1903) was the elder, exercising an influence over Paul Cézanne (1839-1906) which surpassed their age difference. Pissarro is the wise, gentle brother whose oeuvre exudes a poetic love of nature. Cézanne is the brooding brother, with supercilious, arched eyebrows.

The father of modern art painted his self-portrait about the time he wrote to his mother: 'I know that Pissarro has a high opinion of me, and I have a high opinion of myself. I am beginning to find myself better than all those around me ...'

Pissarro's generosity was so profound that in later life he rejoiced in the success of his friends Monet and Renoir. He would live to see the beginning of Cézanne's fame. 'He felt only joy for their triumph, which he considered his own, and had never doubted,' the art historian Thadée Natanson wrote in 1948. 'For this good man did not know the meaning of envy.'

Despite Cézanne's bourgeois upbringing – his father Louis-Auguste founded the only bank in Aix-en-Provence – he was something of a social misfit. Though he admired Édouard Manet, Cézanne shied from contact with him. In later life, Cézanne broke off a forty-year friendship with the writer Émile Zola, and railed against the 'invasion of bipeds' on the Côte d'Azur.

Cézanne and Pissarro met at the Académie Suisse, a school frequented by painters who wanted to break out of the academic tradition, in 1861. For a decade, they crossed paths in galleries and painters' studios, but the acquaintance deepened into friendship after the 1870-71 Franco-Prussian war and the Commune which followed.

Pissarro had taken his wife Julie and their children (they would have seven) to London to escape the violence. When they returned, they found the painter's house in Louveciennes ransacked, his artist's studio destroyed. Pissarro's paintings had disappeared, 'which represented a considerable amount of work', the art dealer Ambroise Vollard wrote. 'But Pissarro did not give in to discouragement and painting followed painting.'

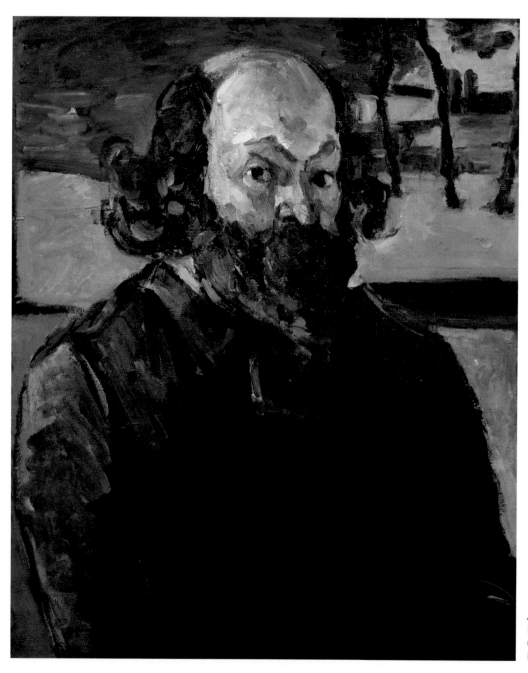

Autoportrait, 1873-76,
Paul Cezanne. Photo:
© White Images/Scala,
Florence.

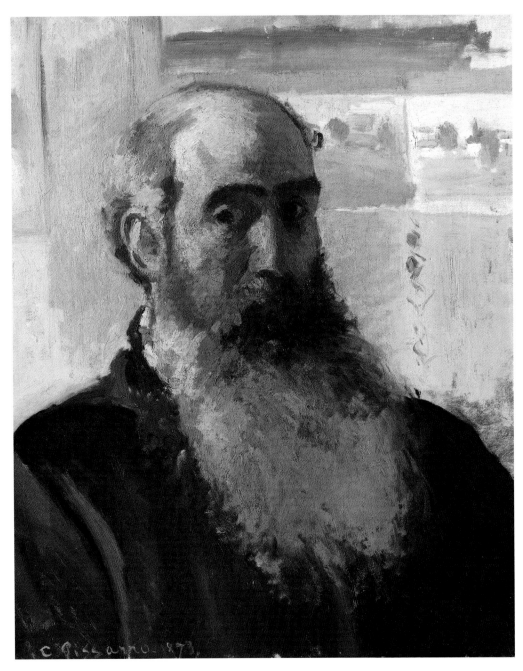

Self-Portrait, Camille
Pissarro. Photo © Scala,
Florence.

Pissarro and his family moved ten times between 1866 and 1881. He found it difficult to sell his paintings, and in the countryside northwest of Paris there were always cheaper lodgings to be found. Cézanne visited the Pissarros often in Pontoise, sleeping over when he missed the train back to Paris. The younger painter's model and mistress Hortense Fiquet was pregnant with their son Paul. They decided to leave their cramped apartment in Montparnasse for Auvers-sur-Oise, to be near the Pissarros.

In Auvers in the 1870s, painters gathered for a glass of absinthe at the Auberge Ravoux, spent evenings discussing atheism and anarchism. Cézanne was quiet during these debates; he enjoyed his time alone with Pissarro most of all.

For the better part of a decade, Cézanne and Pissarro tramped around the countryside together, setting up their easels to paint roads, bridges and village houses. While Monet and Sisley concentrated on the effects of light on water, Cézanne and Pissarro were drawn to the land. 'In Pontoise, Cézanne was influenced by me and I by him,' Pissarro wrote to his son, Lucien, in 1895. 'What is striking is . . . the affinity between certain landscapes he painted in Auvers and Pontoise and mine. By Jove! We were inseparable! But one thing is certain: each of us retained the only thing that matters, his "sense of feeling".'

In 2005 and 2006, the Musée d'Orsay in Paris, the Museum of Modern Art in New York and the Los Angeles County Museum of Art pooled resources to chronicle this artistic endeavour, in 'Cézanne and Pissarro 1865-1885'. (The dates were fudged by several years in either direction in the title; the two men painted together for the last time in 1881.) The exhibition was one of two major shows marking the centenary of Cézanne's death. The other, 'Cézanne in Provence', was at the National Gallery in Washington, then the Musée Granet in Aix-en-Provence, in 2006.

Comparative exhibitions were fashionable in the last decade, but none of the artists paired before shared an artistic bond as close as that between Cézanne and Pissarro. Pissarro temporarily brought the younger painter into the Impressionist movement, by convincing Cézanne to abandon his cumbersome literary and mythological themes, and to lighten his sombre palette.

Pissarro was such a skilled teacher that 'he could have taught rocks to draw properly', the American artist Mary Cassatt wrote. Cézanne said he wasted his youth before he worked with Pissarro: 'It was only later, when I knew the indefatigable, relentless Pissarro, that I acquired the taste for work.' After Cézanne left the Paris region to return to his native Provence, van Gogh and Gauguin followed him as Pissarro's students.

Cézanne and Pissarro participated in the first Impressionist exhibition in 1874. But Cézanne was so angered by the critics' response that he boycotted the second, and participated for the last time in the third, organised by Gustave Caillebotte in 1877. Pissarro, sometimes considered the most Impressionist of all Impressionists, did not miss any of the eight exhibitions.

The contrast between Pissarro's and Cézanne's 'sense of feeling' was most obvious when they painted the same scene. Cézanne borrowed Pissarro's *Louveciennes* to copy it. Pissarro's original exudes the beauty of a sunlit autumn day in the country. Cézanne did not usually paint human figures in his landscapes, but in Louveciennes he kept Pissarro's figure of a woman and small girl walking towards the village. Cézanne's version of the painting is stripped of superficial detail, with a coldness not present in Pissarro's canvas.

Cézanne was never at ease with the precepts of Impressionism, which to his mind lacked structure and form. 'I want to make of Impressionism something solid and lasting like the art in the museums,' he said. Their different visions are even more evident in *The Maubuisson*

Garden, Pontoise, painted in the spring of 1877. Pissarro's garden is a delicate, shimmering vista of fruit trees in blossom. White and pale green brushstrokes almost hide the houses on the hill behind the trees. Cézanne merely hints at the fruit trees. He is far more interested in the heavier substance of walls with their parallel lines, in a grey slate trapezoidal roof. The ploughed earth of the foreground is rendered in horizontal strips of colour.

Even during his years with Pissarro, a certain visual dissonance, the seeds of Abstraction and Cubism, can be seen in Cézanne's painting. A painter 'should treat nature in terms of the cylinder, the sphere and the cone,' he once told a young follower.

Though he was faithful to the Impressionists' rule of painting outdoors, one may legitimately ask if Cézanne was ever truly an Impressionist. 'Cézanne was never, even in 1874-1878, the period of his most beautiful landscapes of the Île-de-France, a true Impressionist like Pissarro, Sisley or Monet,' the art historian Liliane Brion-Guerry wrote in 1966.

Though their styles eventually diverged beyond compatibility, Pissarro never ceased admiring Cézanne's work, which he called 'truly extraordinary in its savagery and character'. In a nostalgic mood in the early 1880s, Cézanne reinterpreted several of Pissarro's early landscapes. 'If Pissarro had continued painting as he did in 1870, he would have been the best of us all,' Cézanne said.

Cézanne disapproved of Pissarro's flirtation with pointillism and post-Impressionism, but he never forgot his debt to the man he called 'the humble, colossal Pissarro'.

Pissarro died in 1903. Three years later, in the year of his own death, when Cézanne exhibited in Aix, he insisted that his name be followed with the words 'student of Pissarro'.

Manet/Velázquez

French Flair, Spanish Darkness

Jean-Auguste-Dominique Ingres and Eugène Delacroix personified the conflicting pulls of Classicism and Romanticism in early nineteenth century art. For Ingres and the conservative establishment, Raphaël was the ultimate reference. But Delacroix, influenced by his friendship with a former French ambassador to Madrid – and the paintings he brought back – looked to Spain, copying the work of his contemporary, Francisco de Goya y Lucientes (1746-1828), and studying seventeenth-century Spanish masterpieces.

After the Napoleonic wars, the French briefly hung looted seventeenth-century paintings by Ribera, Murillo and Zurbarán in the Louvre, but they had to give them back after the 1814 Congress of Vienna. A couple of decades later, some of the same canvases were among four hundred purchased by King Louis Philippe for his 'Spanish Gallery' in the Louvre. That lasted from 1838 until 1848. After Louis Philippe was overthrown, the Spanish works were auctioned in London.

The exhibition 'Manet/Velázquez: The Spanish Manner in the 19th Century' at the Musée d'Orsay in the autumn of 2002 again gathered fine works of Spain's 'golden century', and showed the profound influence of seventeenth-century Spain on French cultural life two hundred years later. The exhibition moved on to the Metropolitan Museum in New York in 2003.

French painters mimicked the realism of their Spanish predecessors, taking beggars, buffoons, cripples and martyrs as subjects. Édouard Manet, Gustave Courbet and others adopted a Spanish palette of ochre, grey, brown, black and chalky white.

Like the Spaniards, they gave precedence to light and shadow, quick brushstrokes and colour, over draftsmanship and exactness.

The Spanish craze extended to fashion, literature, dance and music. As shown in Henri Regnault's 1869 portrait of the *Countess of Barck*, French ladies wore black lace mantillas and held fans. Prosper Mérimée wrote *Carmen* in 1846, which inspired Georges Bizet's opera twenty-nine years later.

Seventeenth-century painters were the main source of inspiration, among them Francisco de Zurbarán, whose dramatic painting of Saint Francis was admired by Manet and Camille Corot when it hung in King Louis Philippe's gallery. Today it belongs to the National Gallery in London.

The nineteenth-century art historian Charles Blanc described how frivolous visitors to the Louvre would fall silent when they found themselves before Zurbarán's monk, with his frayed brown cassock and a skull clutched to his body. The painting still exudes ascetic spirituality.

The Fife Player 1866, Edouard
Manet. Photo: © Scala. Florence.

Goya served as a link between the seventeenth and nineteenth centuries, by engraving his own copies of Velázquez's portraits, widely published from the late eighteenth century. Goya's *The Letter* or *The Young*, painted around 1812-14, shows a flirtatious young woman and her parasol-bearing servant. Behind the two women with the cavorting Pekinese dog, Goya painted a strange background of laundry women working. The same labourers can be found in later Degas and Caillebotte paintings.

French Hispanophiles revered the seventeenth century so much that many neglected Goya, the artistic heir of Velázquez. Delacroix was an exception, as shown in his poignant *Young Orphan in the Cemetery* (1824).

Goya's paintings of tragic contemporary events have the immediacy of news photography. His graphic painting of the French execution of Spanish rioters in *Tres de Mayo* (painted in 1814) would inspire Manet's *Execution of the Emperor Maximilian* in 1867. Goya's *Cannibals Contemplating Human Remains* is as gruesome as a modern horror film.

The Spanish influence is most marked in the work of Édouard Manet (1832-83). Manet and Degas are believed to have met in the Louvre, when both were copying the *Portrait of the Infante Marguerite*, attributed to Velázquez.

Long before his first journey to Spain in 1865, Manet imitated the Spanish style from engravings and reproductions, with mixed results. He purchased a collection of Spanish costumes and accessories from a Paris tailor and painted *The Spanish Singer* (wearing espadrilles and playing a guitar) in 1860. Two years later, Manet's favourite model, Victorine Meurent, looked ridiculous disguised as a bullfighter.

The more successful *Boy with a Sword*, painted in 1860-61, was inspired by a group portrait of thirteen men attributed to Velázquez, which Manet also copied. Émile Zola, the novelist who stood by Manet when the French Salon shunned him, said *Boy with a Sword* definitively established Manet's affiliation with the Spanish masters. It belongs to the Metropolitan in New York and was the signature painting of the 2002-03 exhibition.

Manet's grasp of things Spanish improved with a stay in Spain in 1865. The bullfights he painted, in bright sunshine with teeming crowds in the background, were 'one of the most beautiful, strangest and terrible scenes you could imagine', he wrote. Manet's praise for Diego Velázquez (1599-1660), whose work he studied in the Prado, was boundless. 'He is the greatest painter there ever was,' Manet wrote to Baudelaire in the same year. 'I saw between thirty and forty of his canvases in Madrid . . . all of them masterpieces. He surpasses his own reputation and he alone is worth the fatigue and difficulties that are impossible to avoid on a journey to Spain.'

Thereafter, Manet's work was permeated with Spanish allusions. His *Tragic Actor* took the same stance, with the same shadows falling behind his legs, as Velázquez's *The Buffoon Pablo de Valladolid*. Manet's three figures on a balcony repeat the theme of *Majas on a Balcony* from the school of Goya. Manet's *Philosopher*, *Beggar* and *Artist* are his most powerful studies in human psychology. They were inspired by two Velázquez portraits of philosophers in the Prado.

Zola wrote in 1866 that his favourite painting of the period was Manet's *The Fife Player*. Like most of Manet's work, it was rejected by the Salon. The boy's round, dark eyes, the black, red, ochre and grey colours, convey a Spanish feeling. But although the plain background and full-length standing portrait hark back to Velázquez, *The Fife Player* is a strikingly modern painting, a precursor to the work of another great Spaniard, Pablo Picasso.

Berthe Morisot

Berthe Morisot, the first female Impressionist painter, seemed to lead a charmed life. Born into the *grande bourgeoisie* in 1841, she grew up in the stylish Paris neighbourhood of Passy. When Berthe was twelve, she and her elder sister Edma began private art lessons and later studied for two years with the realist master Jean-Baptiste Corot. When Morisot was only twenty-three, she and Edma exhibited for the first time at the official Salon. Their father indulged his talented daughters, building a studio for them in the garden.

But more than all else, the Morisot sisters' mother, Marie-Cornélie, wanted them to find suitable husbands. Pierre-Auguste Renoir, who was born in the same year as Morisot and who was, along with Claude Monet, Edgar Degas and the poet Stéphane Mallarmé, one of her closest friends, said she came 'from the most austerely bourgeois milieu ever, at a time when a child who wanted to be a painter wasn't far from being considered the dishonour of the family'.

Edma's fine portrait of Berthe at her easel in 1865 shows what talent the elder Morisot had. But Edma gave up painting to marry a naval officer. Perhaps frightened by her sister's regrets, Berthe Morisot rejected suitor after suitor. 'I will only obtain my independence through perseverance and by showing very openly my intention to emancipate myself,' she wrote to Edma in 1871.

Morisot was such a perfectionist that she destroyed most of her early works. Though the surviving paintings are as wonderful as any by her male contemporaries, the misogyny of art historians long deprived her of the recognition she deserved.

The Palais des Beaux-Arts in Lille went some way towards righting that wrong by holding a superb exhibition of ninety Morisot paintings in 2002. The same show moved on to the Fondation Giannadda in Martigny, Switzerland. Many of the paintings were loaned by museums and private collections in the US and had not been seen in Europe for more than a century.

Morisot's *Young woman dressing up, seen from the back* was owned by the American Impressionist Mary Cassatt, who was her friend. It shows one of Morisot's favourite themes: an elegant woman in a beautiful dress before a mirror, amid a swirl of flowers and Degas-like colours. Morisot said her goal in painting was 'to capture something as it passes'. It could be anything, she elaborated, 'the smallest thing ... a smile, a flower, a fruit, the branch of a tree. ...' *Young woman in a ball dress* was the only Morisot painting bought by the French

state before her death in 1895. The blonde model in her décolleté dress has charm, but no emotional charge. 'Everything floats, nothing is formulated,' the critic Paul Mantz wrote when he saw *Young woman* at the fifth Impressionist exhibition in 1880. 'Even the tone is indecisive, and there is a finesse like that found in Fragonard'

Did Mantz know that Morisot was the great-grand-niece of that eighteenth-century painter? When Morisot completed *View of Paris from the Trocadero*, she fretted that it resembled a painting by her close friend – possibly lover – Édouard Manet. Although it was painted in the year of the Paris Commune, there is no trace of destruction in the bucolic scene. The familiar landmarks of Les Invalides and the Panthéon form the backdrop behind two elegant ladies and a child.

Morisot painted the intimate, feminine world of women and children. With the exception of her late self-portraits, showing her as a careworn, grey-haired woman, her canvases betrayed nothing of her inner mystery and turmoil.

Paintings such as *Summer Day*, showing two women with straw hats and parasols boating in the Bois de Boulogne, strengthen the image of an idyllic life.

Biographers suspect that Morisot pined for Édouard Manet. Yet she defied his advice and participated in the first Impressionist exhibition in 1874. (Manet himself chose never to exhibit with the group.) She showed nine paintings, including *The Cradle*, still her most famous work. Until Mary Cassatt joined them in 1879, Morisot was the only woman in the movement, and was treated by her male colleagues as an equal.

Art critics of the time described Morisot as the only true Impressionist. Albert Wolff wrote in *Le Figaro* in April 1876: 'There is also a woman in the group . . . and she's curious to watch. She manages to maintain

female grace in the midst of the excesses of a delirious mind.' Morisot's husband, Eugène, was so angry that he challenged Wolff to a duel.

The Morisot sisters had spent most of the 1860s copying masterpieces in the Louvre, a normal pastime for artists of the day. Although Berthe noticed the handsome blond painter Édouard Manet as early as 1860, eight years passed before she was formally introduced to him. Manet earned a scandalous reputation with the nudes in *Olympia* and *Déjeuner sur l'herbe*, and when he asked Morisot to pose for him – fully clothed – her mother went with her to his studio.

Manet painted fourteen portraits of Morisot in six years. That he kept seven showed his attachment to the intelligent, wild-looking young woman with dark hair and eyes. The poet Paul Valéry, a nephew of Morisot's by marriage, said the stunning Berthe Morisot with a bouquet of violets was Manet's finest work. Manet painted a smaller canvas showing only the violets pinned to Berthe's bosom, with the words, 'To Mademoiselle Berthe Morisot . . .' written on the card beside them. Morisot kept the painting her whole life, and tried to buy two of Manet's portraits of her after he died in 1883.

Were Manet and Morisot lovers? The question is a mystery of the history of art. Morisot never spoke of her many sittings for the married painter, and in 1874, she married his brother, Eugène. The day after Édouard died of syphilis, Berthe wrote to Edma: 'Add to these almost physical emotions the long friendship that tied me to Édouard, our shared past made up of youth and work, that has disintegrated, and you will understand that I am broken.' Morisot said she would never forget 'the old days of friendship and intimacy with him, when I posed for him and his lively mind kept me alert for long hours'.

Eugène Manet did not have his brother's charm or talent, but he devoted himself completely to his wife's

career. Their only child, Julie, was born in 1879. Morisot described her as 'a Manet to the tip of her fingers'. Her daughter was the greatest love of her life, and one of her favourite models. 'I look sad in this graceful portrait,' Julie wrote in her diary in 1894, describing one of her mother's last paintings. Eugène Manet had died two years earlier. 'In Mama's last works, there is often an impression of sadness. Ah, she was so sad, so unhappy.'

View of Paris from the Trocadero, 1871-72, Berthe Morisot.
Photo: © White Images/Scala, Florence.

III Classic Painters

'I am tormented by an insatiable desire for glory.'
Jean–Auguste-Dominique Ingres

Ingres

Jean-Auguste-Dominique Ingres (1780-1867) lived through three French revolutions, three monarchies and two empires. He showed an extraordinary ability to adapt to successive regimes.

Ingres glorified Napoleon Bonaparte in a neo-Byzantine portrait so opulent that it was ridiculed in the Salon of 1806. 'What horrors have I just learned?' Ingres said on hearing of the criticism heaped on his *Napoléon sur le trône impérial*. 'So the Salon is the theatre of my shame? I am the victim of ignorance and bad faith.'

Two hundred years later, Napoleon was exhibited in a splendid Ingres retrospective at the Louvre. The first in forty years, it explored all aspects of the artist's work – portraits, drawings, watercolours, religious paintings and nudes.

If the 79 paintings and 101 drawings proved anything, it was the impossibility of classifying this great artist. Like his teacher David, Ingres was a neo-classicist; like his rival Delacroix, a romantic. But he was also a mannerist, a symbolist and a hyper-realist, whose influence continues to this day.

Ingres was so crushed by the cold reception accorded his work in 1806 that he stayed on in Italy for eighteen years, not even returning to France to meet Madeleine Chapelle, the hat-maker with whom he'd struck up an epistolary romance. Instead, she came to Rome, where the couple married in 1813. It was a happy union, lasting until Madeleine's death thirty-six years later.

Ingres befriended Napoleon's sister and brother-in-law, Caroline and Joachim Murat, newly crowned Queen and King of Naples. They commissioned Ingres' *Odalisque*, doubtless his best-known masterpiece. In tribute to Murat's participation in the Egyptian campaign, Ingres accoutred the reclining beauty with a turban and Oriental jewellery, a hookah pipe, incense, and peacock feather fan.

Six years earlier, in 1808, Ingres had painted *La Baigneuse Valpinçon*. She too was shown from the back, in a pose that would later be imitated by Renoir. The bather also wore a turban, and has let her Turkish slippers fall beneath her feet.

Today, Ingres's nudes, with their creamy, velvet skin, inviting cushions and rich draperies, are considered among the most sensual in the history of painting. But they were savaged by early nineteenth century critics.

Ingres called anatomy 'a dreadful science, a horrible thing I cannot think of without disgust'. The interminably long back of his *Odalisque* allegedly has three too many vertebrae. The sublime *Baigneuse Valpinçon* seems to hide her atrophied legs in shadow; once you've noticed the defect, it is difficult to ignore it.

Ingres lived long enough to see the critics' taste transformed. Nearly four decades later, in 1852, Louis de Cormenin wrote: 'No one knows the neglected art of the nude better than Ingres, knows the secret beauties of woman. No one softens a throat more lovingly He takes women by surprise from every angle, the most elegant and the most sensual.'

Once of Ingres's last masterpieces, *Le bain turc* (1859-63), was inspired by letters from the wife of an ambassador to the Sublime Porte. Ingres was nearly eighty years old when he imagined this scene from a Turkish harem, where naked beauties dance, play music and fondle each other.

Picasso painted his own version in *Les Demoiselles d'Avignon*. Distraught though he was over Madeleine's death, Ingres remarried three years later, at the age of seventy-one. His second bride, Delphine Ramel, was forty-three.

Art and love seem to have preserved him. 'The older I grow, the more my work becomes an irresistible need for me,' he said.

Ingres's vitality in old age was legendary. Well into his eighties, the chronicler Edmond de Goncourt wrote, 'when Ingres started to feel aroused by a dancer at the Opera, he exclaimed, "Madame Ingres, to the carriage!" and he did the deed on the way home.'

Going to the Opera was also a way for Ingres to fill his order book. He was haunted by the memory of hard times, especially after the fall of Napoleon I, when he and the first Mrs Ingres scrimped by in Italy on Ingres's pencil portraits of British tourists who had resumed the 'grand tour' after the Napoleonic wars.

Ingres's career was saved by the Restoration. His canvas of Louis XIII placing France under the protection of the Virgin was the triumph of the 1824 Salon, and marked the reconciliation of king, church and country. The following year, King Charles X made Ingres a *chevalier de la Légion d'Honneur*.

Ingres so adored Raphael that he wept when he contemplated the Renaissance genius's work. Ingres's gave many of his Virgins – and *Odalisque* – the face of Raphael's Fornarina. But despite the startling sensuality of his Madonnas, Ingres's religious paintings seem lost in no-man's land, between the Renaissance and the now unfashionable, gaudy nineteenth-century Saint-Sulpice school.

Ingres was motivated by the need for recognition and extreme perfectionism. 'I am tormented by an insatiable desire for glory,' he said.

His life was a pendulum of pain at the incomprehension of public and critics, and joy when he was honoured.

When *Le Martyre de Saint Symphorien* flopped at the Salon of 1834, Ingres packed up and went back to Rome for six more years, this time as director of the Académie de France, the government-run artists' refuge also known as the Villa Médicis.

In Rome, Ingres indulged his passion for music, playing his violin with Paganini and Cherubini, whose portraits he drew and painted. His musical talent gave the expression *violon d'Ingres* (meaning 'a hobby') to the French language. The Surrealist photographer Man Ray put music holes on the back of a model resembling the *Baigneuse Valpinçon* and called it *Violon d'Ingres*.

Encouraged by the new-found patronage of the Duc d'Orléans, Prince Ferdinand-Philippe, Ingres returned from exile in 1841 and was fêted with a banquet for four hundred people.

La Grande Odelisque, 1814,
Jean-Auguste-Dominique Ingres.

Prince Ferdinand-Philippe was killed in an accident the following year, the Diana, Princess of Wales of his day. France went into an orgy of mourning, and Ingres's portrait of the young prince became a famous image that inspired Édouard Manet's *The Fife Player*.

Throughout the 1840s and 1850s (when his allegiance shifted effortlessly from the house of Orléans back to the Bonapartes), Ingres was to French high society what his teacher David had been to the court of Napoleon I: the favoured painter of French aristocracy.

Ingres was made a senator and promoted to the rank of *grand officier de la Légion d'Honneur*. An entire room was reserved for his work at the 1855 World's Fair, where his *Princesse de Broglie* was hailed as a masterpiece. It had taken Ingres three years to paint the symphony of white flesh, blue and gold satin, lace and pearls.

Ingres was apparently as poor a judge of his own work as were the critics of his day. He valued his large narrative paintings on biblical, mythological and classical themes more than his portraits. 'Cursed portraits which always prevent me from getting to the great things that I cannot do more quickly,' he said of them.

Yet the portraits are what has remained. From the Rivière family, painted in the first decade of the nineteenth century and shunned along with Napoléon and the *Baigneuse Valpinçon*, to the French civil servants who administered Napoleonic Italy, to the aristocratic ladies of the July Monarchy and Second Empire, Ingres captured the character of his century.

Each painting tells a story worthy of Balzac or Stendhal: Caroline Rivière, painted in 1805, like a white lily in the countryside, would die within a few months of Ingres painting her portrait. Louis-François Bertin, owner of *Le Journal des débats*, opposed Napoleon in the name of the Republic. He has the powerful, piercing stare of a newspaper editor, his hands on his knees like an eagle's talons. Picasso's portrait of Gertrude Stein would later mimic Bertin's posture and massive physique.

For sheer, breath-taking virtuosity, nothing can equal five Ingres portraits of the women who, Théophile Gautier said, characterised *la grande dame moderne*: Vicomtesse d'Haussonville, Baronne Betty de Rothschild, Princesse de Broglie and Madame Moitessier. The clothes, jewels and settings are sumptuous, the expressions on the faces at the same time haughty and come-hither.

Chardin

The Painter of Silence

Jean-Siméon Chardin was perhaps the greatest painter of the eighteenth century. Yet he was atypical, preferring everyday reality to the pompous historical and mythological themes then in fashion. Chardin's tranquil scenes of home life could not be more different from Boucher's voluptuous nudes and cherubs, Fragonard's flirtatious ladies and Watteau's pastoral idylls.

'He is the painter of silence, peace, stillness, reflection . . . of modesty and chastity,' says Pierre Rosenberg, the academician, former director of the Louvre and the world's foremost expert on Chardin. In 1999, to mark the 300th anniversary of Chardin's birth, Rosenberg brought together ninety-six Chardins in the main autumn exhibition at the Grand Palais. The exhibition went on to Dusseldorf, London and New York.

The editor of the *Encylopédie*, Denis Diderot, was one of the *philosophes* who admired Chardin. 'So, here you are again, great magician, with your mute compositions!' Diderot wrote in his 1765 commentary on the annual artists' salon.

Chardin's refusal to paint religious, mythological or historical themes endeared him to the *philosophes* and helped usher in modern painting. A century later, Manet and Cézanne would be influenced by him.

Chardin was so attentive to reality that, Diderot recounted, he once abandoned a painting when the dead rabbits he was using as models began to rot. Other rabbits brought as replacements were simply not the right size or colour.

The twentieth-century Franco-American writer Julien Green used to say, 'What I love in Chardin's paintings is that he could not lie.' There is not a hint of the rococo, not a trace of excess, in his canvases.

The fur on Chardin's rabbits looks so soft one could stroke it, the fruit in his still lifes so luscious you want to taste it. Yet the paintings exude a gentle emotion.

'Who told you that one paints with colours?' Chardin once chided a contemporary. 'You use colours, but you paint with feelings!'

In the wittiest, most sexually liberated of centuries, Chardin's peaceful images were nonetheless appreciated. Prints of his domestic scenes were widely circulated. In 1740, the artist was introduced to Louis XV, to whom he gave two paintings. *Grace* shows a mother at a table with two children. In *The Hard-working Mother*, a woman sits before a spinning wheel, assisted by her daughter. The aristocracy craved these odes to ordinary life.

Girl with Shuttlecock, Jean Baptiste Simeon Chardin. Photo: © Scala, Florence - courtesy of the Ministero Beni e Att. Culturali.

Chardin received commissions from Louis XV, from the courts of Austria, Sweden and Russia. Catherine the Great owned five Chardins, including the exquisite *Little Girl with a Shuttlecock*, which was the 1999 exhibition's signature painting, and which now belongs to the Rothschild family. Like all the children in Chardin's paintings, the child is a miniature adult, dressed as a grown woman, serious and poised.

Despite his fame, Chardin was incapable of working quickly. Although he lived to the age of eighty, his entire output numbers only two hundred paintings, and he never became a rich man. Art historians attribute his habit of creating several copies of a painting to his desire to produce more, or his need to satisfy so many eager royal clients.

Critics of his day accused Chardin of being slow and lazy. 'I take time because it is my habit never to leave my works until, in my eyes, they leave nothing more to be desired,' Chardin responded. Unlike most eighteenth-century French painters, Chardin never studied in Italy. The son of a carpenter who made billiard tables, he was largely self-taught and spent his entire life within a few square kilometres between the Louvre and Saint-Sulpice Church on the Left Bank.

The mischievous cats, alert hunting dogs and pensive women and children in his paintings betray no sign of the tragedy which stalked Chardin. He buried his first wife, and two of his three children died in infancy. His third child, a son named Jean-Pierre, became a painter, though less successful than his father. They quarrelled over money, and probably over aesthetics: Jean-Pierre Chardin produced the sort of fashionable historical paintings his father hated. In a probable suicide, the younger Chardin drowned in a Venice canal in 1772.

In the last decade of his life, Chardin's eyesight began failing. He abandoned oils for pastel crayons and, for the second time, set aside still lifes to paint only human figures. His self-portraits, and a portrait of his wife, reveal nothing of his inner thoughts. The mysterious expression on the old man's face – rakishly wearing a pink scarf around his neck, and a nightcap tied down with blue ribbon – has fascinated artists and writers.

'He's a crafty old man, this painter,' Cézanne wrote in 1904. Marcel Proust found Chardin 'comical as an old English tourist' and wondered if he was looking at 'the boisterousness of an old man who doesn't take himself too seriously'. To Proust, the ageing painter seemed to say, 'Ah! So you think you're the only young ones left?'

Back in Fashion: The Eighteenth Century

Karl Lagerfeld ties his powder-grey ponytail with a silk ribbon and flutters a fan in front of his eyes. The high fashion designer says he would give anything to have lived in the eighteenth century. His fellow couturiers share his nostalgia. In the collections of Vivienne Westwood, John Galliano, Alexander McQueen and Christian Lacroix, brocade, whale-bone corseted busts and petticoated hoop skirts became a recurring theme through the 1990s.

Around the world, from the nursery schools of Tokyo to the gay and lesbian studies departments of American universities, from the auction houses of France to the Swiss and German châteaux-turned-tourist-attractions where Voltaire took refuge from the monarchs he offended, the eighteenth century is in fashion. The revival is quietly working its way into the clothes we wear, the furniture we buy, the books we read, the films we watch and the exhibitions we go to.

Films set in the eighteenth century, including *Les Liaisons Dangereuses* and *Ridicule*, found a wide cinema audience. The German writer Patrick Süskind's eighteenth-century saga, *Perfume*, was an international best-seller. Philippe Sollers in France and Peter Ackroyd, Stella Tillyard and Amanda Foreman in Britain made a specialty of colourful eighteenth-century biographies. The BBC's *Aristocrats* series, about the Lennox sisters, daughters to the Duke of Redmond in the eighteenth century, was as popular as the Tillyard book upon which it was based.

In France as in Ireland, the simple, elegant lines of eighteenth-century furniture have always been regarded as the epitome of good taste. In both countries – and throughout Europe – there is a booming market in eighteenth-century reproductions, as well as originals. *Marie-Claire Maison* now exhorts readers to follow leading French decorators such as Jacques Garcia and Frédéric Méchiche in using eighteenth-century furniture alongside modern pieces.

Why, you may wonder, on the eve of the new millennium, did we indulge in a throwback to three centuries ago? The glamorous life of the aristocrats – the jet-set of their age – was certainly a magnet. 'Anyone who has not lived before [the French revolution in] 1789 does not know what it is to enjoy life,' Talleyrand wrote. Perhaps we sense a parallel between the privileged of that time and ourselves – prosperous and pleasure-seeking, with a safe distance between us and the hungry masses. Or are we merely fascinated by the axis between old and new?

Voltaire

Rousseau

'The eighteenth century is a time which is recognisably modern, with banks and stock exchanges, hotels and shops,' said Andrew Miller, the English writer whose first novel, the story of a medical doctor in the eighteenth century entitled *Ingenious Pain*, won the IMPAC award in 1999. 'On the other hand, it is part of a much older, almost medieval, remote and brutal world, where a nine-year-old girl was hanged in Norwich for stealing a petticoat.'

When one considers the publicity given to the fiftieth anniversary of the Universal Declaration of Human Rights in 1998, the workings of the International Court of Justice in the Hague, the high-minded moral rhetoric that surrounded the 1999 war in Yugoslavia; it is not surprising that we're returning to the origin of these concepts.

'There are political reasons for liking the eighteenth century,' said Professor Nicholas Cronk, a fellow at St Edmund Hall, Oxford, and the director of the Voltaire Foundation. 'It was the time when modern ideas of humanism and freedom evolved. All our automatic liberal assumptions about parliamentary democracy and freedom and human rights have their germ there.'

The *philosophes* died before the great cataclysm of the French revolution. 'Voltaire and Rousseau were made heroes of the revolution,' Professor Cronk added. 'When the revolution abolished Christianity and decided to turn the Panthéon into a monument rather than a church, they held big ceremonies to rebury the bones of Voltaire, then Rousseau.'

The Age of Enlightenment represented by its two best-known, quarrelling thinkers is sometimes blamed for fostering the Terror. 'The *philosophes* brought us to the revolution and the revolutionaries brought us to the terror,' said Marc Martinez, a professor of eighteenth-century theatre at the University of Bordeaux. 'It wasn't the fault of the *philosophes*.'

Mary Woolstonecraft – the mother of Mary Shelley and a member of Dr Johnson's circle – wrote in her *Vindication of the Rights of Women* that the ideals of Voltaire and Rousseau should apply to women.

High-born women like the witty Marquise du Deffand held literary salons, especially in Paris. 'Ladies like her don't exist any more,' said Professor Jean-Didier Vincent, a French neuro-physiologist who wrote the best-selling *Biology of the Passions*, as well as a book on the sex-life of Casanova. 'They were women of extraordinary freedom of thought and morals. They made love with whomever they wanted, went from one partner to another, ignored all the taboos.'

The sexual decadence of the eighteenth-century aristocracy still fascinates. Publishers report a rush on the books of the Marquis de Sade, who paid for his writings by spending most of his life in prison. In the century when the Church was first openly questioned, Sade went too far. His novel *Juliette*, for example, recounts satanic Masses conducted by lascivious priests who whipped, sodomised and murdered young girls.

The eighteenth century is a popular topic in gay and lesbian studies programmes in the US, because in that era, for the first time, homosexuality was practised relatively openly, in 'Molly Clubs' throughout Europe.

Homosexual characters began to appear in literature. 'Society was very homosexual,' Professor Vincent said. 'In the army most of the officers were homosexual; for example the Duc de Vendôme, who won the Spanish war of secession, and Turenne, the Maréchal de Villiers.'

The Venetian-born male courtesan Giacomo Casanova (1725-98) embodied the reckless, cosmopolitan existence of eighteenth-century Europe. 'He was insolent. He loved luxury and the rich and powerful, but at the same time he loved being free,' Professor Vincent said. French was the *lingua franca* of the day, and Casanova wrote his twelve-volume memoirs of seduction in French. He is believed

to have been the model for Mozart's Don Giovanni – and may have helped to write the libretto. 'You can study almost any aspect of eighteenth-century life through the life of Casanova,' Andrew Miller said. 'Food, travel, morality, medicine' Miller's second novel, published in 1998, chronicles Casanova's brief exile in London.

Promiscuity had a price: venereal disease was rampant. 'If you had a good constitution, you might get over it,' said Miller, who did extensive research on eighteenth-century medicine before writing *Ingenious Pain*. 'James Boswell, the biographer of Samuel Johnson, was constantly going down with what he called 'signor gonorrhoea'. They treated it with mercury, which is highly toxic and makes your teeth fall out. A man like Boswell, from a good family, would not have been considered unrespectable for going with whores. Being rather mean, he went with the cheapest ones.'

While eighteenth-century medicine was often primitive, the period produced some of the millennium's most brilliant music. Mozart has never gone out of fashion. The works of almost forgotten composers including Jean-Philippe Rameau have been revived in France by groups such as William Christie's *Arts Florissants* and Marc Minkovsky's *Musiciens du Louvre.*

Academe too, is filled with eighteenth-century nostalgics. More than three thousand academics from around the world attended the 10th Enlightenment Congress, organised by Professor Andrew Carpenter at University College Dublin, in the summer of 1999. 'There is nothing equivalent for the sixteenth, seventeenth or nineteenth centuries,' Professor Cronk said. 'There are eighteenth-century societies in Britain, Ireland, France – even in Hungary and Estonia; it's absolutely flourishing.'

As director of the Louvre, the academician Pierre Rosenberg organised three eighteenth-century exhibitions in 1999. A major exhibition of the works of Jean-Siméon Chardin marked the 300th anniversary of Chardin's birth.

Another recounted the life of the Louvre's founder, the artist, diplomat, writer and occasional spy Dominique Vivant Denon (1747-1825).

Denon adeptly manoeuvred from the court of Louis XV through the French revolution and into the favour of Napoleon Bonaparte. 'Denon was very much a man of the eighteenth century,' Rosenberg said. 'Under the [Napoleonic] Empire he transformed the Louvre into the world's first modern museum. He had in mind the ideas of the eighteenth century and of the French revolution – to make art accessible to the masses; to make art clear; to present it chronologically. He shared the obsession of the *philosophes* and *encyclopédistes* with classification.'

Throughout the 1990s, Charles Wirz, a Rousseau specialist and the director of the Voltaire Institute and Museum in Geneva, corresponded with eager teachers in Tokyo, where the theories of Jean-Jacques Rousseau (1712–78) were very much in vogue. The idea of raising children as 'noble savages' uncorrupted by society seems to please Japanese parents who disliked their own regimented upbringing. 'The idea is to create an environment conducive to the effect you want to achieve, without the child realising it,' Wirz said. 'You work on the environment – not the student.'

Rousseau had a similar effect in eighteenth-century France. When he counselled women to breast-feed their babies rather than entrust them to wet nurses, fashionable pre-revolution ladies responded by nursing their babies in opera boxes. Rousseau's idealisation of work and country life influenced the royal palace and spread beyond French borders. The *dauphin* was taught to plough.

Marie-Antoinette built a mock dairy farm at Versailles so that she could pretend to be a milkmaid. In the BBC's *Aristocrats*, Sarah Lennox dressed up as a peasant, pitching hay in the hope of catching the eye of George III.

For the rich, the eighteenth century was a game of seduction in 'pleasure gardens' and masquerade balls. But

the vast majority of Europeans were illiterate peasants for whom life was cruel. Professor Vincent nonetheless confessed he would have liked to have lived in that period. 'I love freedom, beauty, women,' he says. 'Yes, I'm nostalgic for the eighteenth century. But I admit there was deep injustice; I admit it had to end – like all great moments of pleasure.'

Georges de La Tour

Georges de La Tour was probably the most famous French painter during the early seventeenth century. Louis XIII liked his *Saint Sebastian with the Lantern* so much that he removed all other paintings from the royal bedroom. But after de La Tour died of the plague in 1652, his work disappeared without trace for the next 263 years. It took a German art historian, Hermann Voss, to resurrect de La Tour in 1915, by identifying *The Newborn* as the work of the baker's son from Lorraine.

All but one of the forty-three authenticated paintings by Georges de La Tour were exhibited at the Grand Palais in the autumn and winter of 1997-98. The missing painting, *Saint Jerome Reading*, belongs to Britain's Queen Elizabeth II and was judged too fragile to travel.

Perhaps the greatest mystery is how such a remarkable pioneer of realism and the use of light fell into oblivion for more than two and a half centuries. Because he signed few of his canvases, de La Tour's works were wrongly attributed to Murillo, Velázquez, the Le Nain brothers and others.

Two explanations have been given for de La Tour's long eclipse. Was it simply the result of a radical change in taste and aesthetic values, as claimed by the sociologist Jean-Pierre Changeux? Or was Pierre Rosenberg, then director of the Louvre, right in blaming the invasions and wars that ravaged the painter's native Lorraine?

Lorraine in the seventeenth century was not unlike former Yugoslavia in the early 1990s. Mercenaries from Croatia, Sweden and Switzerland raped, pillaged and massacred their way through the countryside. Written accounts of cannibalism have survived. In 1638, the town of Luneville, where de La Tour had settled with his noble-born wife, was burned to the ground. Most of the painter's early works are believed to have perished.

Other mysteries surround the life of de La Tour. We do not know who taught him, or whether he travelled to Italy, like most of the painters of the period. He seems to have been influenced by the Italian Caravaggio (1571-1610), but he may have studied Caravaggio's works in the Netherlands or in Paris. Some historians see a Dutch, Germanic or even Bohemian influence in paintings such as *The Brawl*, in which one street musician attacks another with a knife.

Strangely, there is no trace of the rapine and disease of the period in de La Tour's paintings, although his canvases portray a hard world of crooks and thieves, liars and beggars. The most stark representation of poverty is to be found in *The Pea Eaters*, in which two ragged men, each isolated in his own solitude and hunger, eat from bowls of chickpeas they have received at the door of a hospital or convent.

The Newborn, Georges de La Tour.
Photo: © Scala, Florence.

Even the elegantly dressed courtesan of *The Cheater*
– for which the model was believed to have been de La
Tour's wife Diane Le Nerf – connives to deceive a young
dandy at cards. Gambling, especially an early version of
poker, was a popular pastime in the early seventeenth
century. At least two versions of *The Cheater* exist. One
belongs to the Louvre, the other to the Kimbell Museum
in Fort Worth, Texas. The Louvre's copy had belonged to
an antiquarian who found it so ugly he hid it on top of a
clothes cupboard.

The Fortune Teller shows the same cynicism about
human nature as *The Cheater*; three women gang up on a
naive youth to rob him. This painting's fate also illustrates
the passion for de La Tour that has seized collectors and
museums in more recent years. Its purchase by the New
York Metropolitan Museum of Art in 1960 caused an
uproar in France. André Malraux, who was then Minister
of Culture, was dragged into parliament to explain how
the masterpiece had slipped out of French hands.

De La Tour painted secular and sacred themes,
sometimes blurring the distinction between the two
by using ordinary characters in Biblical situations. As
he grew older, he painted more and more night scenes,
where the faces of his subjects – like the magnificent
series of repentant Madeleines – are hauntingly lit by
candles. His style became simpler and more reflective, and
all excess detail was abandoned. *The Newborn*, de La Tour's
best-loved painting, imparts great serenity and tenderness.

Another late masterpiece, *Saint John the Baptist in
the Desert* was not discovered until 1993. It was hurriedly
withdrawn from auction when its value was recognised.
Art historians believe de La Tour may have produced as
many as four hundred paintings. Only forty-three have so
far been found, thirteen since the 1970s.

Mona Lisa's Mysterious Smile

Crowds, thieves and an unbalanced, rock-throwing tourist have come and gone. Six million people – 90 percent of all visitors to the Louvre – reverently filed past her in 2004. Hundreds of journalists clamoured to see Leonardo's *Mona Lisa* in her new apartments in April 2005, but the 500-year-old lady sat as placidly as ever, hands folded across her stomach, leaving visitors to decide whether her gaze conveys seduction or humour, melancholy or amusement.

To the Italians she is *La Gioconda*, the spouse of Francesco del Giocondo, the Florentine merchant who asked Leonardo to paint her portrait in 1503. To the French she is *La Joconde*, a distortion of the Italian name. The rest of the world knows her as *Mona Lisa*, a contraction of the old Italian title, *Ma Donna* (my lady) Lisa.

For decades, the popularity of the *Mona Lisa* has been a problem. With more than 20,000 people queuing to see her daily, museum gridlock is chronic. The success of Dan Brown's *The Da Vinci Code*, in which the curator of the Louvre leaves a clue to his murder in invisible ink on the glass screen in front of the *Mona Lisa*, has worsened the congestion. Brown's novel sold 20 million copies in two years, and his readers piled into tour buses to visit the Louvre.

Nippon Television Network came to the rescue, offering €4.81 million to refurbish the Salle des États in the Louvre. After four years' work, under the direction of the architect Lorenzo Piqueras, the *Mona Lisa* made the short journey from the cramped Salle Rosa.

Traffic should move more smoothly through her new, 840-square-metre room. Piqueras finished the walls in beige earth tones, reopened two windows looking on to the Louvre's courtyards, restored the skylight and improved air-conditioning and acoustics.

Critics complained that it was inappropriate to place the *Mona Lisa* in a room devoted to sixteenth-century Venetian masters – the right century and country, but a different school of painting. The pragmatic suggestion of placing the *Mona Lisa*, the *Winged Victory* and the *Venus di Milo* in a 'best of' gallery for hurried tourists was a non-starter in France's staid museum milieu.

The mysteries of the *Mona Lisa* have strengthened her legend. The woman's thin black veil indicated she was in mourning, said one theory. Hands folded over her stomach showed she was pregnant, said another. Some speculated she was actually a self-portrait of Leonardo, or a male model in drag. A few years ago, an art magazine created controversy by suggesting that a coat of yellowing varnish should be removed from the thin poplar-wood panel.

The greatest mystery, *Libération* newspaper noted, 'remains how the not-so-beautiful spouse of a bourgeois Florentine of the early sixteenth century can be the most famous woman in the world in the twenty-first century'.

The *Mona Lisa* marked a sharp departure from earlier

portraiture, because the subject looks at the viewer and smiles, and because of Leonardo's *sfumato* (shading) technique. There are no visible brushstrokes on the canvas. A barrage of laboratory tests in 2004 revealed that Leonardo used the thinest possible layer of paint, probably applying it with a fingertip.

Libération suggested that the lady's modernity stems from her ordinariness. Leonardo made her 'the icon of the emotion born of contemplation of the ephemeral nature of happiness and beauty', the newspaper said. *Le Monde* found another explanation for the painting's success: 'The serenity of the model's face has become a highly sought after virtue in the modern world.'

In his *Lives of the Artists*, first published in 1568, the Italian art historian Vasari wrote that Leonardo 'employed singers and musicians or jestors to keep [*Mona Lisa*] full of merriment and so chase away the melancholy that painters usually give to portraits'. The result, Vasari concluded, was 'a smile so pleasing that it seemed divine rather than human; and those who saw it were amazed to find that it was as alive as the original'.

It was apparently out of national pride that Vincenzo Perrugia, a window cleaner at the Louvre, stole the painting in August 1911, because he believed that France had stolen her from his native Italy. Louvre employees were fingerprinted by Alphonse Bertillon, the father of forensic science. But Perrugia had fled to Florence, where he tried to sell the painting two years later. A few months before the theft, the poet and art critic Guillaume Apollinaire said the *Mona Lisa* should be burned. He was trying to strike a blow for modern artists, but the remark sent him briefly to La Santé prison.

The theft also drew unprecedented attention to the painting, with constant newspaper coverage, postcards, posters and even street demonstrations. In the run-up to the First World War, some accused the German intelligence services.

This popular hysteria was mocked by the Dadaist artist Marcel Duchamp in 1920. He published a picture of the *Mona Lisa* with a thin moustache and the letters 'LHOOQ', which when read letter by letter sounds like the French for 'She has a hot ass'. Other twentieth-century artists, among them Fernand Léger and Andy Warhol, continued the de-mythification of the *Mona Lisa*.

Charles de Gaulle and Georges Pompidou used the *Mona Lisa*. as a tool of diplomacy. When she travelled to New York for the 1963 World's Fair, she was accompanied by André Malraux and occupied a first-class cabin on the ocean liner *France*. President John F. Kennedy, his wife Jackie and Vice President Lyndon Johnson met the portrait on arrival. She made her last journey, to Moscow and Tokyo, in 1973. The Louvre says she will never again be allowed to travel.

For the *Mona Lisa* is truly priceless. As the French art historian André Chastel wrote: 'This painting is not a painting but a fable, a poetic fiction, a dreamlike fixation, an offering of the subconscious.

Portrait: The Life of Lisa

1503 Florentine merchant Francesco del Giocondo commissions Leonardo da Vinci to paint a portrait of his wife, Lisa Gherardini. Leonardo keeps the unfinished painting for the rest of his life. **1518** King Francis I of France buys the *Mona Lisa* from one of the art students whom Leonardo made his heirs. **1800-04** Napoleon Bonaparte hangs the *Mona Lisa* in his bedroom in the Tuileries Palace, after which the painting moves to the Louvre. **1911** A worker in the Louvre steals the *Mona Lisa*. It is recovered two years later. **1956** A mentally ill Bolivian tourist throws a rock at the *Mona Lisa*. The painting is put behind a glass screen. **April 2005** The *Mona Lisa* moves to its new, purpose-built home in the Louvre, refurbished at a cost of €4.81 million.

Titian

Revealing the Faces of Power

Tiziano Vecellio – whose name is anglicised as Titian – was the most famous painter of the Venetian Renaissance. Through much of the sixteenth century, he decorated churches and palaces, painting holy virgins and alluring Venuses with equanimity.

Titian apparently saw no contradiction between religious faith and an appreciation of the courtesans who were an integral part of life in the liberal city-state. His rich colours, particularly Venetian red, are instantly recognisable.

Titian bequeathed to the history of art the reclining nude and the equestrian portrait.

Nicola Spinosa, superintendent of the Naples museums, brought together paintings from fourteen countries, including thirty-five Titians and twenty-five comparative works by Rubens, Lorenzo Lotto, Parmigianino and Tintoretto in the exhibition 'Titian: the Face of Power' at the Musée du Luxembourg in Paris in the winter of 2006-07.

Titian painted kings, popes, intellectuals and beautiful women, all of them wielding different kinds of power, hence the title of the exhibition. As Giorgio Vasari wrote in his *Lives of the Artists*: 'There has been hardly a single lord of great name, or prince or great lady who has not been portrayed by Titian, a painter of extraordinary talent in this branch of art.'

Titian was born to a family of local nobles in the foothills of the Dolomite mountains, between 1488 and 1490. By the age of nine or ten he showed such artistic talent that he was sent to Venice as an apprentice. He ended up in the workshop of Gentile and Giovanni Bellini, where he met Giorgione, whose arcadian style he adopted.

Giorgione's death from the plague in 1510, and Giovanni Bellini's great age, brought Titian success in his twenties. When his master Bellini died in 1517, Titian became the official painter of the Venetian Republic by offering to paint the Great Council Room of the Doges' Palace free of charge.

All his life, Titian was known for his business acumen. Like many a modern-day builder or house painter, he began adding on expenses once he'd landed the contract, demanding that the republic of Venice rebuild the roof of his studio.

Despite his high prices, Titian could not keep up with demand. In 1537, Venice briefly suspended his stipend because he was so far behind on work commissioned by the city.

Titian's most important encounter was with Charles V, when he was crowned Emperor of the Holy Roman Empire in 1530. Having inherited Spain, Flanders, Latin America, parts of Italy and the Hapsburg possessions, Charles V was one of the most powerful men who ever lived.

'The invincible emperor was so pleased by Titian's work that, once they had met, he would never be painted by anyone else,' Vasari wrote. 'Every time Titian did his portrait he made him a gift of a thousand crowns in gold. His Majesty also ennobled Titian, giving him a pension of two hundred crowns'

An anecdote recounted by the Italian art historian Carlo Ridolfi a century later shows how highly the emperor regarded the painter. One day when Titian was painting, he dropped a paintbrush, which the emperor picked up.

'Sire, your servant does not deserve such an honour,' Titian said.

'Titian is worthy of being served by Caesar,' the emperor replied.

An equestrian portrait of Charles V at Mühlberg, where the emperor conquered Protestant princes in 1547, was later imitated by Rubens, Van Dyck, Velázquez and Rembrandt.

Fourteen years earlier, Titian painted Charles V more simply, wearing the black clothing then in fashion with Venetian aristocracy. Without the trappings of power, the emperor looks like an ordinary person. Titian's 1533 portrait conveys a sense of disquiet, and hints at the mysticism that would lead Charles V to abdicate and retreat to a monastery two years before his death.

The emperor spent much of his life fending off threats from the French King Francis I, the Turkish Sultan Suleiman the Magnificent, Roman popes and Protestant reformers. Coats of armour and a one-eyed knight in the 2006-07 exhibition served as a reminder that it was a century of religious war.

Titian infused his portraits with character, as if he could read the souls of his sitters. Though the faces are immensely expressive, they are difficult to interpret, as in real life.

One of Titian's duties as Venice's official artist was to paint the doge, the official elected by an assembly of patricians to rule the city-state. Doge Marcantonio Trevisan seems intent on communicating with us. The cloth bunched up in his right hand conveys a certain tension. But the look on the strong, middle-aged face might be one of wisdom, sadness or cruelty; we cannot be certain.

Titian portrayed women as thinking, feeling, sensual human beings. In most cases, their power is the power of seduction. But Isabella d'Este, Marquise of Mantua and one of the great patrons of the Italian Renaissance, also had the power of intellect and money. Titian met her when she was sixty, and proposed painting two portraits: one as she was at the time, and a second, based on canvases executed in Isabella's youth.

The realistic portrait was lost, but we know from a copy by Rubens that it showed an overweight, over-made-up Isabella with dyed hair.

By contrast, the portrait of the young Isabella, which Titian based on a twenty-year-old painting by the Bolognese painter Francesco Francia, portrays a determined, attractive and eccentric young woman.

Titian never shrank from flattering his subjects: in portraits of the Hapsburgs, for example, he minimised the prominent family chin. But even Isabella had to admit he'd idealised her.

Isabella d'Este, 1534, Titian. Photo: ©
Austrian Archives/Scala, Florence.

'The portrait by the hand of Titian pleases us so much that we doubt having been, at the age represented, of the beauty that appears here,' she said.

The noble families whom Titian painted were called Este, Gonzaga, della Rovere and Farnese. The Musée du Luxembourg's exhibition conveyed the feeling of a pictorial family album. Portraits of Isabella d'Este's son Federico II Gonzaga, and her brother Alfonso, Duke of Ferrara, Modena and Reggio, hung near her.

Titian painted a superb portrait of Laura Dianti, who became Alfonso's official mistress after his second wife, Lucrezia Borgia, died in 1502.

Most of Titian's models had the strawberry-blonde hair which the French call Venetian blond. But Laura Dianti's dark hair is swept up into a gold, pearl-encrusted turban. The young woman wears a royal blue gown with a gold shawl. The gold colour is repeated in threads on her sleeves and in the clothing of an African page who holds Laura's gloves. Ethiopian boy servants were a status symbol for sixteenth-century society ladies.

Titian also painted his friends, including Pietro Aretino, the boisterous, cynical, well-connected dramatist and poet who called himself the 'secretary of Europe'.

When Aretino moved to Venice after the sack of Rome in 1527, he and Titian became close friends, with Aretino acting as Titian's agent and artistic adviser.

In Titian's portrait of Aretino, the writer wears the gold chain which Francis I of France gave him out of gratitude for a Titian portrait. The luxurious Venetian-red robe emphasises Aretino's bulk. His long beard is neatly brushed. Again, the expression is ambiguous; it could be anger, amusement or rapt attention.

In one letter, Aretino called this portrait 'a terrible marvel'. In another, to Cosimo de Medici, he said: 'It breathes; the pulse beats; the mind works as mine does in life.'

But then, referring to Titian's legendary stinginess, he added: 'If I had given him more ecus, the cloth would be truly shining, soft and full of texture, like satin, velvet and brocade' To Titian, Aretino complained: 'The portrait is more sketched than completed.'

Even as an old man, Vasari wrote, Titian was 'in sound health and as fortunate as any man of this kind has ever been; from heaven he has received only favours and blessings'.

Perhaps the greatest blessing was to be remembered through five centuries as a Renaissance genius, while most of those he painted were forgotten.

'In fact, the one who holds real power is the painter who met all these people and painted their portraits,' said Nicola Spinosa, the curator of the Musée du Luxembourg exhibition.

Botticelli

Alessandro di Filipepi was the son of a Florentine leather worker, born near the Ponte Vecchio in 1445. The man who gave the world *Springtime* and *The Birth of Venus* was meant to be a goldsmith, and is believed to have taken the name Botticelli from a goldsmith with whom he trained.

When he was nineteen, Sandro became an apprentice painter to Fra Filippo Lippi, the monk who shocked Florence by eloping with a nun and fathering two children. The Medici family, who ruled the city-state, liked his paintings so much that they excused the priest's foibles. One son, Filippino, later studied with Botticelli.

Botticelli's *Portrait of a Man with the Medal of Cosimo the Elder*, painted in 1475, may be of his brother Mariano, who was a goldsmith. The handsome young man, wearing a red cap and holding a gold medallion, bears a resemblance to Botticelli's only known self-portrait, as an onlooker in *The Adoration of the Magi*, painted the same year. Botticelli's brief period as a goldsmith left its mark in the gold leaf he used to decorate the hair and clothing of madonnas and mythical heroines.

The young man of mysterious identity was one of three portraits by Botticelli shown at the Musée du Luxembourg in Paris, then at the Palazzo Strozzi in Florence, in 2003-04. The exhibition included twenty paintings by Botticelli and six of his drawings, intermingled with works by Filippino Lippi and contemporaries Leonardo da Vinci and Piero di Cosimo.

The presence of other artists' work filled out what would otherwise have been a small exhibition. Tiny cameo portraits of Lorenzo the Magnificent, the supreme patron of the arts until his death in 1492, and the mad monk Girolamo Savonarola, who seized control of Florence two years later, were fascinating. So was the 1498 painting of *The Execution of Savonarola on the Piazza della Signoria*, attributed to Francesco Rosselli.

Botticelli's *Springtime* is never lent by the Uffizi, the art gallery and museum in Florence. But a similar painting from the series of four *Mythologies* commissioned by Lorenzo de Medici, *Pallas and the Centaur*, was included in the Paris exhibition.

The absence of Botticelli's most famous masterpieces made it easier to focus on less-known treasures. Hence, the two small panels of *Judith's Return to Bethulia* and *The Discovery of the Body of Holofernes* were given pride of place in the exhibition.

The diptych was painted in 1470, the year that Botticelli established his own workshop. It illustrates the Old Testament story of a young Jewish widow who killed the Assyrian general whose troops besieged her village.

In the Bible, Judith perfumes herself, puts on her finest clothes and jewellery and walks into the Assyrian camp with her maid Abra. Her beauty inspires Holofernes's to declare a three-day feast. When he finally takes Judith to his tent, she seizes his scimitar and beheads him.

Botticelli's Judith is luminous and wistful, striding home with the blood-drenched scimitar in one hand and an olive branch in the other. Abra carries Holofernes's head in a basket. The elegant drapery of their clothing prefigures the *Mythologies* Botticelli painted in the early 1480s.

Judith has left behind a scene of horror for Holofernes's generals and his faithful horse to discover. A man's body lies on the bed, blood pouring from its severed neck. The body is young and muscular, and does not seem to belong to the grey-haired head carried by Abra. Here, Botticelli's palette is far darker than in the picture of Judith's triumph.

In the fifteenth century, Florence was considered the most beautiful city in the world. 'Botticelli is the most Florentine of the quattrocento painters,' said the art historian Daniel Arasse, a curator of the exhibition. Apart from a two-year stay in Rome, when he painted a fresco in the Sistine Chapel, Botticelli never left his beloved Florence.

With Botticelli, Italian painting broke definitively with the Middle Ages. 'Botticelli invented mythological allegories,' Arasse said. 'Before him, painting was either religious or narrative. You didn't show abstract ideas; you told a story. He was also the first painter to undress Venus.'

Like Judith and Holofernes, Botticelli's *Annunciation* is a little-known masterpiece. The angel who interrupts Mary's reverie is still in flight, clutching an exquisite branch of lilies to his chest. Mary kneels on a carpet woven with Arabic script. The interior details – the bed placed on a platform in a recess behind a drawn-back curtain – give the scene a Vermeer-like feeling. On the same plane as the bedroom is a garden where faintly suggested trees recall Leonardo's rude remark that Botticelli claimed 'it was enough to throw a sponge imbibed with colour onto a canvas to obtain a suitable landcape'.

The 1490s were a troubled decade. Amid predictions of apocalyse, the Medici fled a French invasion and Savonarola took over, his reign of terror culminating in 1497 in a seven-storey 'bonfire of the vanities' representing the seven cardinal sins. Florentines were ordered to burn embroidered cloth, books, carpets, jewellery, wigs and artworks. Countless Renaissance paintings perished, some of them perhaps Botticelli's.

Henceforward, Savonarola ordered, painters would represent only religious subjects. Botticelli's last profane painting, *Calumny*, was executed that same year. He was accused of sodomy – a capital offence – by an anonymous informer, though no proof was ever presented. *Calumny*, in which the allegorical figures of Ignorance, Suspicion, Hatred, Envy and Fraud drag a man before the king, is believed to have been Botticelli's way of defending his own reputation.

Art historians long based their belief that Botticelli followed Savonarola on the writings of Vasari, and the change in his painting style. That belief is now contested, but although Savonarola was hanged and burned in 1498, Botticelli never again produced anything resembling the gossamer-clad graces of *Springtime*.

Botticelli's religious paintings took a sombre turn. The Saint Augustine he painted in Ognissanti Church in 1480 was a sophisticated man of knowledge, surrounded by scientific instruments, in a brightly coloured study. A second Saint Augustine, painted in the 1490s, writes in a soot-grey cell, the floor beneath his feet littered with discarded papers.

Likewise, the figures in *Madonna and Child with the Infant Saint John*, painted around 1500, have sad faces. Mary's body fills most of the canvas, and is hunched over as if she has difficulty bearing the weight of the infant Christ. The tone is tragic, without the sugary translucence of Botticelli's early madonnas.

Botticelli painted with tempera – egg yolk mixed with pigment – on wood. At the end of the fifteenth century, he rejected the innovations embraced by Leonardo and Michelangelo: oil paint imported from Flanders, interest in anatomy and landscape, with the goal of replicating nature.

Botticelli went out of fashion, and until his death in 1510, he virtually stopped painting. He never married, and lived with his brother. It was not until the late nineteenth century, and the pre-Raphaelite movement in Britain, that the first great romantic painter was rediscovered.

Annunciation, Sandro Botticelli. Photo: © Scala, Florence - courtesy of the Ministero Beni e Att. Culturali.

IV Collectors

'This picture business was really getting under my skin. I found that when I was downtown getting the wherewithal to buy pictures, my mind was on pictures. Perhaps all that was good timing, because you could not buy pictures with hay, and I wanted more pictures.'

Chester Dale

Chester Dale and the Davies Sisters

In April 1911, a few days before his twenty-eighth birthday, a promising stockbroker named Chester Dale married Maud Thompson (née Murray), a divorcée seven years his senior. Chester was the son of a British immigrant academic, and had dropped out of military academy at the age of fifteen because he wanted to work as a messenger on Wall Street. An erstwhile boxer, Dale was short, ginger-haired and pugnacious. Maud, the daughter of a newspaper journalist, had the beauty and sophistication Chester lacked.

Though the Dales had no children, their union gave birth to a collection of almost mythical quality and proportions, which at one point numbered seven hundred works of art. 'My pictures are like a family,' Dale said. 'Each one has a special niche in my heart.'

The role of collectors in art history is often underestimated. Yet it is collectors who largely determine, through their choices and museum endowments, what will be considered great art. In the spring of 2010, exhibitions in Washington paid homage to two singular pairs of nineteenth- and early twentieth century collectors of French art: the Dales, and the Welsh sisters Gwendoline and Margaret Davies.

Dale defined his and Maud's role thus: 'We have always held that a collector of art is merely a custodian who is serving posterity.' After quarrelling with several major museums, the Dales eventually left the bulk of their collection to the National Gallery in Washington, where it became, in the words of one director, 'the whole rib structure of the modern French school here'. For the past forty-five years, the Dale paintings were not shown as an ensemble, because it would have left too many blank spaces on the museum's walls. While the French rooms were renovated in 2010 and 2011, eighty-one works from the Dale's 'family' were reunited.

Maud Dale had briefly studied French language and art in Paris. For the first fifteen years of their marriage, Chester contentedly amassed his fortune – he was particularly expert on railway bonds – and enjoyed New York soirées with Maud and her artistic friends. They bought paintings from several neighbours in Manhattan who were artists, including George Bellows and Robert Reid.

The turning point came in December 1925, when the Dales bought their first French painting, Henri Matisse's *Plumed Hat*, for $2,000 in New York. Matisse's reputation was not yet fully established, and it was a daring, avant-garde purchase.

Maud encouraged Chester to begin a collection of French paintings, concentrating on modern artists, but including what she called their 'ancestors'; not only Renoir, but Boucher; not only Cézanne, but El Greco.

Chester Dale, 1945 © Diego Rivera / IVARO 2011. Image
courtesy of the National Gallery of Art, Washington.

Chester and Maud bought paintings with a gusto that bordered on gluttony. 'This picture business was really getting under my skin,' Chester said later. 'I found that when I was downtown getting the wherewithal to buy pictures, my mind was on pictures. Perhaps all that was good timing, because you could not buy pictures with hay, and I wanted more pictures.'

Dale's fortune fell from $60 million to $10 million in the 1929 stock market crash, but it didn't discourage him. On the contrary, he purchased 123 paintings in 1929, his bumper year, and another 100 in 1930. Murdock Pemberton, an art critic who accompanied Dale on a buying spree in Paris, described him snapping up canvases 'as you or I would buy neckties'. This encounter of American money and European artistic genius left a dazzling legacy. In one room of the National Gallery's exhibition, devoted to outdoor scenes, five Monets (two cathedrals, Venice, the Houses of Parliament and the Seine) hung alongside two Cézannes, a van Gogh, a Gauguin and an assortment of lesser Impressionists.

Dale stipulated that none of his paintings ever be lent, because he couldn't bear the idea that Americans would travel to Washington to see a specific painting, only to find an 'on loan' sign in its place. Many works from his collection have nonetheless become instantly recognisable visual clichés. Renoir's *Little Girl with a Watering Can* makes us nostalgic for the golden childhood we never had. Picasso's *The Lovers* shows the turbulent Spaniard at his most tender.

Maud Dale had a penchant for the recently deceased Modigliani, and began buying his works in 1927. The Dales went on to own twenty-one of Modigliani's works, probably the finest selection in the world. Maud's fondness for portraits explains the pre-eminence of the genre in the collection – nine by Degas alone. 'Portraits are the documents by which not only the individual, but his epoch, can be recreated,' she wrote.

Ever the brash American, Chester would stop at nothing to obtain a painting. He shocked a French dealer by demanding that he make an offer for a Corot seen in the home where the Dales had dined the previous evening. Around 1927, Dale fell under the spell of Manet's *The Old Musician*, a huge canvas showing a seated fiddler flanked by six other figures. 'I had no more thought of buying it than I did of buying the Palace of Versailles,' Dale said. The Manet was not for sale, but in 1930, he offered $250,000 for it – a colossal sum in those days, and Dale's most expensive purchase.

The Dales bought most of their twelve Picassos in the 1930s, including the *Family of Saltimbanques*, purchased sight unseen from a bank vault in Switzerland for just $20,000. The masterpiece is similar in size and theme to *The Old Musician*, and the two paintings seemed to speak to each other across the room where they hung in the National Gallery exhibition.

Not least among the Dales' superb collection were the portraits they commissioned of themselves: Maud by George Bellows and Fernand Léger; Chester by Salvador Dalí and Diego Rivera.

Gwendoline and Margaret ('Daisy') Davies were contemporaries of the Dales, though it is unlikely the heiresses to a Welsh coal and shipping fortune ever met the flamboyant New York couple. The Davies sisters belonged to a harsh, Calvinist sect, did not drink, never married – and, unlike the Dales, never sought to meet the artists whose work they collected.

Described as 'cripplingly shy', the sisters bought their first two paintings, both Corot landscapes, on successive days when they were in their mid-twenties. Over the following decade, they assembled a fine collection from the Barbizon, Impressionist and post-Impressionist schools. Fifty-three works ranging from Turner to Cézanne were loaned by the National Museum of

Wales to the Corcoran Gallery, near the White House in Washington in the spring of 2010, before moving on to the Albuquerque Museum of Art in New Mexico.

The paintings were arranged chronologically, so one saw the evolution of painting, including the influence of Turner on Monet. The Davies sisters' social conscience was evident in paintings by Daumier and Millet.

The same conscience led the spinsters to work as Red Cross volunteers in France during the Great War. Gwendoline made a side trip to Paris, to buy two Cézannes. Their last purchase was *Rain – Auvers*, painted by van Gogh shortly before his death.

The upheaval of the war made the sisters more confident and daring in their artistic taste, but it also led them to abandon collecting for more serious pursuits, such as fostering the nascent League of Nations.

The undisputed star of the show was Renoir's *La Parisienne* (see page 8), an uncharacteristically frivolous – but breathtaking – choice by the staid sisters. It was painted in 1873 for the first Impressionist salon the following spring, and shows Henriette Henriot, an aspiring actress who posed for eleven of Renoir's paintings. She seems to have stepped out of a Zola novel, in indigo blue dress and hat; all ribbons, flounces and bustle.

Renoir painted Henriot as a social prototype. 'The face, strangely old-looking and childish at the same time, meets us with a false smile,' a contemporary art critic wrote. 'Yet the figure has an innocence about her. One could say that this little person is doing her best to be kittenish.' Nearly 140 years after Renoir painted her, the same could be said of many a present-day *Parisienne*. Perhaps the painter Paul Signac best described this captivating painting: 'How simple it is, how beautiful, and how fresh.'

Yves Saint Laurent and Pierre Bergé

Paris's Art Sale of the Century

It was the story of not one, but hundreds of *coups de foudre*, of a magnificent art collection amassed over fifty years by the late high fashion designer Yves Saint Laurent and his partner, the businessman and patron of the arts Pierre Bergé.

The Saint Laurent-Bergé collection came under the gavel at the Grand Palais on 23 February 2009, in what was called the sale of the century. It took three days to sell off the 733 paintings, sculptures, pieces of furniture and objets d'art. The sale broke all records, raising €373.5 million for the Fondation Pierre Bergé–Yves Saint Laurent and the fight against AIDS.

The original *coup de foudre* was that between Saint Laurent and Bergé, when the designer showed his first collection for Dior in 1958. Their passion eventually subsided into a loving friendship, but the creator and entrepreneur remained the best-known homosexual couple of late twentieth century France.

François de Ricqlès, the vice-president of Christie's, the auction house that organised the sale, called Saint Laurent and Bergé 'renaissance princes'. More than thirty thousand people flocked to the Grand Palais to view the collection in the three days preceeding the sale. As we queued in the rain, I talked to Alberto Pereira, 21, a jewellery salesman for Dior. Pereira was so impressed by the collection that he brought his companion, Mathieu, for a second visit. If he could have bought any painting, it would have been Goya's portrait of a boy from the Spanish royal family, which Bergé has donated to the Louvre.

'I was moved by the motivation of Pierre Bergé, who said the collection had no meaning from the day Saint Laurent died,' Pereira told me. (Saint Laurent died in June 2008.) Bergé is keeping only two works: an African sculpture of a mythical bird, the first piece they bought together, and their friend Andy Warhol's portrait of Saint Laurent. Though not for sale, it too was on display in the Grand Palais. Despite the exuberance of the 1960s' colours, one senses the tension in the designer's face. His greatest quality, Saint Laurent said of himself, was determination; his greatest weakness, timidity.

In Saint Laurent's death, as in his life, Pierre Bergé played the role of supreme organiser. He stood at the centre of the collection on the day the auction started, dressed in a pin-striped suit, overcoat, black felt hat and purple scarf.

'This collection was about the quest for beauty,' Bergé told me. 'I have lived my life surrounded by beauty.'

Bergé's favourite painting was Frans Hals's *Portrait of a Man Holding a Book*, which hung in his library. 'I went to see the Hals painting and I told him, "Farewell. We won't see each other any more, but we loved each other."'

Amid much bittersweet nostalgia over the auction, the editorial in *Libération* quoted the lyrics of the late French singer Barbara, about an auction house and 'the fabulous treasures of a past that is no longer . . . Things have their secrets/ things have their legend,' Barbara sang. 'But things speak to us if we know how to listen.'

Bergé saw the dispersal of a lifetime's collection as a process of renewal. He quoted the nineteenth-century writer Edmond de Goncourt: 'My wish is that the works of art which have been the joy of my life not be consigned to the cold tomb of a museum . . . that the joy each acquisition gave me can be experienced by someone who inherited my taste.'

A crowd pressed around the glass case where bronze Chinese sculptures, the head of a rat and a rabbit, from the eighteenth-century Qianlong dynasty, were exhibited. They were looted from the emperor's summer palace in Beijing in 1860. A Chinese lawyer attempted, unsuccessfully, to block their sale.

Should France have given the animal heads back to China? I asked the French people around me. 'Absolutely not!' replied a white-haired woman. 'Saint Laurent and Bergé didn't steal them. Other countries don't give back artworks. Why should we?'

Bergé said he would give the bronze heads to China immediately if the Chinese 'respect human rights, give freedom to the Tibetans and accept the Dalai Lama on their territory'.

The treasures sold included a Cubist painting by Picasso, a Brancusi sculpture, works by Ingres, Degas, Cézanne, Modigliani and Munch. There were canvases by Léger, Matisse and Mondrian, all of whom inspired Saint Laurent dresses.

The sale was presented as a test of the survival of the art market during the recession. 'These things have a dual value: the inherent value of the works themselves, and the fact they belonged to these two exceptional men,'

observed Julie Prevel, who works for a contemporary art foundation.

Yves Saint Laurent said he hated 'the snobbishness of money'. He and Pierre Bergé invested their earnings from high fashion in art, not banks or the bourse.

A homosexual who loved women, Saint Laurent recognised nature as ultimately superior to art. 'Nothing is more beautiful than a naked body,' he said. And he kept his own genius in perspective, adding that 'the most beautiful garment that can dress a woman is the arms of the man she loves'.

Vollard the Visionary

Years later, Ambroise Vollard compared the visual jolt of seeing his first Cézanne to being hit in the stomach. Vollard was a law student in 1890s' Paris, and he spotted the brightly coloured canvas in the window of a paint shop in the ninth *arrondissement* known as Le Père Tanguy.

That moment in the rue Clauzel destined Vollard to become the most influential art dealer of the twentieth century, the man who 'discovered' Cézanne, van Gogh, Matisse and Picasso. As a struggling twenty-nine-year-old who had only recently opened his own gallery, Vollard created a sensation by exhibiting 150 Cézannes at the end of 1895. Cézanne, then forty-six, had withdrawn to Aix and had not shown a painting for eighteen years.

Vollard's father, Alexandre Ambroise Vollard, had emigrated from Paris to the Indian Ocean island of La Réunion, where he married Marie-Louise-Antonine Lapierre, whose family belonged to the local white ruling class.

The eldest of ten children, Ambroise claimed to have grown up happily in a tropical paradise, not unlike the Gauguin paintings he would one day sell.

In 1885, Vollard, then nineteen, went to Montpellier to study law. He would never return to his native island. Vollard moved to Paris to continue his studies and spent his stipend on engravings and drawings from the little stands along the Seine. Though his father cut off Ambroise's allowance, he managed to purchase some of Édouard Manet's sketches from the artist's widow.

Vollard's first stroke of luck was the auction in June 1894 of the contents of Le Père Tanguy's shop. Julien Tanguy had been a kindly figure who gave artist supplies to painters in exchange for their work. For the modest sum of 845 francs, Vollard walked away with nine important paintings, including four Cézannes, a Gauguin, a van Gogh and a Pissarro.

Vollard was a visionary, hoarding post-Impressionist paintings that no one wanted at the time. 'Vollard's mistakes can be counted on the fingers of one hand,' said another famous art dealer, Daniel-Henry Kahnweller.

The Musée d'Orsay, Metropolitan Museum of New York and Art Institute of Chicago joined forces in 2007 to pay homage to Vollard's contribution to modern art, in an exhibition entitled 'From Cezanne to Picasso: Masterpieces from the Vollard Gallery'. The show included the finest works of Cézanne, van Gogh, Degas, Renoir, Gauguin, the Nabis and Fauves groups, and Picasso.

Rich Americans, including Gertrude and Leo Stein, the sugar magnate H. O. Havemeyer and the philanthropist Albert C. Barnes, were among Vollard's best customers. They bought up post-Impressionist

art when French museums would not even accept the paintings as donations.

In the 2007 exhibition, it sometimes felt as if Vollard's name had been used as a pretext for bringing together an amazing assortment of 190 works in an artistic tourist trap. But who, on contemplating van Gogh's *Starry Night* or Picasso's *Pierreuse with Hand on Shoulder* (the signature painting for the exhibition) could possibly resent it? Picasso was only nineteen and spoke not a word of French when Vollard first showed his paintings, including *Pierreuse* – under the title *Morphine Addict* – in 1901.

Vollard's register of sales from 1904 until 1907, written in beautiful italics, is enough to make any art-lover drool: 'Matisse still life coffee pot soup bowl etc on table 150 francs; five Matisses – all 150 francs; Renoir – hunter – 500 francs; Cézanne landscape 300 francs; Renoir – woman in country combing a young girl's hair 1000 francs'

The last two rooms of the exhibition were devoted entirely to portraits of Vollard, and to his role in prompting painters to sculpt, engrave and make pottery. Publishing art books was Vollard's passion in later life.

Vollard loved being painted by his favourite artists, and often posed with his cat, who was also called Ambroise. Cézanne's portrait required more than a hundred sittings. Bonnard painted the art dealer eight times; Renoir three.

'The most beautiful woman in the world never had her portrait painted, drawn or engraved more often than Vollard,' Picasso wrote. 'I believe they all did it out of emulation, each one wanting to do better than the others. Renoir painted him as a bullfighter, stealing my speciality. But all the same, my Cubist portrait is the best one.'

Painters were among Vollard's best customers. He met Monet, Renoir and Degas when they visited his Cézanne exhibition in 1895. Renoir and Degas became lifelong friends, and often traded their own works for paintings in Vollard's gallery.

Matisse fell in love with Cézanne's *Three Bathers* and sold his wife's emerald ring to pay the 1,200 francs that Vollard asked for it. When Matisse donated the curious painting to the city of Paris in 1936, he said: 'It gave me moral support during critical moments of my artistic adventure. I drew my faith and perseverance from it.'

Vollard would often buy up a painter's entire stock of canvases, then slowly sell them as the artist's price rose. He concluded a 'treaty' with Paul Gauguin whereby Vollard advanced Gauguin 300 francs per month and agreed to buy all his paintings for 200 francs each. Gauguin accused Vollard of waiting until painters died to make exorbitant profits on their work. But he would not have been able to stay in the South Pacific without the help of the art dealer.

In the early 1890s, Vollard took several of Henri *le Douanier* Rousseau's dreamlike jungle scenes on consignment. But in 1895, he gave them back to the impoverished artist, saying they didn't sell. Rousseau died in 1909. Four years later, Vollard sold Rousseau's wonderful *Representatives of Foreign Powers Coming to Salute the Republic as a Sign of Peace* – for which he had paid only 10 francs – to Picasso for a tidy sum.

Yet Cézanne, who gave Vollard exclusive rights to his paintings for over a decade, described him as an honest man. Renoir made Vollard his agent in Paris when he moved to the south of France in old age, and Vollard encouraged the arthritic painter to make wax sculptures, which Vollard had cast in bronze.

Vollard often invited Renoir to the dinners he held in the windowless mezzanine of his gallery in the rue Laffitte, in the ninth *arrondissement*. The Anglo-German diplomat and writer Count Harry Kessler recorded Renoir's 'gaunt face, with a delicate white beard, his hands and fingers twisted by rheumatism like the roots of a tree'. But when he started talking, Kessler noted, Renoir became 'a sort of ravishing prince charming . . . with the voice of a man of twenty, and in everything he says you sense he is thinking of love and women'.

Degas was more difficult. In his memoirs, Vollard recorded the painter's reply to a dinner invitation: 'With pleasure, Vollard. But pay attention: there is to be no butter in my food. No flowers on the table. Very little light. You shall shut your cat away, and no one shall bring a dog. And if there are women, ask them not to wear perfume. . . . And we shall sit down at table at 7.30 on the dot.'

A century after he forged the reputations of so many great painters – and became a millionaire many times over – Vollard remains an enigma. The American heiress, writer and art collector Gertrude Stein described him as 'a tall, dark man, full of melancholy'. And that was Vollard in a good mood, she added. 'When he was truly morose, he leaned his heavy form against the glass door of his shop, which looked on to the street. Stretching his arms above his head, he hooked his hands on to the top corners of the door frame and stared into the street with his dark eyes. Then no one would dream of trying to enter.'

Vollard was famous for falling asleep in his gallery. He boasted that potential customers mistook his attitude for one of rejection and repeatedly raised their offers while he was dozing. The art historian Daniel Wildenstein said that Vollard was 'gruff, often unpleasant with those he didn't know, and terrified someone would steal from him. Apart from that, he was sensitive to others, simple and quite funny. He loved to talk'.

When he was fifty-eight, Vollard purchased a mansion at 28 rue Martignac in Paris's seventh *arrondissement*. The photographer Brassaï recorded that he lived in just two rooms – the dining room and his bedroom – while the rest of the mansion was filled with dusty piles of masterpieces.

When Vollard was killed in a car crash in 1939, he is believed to have owned between five thousand and ten thousand paintings. He had no direct heirs, and many of the paintings went missing during subsequent years while his estate was disputed.

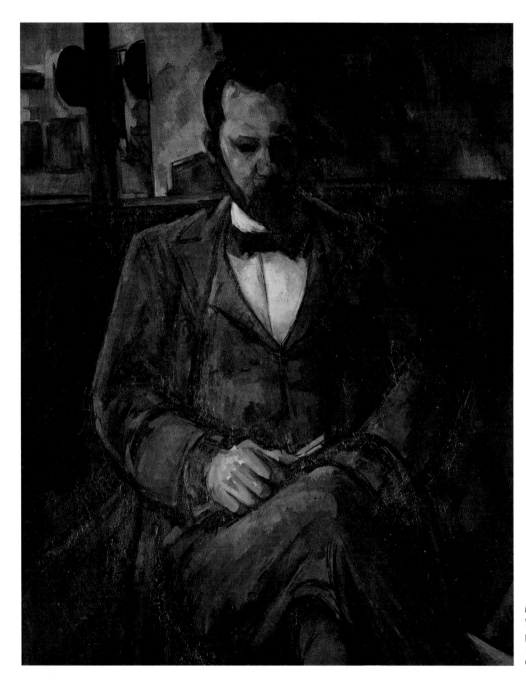

*Portrait de M. Ambroise
Vollard, the art dealer*
painted by Cézanne 1899
© Imagno/Hulton Archive/
Getty Images.

V Twentieth Century Writers

'Me, I live alone, entirely alone. I don't talk to anyone, ever. I receive nothing. I give nothing.'

Antoine Roquentin, the fictional narrator of Jean-Paul Sartre's first novel, *La Nausée*

Jean-Paul Sartre

Existentialist on Exhibition

The archetypal French intellectual Jean-Paul Sartre was lionised by generations of leftists around the world. The extreme right hated him so much that they blew up his office and apartment during the Algerian war.

Philosopher, novelist, playwright and political militant, Sartre embodied the foibles, passions and ideological wanderings of the twentieth century. He lived through two world wars and transposed the ideas of German philosophers Heidegger and Husserl into the philosophy of existentialism.

Sartre took seriously his own admonition that writers should be *engagés* – committed to the great social causes of their time. The *nouveaux philosophes* who followed, Bernard-Henri Lévy and André Glucksmann, are pale imitations.

The Algerian war, Vietnam, Maoism and the student revolution of May 1968 were but a few of the myriad causes Sartre took up. He sometimes got it dreadfully wrong, as when he returned from Moscow in the early 1950s and declared: 'The freedom to criticise is total in the USSR.' Yet Sartre's adoring fans forgave him, crowding into his lectures because they couldn't read his voluminous treatises on *L'Être et le Néant* (Being and Nothingness) and *Critique de la raison dialectique* (Critique of Dialectical Reason).

When Sartre died on 15 April 1980, Serge July, who had co-founded *Libération* newspaper with him, wrote: 'The immense Sartre filled the century as Voltaire and Hugo did theirs. . . . He was everywhere for forty years, in all schools of writing, in every battle.'

To celebrate the hundredth anniversary of Sartre's birth on 21 June 1905, the Bibliothèque Nationale dedicated an exhibition to him that was nearly as ambitious as the five-volume biography of Flaubert which Sartre took thirty years to write and left unfinished.

Curators used hundreds of original photographs, manuscripts, newspapers, posters and letters to illustrate Sartre's life. One felt almost voyeuristic, reading his handwritten missives to 'Mon charmant Castor,' the nickname of the love of Sartre's life, Simone de Beauvoir.

Shown in the exhibition were works by the artists and photographers Sartre knew, including Picasso, Giacometti, Brassaï and Cartier-Bresson. Filmed versions of Sartre's plays, including *Huis clos* (No Exit), considered his theatrical masterpiece, played in half a dozen curtained rooms spread throughout the exhibitions. In *Huis clos*, three characters – Garcin the cowardly traitor, Estelle, who drove her lover to suicide, and Inès, a cruel lesbian – meet in hell after their death. 'Hell is other people,' Garcin says. It is the most quoted line of Sartre's oeuvre.

Television screens marked each stage of Sartre's life. One could listen to his television interviews of the 1960s and 1970s by picking up a telephone receiver next to the screens.

Sartre's father, a naval officer, died of bronchitis when Jean-Paul was fifteen months old. The boy's mother, Anne-Marie, took him to live with her parents, the Schweitzers, a Protestant family from Alsace who had produced eight generations of pastors and teachers. In 1952, Anne-Marie's first cousin, Albert, a missionary doctor, received the Nobel Peace Prize for his work in Africa.

Sartre's young mother focused all her attention on Jean-Paul, who decided to become a writer when he was eight years old.

'My mother and I were the same age,' he wrote in *Les Mots* (Words), the autobiography that is considered his finest work. 'She called me her servant knight, her little man. I told her everything.'

To Sartre's despair, Anne-Marie remarried when he was twelve.

'My family broke,' he wrote. 'I found myself with a monsieur who pretended to be my father and who was totally foreign to me. He was the one against whom I constantly wrote, my whole life.'

Much later, in her second widowhood, Sartre's mother would live with him in the rue Bonaparte, overlooking Saint-Germain-des-Prés. Sartre professed to hate the bourgeoisie, but his apartment was furnished with faux Louis XVI. His male secretary, Beauvoir (who kept her own apartment) and a gaggle of mistresses visited.

Sartre had met Beauvoir when they were students at the École Normale Supérieure. 'I love you, but I am polygamous,' he told her. For the rest of their lives, they addressed one another by the formal *vous*. They agreed to a two-year renewable contract for their relationship, which they based on complete transparency. Both

recounted their affairs in detail to the other. Beauvoir usually managed to overcome her own jealousy.

Actresses in Sartre's plays and the women who translated his books often became his mistresses. How did a short, ugly, cross-eyed philosopher attract so many beautiful women? Dolores Vanetti, the mistress who 'gave [Sartre] America' explained his seductiveness.

'He poured himself into listening to you, understanding you, loving you,' she said. 'All his intelligence, all his talent, went into it, and he managed to create an irresistible magnet. . . . When he wanted to seduce you . . . he asked you questions and listened to you like nobody else.'

In *La Nausée* (Nausea), his first novel, published in 1938, Sartre foregrounded his philosophy of existentialism. 'Me, I live alone, entirely alone,' his narrator, Antoine Roquentin, says. 'I don't talk to anyone, ever. I receive nothing. I give nothing.'

One winter's day in the public park, Roquentin is seized by nausea, sitting 'between the great black trunks, between the black and knotted hands that reach towards the sky. . . . A tree scratches the earth beneath my feet with a black fingernail . . . existence penetrates me everywhere, through the eyes, through the nose, through the mouth'

Sartre claimed that existentialism was a modern form of humanism. Despite the absurdity of the world, man could create meaning through action or artistic endeavour. Man had to understand 'that he can count on nothing other than himself, that he is alone, abandoned on earth in the midst of his infinite responsibilities, without succour, with no goal other than the one he gives himself, with no destiny other than that which he makes for himself on this earth'.

But for the public, existentialism was a 1950s' fad evoking jazz clubs in the cellars of Saint-Germain-des-

Prés, where Sartre partied with singer Juliette Greco and trumpeter and writer Boris Vian.

In 1951, Sartre and de Beauvoir broke off their friendship with Albert Camus because he condemned Stalinism in *L'Homme révolté* (The Rebel). Sartre was in his pro-Soviet period, and published a nasty review of Camus's book, to which the ever-lucid Camus responded in writing: 'You cannot decide whether a thought is true according to whether it is on the right or on the left, and even less so according to what the right and left decide to do with it.'

The Soviet invasion of Hungary in October 1956 ended Sartre's love affair with the USSR. He described himself as 'a man who wakes up, cured of a long, bitter and gentle folly'. But he and Beauvoir did not repair their friendship with Camus, who was killed in a car crash four years later.

In 1957, Camus accepted the Nobel Prize for literature with an eloquent speech in Stockholm. When Sartre won the Nobel in 1964, he refused it on the grounds that 'the writer must refuse to allow himself to be transformed into an institution'.

Though Sartre loved the novels of William Faulkner and John Dos Passos and American jazz music, from his first visit to the US in 1946 – financed by the US State Department – he became an unrelenting critic of the US government. His anger reached its apogee in the 1950s, with McCarthyism and the execution of the Rosenbergs, accused of spying for the USSR.

'Watch out! America has rabies,' Sartre said. 'Let us cut all ties that bind us to her, otherwise we shall in turn be bitten and come down with rabies.'

Sartre was even more virulent against colonial powers. 'At the beginning of a revolt, you have to kill,' he wrote in his controversial preface to the Martiniquais psychiatrist Frantz Fanon's *Les Damnés de la terre* (The Wretched of the Earth) in 1961. 'Killing a European kills two birds with one stone. It gets rid of an oppressor and an oppressed: one dead man and one free man remain.'

In the 1960s, Sartre became a roving ambassador for left-wing causes, calling on Castro, Che Guevara, Khrushchev, Tito and Mao. The Arab nationalist leader and president of Egypt Gamal Abdel Nasser talked to him for three hours.

In 1973, Sartre went blind. The last seven years of his life would be a torment. 'My profession as a writer is completely destroyed,' he said on his seventieth birthday. 'The sole goal of my life was writing.... I was, and I am no longer.'

When Sartre died, Simone de Beauvoir led the huge funeral procession to Montparnasse cemetery. The story of a young man who was asked that night by his father how he'd spent his afternoon entered French legend. 'I went to the demonstration against Sartre's death,' the young man replied.

Sartre and de Beauvoir

Enfants Terribles

In the preface to *A Dangerous Liaison: Simone de Beauvoir and Jean-Paul Sartre*, her brilliant, devastating biography of existentialism's terrible twins, Carole Seymour-Jones wrote that 'It would be wrong . . . to suppose that my admiration for both Beauvoir and Sartre . . . has been in any way eroded.'

The statement may have been a sop to Sylvie Le Bon de Beauvoir, Simone de Beauvoir's adopted daughter and companion for the last twenty years of her life. As Seymour-Jones acknowledged, the book could not have been written without Le Bon's help.

To a detached reader, however – and all the more so to one whose French literature professors idolised the couple – *A Dangerous Liaison* dismantles another twentieth-century icon. After reading Seymour-Jones's impeccably researched and documented portrayal of the founders of existentialism, it is hard not to conclude that they were dreadful people: politically and morally reprehensible, and unwashed and smelly into the bargain.

Seymour-Jones seems to say that Sartre and Beauvoir's hypocrisy, lack of scruples, self-obsession, lying, and what by today's standards could only be labelled child abuse, do not lessen the considerable impact of their work, or the literary quality of a masterpiece like Sartre's autobiographical *Les Mots*. Doubtless their respective oeuvres stand as great works of twentieth-century literature. But at the end of this riveting book you are disgusted with both of them, and annoyed with yourself for being so puritanical.

Most reviewers have concentrated on the couple's wild sexual lives (of which more later), but their political stupidity arguably ranks higher in the scale of immorality. Until the Second World War, both of these future champions of engaged literature were curiously uninterested in politics. During a stay in Berlin in 1933, Sartre managed to ignore the rise of Nazism. Neither of them cared about the Spanish Civil War or the election of the left-wing Popular Front government in France in 1936.

Sartre and Beauvoir loved American jazz and cinema, but hated the US government. Soviet culture bored them, but they didn't have the common sense to figure out that their judgement was flawed. Beauvoir wrote in the early 1930s: 'Paradoxically, we were attracted by America, though we condemned its regime . . . while the USSR, the scene of a social experiment which we wholeheartedly admired, nevertheless left us quite cold.'

The behaviour of Sartre and Beauvoir during and immediately after the Second World War is probably the greatest stain on their reputation. Sartre knowingly took a plum teaching post at the Lycée Condorcet when it was vacated because Henri Dreyfus-le-Foyer (a grand-

nephew of Captain Alfred Dreyfus of the Dreyfus Affair) was sacked under the Vichy regime's laws against Jews. 'Careerist to the bone, it was his hunger for fame which led him to step over Dreyfus,' Seymour-Jones writes.

Far from opposing Vichy's laws, Sartre took advantage of them. Though he denied it after the liberation of Paris, he wrote for the collaborationist weekly *Comoedia*. Jean Guéhenno, one of the principled writers who refused to publish during the occupation, wrote of Sartre and those like him: 'Incapable of living a long time hidden, he would sell his soul in order to have his name appear. A few months of silence, of disappearance – he can't stand it.'

Sartre submitted his play *The Flies* to German censors and socialised with German officers who came to see it. When Simone de Beauvoir lost her job in 1943 for teaching the works of the homosexual writers Gide and Proust, Sartre got her a post at French national radio, which was by then part of the German propaganda machine.

Sartre and Beauvoir compare badly with Albert Camus, who was their friend for less than a decade. Camus risked his life by writing anti-Nazi articles in the Resistance newspaper *Combat*, and by using his office at the Gallimard publishing house as a postbox. Yet he was always modest about his role.

Not only did Sartre reject every opportunity to play a role in the Resistance, but when the Americans arrived in Paris, he considered them to be invaders, like the Germans. 'The arrival of the American army in France seemed to many people, including myself, like a tyranny,' he wrote. Shortly after the Liberation, he added: 'Never were we more free than under the Germans.' It was meant to be a *boutade* or witticism, signifying that freedom had to be a deliberate choice, especially under oppression.

Sartre nonetheless performed an amazing flip-flop, becoming a post-war spokesman for the Resistance. As Olivier Todd wrote: 'The less they themselves had resisted, the more certain people wanted to punish others for having collaborated.' On principle, Camus – a true member of the Resistance – opposed the death sentence for the collaborationist newspaper editor Robert Brasillach, while Sartre and Beauvoir refused to sign a petition asking for a pardon. Brasillach was executed.

Years later, Sartre mendaciously wrote that he had 'taken an active part in the Resistance on the barricades'. As Seymour-Jones comments in a rare ironic moment, 'By then he probably believed it.' The philosopher's fame as the founder of existentialism spread to the US, where the *Atlantic Monthly* claimed he had 'devoted himself to underground activities with sublime courage, organising illegal publications [and] representing the most brilliant tendencies of post-war French literature'.

Abhorrence of the treatment of blacks in America was one of the few things Sartre got right, in the late 1940s: 'In this land of freedom and equality, there live 13 million untouchables. They wait on your table, they polish your shoes, they operate your elevator, they carry your suitcase, but they have nothing to do with you, nor you with them. . . . They know they are third-class citizens. They are Negroes. Do not call them "niggers".'

Yet even when he was arguably right – about independence for Algeria, the Vietnam war or the May 1968 riots – Sartre's extreme views undermined his position. In 1961, during the Algerian war, he shocked many by advocating the murder of Europeans in his preface to Frantz Fanon's book.

Sartre made a similar apology for violence in May 1968: 'These young people don't want the future of our fathers – our future – a future which has proved we were cowardly, worn out, weary. . . . Violence is the only thing that remains, whatever the regime, for students who have not yet entered into their fathers' systems. . . . The only relationship they can have to this university is to smash it.'

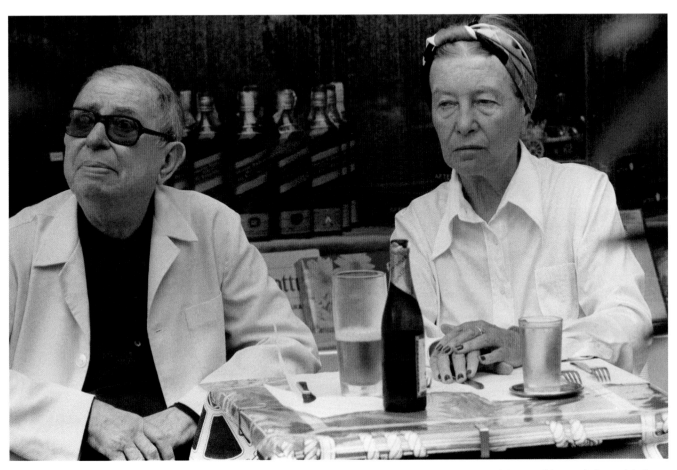

Jean-Paul Sartre and Simone de Beauvoir in Rome,
September, 1978. Photo: © Francois Lochon/
Gamma-Rapho/Getty Images.

Sartre and Beauvoir were wilfully blind to the evils of the Soviet Union. They broke with Camus in 1952, in part because he condemned Sartre's support for Stalin, pointing out the older writer's 'taste for servitude'. Jealousy and spite were also factors in the spectacular literary break-up: Camus had rejected sexual advances by Beauvoir, and he seduced one of Sartre's mistresses, Wanda Kosackiewicz. Sartre asked an underling to demolish Camus's book *The Rebel* in a review in *Les Temps Modernes*.

Sartre later admitted that his remark about 'total freedom to criticise in the USSR' was a lie. 'Obviously it's not true yet,' he said. 'But if you want it to become so, you have to help them.' Little wonder Solzhenitsyn later refused to shake his hand.

Sartre had an excuse, however poor: he was besotted by Lena Zonina, a Soviet agent who served as his interpreter on his Russian visits. Zonina became his mistress and dutifully reported everything he said to the KGB. Jealous as she was of Zonina, Beauvoir, like Sartre, was a 'fellow traveller' and propagandist for the USSR. In 1962 she claimed that the Soviet labour camps that made up the Gulag were 'really rehabilitation centres', adding that the internees they met approved 'in principle' of the system.

It was Sartre's admiration for the USSR which led him to refuse the Nobel Prize for literature in 1964, though Beauvoir warned him: 'People are going to think that you're refusing it because Camus got it first.' He refused the prize, he said, because it 'appears to be a distinction reserved to leaders of the Western bloc and rebels of the Eastern bloc'. He reproached the jury for having given the award to Boris Pasternak, disapproving of the fact 'that the only Soviet work to be honoured should be a work published abroad and banned at home'.

By the time he turned down the Nobel Prize, Sartre was supporting five women (not including Beauvoir) and he needed the prize money. 'You're spitting on 26 million [old francs]!' Wanda Kosackiewicz reproached him.

In 1978, two years before his death, frail, diabetic and blind, Sartre boasted of having nine women in his life – not counting Beauvoir and her companion Sylvie Le Bon. The extended, incestuous 'family' (as Sartre and Beauvoir called it) of mistresses and lovers was the result of their famous pact, concluded on 14 October 1929, which the couple celebrated for the next fifty years as if it were a wedding anniversary.

Sartre wanted to marry Beauvoir, whom he'd met that year at the École Normale Supérieure, but having witnessed her parents' miserable marriage, she refused. Instead, they swore to maintain their 'essential' love but allow other 'contingent' loves on the side, with the condition that they would never lie. Though infidelity has for centuries been a hallmark of French marriage, the idea of 'transparency' was new, and would become a model for changing mores in the 1970s and 1980s.

In her memoirs and interviews, Beauvoir, however, lied about the relationship, claiming she had never even kissed a man on the mouth before Sartre, and minimising her 'contingent' loves, in particular her relationship with Jacques-Laurent Bost, one of Sartre's students, with whom she had a long affair.

In fact, Beauvoir's first lover was René Maheu, a married fellow student at the École Normale who gave her the lifelong nickname of 'Castor' – French for 'beaver' – because 'beaver' sounded like 'Beauvoir'.

Within ten days of her pact with Sartre, Beauvoir was reunited with Maheu, and rejoiced in her journal at having him 'in my bedroom . . . this enchanted room . . . How I love him!'

There was a basic imbalance in the relationship. While Beauvoir bordered on the nymphomaniac, Sartre was not very interested in sex. Both had passed the daunting *agrégation* in philosophy that year. He was ranked first,

she second. Sartre was assigned to a teaching job in Le Havre, Beauvoir to Rouen.

In Rouen, Beauvoir established a pattern she would repeat at least three times. She seduced an immigrant, teenage female student, in this case Olga Kosackiewicz, had a lesbian affair with her, then tried to pass her on to Sartre. Olga's sister Wanda would also become entangled in the Sartre–de Beauvoir 'family'.

Sartre was suffering from depression provoked in part by a 'bad trip' on mescaline, and Beauvoir dispatched Olga to Le Havre in the hope of cheering him up. She was annoyed by his breakdown, writing: 'Psychology is not my strong suit. He had no right to indulge such whims when they threatened the fabric of our joint existence.'

Though Olga always refused to sleep with Sartre, two girls who were later seduced by Beauvoir, Bianca Bienenfeld and Nathalie Sorokine, succumbed to his advances. Seymour-Jones documents his fetish with watching women make love. Both Sartre and Beauvoir confessed to a preference for virgins. When the couple did not share lovers, they wrote to each other in sadistic detail of their conquests.

For a man who did not enjoy sex, Sartre consumed an incredible number of women, who were attracted by his fame. Bianca Bienenfeld recalled that 'Sartre was very ugly, with his dead eye. He was small, but with a big tummy.' Bianca was only seventeen when Sartre lured her to the Hôtel Mistral in Paris, where he lived at the time. As they went to his room, he remarked: 'The hotel chambermaid will be really surprised, because I already took a girl's virginity yesterday.'

Beauvoir's early stay in Rouen was particularly sordid. She and Olga settled in Le Petit Mouton, a seedy, mice-infested hotel given to prostitution and fist-fights. The women drank heavily. Olga once got so drunk that she rolled down the stairs and slept at the bottom until a hotel guest kicked her awake.

Olga was the first victim of Sartre and Beauvoir's sexual adventurism. Seymour-Jones suggests that she 'may have been violated by Beauvoir' and knew about Sartre's rape fantasies, because he had written about them. The young woman began to mutilate herself. Sartre and Beauvoir recounted Olga's self-mutilation in graphic detail in their fiction. In Beauvoir's *She Came to Stay*, Françoise (Beauvoir) and Pierre (Sartre) watch Xavière (Olga): 'In her right hand she held a half-smoked cigarette which she was slowly moving towards her left hand. Françoise barely repressed a scream. Xavière was pressing the glowing brand against her skin with a bitter smile curling her lips. *C'était . . . un sourire de folle*, it was the smile of a mad woman'

The older couple watch speechlessly as Xavière/Olga continues: 'With her lips rounded coquettishly and affectedly Xavière was gently blowing on the burnt skin which covered her burn. When she had blown away this little protective layer, she once more pressed the glowing end of her cigarette against the open wound. Françoise flinched'

Sartre called Olga 'Ivich' in his novel *The Age of Reason*. In a scene in a nightclub, Ivich grabs a pocket knife and someone shrieks: 'Mathieu [the Sartre character] looked hurriedly at Ivich's hands. She was holding the knife in her right hand, and slashing at the palm of her left hand. The flesh was laid open from the ball of the thumb to the root of the little finger, and the blood was oozing slowly from the wound.'

The Sartre-Beauvoir love triangles sold well as fiction. Bianca Bienenfeld, the Jewish girl they abandoned at the beginning of the Second World War because she became too demanding, and Nelsen Algren, Beauvoir's American lover, pleaded not to appear in their novels, to no avail. After he read Beauvoir's *Force of Circumstance*, Algren wrote: 'I've been in whorehouses all over the world and the woman there always closes the door . . . but this

woman [Beauvoir] flung the door open and called in the public and the press. . . . I don't have any malice against her but I think it was an appalling thing to do.'

When Albert Camus's friends urged him to respond to the unflattering portrait Beauvoir painted of him in *The Mandarins*, he refused, saying: 'You don't discuss things with a sewer.' Yet doubtless the most scathing critique of a Beauvoir novel (*She Came to Stay*) was recorded by the poet and film-maker Jean Cocteau in his diary: 'She's a bitch who recounts the lives of dogs, who gnaw at bones, who take turns to piss on the same lamp post, who bite and sniff each other's bottoms'

Sartre and Beauvoir were revolted by the idea of children, but both legally adopted young women with whom they had had affairs. Their 'daughters' became the executors of their respective literary estates.

Sartre probably gave Beauvoir the idea. He adopted Arlette Elkaïm, an Algerian mistress who was thirty-two years his junior, in 1965. Seymour-Jones implies that another Sartre mistress, Evelyne Lanzmann (the sister of Beauvoir's lover Claude Lanzmann), committed suicide because she was so upset by the adoption.

Sartre, and especially Beauvoir, portrayed their partnership of a half-century as exemplary. But it quickly ceased to be a sexual relationship and did a great deal of damage to their 'contingent' lovers. Sartre proposed marriage to at least three women other than Beauvoir; it is doubtful their partnership would have survived his marriage.

Though their sexual behaviour appeared predatory, Sartre and Beauvoir rarely broke off with members of their extended 'family'. He in particular felt a duty to provide financially for his mistresses.

Both had unhappy childhoods, which go a long way to explaining the way they lived. 'Childhood decides everything,' wrote Sartre, whose father died when he was just a year old. The boy enjoyed an almost incestuous love with his mother until he was twelve, when she remarried.

Sartre identified with the poet Baudelaire, who also felt outraged and abandoned when his widowed mother found a second husband. 'When you have a son like me, you don't remarry,' Baudelaire wrote. Sartre's stepfather, Joseph Mancy, was the authority figure he would rebel against, in other forms, for the rest of his life.

The hatred was mutual. When Sartre finally succeeded in publishing his first collection of short stories in 1937, his stepfather particularly objected to 'The Childhood of a Leader', a vicious attack on the far right and Charles Maurras's Action Française. 'My little one, Uncle Jo has asked me to return your book . . . he is outraged,' Sartre's mother, Anne-Marie, wrote to him. She admitted she hadn't read the story herself. 'But why do you write such unseemly things? . . . My little one, try to regain a little purity.'

All his life Sartre delighted in provoking the hated bourgeoisie from which he came. By the time he met Beauvoir at the École Normale in 1929, he'd earned a bad reputation for acts of rebellion that were little more than pranks: going naked at the student ball, dropping water balloons from the roof of the École Normale while shouting, 'Thus pissed Zarathustra!' , getting drunk and vomiting on the feet of the principal of the Lycée Henri IV when he passed the baccalauréat, performing in drag in *La Belle Hélène*.

His years as a lycée teacher in Le Havre inspired Sartre to write *Nausea*, in which the existentialist anti-hero, Roquentin, is sickened by, among other things, the local bourgeoisie looking at paintings in an art gallery. On prize day at the lycée where he taught, Sartre was too drunk to speak, rushed offstage and was heard vomiting. He was said to have spent the previous night in a brothel with students.

Beauvoir too was a rebel. Her mother, Françoise, was a banker's daughter whose dowry was never paid because

the bank went bust. Despite his aristocratic-sounding name, her father, Georges, was a dandy who was too lazy to finish law school and frittered away his money on mistresses and prostitutes. As the Beauvoir family grew ever poorer, they were forced to move to a fifth-floor walk-up flat without a lift, bathroom or running water. The plight of her mother, trapped in a loveless marriage and doomed to drudgery, made the young Simone determined to escape, and prefigured her most successful book, the feminist manifesto *The Second Sex*. In her diary, Beauvoir recorded: 'Every day lunch and dinner; every day washing up; all those hours, those endlessly recurring hours, all leading nowhere: how could I live like that? … No, I told myself, arranging a pile of plates in the cupboard; my life is going to lead somewhere.'

Sartre's physical ugliness was another determining factor. When his grandfather had 'Poulou's' golden curls shorn when Jean-Paul was seven, his mother went on a crying jag in her bedroom because her little girl had been changed into a boy, and an ugly one at that.

Anne-Marie accompanied Jean-Paul to the Luxembourg Gardens, where other children refused to play with him. As an adult, he was only five foot two and a half inches tall; one of the attractions of Beauvoir was that she was only an inch taller. As a boy, he was tiny in size, and already had a squinting cross-eye. 'Shall I speak to their mothers?' Anne-Marie would ask, and the little boy shook his head no.

Sartre was, he wrote, 'ever pleading and ever rejected', an experience he said he never recovered from. But he learned to befriend little girls with a Punch and Judy theatre his mother gave him. He reconciled himself to his ugliness, and learned that intelligence is the greatest seduction: 'I should have hated anyone to love me for my looks or my physical charm…. What was necessary was for them to be captivated by the charm of my … plays, my speeches, my poems, and to come to love me on that basis.'

When Sartre and Camus initially became friends in 1943, the two writers chased women together in St-Germain-des-Prés. Camus asked Sartre why he was going to so much trouble, showing off in front of a pretty woman. 'Have you taken a look at my face?' Sartre replied.

Despite their rebelliousness, Sartre and Beauvoir shared a hunger for praise and success. In the 1930s, both suffered from repeated publishers' rejections. But both had decided in childhood that they would be writers. Beauvoir was fifteen when she answered the question in a friend's album: 'What do you want to do in later life?' with the words 'to be a famous author'.

'I was born from writing,' Sartre wrote. 'By writing, I existed, I escaped from the grown-ups; but I existed only to write, and if I said: me – that meant the me who wrote.'

Writing was their shared passion, the glue that kept them together.

Sartre often quoted Dostoevsky: 'If God does not exist and man dies, everything is permissible.'

With a little help from Kierkegaard, Heidegger and Hegel, he and Beauvoir spun out the philosophy of existentialism: simply stated, that we must strive to create meaning in an absurd, Godless world.

Now Sartre and de Beauvoir's flawed lives risk overshadowing whatever meaning they created.

This chapter originally appeared in the autumn 2008 issue of the Dublin Review of Books.

Camus

Lover of the Absurd

Albert Camus's contribution to twentieth-century thought is his philosophy of the absurd, first defined in two works published in 1942, before he was thirty, the novel *The Stranger* and *The Myth of Sisyphus*.

Absurdity, the Nobel Prize-winning author said, was not in man, nor in the world, but in their 'common presence'. Camus often told friends that to die in a car accident was the height of absurdity. The remark was prescient, and the high priest of the absurd was killed when he crashed into a plane tree on the Nationale 5 highway southeast of Paris on 4 January 1960. His friend and publisher, Michel Gallimard, was at the wheel, and died five days later.

Camus's Diana-like death at the age of forty-seven transformed him into a myth, a literary and philosophical guru for generations to come. His physical resemblance to the actor Humphrey Bogart helped. The Anglo-French author Olivier Todd's 1996 biography explored three previously neglected aspects of Camus's life: his impoverished childhood, his lifelong battle with tuberculosis, and his love life.

Until Camus's second wife Francine died in December 1979, 'decency imposed a certain reserve' upon biographers, Todd wrote in his preface. Based on interviews with Camus's mistresses and private correspondence, Todd recounts the great writer's philandering. From his first, brief marriage at the age of twenty to a promiscuous morphine addict, to his conquest of a Danish art student in Paris twenty-four years later, we follow Camus's seemingly unstoppable seduction of his friends' wives, literary women, actresses and others.

Perhaps, as the sister of Camus's wife said, 'you can't expect Albert to fight against tuberculosis and his passions as well, that's too much to ask'. One wonders how Camus, who coughed blood and had difficulty breathing, possessed the stamina to write novels, plays and essays, edit newspapers, work in publishing and collect so many lovers. Because he found it difficult to break up, he often carried on several affairs at once. Todd quotes love letters to four mistresses in the month before Camus's death.

Over the 1959 Christmas holidays, spent with Francine and the couple's twin children, Camus told his wife: 'You are my sister, you resemble me, but one shouldn't marry one's sister.' He had used the analogy of a sister in 1945, when Francine rejoined him in Paris after their wartime separation. Camus had begun a passionate affair with the Spanish-born actress Maria Casares. Don't worry, he told Casares, 'Francine is like my sister'. But when she learned that Francine was pregnant, Casares broke off with Camus, until they met by chance three years later. For the rest of his life, Casares would be the official mistress. Camus called her 'the Unique one' and 'the genius of my life'.

Francine Camus was hospitalised for depression in 1953, doing nothing but weeping, sleeping and talking about Maria Casares. She broke her pelvis when she attempted suicide by jumping from the window of the clinic. While his wife underwent insulin and electro-shock therapy, Camus grew impatient. 'I hope that by autumn it will be over,' he said. 'And it had better be, as I am tired and can't help her any more.' Despite his crassness, the experience gave him one of the most haunting scenes in his oeuvre, when a young woman throws herself from a Paris bridge as the protagonist of *The Fall* walks by – and does nothing to save her.

Camus hated being called an existentialist, and wearied of being compared to Jean-Paul Sartre. The two friends split up in a spectacular, public, literary row over Camus's criticism of the Soviet Union and communism, carried out in the pages of Sartre's magazine *Les Temps Modernes* in 1952.

A few years later, their rift deepened when Camus, a *pied-noir* from Algeria, refused to advocate independence for the north African colony, saying famously that between his mother and justice, he chose his mother.

'My dear Camus,' Sartre wrote, 'our friendship was not easy, but I shall miss it.'

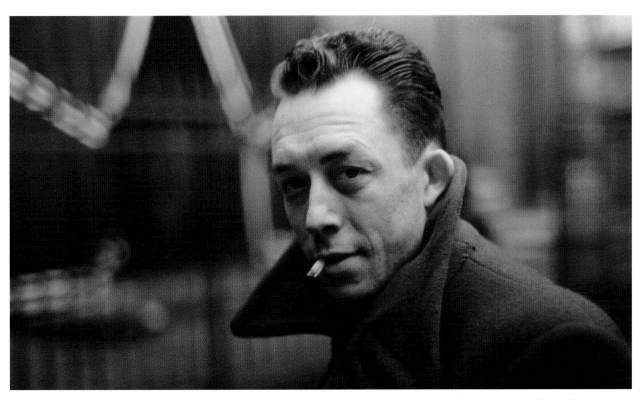

Albert Camus, 1944. Photo: © Henri Cartier-Bresson/Magnum Photos.

Malraux Ascends to French Civic Heaven

Like the hero of one of his novels, André Malraux was determined to leave 'the scar of his passage' on earth. He was a man of action as well as a man of letters, an *écrivain engagé* before the existentialists made it fashionable. An anti-colonialist before decolonisation, an anti-fascist in the early 1930s, Malraux was gifted with a rare historical prescience.

On the twentieth anniversary of his death, in November 1996, Andre Malraux's ashes were taken to the Panthéon, where France has buried its great men since the 1789 revolution. President Jacques Chirac read a eulogy to the former Minister of Culture, and his coffin lay in state for two days while Parisians filed past in homage.

It was an ironic end for a man of rebellious spirit, who was often a controversial figure. After studying Oriental languages, Malraux travelled to Asia. He was arrested in 1923 for pilfering statues and bas-reliefs from an ancient temple near Angkor in present-day Cambodia, but was freed when French writers mounted a campaign on his behalf.

Malraux's love for the Orient included a fascination with opium. In his 1933 Prix Goncourt-winning novel *Man's Fate*, he described the feelings of an opium user as 'a desolation which approached the divine'. Death is a constant theme in Malraux's work. 'Man is the only animal who knows he is going to die,' he often said. For him, art was 'anti-destiny', a form of salvation which enabled man to transcend his own mortality.

Born to a poor grocer's family in the Paris suburb of Bondy, Malraux was raised by his mother, grandmother and aunt; his father had abandoned them when Malraux was just two years old. At twenty, he met Clara Goldschmidt, the wealthy German Jewish woman who would be his wife for twenty-six years. With Clara, Malraux founded an anti-colonialist newspaper, *Indo-china in Chains*, in 1925. He joined an underground Communist movement, the precursor of the Viet Cong. The 1927 Communist revolution in Shanghai provided the subject for *Man's Fate*.

Two days after the Spanish civil war broke out in 1936, Malraux joined on the Republican side. Before the international brigades were set up, he scavenged a few aircraft and established the 'España' squadron. He flew a dozen combat missions himself, and briefly saved Madrid for the Republicans by bombing the road from Medellin. The experience yielded *Man's Hope*, Malraux's novel about the Spanish civil war, which he later turned into a film.

The greatest passion of Malraux's life was General Charles de Gaulle, for whom he abandoned the left forever. In 1958, de Gaulle made Malraux his Minister of Culture. It was through his advocacy for State promotion of the arts that the grocer's son from Bondy would 'leave

his scar'. 'The State is not made to manage art, but to serve it', Malraux often said.

'Malraux considered culture an important instrument of politics', said Bernard Spitz of the French Culture Ministry. 'He believed that culture fosters knowledge and tolerance. By making culture accessible to the largest number of people, he thought he was creating a democratic society worth living in.'

Convinced that art belonged to everyone, not just rich Parisians, Malraux built dozens of *Maisons de Culture* around the country. He also pioneered the idea of international exhibitions.

It was Malraux who first sent Leonardo's *Mona Lisa* abroad, against the protests of Louvre curators. Other European countries followed suit. 'Everywhere there is a Minister of Culture in Europe it is thanks to Malraux,' Mr Spitz said.

Andre Malraux, 1934. Photo: © Fred Stein Archive/Getty Images.

Alain Robbe-Grillet

Uncorking the Genie of Grammar

'He had an incredible capacity for fantasising, which led him constantly to transform everyday life and the most simple events into strange, romantic adventures.'

'Yes, yes that's me!' the French filmmaker and novelist Alain Robbe-Grillet admitted, identifying himself with the main character of his latest novel, *Djinn*.

'It is a description of a child, of someone in love. That's how one falls in love – the euphoria – love is like that, something that transforms. The writer does that too, at least I do.'

The little girl in his novel, 'like all children and poets … enjoys playing with meaning and nonsense'. Robbe-Grillet considers himself, at fifty-eight, to be both a child and poet. In *Djinn*, the influence of Lewis Carroll ('*Alice in Wonderland* and *Through the Looking Glass* are the books I have read most in my life') is felt in the obstacle-course nature of the hero's adventures and in the absurdly wise reflections of the characters.

On another level, *Djinn*, as far as its author knows, is the only literary work to have been written with the intention of teaching grammar.

It is especially the playful humour of *Djinn* that separates it from Robbe-Grillet's earlier books. One passage, a 'love and science fiction story' told by the narrator, is a tale of a young noblewoman, who, unaware of his 'cybernetic character', marries a robot. She begins

to grow suspicious when she wakes up early one morning to catch him 'oiling the mechanism of his coxo-femoral joints'. The robot goes to the crusades and dies at the walls of Jerusalem when an infidel's poisoned arrow pierces his armour and short-circuits his electronic brain.

Ironically, the narrator, under the influence of love, grows robot-like himself, till at the end of the novel we are not sure whether he was human.

'Are these people human beings or not?' Robbe-Grillet asked rhetorically. 'I don't know. They are terribly well made for robots, but on the other hand, they have bizarre features for human beings; for example the fact that they all look alike. Maybe they are being experimented on by someone else.' He chuckled.

'Love and science fiction have a lot in common. When a young man meets a young girl and falls in love with her, she is something marvellous, improbable, inexplicable – as if she had fallen from the planet Mars. This is the theme of all romantic literature – and also of science fiction.'

Simon Lecoeur, the narrator-hero of *Djinn*, meets blonde, green-eyed American Jean in Paris when he answers a job advertisement. In true Robbe-Grillet detective-story style, the young woman, who apparently heads an international secret organisation against machines, appears in an abandoned warehouse at dusk,

dressed in a trenchcoat, dark glasses and fedora. From this moment the novel becomes, in the narrator's words, 'a shaggy dog story'.

The story becomes a jumble of recurring places and objects: a café which no longer serves pizza, the alley where only Simon and the children go, dirty windowpanes, dummies, red liquid between paving stones, a photo of a sailor who perished at sea (his Breton grandfather, Robbe-Grillet reveals).

'The world is much more bizarre than people want to admit, much more strange, rich, exciting.' As in Robbe-Grillet's other novels, time, space and personal identity have no meaning here.

Djinn, the French equivalent of 'genie' or 'jinn' in English, and pronounced like the American woman's name Jean, came out simultaneously in Paris and New York on 3 March 1981, a first for any French novel. The New York version, titled *Le Rendez-vous*, is a university text with grammatical notes, exercises and glossary by Yvonne Lenard, who wrote the 'Parole et Pensée' series familiar to many Americans who have studied French.

Alain Robbe-Grillet, 1985. Photo: © Robert Doisneau/Gamma-Rapho/Getty Images.

When Robbe-Grillet was teaching a seminar at UCLA in 1978, Lenard complained to him that not only did her French texts bore her students, they often found them laughable. 'The ideal would be for a novelist to write them, but no writer would accept the constraints of preparing a textbook,' she told Robbe-Grillet, who replied that he would do it.

He quickly wrote the first chapter of *Djinn* in the present indicative tense. She added the lessons, and sent it to Holt, Rinehart and Winston, who, in Robbe-Grillet's words, 'said "fantastic" and signed a contract right away.'

The New York publishers have been testing the book on readers and students, who report that although they found the story a bit complicated, they always wanted to go on reading. Successive chapters are increasingly difficult grammatically, and the novel, about people (or robots?) who end up having memories of their future, is written in such a way that the complex verb tenses are consistent with the story.

'We won't know how many American professors will decide to use the book until next fall,' Robbe-Grillet said, 'but the surprising thing is that there are lycées in France which have already adopted the book for their curricula. They're saying, "It's not fair, why only for the Americans, why not for French students too?" They need exactly the same thing, since the French they learn at home is neither complex nor complete.'

Versions of the book are already being prepared for Spanish and Japanese students of French. The French version of the book is published (by Éditions de Minuit) without the lessons.

'When the book was finished, I had French friends read it without telling them it was meant to teach grammar. None of them realised it. It was a novel like any other. There is something else even funnier than that. All of a sudden, the whole dispute about the *nouveau roman* broke out again.'

The *nouveau roman*, a literary genre begun by Robbe-Grillet and others in the 1950s, has never been accepted by French literary traditionalists. The *nouveau roman* writers reject all the elements of what Robbe-Grillet calls nineteenth-century fiction; that is to say characters, plots, chronology, consistency. These conventions create a false semblance of reality, which, they say, is on the contrary fraught with confusion, repetition and continual transformations. Needless to say, *nouveaux romans* can be difficult reading, and their complexity has often given them the reputation of being mere intellectual obfuscation. *Djinn* is a delightful exception to the popular wisdom that such novels are boring.

The debate was revived when *Le Monde* published a review of *Djinn* which stated that not only did the *nouveau roman* still exist, it was the only contemporary French novel, for there had been no other literary movements in France since the war. Other publications took sides.

Written into the exercises of the textbook version of *Djinn* is a comparison of the *nouveau roman* and traditional forms of fiction. Robbe-Grillet takes obvious pleasure at the thought that he may thus win a whole generation over to the *nouveau roman*.

'I had a great time doing it,' he said gleefully, 'and I know that all of the people who detest me are furious at the idea that I am going to contaminate students learning French all over the world.'

I did this interview with Alain Robbe-Grillet for the International Herald Tribune in 1981, three years after I took a seminar taught by him at UCLA. This was the first newspaper article I ever published.

Master of the Hypertrophied Ego

Château du Mesnil-au-Grain, Normandy, June 2002. Gravel crunches under the tyres as we approach the château; a sound from *L'Année dernière à Marienbad?* Or was it *La Jalousie?* Probably both. Half-remembered images and sounds of uncertain provenance are a constant motif in Alain Robbe-Grillet's novels and films. Beyond a field of daisies in long grass, Le Mesnil-au-Grain stands stone silent, its front doors shuttered. The master will see you at 2 PM, I was told. Don't keep him waiting. He can't bear people being late.

Could 'the master' have forgotten our appointment? I'm considering a fruitless journey back to Caen, 30 kilometres away, and the two-hour train ride to Paris, when Alain Robbe-Grillet's shadow finally passes behind a window. The white shutter door opens and Robbe-Grillet emerges, little changed since I last interviewed him twenty-one years ago. The same black polo-neck jumper, tweed jacket and hirsute look of a French intellectual.

Robbe-Grillet walks down the limestone steps of the château as if intent on a stroll around his domain, ignoring me and the taxi driver. He stares and points at gaps in the forest where trees fell during the great storm of December 1999. There was a plane tree here, an elm there. He seems to have taken it as a personal affront; he now has scores to settle with nature. In *La Reprise*, his new novel set in Berlin in 1949, he diverges for a whole page to describe the devastation of the grounds of his château, saying he leaves the shutters of his study closed 'so as not to see the obscure disaster where I live since the hurricane that ravaged Normandy just after Christmas, marking in an unforgettable way the end of the century and the mythical passage to the year 2000. The beautiful layout of the foliage, the ornamental pools and lawns, has left in its place a nightmare from which one cannot awake'

'But Monsieur Robbe-Grillet,' the taxi driver interrupts him, 'you're in great shape for a man of eighty.'

The writer shoots a withering look at the impudent driver, turns and heads into his castle. 'It is all Louis XIV, except for the staircase, which is Louis XV,' he says absently as we stand in the entry. 'Not many writers can buy a Louis XIV château with their royalties.'

Jérôme Lindon, Samuel Beckett's publisher and the director of Les Éditions de Minuit, who died in 2001, helped Robbe-Grillet and his wife Catherine buy Le Mesnil-au-Grain in 1963, two years after Robbe-Grillet wrote the screenplay for Alain Resnais's *Marienbad* with Alain Resnais. The château doubtless reminded him of the cold grace and timelessness of the Mitteleuropa spa where the film classic was made.

Robbe-Grillet had insisted that I visit an exhibition on his life and oeuvre in Caen en route to Le Mesnil; no exhibition, no interview. In one of the display cases I found the famous black-and-white photograph taken by Mario Dondero in 1959, which came to symbolise *le nouveau roman*. It shows Robbe-Grillet, Claude Simon (who won the Nobel Prize for literature in 1985), Claude Mauriac, Jérôme Lindon, Robert Pinget, Samuel Beckett (who won the Nobel in 1969), Nathalie Sarraute and Claude Ollier on the pavement outside Les Éditions de Minuit. Number 7, rue Bernard-Palissy – a former brothel in a tiny alley in Saint-Germain-des-Prés – was not yet a literary shrine.

Of the eight figures in Dondero's photograph, only three are alive today. Because he entered anthologies of French literature when he was barely middle-aged, Robbe-Grillet grew accustomed to students saying: 'I thought you died a long time ago!'

Like Éditions de Minuit, Robbe-Grillet attained mythical status but remained active. He has just published two books, *Le Voyageur*, a collection of essays and interviews completed between 1947 and 2001, and *La*

Reprise, his first novel in two decades. Both sum up Robbe-Grillet's oeuvre, which is characterised, in the words of Jean-Didier Wagneur of *Liberation*, by 'this permanent rebellion, this rejection of any compromise, this constant desire to experiment rather than to reassure the reader.'

Robbe-Grillet's essays are lucid, well-reasoned; his films and fiction a self-contradicting stream of consciousness. In life, his endless journeys as the self-appointed 'travelling salesman of the *nouveau roman*' mimic the chaos of fiction, yet he always returns to Reason, to the flawlessly ordered, museum-like château.

It is not surprising that Robbe-Grillet's secret garden is a hothouse full of cacti – the comical, oneiric forms, the geometric repetition of needles Asked why he recently began collecting the prickly plants, Robbe-Grillet counters defensively, 'What's your favourite plant? Why?' The interviewer falls into the trap, blathering on about roses and lilacs. Robbe-Grillet smiles contentedly. He hates being asked why.

The afternoon sun floods into the west wing salon, where we settle into feather-cushioned armchairs. 'There's more light since the trees fell,' Robbe-Grille muses to himself, as if filing the observation for future reference. There are two things which critics always forget to mention, he continues: his sense of humour and the poetic character of his prose. He sees himself as Kafka's heir, and thinks *The Trial* was funny. Without Robbe-Grillet's devilish laugh trailing behind every sentence, his arrogance would be insufferable.

'When my first books were rejected by publishers, I already had the intimate conviction that I was a great writer. It changed nothing when I was recognised later. Even as a child, I had a hypertrophied ego,' he says, using the scientific term for 'abnormally enlarged'. 'It happens a lot with writers. I distrust writers who don't have a hypertrophied ego – modest writers. But it doesn't make me unbearable, whereas often hypertrophy of the ego . . .

[Marguerite] Duras at the end of her life was totally unbearable . . . it gives them a kind of arrogance, that I don't have at all.'

Nathalie Sarraute called the *nouveaux romanciers* '*une association de malfaiteurs*', or conspiracy, of which Robbe-Grillet was the ringleader. His essays published in 1963 as *Pour un Nouveau Roman* announced the death of the 'Balzacian novel'; an end to literary conventions of plot, character, metaphor. Fiction should be like real life, Robbe-Grillet argued – jumbled, confusing, repetitious.

Like abstract painting, novels that once seemed incomprehensible came to be accepted. As Jérôme Lindon's chief literary adviser, Robbe-Grillet had immense power over what would be recognised as modern French literature. 'When people call me the "Pope of the *nouveau roman*", it seems grotesque, because I wasn't,' he says. 'I pushed each of them to go as far as possible in his or her excesses, in their folly. Duras started writing like Duras when she arrived at Minuit. Before that, she tried to be a 'normal' writer. Claude Simon too. I saw something much more interesting in them; that they had to go in that direction, and not worry about what the public wanted. When they tried to write for the public, they had no public. They gained fame and readers in the long run, because it's the works that create readers.'

Robbe-Grillet's *La Reprise* sold forty thousand copies in four months last winter – a large number for a *nouveau roman*. He has not changed, he insists; the reading public has grown up. No one can accuse him of inconsistency, he writes at the beginning of *Le Voyageur*. Its title was the original name of *Le Voyeur* in 1955. He simply took two letters out of the middle.

Robbe-Grillet left a blank page in the middle of *Le Voyeur*, where the reader was supposed to imagine the murder of the little girl; he wanted the reader to work. As he explained in *Pour un nouveau roman*, the modern author no longer asks the reader 'to receive a completed,

finished world, closed in on itself' but 'on the contrary to participate in a creation, to invent the work – and the world – and thus to learn to invent his own life'.

La Reprise means resumption or repetition, a theme that Robbe-Grillet plays on throughout the 253-page text. The story of a French spy with multiple identities in Allied-occupied Berlin goes forward, backwards and sideways. 'I'm fascinated by stories that can't be made sense of, like Kennedy's assassination,' he says. He describes *La Reprise* as two narrators struggling to impose their version of a crime. One of them is eliminated by a perverse nymphette named Gigi. The novel has constant allusions to the nineteenth-century Danish philosopher Søren Kierkegaard, and repeats many elements of *Les Gommes* (1953), itself a variation on Sophocles' *Oedipus*...

Robbe-Grillet scorns the 'mediocrity' of Michel Houellebecq, the French writer who was awarded the IMPAC prize in Dublin in June 2002. Both men studied at the French National Institute of Agronomy, and Houellebecq sent 'the master' some of his early works. 'His novels are about f**king,' Robbe-Grillet says.

'People f**k very little in my novels; there are sado-erotic scenes, but with Houellebecq, it's vulgar f**king.'

Young girls being molested and tortured are a recurring fantasy with Robbe-Grillet – most recently, Gigi in *La Reprise*. Josyane Savigneau of *Le Monde* says the ropes, chains, whips and moaning are 'not so much pornographic as a parody of the genre'. Robbe-Grillet refuses to entertain questions about taste or morality.

'I make no difference between fantasy and real life,' he says dismissively.

He laughs at the American feminists who ran him out of the University of Saint Louis, Missouri, in the early 1990s. In France, his films have often been banned for minors. In an interview re-published in *Le Voyageur*, Robbe-Grillet mentions the controversy over *Trans-*

Europ-Express (1966), in which Jean-Louis Trintignant rapes Marie-France Pisier three times.

'A little later, these films cost me the Nobel,' he says. 'I was well placed to have it in 1985, but the Swedish Cinémathèque organised a retrospective of my films, unleashing the indignation of the local press against French pornography. So Claude Simon got the Nobel'

Robbe-Grillet makes no apologies. Literary prizes are awarded to bad books every day, he says.

'The *nouveau roman* is the true novel; the rest are all novels for mass consumption.'

February 2008: The Death of Alain Robbe-Grillet

Robbe-Grillet's rise to fame began in the 1950s, when every trend in France was labelled 'new'. Just as Christian Dior brought *le new look* to fashion and François Truffaut *la nouvelle vague* to cinema, Robbe-Grillet was the chief theoretician of the *nouveau roman*.

Nathalie Sarraute, Claude Simon (who won the Nobel Prize for literature in 1985), Michel Butor and Marguerite Duras were Robbe-Grillet's cohorts in his crusade to kill what he called 'the Balzacian novel'. Modern prose, these writers believed, should be comparable to abstract painting: without definable plot, characters or narrative.

'Henceforward, we write joyfully on [a foundation of] ruins,' Robbe-Grillet wrote gleefully in *Pour un Nouveau Roman* (1963). French critics like Roland Barthes took the art form seriously, but the public found it daunting.

'American universities saved the *nouveau roman*,' Robbe-Grillet often said with a devilish laugh. He spent much of the 1970s lecturing on US campuses, where he turned the *nouveau roman* into a cottage industry.

A collection of his work published in 2002 was entitled *Le Voyageur*. Though he settled in the seventeenth-century château in Normandy that he

purchased with his royalties, Robbe-Grillet thought of himself as a constant traveller since his year in a forced-labour camp in Germany during the Second World War.

'Since the 1940s, I rarely ceased pacing the planet,' he wrote, describing himself as a 'missionary for the *nouveau roman*, a crusader for the literature of the future, and willing professor of myself'.

Critics believed Robbe-Grillet's first novel, *Les Gommes*, published in 1953, was a metaphysical detective story, but they weren't certain. In *Le Voyeur*, published two years later, a travelling salesman criss-crosses an island on a bicycle; the reader is not sure if a crime has been committed. *La Jalousie* (1957) drew on Robbe-Grillet's experience as an agronomist in the West Indies. In it, a centipede, watched by a jealous husband, slowly climbs the wall of a house.

In 1955, Robbe-Grillet became a literary adviser to Jérôme Lindon, the founder of Éditions de Minuit. Samuel Beckett, who was also published by Minuit, was a friend. As an editor at Minuit until 1985 and as a member of several juries for literary prizes, Robbe-Grillet held great power over twentieth-century French literature.

Robbe-Grillet began a parallel career when he wrote the film classic *L'année Dernière à Marienbad*, which was directed by Alain Resnais in 1961. In it, the actors Delphine Seyrig and Dirk Bogarde wander through the labyrinthine rooms and gardens of a central European château, eternally wondering whether or not they've met before.

Perhaps in the hope of attracting the public's attention, Robbe-Grillet's books and films were increasingly based on his own sado-erotic fantasies, often involving pubescent girls and bondage. In his 1966 film *Trans-Europ-Express*, Jean-Louis Trintignant raped Marie-France Pisier three times. Robbe-Grillet's tendency to mistake his sexual obsessions for art reached its paroxysm

in his last book, ironically entitled *Un Roman Sentimental* and published last autumn.

Under the pen-name Jean de Berg, Robbe-Grillet's wife Catherine, who survives him, also wrote semi-pornographic novels.

Robbe-Grillet revelled in his own notoriety, and in the scandals created by his work. 'I am famous for being famous,' he often said, quoting Andy Warhol. Students, readers and the public sometimes suspected he was having a laugh at their expense.

Upon his death, *Libération* described Robbe-Grillet's 'Mephistophelean [after the evil spirit to whom Faust sold his soul] laugh, pitiless and without tenderness, but nonetheless a form of gaiety, of stainless steel youth, sardonic and flamboyant'. Robbe-Grillet often mocked the august Académie Française, telling interviewers he'd rather die than join it.

Yet imitating the unexplained twists of his novels, he sought election to it in 2004, and was accepted. 'He was not a good writer, but he was a fine grammarian,' explained Michel Déon, an academician who lives in Ireland.

However, for more than three years after his election, Robbe-Grillet never set foot in the Académie. His death found the group in crisis, with seven of forty seats vacant. France's great men could not agree on new candidates — a stalemate to which Robbe-Grillet contributed. Once again, he had the last laugh.

Alain Robbe-Grillet: born 18 August 1922;
died 18 February 2008.

Claude Lévi-Strauss

The Father of Structuralism

France paid tribute to the father of modern anthropology and structuralism, Claude Lévi-Strauss, on his hundredth birthday in November 2008 with a host of publications and radio and TV programmes. President Nicolas Sarkozy visited the aged intellectual's Paris flat.

The Bibliothèque Nationale exhibited Lévi-Strauss's manuscripts, and the typewriter on which he wrote *Tristes Tropiques* (Sad Tropics), the 1955 classic that made him famous. The Musée du quai Branly, France's museum of 'first arts' from Africa, Asia, Oceania and the Americas, held an admission-free tribute day, staging hourly tours with guides pointing out some of the 1,478 artefacts – feather headdresses, bows, arrows, musical instruments, baskets, sculptures and ceramics – which have belonged to Lévi-Strauss.

The quai Branly museum's main amphitheatre bears Lévi-Strauss's name, and he attended its inauguration in June 2006. In 2007 he donated 224 black-and-white photographs from his 1935-39 expeditions to Brazil. Many show girls and women from the Caduevo tribe, who painted their faces and bodies with geometric designs.

Some of the Indians whom Lévi-Strauss studied spent up to three-quarters of their time decorating themselves.

Lévi-Strauss defined anthropology as 'an act of faith in human universality'. In Brazil, he studied myths, customs, languages, religion, institutions and laws of kinship among the Caduevo, Bororo, Nambikwara and Tupi-Kawahib tribes.

In *The Elementary Structures of Kinship*, Lévi-Strauss later wrote that the prohibition of incest was the foundation of all societies. In another seminal work, *Mythologiques*, he traced a single myth from the tip of South America to the Arctic circle.

In his second Brazilian expedition, Lévi-Strauss studied the Nambikwara, whom he described as human society reduced to its simplest expression. These Indians went naked and slept on the ground, without blankets, with families drawing close together for warmth. In his photographs, they are almost always smiling.

Lévi-Strauss recorded his long sojourns with these secluded tribes in *Tristes Tropiques*. The book begins with the words 'I hate travelling', and its first-person narrative makes it more accessible than most scientific works. He originally intended it to be a novel. 'After fifty pages, I realised I was writing a poor imitation of Conrad,' he said.

In dire financial straits, Lévi-Strauss wrote the book at the urging of the Arctic explorer Jean Malaurie 'in exasperation and horror, in four months'. The book is so well written that the Académie Goncourt issued a statement saying that if *Tropiques* had been a novel, they would have awarded it the Prix Goncourt.

At the beginning of the Second World War, Lévi-Strauss returned from Brazil to France to do his military service. During the 1939–40 'phoney war', as an aimless soldier on the Maginot Line, he had the inspiration that made him the founder of structuralism, the intellectual movement that followed existentialism.

'I was lying in the grass, looking at flowers, in particular a dandelion,' Lévi-Strauss recalled. 'It was then that I became a structuralist, though I didn't know it yet. I was thinking of the laws of organisation that must have presided over such a complex, harmonious and subtle arrangement, and I could not imagine that it was the result of a series of accidents.'

Because Lévi-Strauss, who is Jewish, was not allowed to teach in France under the Vichy régime, he took up a post at the New School for Social Research in New York – probably saving him from the Nazi death camps. In New York, he became a close friend of André Breton and other founding members of Surrealism. Lévi-Strauss introduced the Surrealists to 'primitive' art, and he credited Breton with imparting an understanding of the value of objets d'art.

When he returned from New York in 1951, Lévi-Strauss had to sell two Canadian artefacts which he'd collected during his New York years, a wooden ceremonial head ornament with startling blue eyes, and a sculpture of a shaman or sorcerer. The head ornament was sold to a private buyer, and Lévi-Strauss was thrilled to find it in the Musée du quai Branly in 2006.

The eighty-centimetre-high shaman had pride of place in the Lévi-Strauss living room, where the children called it 'the witch'. Lévi-Strauss's son Laurent told *Le Monde* that his father was particularly attached to the sculpture, made of wood, leather, copper, fur, bear claws and dogs' teeth.

'He especially liked the fact that it was neither ritual nor decorative. The Indians had made it to sell to passing sailors.' The sculpture was bought by the Musée de l'homme in 1951. 'My father was upset to lose it. Every Thursday morning, he took me to the museum to visit the witch.'

Tristes Tropiques ensured that Lévi-Strauss would prosper. From 1959 until 1982, he held the chair of social anthropology at the Collège de France. When he was admitted to the Académie Française in 1973, he donned the green velvet habit and plumed Napoleonic hat, joking that it was the least he could do to uphold French rituals, having spent so many years observing the rituals of others. Lévi-Strauss was awarded more than a dozen honorary doctorates, from universities including Oxford, Harvard and Yale.

Lévi-Strauss lived long enough to see his theories go out of fashion and come back again. But he often remarked that he felt out of place in an overpopulated world where the very existence of 'peoples we wrongly call primitive' is threatened and the environment is being destroyed. 'I can't say I feel at ease in the century where I was born,' he said. 'And the way things are evolving makes me think my descendants will not be any more at ease than I am.'

Claude Lévi-Strauss died on 30 October 2009.

Jean Baudrillard, or the Proper Use of Imposture

June 2001

Talking to Jean Baudrillard is easier than reading his books. For one thing, he drops the cumbersome vocabulary of signified, signifiers and simulacra. It's nonetheless a mental obstacle course, where moments of illumination alternate with the recurring question, 'What does he *mean*?'

There is something frustratingly elusive about the seventy-one-year-old thinker. It's hard even to know how to describe him. A French intellectual rejected by the French, but revered by *les Anglos-Saxons*, he is and is not a sociologist, philosopher, theorist, diarist, photographer … Baudrillard explains that he has several value systems corresponding to several strata of daily and intellectual life.

'At the last strata, there are no more values at all. I live in a non-system of values,' he says. I naively ask if that is what makes him postmodern – the textbooks and commentaries describe him as a postmodern philosopher.

'Ah, *non*!' Baudrillard cries out in mock exasperation. 'I am not postmodern. Stop this nonsense, because it's total mythology. I've always passed for a postmodernist. I've always repeated that I wasn't one. Nobody listens. For *les Anglos-Saxons* I'm the "pope of postmodernism", "the guru of postmodernism". It's ridiculous, because I can do nothing about it.'

I promise to correct the misimpression. 'Correct, correct – but it will do no good,' Baudrillard warns me. 'They stuck me with the postmodernists because I worked a lot of simulacra [images, semblances] and simulations [reality as constructed by signs]. They are beyond truth and falsehood, beyond good and evil, and therefore beyond the principle of value. People saw the attributes of postmodernism in that.' His philosophy was vulgarised, Baudrillard says, reduced to, 'He says everything in signs, that there is no more reality.'

Interspersed with what Baudrillard calls his 'serious' work, he wrote a least five books and pamphlets to provoke debate: *Forget Foucault*, *The Beaubourg Effect*, *The Art Plot*, *The Divine Left* and *The Gulf War Did Not Take Place*, in which he attacked the French philosopher Michel Foucault, the Pompidou Centre in Paris, contemporary art, the French Socialist Party and CNN's coverage of the 1991 Gulf war.

'From time to time I like to knock things down,' he explains. 'I wasn't provocative for the sake of provocation. I was going to the limit of a concept, of a mood. Each time it created a reaction, a massive, negative counter-transfer. Each time my reputation – which I had proudly built up [he laughs] – collapses over things like that.' Alan Sokal and Jean Bricmont devoted a chapter to Jean Baudrillard in their 1998 book *Intellectual Impostures: Postmodern*

Philosophers' Abuse of Science (published as *Fashionable Nonsense* in the US). Baudrillard seems slightly miffed when I mention it.

'I found this debate so sordid – not sordid, I understood what was at stake – but I didn't feel like responding,' Baudrillard says. As usual, he immediately contradicts himself. 'Except once in New York, I responded indirectly. I gave a lecture on the proper use of imposture.... Yes, I'm an imposter. But they were too.' Baudrillard argues that imposture is 'a way of never being where you think you are, of always being elsewhere'. For him, everything has at least two sides. 'There is duplicity, duality.... Obviously, in a world that purports to be transparent, uni-vocal, clear, significant, people have a hard time admitting this. So they call you an imposter.'

The son of civil servants from the champagne capital, Reims, Baudrillard taught German in a lycée before writing his doctoral thesis in sociology on 'The System of Objects' in the 1960s. His early work, he says, was permeated with *l'air du temps*: semiology, psychoanalysis, Marxism.

Baudrillard wrote that consumption, rather than production, had become the driving force in western society, that we were all doomed to 'perpetual shopping' because there was no longer a difference between real and artificial needs. 'I was also a Sartrien, and I worked with [Roland] Barthes,' he says. 'After that, it aired out a bit. I abandoned all references and I went off and did my own thing.' In the course of what Baudrillard calls his 'disinvestment' in politics, culture and art, he managed to offend nearly everyone.

The 1981 triumph of the socialist-communist alliance in France left the former Marxist indifferent. 'It was a devitalised ideology, that no longer had political or historical meaning,' he says.

Baudrillard's work, like that of the Canadian culturologist Herbert Marshall McLuhan, came to focus on the role of media. 'I wasn't particularly fascinated by media,' he says. 'But the media were the instrument of this political disinvestment – not only political, but cultural and artistic. For me, everything has undergone the same fate, not just the politicians. Art has taken a blow, a sort of lobotomisation.

'I wrote *The Plot of Art* about the nullity of contemporary art. It created a misunderstanding because people thought I was defending traditional art, or that I was against contemporary art, when it was a more general problem of the loss of aesthetic values, the loss of illusion, of the power of illusion in art, of the ability of art to create any scene other than reality. Art had fallen into a banal repetition of things as they are. It became one more medium.'

Baudrillard enraged feminists with his 1979 book *On Seduction*. It was not meant to be about women or feminism, he says. 'I was trying to get beyond sexual difference. For me, seduction is more vast than sexuality. It praised the power of seduction, which I believe has more to do with femininity than masculinity. Seduction is mastery of the symbolic universe, whereas masculinity is about mastery of power and the real world. At the time, feminists wanted nothing to do with seduction, because for them it was the sign of the servitude of women. The misunderstanding was total, and it continues.'

In the US, Baudrillard has an almost cult following. But in 1986, his book *America* caused another scandal. 'What I liked about America was the lack of culture, the flip-side of all this European culture that is decayed, fossilised. I was interested in the desert, in America as a primitive stage.

'The Americans didn't like my saying theirs was a primitive society. For me, it's the great primitive society of modernity. The book is really in praise of America, but it was even burned on one campus. It was very successful, but a success out of revulsion.'

The French lost patience with Jean Baudrillard a long time ago. His last gasp in France, a twice-monthly column in *Libération* in 1996, was short-lived. Baudrillard speaks of a sort of boycott against himself. 'There was the whole intellectual milieu because of *Forget Foucault*. The feminists, the artists. When you're in your home country it has quite an effect, but abroad our little French fights have no importance.' Baudrillard's war on television has shifted to the Internet, what he calls 'the enormous thing that is virtual, digital, the computer . . . that's in the sights now.'

He confesses to being 'completely incapable' of operating anything with a screen. 'I'm not living in nostalgia for a lost culture, or for traditional humanist values,' he continues. 'Not at all. It's just that there is something that counts for me which is a symbolic place of secret and seduction. They have completely disappeared from the virtual, digital world. I resist every system which recycles everything into a sort of generalised communication, perpetual information. I don't want to enter into it, because for me it's worse than alienation.

'Everything disappears into it,' he continues. 'The body, the senses, pleasure, judgement – because there is no longer the distance for judgement. You cannot judge it, you're inside it. What is lost, what is disappearing, is secrecy. Everything has to be rendered visible. Nothing exists unless it is hyper-visible.'

Baudrillard says that western society no longer has a goal or objective other than 'this organic development of technologies, in the total absence of any idea about what it may signify. We no longer need meaning. Things function. Full stop. That's it.' The system is 'homogenising itself radically', he says.

'Everything is integrated. That is what is radical – this sort of total integration, almost fundamentalism of the system.' He doesn't mean conformity; 'We are far beyond conformism. That was a dimension of bourgeois society. We no longer conform, we're informed. We're an element of information of the system itself. We're not even in conformity with something outside ourselves. We are ourselves caught in the formatting of the system. That is worse than conformity of conformism.'

Jean Baudrillard's unfiltered cigarettes, blue jeans and aviator glasses give him the air of an ageing Left Bank leftie. Yet through the irony runs a streak of common sense about the ravages of the information age on our minds.

Before leaving to meet a friend for lunch at Hemingway's old haunt Le Select, he proudly shows me the photographs he has exhibited around the world. One framed colour image looks strikingly like a painting by the American artist Edward Hopper. There are black-and-white cityscapes from the US. Reproductions of reality, in Baudrillard lingo, simulations. 'I like images,' he says simply.

Jean Baudrillard died on 6 March 2007 at the age of seventy-seven.

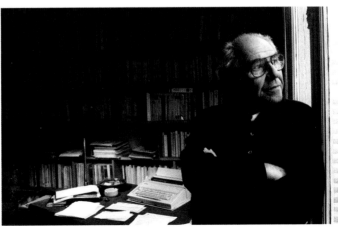

Jean Baudrillard © Antonio Ribeiro/Gamma-Rapho/Getty Images.

Antoine de Saint-Exupéry

Growing up was the tragedy of Antoine de Saint-Exupery's life. Despite the death of his father when he was three years old, the writer and aviator always remembered summers at the family château at Saint-Maurice-de-Rémens, 35 kilometres northeast of Lyon, as an enchanted time whose magic could not be recaptured.

The Comtesse de Saint-Exupéry and her five children wintered in the Lyon apartment where Antoine was born in 1900, at what is now number 8, rue Antoine de Saint-Exupéry. 'It's completely by chance I was born in Lyon, this city of beautiful silences,' he later wrote. His parents were married at Saint-Maurice. His father Jean and his only brother François were buried there. His mother, Countess Marie, inherited the château from her great-aunt Gabrielle. During their annual April-to-October stays at Saint-Maurice, up to eight servants looked after the family. The village priest was a frequent dinner guest, and Mademoiselle Anne-Marie Poncet travelled once a week from Lyon to give the children piano and violin lessons.

Every Thursday, Marie de Saint-Exupéry invited the village children to the château to join her own progeny in producing plays and concerts. Antoine began a life-long habit of waking up the château's inhabitants in the middle of the night to force them to listen to a poem or short story he had written.

Saint-Ex wrote about life at Saint-Maurice in *Pilote de Guerre* (Flight to Arras), *Courier Sud* (Southern Mail) and *Terre des Hommes* (Wind, Sand and Stars). The character of *The Little Prince* – the best-selling book in the world after the Bible – resembles the writer as a child, with the mop of yellow hair for which his family nicknamed him 'the sun king'.

Today only the entry, with its limestone and black basalt chequered floor, and the massive carved oak china cabinet and dining-room table are as they were in Saint-Ex's childhood. The house was the adults' domain, the five and a half hectare garden and adjacent farm the children's. In her book, *Five Children in a Garden*, Antoine's older sister Simone recalled that 'the garden offered a thousand treasures. We built tree houses and huts carpeted with moss; we raided the redcurrant bushes.'

The château turns its back on the village, facing a vast meadow dotted with pine, linden and chestnut trees, the Bugey hills and the Jura mountains. The iron horse-heads on the stable doors, the doll-house aviary and the marble carving on the chapel door of two angels carrying Tante Gabrielle's six-year-old daughter (who died of diphtheria in 1875) to heaven are as they were when Saint-Ex was a child.

'I feel much closer to Saint-Ex in the garden,' says Michel Richelmy, who founded the Centre Saint-Exupéry

in Lyon in 1950. 'The family took the train from Lyon to Amberieu. A horse-drawn carriage picked them up at the station,' Richelmy says as we walk up the overgrown drive. 'One of the children's favourite games was to run from the bottom of the garden to the château when a storm broke. The last child to be hit by raindrops became the "Chevalier Aklan".' In *Flight to Arras*, Saint-Ex compared the game to dodging German bullets in his reconnaissance plane.

In 1930, Saint-Ex wrote to his mother from Buenos Aires: 'I cannot think of my corner of the world without a great hunger to be there; without clenching my fists amid these crowds, thinking of the smell of the linden trees at Saint-Maurice, of the scent of its cupboards, of your voice.'

Financial difficulties forced the countess to sell the château two years later, but Saint-Ex always felt drawn to it. His nostalgia may have been fatal. One month before he was shot down by the Germans on 31 July 1944, he was scolded for straying from his itinerary to fly over places where he had grown up. Some historians believe he lengthened his last mission to fly over Saint-Maurice.

✦

In 2000, the centenary of Saint-Exupéry's birth, the writer's aristocratic grand-nieces and grand-nephews in the d'Agay family – his only blood heirs – received a jolt. Saint-Exupéry's Salvadoran widow Consuelo Suncin de Sandoval, who died in 1979, struck a blow from the grave, laying open their tortured marriage.

The publishers of *Memoirs of the Rose* claimed the book made Saint-Ex more human; his admirers and heirs feared it portrayed the legendary writer as a womaniser and a cad. Whatever the wrongs on both sides of the marriage, Consuelo's book is a monument to the pain the couple caused one another.

Most of Saint-Exupéry's family never accepted Consuelo, whom they still refer to as 'eccentric' and 'hare-brained'. She was in fact an artist and writer in her own right, whose friends included the painters Salvador Dalí and Joan Miró. Although Consuelo inspired *Night Flight* and *The Little Prince*, she had to wage a legal battle to obtain 25 percent of Saint-Ex's literary estate after his disappearance – a share she left to José Martinez, the Spaniard who took care of her in her old age. Saint-Ex's French publisher, Gallimard, retains 50 percent of the rights, and the nieces and nephews the other quarter.

Martinez found Consuelo's 1940s' memoirs in the bottom of a trunk, and decided to publish them in 2000. The book sold extremely well, though the d'Agay family initially claimed it was a fraud written by one of Consuelo's lovers, the Swiss writer Denis de Rougemont.

When I was writing a thesis about her husband at the Sorbonne in 1976, I spent hours with Consuelo de Saint-Exupéry. In the autumn of 1998, when a fisherman in Marseille discovered Saint-Ex's identity bracelet and a dispute ensued over searching for the wreckage of his plane, I opened my yellowing volume of Saint-Ex's works to find Consuelo's drawing of the Little Prince with his head in the stars, and her message to me, 'in memory of my husband', in an old woman's scrawl.

Consuelo wore a dressing gown and complained that she didn't have the energy to go to the hairdresser. A younger, Spanish-speaking man – Martinez, who would become the executor of her estate – ran errands for her.

'I was the rose in *The Little Prince*,' Consuelo told me repeatedly, referring to the vain and prickly flower, so proud of her pathetic little thorns, that the Little Prince fretted over during his long journey. When he caught her lying, the rose coughed with embarrassment and the Little Prince sadly departed.

'I should not have listened to her,' he wrote in the children's book. 'One should never listen to flowers. One should look at them and smell them.'

Even in old age, Consuelo remained the woman who had enchanted Saint-Ex: exotic and vain, energetic and self-obsessed. She told me she had kept her memoirs, and for me there was no doubt that *Memoirs of the Rose* was authentic.

The tale of innumerable break-ups and reunions began when the couple met at a cocktail party in 1930 in Buenos Aires, where Antoine ran the Aéropostale mail company's South American routes. Within minutes, he insisted on taking Consuelo flying, 'to show [her] the clouds over the Rio de la Plata'. While her friends were throwing up in the back of the plane, Saint-Ex courted Consuelo in the cockpit.

Today, his behaviour would be sexist. He addressed Consuelo as 'little girl' and demanded a kiss. She refused on the grounds that she had just been widowed by the Guatemalan writer Gomez Carillo. Saint-Ex put the plane into a dive, threatening to drown its passengers. 'You won't kiss me because I'm too ugly,' he said. 'I saw teardrops fall from his eyes onto his tie and my heart melted with tenderness,' Consuelo recalled. 'I love you because you are a child and you are frightened,' Saint-Ex told her. A few minutes later, after a passionate embrace while the plane zig-zagged through the sky, he proposed.

They married in 1931, the year that Antoine won the Prix Femina for *Night Flight*. His success made the clumsy, ill-dressed aristocrat more attractive to women, and he maintained a frenetic social life in Paris, without Consuelo. 'I was silly. I thought that I too deserved admiration for his work,' she wrote.

'I thought it was both of ours. What an error! Nothing is more personal to an artist than his creation: even if you give him your youth, your money, your love, your courage, nothing belongs to you. . . . Every woman in the audience,

after an hour of his lectures, dreamed of becoming his girlfriend.'

About four years after their marriage, Saint-Ex began a long affair with Nelly de Vogue, whose husband – like Saint-Ex, a count – had been at school with him. The writer had other affairs, but his relationship with de Vogue, whom Consuelo calls 'the beautiful E' in her memoirs, hurt most. Consuelo came to regard love for her husband as 'a serious disease, a disease from which you never completely recover'. De Vogue wrote a biography of Saint-Ex under the pseudonym Pierre Chevrier, in which she dismisses his marriage to Consuelo in two lines.

When Consuelo discovers a packet of Saint-Ex's mistress's perfumed love letters, they 'sob together like children'. His behaviour towards Consuelo grows steadily more cruel. After she is hospitalised for depression, Saint-Ex takes Consuelo on a Mediterranean tour, only to abandon her in Casablanca with the promise that he will meet her two weeks later in Athens. At the beginning of the Second World War she receives no news of him for months. Saint-Ex finally asks her to meet him at a hotel in Pau, southwestern France, then tells her to go away because he has a train to catch and wants to sleep.

This is Consuelo's version of events. It was out of spite, she wrote, that she took lovers, at least four of whom appear in her book. With the exception of the period when Saint-Ex was writing *The Little Prince* in upstate New York in 1942, the couple lived apart for the last six years of his life, often in separate apartments in the same building.

Yet Antoine wrote to Consuelo daily when he returned to his old reconnaissance unit in North Africa in 1943. The *Guardian* correspondent Paul Webster, who wrote biographies of both Antoine and Consuelo, called the mostly unpublished letters 'the most profuse and beautiful correspondence from a well-known figure to his wife in the twentieth century'. José Martinez

was forced to sell a few of the letters to pay Consuelo's death duties, but hoped to publish the others.

'If I am wounded, I will have someone to care for me,' Saint-Exupéry wrote to Consuelo shortly before his disappearance as a war pilot. 'If I am killed, I will have someone to wait for in eternity. And if I return, will I have someone to return to?'

To publish the letters, Martinez would need the approval of Frédéric d'Agay, the grand-nephew who represents the writer's blood heirs. D'Agay is a fierce defender of Saint-Exupéry's work and name, dispatching registered letters to children who perform *The Little Prince* without his permission. A museum in Japan, and Lyon airport, were allowed to call themselves 'Saint-Exupéry' only after donating undisclosed sums to the foundation which d'Agay established.

While Saint-Ex lived, most of his relatives thought him a failure. He was so financially inept that he could not pay telephone, gas and electricity bills. The utilities were cut. Bailiffs twice seized his and Consuelo's belongings.

When a Marseille fisherman found a charm bracelet in the sea inscribed with Saint-Ex's and Consuelo's names in September 1998, d'Agay claimed it for the heirs.

Antoine de Saint-Exupéry c. 1920s
© Bettmann/Corbis.

Habib Benamor was sorting sardines and mullet on the deck of the Marseille trawler *L'Horizon* when he saw something glitter in a mineral concretion he'd pulled up in his net. Benamor tossed the stone onto the bridge, and when he'd finished with the catch, he hit it with a

hammer. 'It was all black, like coal mixed with seashells and sediment,' the Tunisian fisherman told *Le Figaro*. 'There was a sort of fabric surrounding the piece of jewellery that looked like it had been burned, melted by heat'

The bracelet that Benamor found was tarnished and coated with muck from the seabed. He gave it to his boss, the trawler's captain Jean-Claude Bianco, who rubbed it with an abrasive dish pad. 'I saw 'Antoine' appear, and I said to myself, 'Hey, that's my middle name, after my grandfather'. I kept scratching, and then I read 'Saint-Exupery', and *putain*! I realised I'd hit pay dirt.'

That is how, forty-four years after he disappeared over the Mediterranean on a dangerous mission to collect information on German troop movements in the Rhone river valley, Saint Exupéry returned to haunt his beloved France. The chances of finding the bracelet in the Mediterranean were infinitesimal. Yet when the discovery was revealed at the end of October 1998, no one contested its authenticity. The bracelet also bore the name of Consuelo and the address of his New York publishers. The subsequent media coverage and a dispute over the fate of Saint-Ex's Lockheed P-38 Lightning aircraft were commensurate with his legend.

Had he died an old man in his sleep, *The Little Prince* would have guaranteed Antoine de Saint-Exupéry a place in literary history. First published in the US in 1943, the tale of a planet-hopping blond extra-terrestrial in a yellow aviator's scarf has sold some 80 million copies in more than a hundred languages. French intellectuals turn up their noses at the children's classic – and at the simple humanism and praise of fraternity in Saint-Ex's novels. But the public is still fascinated by this philosophical 'man of action'. The mystery surrounding his death only strengthened the Saint-Exupery legend.

Saint-Ex's father, the Count de Saint-Exupéry, died in 1904 before Antoine turned four. During summer

holidays in the château at Saint-Maurice-de-Rémens, Saint-Ex persuaded an early French aviator to take him up in a plane when he was twelve – without his mother's knowledge. Ten years later, the fledgling pilot fell in love with Louise de Vilmorin, a literary socialite who would also ensnare the writer André Malraux. To please Vilmorin's aristocratic family, Saint-Ex made a failed attempt at a career in business. The engagement ended, but the sad love affair provided him with material for his first novel, *Southern Mail*.

Nursing his broken heart, Saint-Ex went to the director of the French international air mail company, Latécoère, and announced: 'Monsieur, I want to fly, only to fly.' Latécoère's motto was 'the mail must get through', and nearly a hundred of his pilots died in terrible conditions – burned alive in their cockpits, drowned in the sea or frozen in the Andes. Saint-Ex was never a good pilot – his multiple crashes left him with fractured bones and a paralysed upper arm. Mechanics regarded him as reckless because he insisted on flying aircraft with faulty engines or drew sketches of the sea as he flew metres above the whitecaps.

It was in Buenos Aires, where he became the director of Aeroposta Argentina in 1928, that Saint-Ex met the recently widowed Consuelo. He sent some of his substantial earnings home to his mother, the Countess, then squandered the rest in nightclubs. Until Consuelo's memoir was published in 2000, the accepted version of their tormented marriage was that she frequented an artistic crowd and was prone to drinking and having affairs in his absence but that, despite his grief at Consuelo's infidelity, Saint-Ex couldn't stop loving her.

Saint-Exupéry was so depressed by the Nazi occupation of France and Consuelo's infidelity that his friends believed he committed suicide at the controls of his Lightning – just as the Little Prince asked the viper to sting him so he could return to his asteroid. 'I don't

care if I come back,' he wrote to a friend shortly before his disappearance. 'I have the impression that we are marching towards the darkest days in the history of the world', he wrote in a manuscript published posthumously.

The age limit for piloting the Lightning was supposed to be thirty. Saint-Ex was forty-four, but badgered Free French and US officials to let him fly. He was also demoralised by the power struggle among exiled French leaders and the backlash against him from followers of General Charles de Gaulle. Saint-Ex refused to support de Gaulle, and one theory, put forward by Harris Smith in his history of the OSS (Office of Strategic Services, the precursor of the CIA), says he may have been the victim of a political assassination.

The simplest explanation for Saint-Ex's disappearance is probably the correct one. Lieutenant Robert Heichele was a young German pilot whose logbook was discovered in December 1980 by a former Luftwaffe fighter pilot and admirer of Saint-Ex. Heichele was himself killed in combat several days after he appears to have shot down the French writer.

'I got up to . . . 60 metres from him and fired on him,' the German recorded on 31 July 1944, the day Saint-Ex disappeared.

'Then I saw the Lightning falling with a white trail. . . . He passed over the coast and flew at a low altitude towards the sea. Suddenly, flames came out of the right engine. The wing clipped the sea. The plane spun several times and disappeared into the water at 12.05 PM about 10 km south of Saint-Raphael.'

The German apparently did not realise that Saint-Ex's aircraft was unarmed. In his diary the following day, he boasted: 'Without having obtained a fighter pilot's qualification, I downed a Lightning in air combat, and without any damage to my machine.'

The night Habib Benamor found Saint-Exupéry's bracelet, the trawler's captain Jean-Claude Bianco slept

with it on his bedside table. Bianco enlisted the help of the Marseille-based undersea research company Comex, which helped to explore the Spanish armada ship *Gerona* off the coast of Ireland in 1968.

In the same catch with Saint-Ex's bracelet, Benamor and Bianco found two pieces of aluminium debris, one of them the crosspiece that held the radio in the P-38 Lightning. They thought the rest of the wreck must be nearby, so for two months Comex combed 600 nautical miles of seabed with a sonar-equipped oceanographic ship and a remotely operated vehicle.

When word of Comex's search leaked out, d'Agay, the litigious representative of the Saint-Exupéry heirs, asked that Comex abandon the search for Saint-Ex's watery grave.

The request was echoed by those who had known him, including the ninety-one-year-old writer Jules Roy, who told *Le Nouvel Observateur* magazine: 'I am sad and angry. Why the hell don't they leave Saint-Ex alone! Besides the fact that I feel that in July 1944 he really wanted to die, the ocean is his tomb now . . . legendary heroes are the ones never found.'

'The wreck belongs to the French Air Force — not to the Saint-Exupéry family,' a director of Comex told me in 1998. 'We could start looking again quietly, without the public knowing. . . . Sometimes we find wrecks without really looking for them. We have never proposed raising the wreck of Saint-Ex's plane — we only want to identify it. We're not grave robbers. For us, it's in the interest of history.'

Saint-Ex's P-38 Lightning was found in February 2009, smashed into hundreds of pieces, some 200 feet beneath the surface of the Mediterraean, about three kilometres from the coast between Marseille and Cassis. The serial number on the tail — 2734L — left no doubt it was the writer's plane. But there was no trace of Saint-Ex.

Andreï Makine

From Russia with Love and a Sense of Loss

Success holds sweet ironies for a writer who has struggled to gain recognition. When Andreï Makine arrived in Paris in 1987 from Russia, via Africa, Asia and Australia, he spent weeks sleeping rough in Père Lachaise cemetery.

Makine wrote his first novel, *A Hero's Daughter*, sitting on park benches. He lost track of the number of publishers who rejected it.

'Publishers can be awful people,' Makine whispers, for we are sitting in his publisher's office. 'They put their coffee mugs on the manuscripts while they read them, so you cannot re-use them. My tiny studio was filled with wrecked copies of *A Hero's Daughter*. I practically had to sleep on them!'

French publishers lost interest when Makine told them he'd written the novel in French. 'They thought to themselves: "He talks with an accent; he must write with an accent",' he says.

So Makine pretended a French friend had translated his work from the Russian. 'The critics all said: "What an excellent translation!"' he laughs now.

It was only with his third novel, *Once Upon the River Love*, that Makine grew confident enough to end the charade about translations. His fourth novel, *Le Testament Français*, is about a boy growing up in Siberia under Stalin. The child's imagination is fed by a French grandmother's old photographs and stories. The novel made literary history by winning France's two top awards, the Prix Goncourt and the Prix Medicis.

By 2004, Makine had been translated into thirty languages. His ninth novel, *The Woman who Waited*, was on the French best-seller list for months after it was published. When I interviewed Makine in April 2004, *A Life's Music* was being adapted for cinema in the US, and a German composer was writing an opera based on *The Crime of Olga Arbyelina*.

As often happens, the literary establishment reached back for the early gems it had missed. The British publisher, Sceptre, which had already released six of Makine's novels, exquisitely translated by Geoffrey Strachan, published *A Hero's Daughter*, fourteen years after it was first published in France.

'I was planning this book during the last years of the Soviet empire, when everything toppled, when heroes became useless,' Makine says. The hero of the title is Ivan Demidov, a Russian who lies about his age to join the Soviet army after the invading Germans massacre his family in 1941. For his bravery in halting a German advance near Stalingrad, Ivan wins the Gold Star of a Hero of the Soviet Union.

'There were only a few thousand given,' Makine explains. 'The Gold Star was the highest distinction, the *summum*.'

Ivan marries Tanya, a nurse who saves his life in a subsequent battle. The couple endure all the hardships of the Soviet Union. They lose their first child, suffer through drought, famine and life in a crowded communal apartment. Their daughter Olya becomes an interpreter and is blackmailed by the KGB into 'servicing' Western businessmen it spies on. In a disintegrating country where heroes of the Soviet Union are no longer respected, Ivan sells his other medals, but not the Gold Star. Olya is forced to sell the precious symbol to pay for her father's burial, then determines to buy it back. Though the family have lost their illusions, the Gold Star still means something.

Makine's style has been compared to Impressionist painting or cinematography. In *A Hero's Daughter*, for instance, he conveys the magic of falling in love in one simple sentence: 'They talked and listened to one another with feelings of joy they had never experienced before.' Makine's novels move so quickly that one British literary critic complained that inattentive readers would lose their way.

A Hero's Daughter is a devastating portrait of the former Soviet Union in just 163 pages.

'It's very, very condensed,' Makine admits. 'Someone who never went there will understand the essence of Soviet Russia. It's difficult to comprehend; Churchill was right when he called Russia "a riddle inside a mystery inside an enigma".'

But the novel is also a moving love story.

'Life was so tragic, so hard, that the only tie that still protected people was that between a man and a woman,' Makine explains. 'The Soviets broke down ties within countries, social classes and races. Everything became very individual in the great collectivist empire. We were promised we'd belong to a great human undertaking, but it wasn't true.'

The themes of all Makine's novels are already present in *A Hero's Daughter*: love as a respite from the cruelty of the world; espionage and betrayal; war and waiting. Makine juxtaposes horror and beauty to haunting effect. On an evening walk in spring, Ivan tells Tanya how his baby brother was skewered by a German on his bayonet, and Tanya recounts the story of two Russian girls she found lying in a barn, still warm, after they'd been raped and shot by the Russian Polizei who collaborated with the Nazis.

After seeing his comrades' stomachs blown away and fingers lopped off in the battle that wins him his Gold Star, Ivan follows a rivulet to a spring where he drinks greedily, then sees himself in the water:

'For a long time he contemplated this sombre reflection's features. Then shook himself. It seemed to him that the silence was becoming less dense. Somewhere above him a bird called.'

Such moments of beauty were the only source of hope in the Soviet Union, Makine says. 'Finding beauty in the

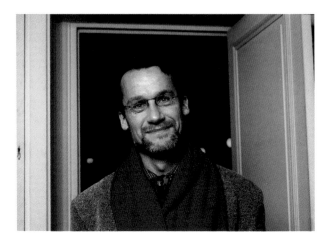

The writer Andreï Makine in France on January 29, 1998. Photo © Louis Monier/Gamma-Rapho via Getty Images.

midst of hell was the only thing that enabled them to survive. A lot of people who did not have the capacity to see beauty sank into alcoholism or crime or committed suicide. There were waves of suicides; people couldn't stand it.'

As a child in Siberia, Makine listened to survivors of Stalin's Gulag.

'One old man told me he'd spent twenty-five years in the Gulag,' he says. 'For a fifteen-year-old, that seemed like an eternity. He told me how he found a bird's nest that had fallen down. All but one of the eggs were broken. He held the unbroken egg in his armpit for several days until it hatched.

'In the mud, amid such cruelty, all of a sudden a little bird popped out. He was so happy.'

In *A Hero's Daughter*, Tanya waits for Ivan; Olya's flatmate waits for her fiancé, who is serving in Afghanistan. Makine's latest novel is about Vera, a schoolteacher who has waited thirty years for a man reported missing in action.

'We lost 25 million people in the Second World War,' Makine explains. 'That means 25 million families separated, divided, wounded, and as many people who asked themselves: "Will he return?" The Gulag was the same thing – millions and millions of people.'

Though he is warm and humorous in conversation, Makine is as circumspect as the KGB agents he writes of when asked about his own life. He resides in Montmartre, rents a cottage in Vendeé, which he cycles to from the train station, and is dismissive of the French literary set. Little else is known of his private life.

The circumstances of Makine's departure from the Soviet Union are a mystery. So is the time he spent wandering through Africa, Asia and Australia.

'I'm writing a novel about it,' he says, slamming shut that avenue of inquiry. 'If I talked about it, you'd hear platitudes. In a novel, you can explain, understand

yourself and what you have lived through. The novel serves that purpose too.'

The battle scenes in *A Hero's Daughter* are so graphic that I assume Makine has been in at least one war – and he has the bearing of a military officer. It is the only personal question that he answers clearly.

'Yes. It was a useful personal experience, because it is very difficult to describe a war if you haven't seen one,' he says. 'People don't understand that you go deaf as soon as the shelling starts, the noise is so loud. You often read about "the smell of blood" on battlefields. It smells like excrement, not blood, because people's guts are blown apart.'

Judging from his age – forty-six – I surmise that Makine served in Afghanistan. But instead of providing a straight answer, he refers again to his work: 'I talked about Afghanistan in my second novel.'

Nor will Makine say whether or not he had a grandmother like Charlotte Lemonnier, the old woman who introduces the Siberian boy to French culture in *Le Testament Français*.

'The important thing is that the character comes to life,' he says. 'There was an old woman who taught me French. That is an autobiographical fact.'

To say if she was a blood relative would, he claims, betray his oeuvre. 'It's as if I said 'the heart is mine but the leg is not.' You end up doing an autopsy. It becomes a surgical act, dissection.'

When asked why he writes, Makine replies: 'It's a battle against time, against being forgotten, against death. It's a way of refusing to reduce man to his political and social being, to his mortal skeleton. I want to show the divine spark within us; show that in a few, exceptional moments, man can reach God.'

Jean-Dominique Bauby

In the Blink of an Eye

Jean-Dominique Bauby had everything a man could want, and he was only forty-three. As editor-in-chief of *Elle* magazine, he had risen to the pinnacle of fashion journalism. He enjoyed fine food and wine and the company of beautiful women. On the morning of 8 December 1995, Bauby woke up 'heedless, perhaps a little grumpy, beside the lithe, warm body of a tall dark-haired girl' – his new girlfriend, Florence.

The local BMW dealer had lent Bauby a gun-metal grey model to try out for the day with his driver. On his way to the office, Bauby heard the old Beatles song, 'A Day in the Life', on the radio; the final crescendo 'like a piano crashing down seven floors' coursed through his brain all day. It was to be, in his words, his last day as a perfectly functioning earthling.

Bauby had just picked up his son Théophile at his estranged wife's house when he felt ill and stopped the BMW. He didn't realise that a cerebro-vascular accident was short-circuiting his brain-stem, which transmits orders from the brain to the body. His last thought, before losing consciousness for three weeks, was that he would have to cancel his theatre tickets for that evening. When he woke up in the old Berck-sur-Mer hospital on the English Channel, he was not able to breathe, speak, eat or move any part of his body other than his left eyelid.

'In the past it was known as a massive stroke and you simply died,' Bauby explained in his best-selling book, *The Diving Bell and the Butterfly*. 'But improved resuscitation techniques have now prolonged and refined the agony. You survive, but you survive with what is so aptly known as "locked-in syndrome". . . . It is a small consolation, but your chances of being caught in this hellish trap are about those of winning the lottery.'

That Bauby was able to 'write' a book in this condition is a monument to his determination. When he learned that the Paris rumour-mill was describing him as 'a total vegetable', Bauby resolved to prove 'that my IQ was still higher than a turnip's'. For two months in the summer of 1996, he awoke before dawn each morning to plan his text. He memorised each word, phrase and paragraph. At 12.30, Claude Mendibil, the woman sent by his Paris publisher, arrived to harvest his prose.

'E, S, A, R, I, N, T' Ms Mendibil repeated the alphabet in the order of the frequency that letters are used in French. When she pronounced the letter which Bauby wanted her to note, he signalled this by widening his left eye. Ms Mendibil read completed phrases back to him; one blink of his eye confirmed she had it right. Two blinks meant no, there was an error. A longer closing of the eyelid signified a full stop. It took more than 200,000 blinks to write the book.

French literary critics have lavished praise on the resulting tightly composed, funny, heartrending text; praise that Bauby had just a few days to savour before he died of respiratory failure on 9 March 1997. *The Diving Bell and the Butterfly* became a best-seller across Europe and has sold millions of copies. The American director Julian Schnabel made it into a motion picture which received four Academy Awards nominations in 2008.

Bauby used metaphors of the deep sea to convey what it was like to live with locked-in syndrome. 'Something like a giant invisible diving-bell holds my whole body prisoner,' he wrote in the foreword. But if his body was chained to the miserable sea-bed, his spirit was free: 'My mind takes flight like a butterfly. There is so much to do'

On the set of The Diving Bell and the Butterfly. *American director Julian Schnabel directing French actor Mathieu Amalric (in wheelchair).* © Etienne George/Corbis.

Bauby was intrigued to learn that the nineteenth-century Empress Eugénie was the patron of his hospital. From his wheelchair, he studied a marble bust of her and fantasised about her visiting the hospital: 'I mingled with the chattering flock of ladies-in-waiting, and whenever Eugénie progressed from one ward to another I followed her hat with its yellow ribbons, her silk parasol and the scent of her passage, imbued with the eau de cologne of the court parfumier. On one particularly windy day I even dared draw near and bury my face in the folds of her white gauze dress with its broad satin stripes. It was as sweet as whipped cream, as cool as the morning dew. She did not send me away. She ran her fingers through my hair and said gently, "There, there, my child, you must be very patient . . .". She was no longer the empress of the French but a compassionate divinity in the manner of Saint Rita, patron of lost causes.'

One day, as he admired the bust of Eugénie, Bauby caught his own reflection in the glass showcase: 'I saw the head of a man who seemed to have emerged from a vat of formaldehyde. His mouth was twisted, his nose damaged, his hair tousled, his gaze full of fear. One eye was sewn shut, the other goggled like the doomed eye of Cain. For a moment I stared at that dilated pupil before I realised it was only mine. Whereupon a strange euphoria came over me. Not only was I exiled, paralysed, mute, half-deaf, deprived of all pleasures and reduced to a jellyfish existence, but I was also horrible to behold.'

Jean-Jacques Beineix, the French movie director who made *Diva* and *Betty Blue*, filmed Bauby and editor Claude Mendebil writing the book in Bauby's hospital room. Beineix's moving documentary, *House Arrest*, was broadcast on France 2 television at the time of Bauby's death. Beineix's camera kept being drawn back to Bauby's single, cyclops-like healthy eye; his whole being, all of his emotions, were expressed through its green iris. There was even a hint of flirtation when he asked – through blinks – the pretty, dark-haired Mendebil as she was leaving: 'What are you doing tonight?'

Mendebil at first had difficulty calling Bauby by the familiar *tu*, rather than the formal *vous*; Bauby begged her to say *tu* – it saved him two letters each time he addressed her. 'Jean-Dominique made me forget he was paralysed,' she said.

Bauby's prose was most powerful when he described his feelings. During a visit from his ten-year-old son, he was overwhelmed by emotion: 'His face not two feet from mine, my son Théophile sits patiently waiting – and I, his father, have lost the simple right to ruffle his bristly hair, clasp his downy neck There are no words to express it. My condition is monstrous, iniquitous, revolting, horrible. Suddenly I can take no more. Tears well and my throat emits a hoarse rattle that startles Théophile. Don't be scared, little man, I love you.'

Eerily, before his stroke Bauby had planned to write a modern version of Alexandre Dumas's *Count of Monte Cristo*, in which a character suffered from locked-in syndrome. Bauby was capable of appreciating the irony of 'the gods of literature and neurology' who made him so resemble this man: 'Described by Dumas as a living mummy, a man three-quarters of the way into the grave, this profoundly handicapped creature summons up not dreams but shudders. He spends his life slumped in a wheelchair, the mute and powerless possessor of the most terrible secrets, able to communicate only by blinking his eye: one blink meant yes; two meant no.'

As punishment for tampering with Dumas's masterpiece, Bauby joked, he would have preferred to have been transformed into a different character.

VI French Literary Classics

'She sent for one of those short and plump little cakes called Petites Madeleines *which seem to have been moulded in the fluted valve of a scallop shell. . . . I brought to my lips a spoonful of tea in which I had soaked a piece of the* Madeleine. *But at the very moment when the liquid mixed with crumbs from the cake touched my palate, I trembled, aware of the extraordinary thing taking place within me.'*

Marcel Proust, *À la recherche du temps perdu*

Jacques Prévert

Surrealist Poet of the Streets

If Jacques Prévert had lived to see his hundredth birthday in February 2000, he probably wouldn't have thought much of the celebrations. The anarchist in him might have raged at the Ministry of Culture dedicating its 'Springtime of Poets' to him, organising Prévert readings in lycées and town halls all over France.

With his droopy eyes and wool cap, the best-loved poet of the twentieth century, the 'surrealist of the streets', would rather sit on a café terrace with his shaggy dog Ergé, a glass of *gros rouge* and a pack of Gauloises Bleues than receive literary honours. It was the cigarettes that killed him in 1977, but true to character, Prévert said on his deathbed: 'A life like mine, I'd wish for a lot of people.'

Nor would the publication of Yves Courrière's seven-hundred-page best-selling biography, and at least four other new books by or about Prévert, have moved him. Prévert's first book, *Paroles,* came out when he was forty-six years old, just after the Second World War ended.

That it was published at all was a fluke, owing to the persistence of an aspiring editor named René Bertelé. Prévert scattered his poems like the autumn leaves he wrote about. He scribbled them on bistro tablecloths, or on bits of paper that he handed to pretty young women. Bertelé scoured obscure literary reviews and Prévert's belongings to assemble the seventy-nine poems.

Paroles was phenomenally successful: 5,000 books were sold in the first week, and more than 2.2 million copies have been sold since. Yet the whole book has never appeared in English. Paradoxically, Prévert's simple, everyday language and slang are difficult to translate. A New York publisher has sold only four thousand copies of *Blood and Feathers*, the most complete selection of his poems in English.

More intellectual poets despised Prévert, calling him a clown and a phoney proletarian. But the public loved him: four hundred French schools have been named after Prévert, more than for Victor Hugo.

His poems are about love at first sight and love that has died, and contempt for the military, the clergy and the bourgeoisie. They are filled with scorn for politicians and empathy for the poor. Yet Yves Montand sang Prévert songs at the White House for Jackie Kennedy.

Prévert inspired Popular Front demonstrators in the 1930s and supported the revolt of May 1968; his themes were so etched on twentieth-century French national character that it's not clear whether Prévert influenced the French or whether he was a distillation of them. The poem *Je suis comme je suis* (I am as I am), about a woman with high-heeled shoes and dark-circled eyes who loves a little too freely, became a mantra for the post-war café society of Saint-Germain-des-Prés, a street expression

of Jean-Paul Sartre's quest for 'authenticity'. Although Prévert never went to university, he kept company with philosophers like Sartre, Simone de Beauvoir and Albert Camus.

In the 1930s and 1940s Prévert became a scenarist, working with the directors Marcel Carné and Jean Renoir on cinema classics that included *Quai des Brumes*, *Le Jour se Lève* and the magnificent *Les Enfants du Paradis*. His characters were draft-dodgers, petty criminals on the run, fallen women. Actors like Jean Gabin and Jean-Louis Barrault, Michèle Morgan and Arletty made his lines famous.

'I'm fed up with men who talk so much about love that they forget to make love,' Arletty said in *Le Jour se Lève*. Prévert seemed doomed in love, and a mistress had left him with those words.

Prévert's background was the sort of anti-hero story that the French find romantic. The son of an alcoholic, failed-writer father, he grew up a street urchin, like Victor Hugo's Gavroche. In his youth, the Courrière biography reveals, Prévert did some pimping and was probably a thief. 'The blankness of my police record remains a mystery to me,' he often said. He tried to avoid military service by feigning mental illness, to no avail.

Former army comrades led Prévert to the Surrealists in the mid-

1920s, but Prévert infuriated their leader André Breton by writing a nasty article about 'the Pope of Surrealism'. Through his flirtation with the movement, Prévert forged lasting friendships with artists like Picasso, Giacometti and Chagall.

Although he wrote against the Nazis and the collaborationist Vichy government, helped Jewish friends and transmitted messages for the Resistance, Prévert never belonged to any movement or political party.

'The least intellectual of French artists knew how to show solidarity and generosity without getting involved with groups,' Pierre Billard wrote in *Le Point*. French writers find it difficult to resist the temptation to espouse causes and pontificate. Perhaps they should learn from Prévert's example?

French poet, screenwriter, and lyricist Jacques Prévert and singer and actress Juliette Greco. © Jacques Haillot/Apis/Sygma/Corbis.

Colette

More than half a century after her death, Sidonie-Gabrielle Colette, known simply as Colette, still inspires fascination, admiration and revulsion. Her energy and daring, the quantity and beauty of her prose, seem miraculous. Her complete egotism, her collaboration with anti-Semitic publications during the Nazi occupation of France, her abandonment of her own daughter, and her calculated seduction of an adolescent stepson thirty-one years her junior remain shocking.

Colette wrote about childhood, pet animals, and especially about love, which she conceived of as a struggle between slave and master. Jean-Paul Sartre, who met her at least twice in the early 1950s, recognised her as a *monstre sacré*. But if she resembled any other French writer, it was her idol Balzac, whose *Comédie humaine* she claimed to have read from the age of seven. Like Balzac, Colette had an insatiable appetite for love, luxury and food. Like him, she grew obese, chronicled the customs of her time (nearly eighty volumes) and spent much of her life begging publishers for advances.

Colette's novels were banned by the Vatican, and the archbishop of Paris denied her a Christian burial, so she became the first woman to receive a State funeral instead. Shunned as a nude dancer in her youth, Colette was the first female to enter the Académie Goncourt. She became an *officier de la Légion d'Honneur*.

Colette was born in a small village in Burgundy in 1873, the daughter of a one-legged war veteran, Captain Jules Colette, and a widowed heiress of partly African Caribbean descent named Sidonie Landoy. She was only sixteen years old when she met Henry Gauthier-Villars, the scion of a Parisian publishing house, who was nearly twice her age. Gauthier-Villars was a playboy journalist and socialite known by his pen-name Willy. He married the provincial Colette and brought her to Paris. Judith Thurman's biography, *Secrets of the Flesh: A Life of Colette*, published in 1999, portrays the theatre-going, sex-obsessed, French fin de siècle – as Zola described it, 'a whole society throwing itself at the cunt'.

Colette joined Willy's stable of ghostwriters, producing four 'Claudine' novels based on her schoolgirl memories – and Willy's fantasies of school uniforms and sexual threesomes. Willy pushed his young wife into the arms of several women, including the former drug addict and transvestite lesbian Marquise de Belboeuf, known as Missy. Colette's long affair with Missy ended when she married Henri de Jouvenel, a newspaper editor who would later become a French ambassador and statesman.

As Stéphane Mallarmé wrote, France is the country where everything ends up in a book, and Colette translated her own adventures into novels as quickly – and sometimes even before – she lived them. 'Can't you write

a book that isn't about love, adultery, semi-incestuous couplings and separation?' Jouvenel asked her.

Their marriage ended too, ostensibly because of Colette's seduction of Jouvenel's son by an earlier union, but mainly because of Jouvenel's philandering. Colette's third and final marriage, to Maurice Goudeket, a Jewish pearl trader seventeen years her junior, was the happiest and most enduring.

Long after Bertrand de Jouvenel's five-year affair with his stepmother had ended, his girlfriend, the American journalist Martha Gellhorn, met Colette. 'She was a terrible woman,' Gellhorn recalled. 'Absolute, utter hell. She hated me on first sight, that was obvious. She was lying on a chaise longue like an odalisque, with green shadow on her cat's eyes, and a mean, bitter little mouth. She kept touching her frizzy hair, which was tinted with henna.'

Simone de Beauvoir was more charitable. Colette was already crippled by rheumatoid arthritis when they met at a dinner in 1948. De Beauvoir described the ageing writer in a letter to her American lover, Nelson Algren. 'She is the only really great woman writer in France. . . . She was once the most beautiful woman. She danced in music-halls, slept with a lot of men, wrote pornographic novels and then good novels. . . . Now she is seventy-five years old and has still the most fascinating eyes and a nice triangular cat face; she is very fat, impotent, a little deaf, but she can tell stories and smile and laugh in such a way nobody would think of looking at younger, finer women.'

Judith Thurman's previous, award-winning biography of Isak Dinesen inspired the film *Out of Africa*. Her biography of Colette leaves an indelible impression of an extraordinary woman and her times. Woven around Colette's imperviousness to what Thurman calls 'the more fundamental forms of ethical maturity' are powerful accounts of the Dreyfus affair and the liberation of Paris. Thurman draws heavily on Colette's abundant correspondence, and her book makes us regret the demise of the letter. Phone calls and email will surely cheat biographers of the future.

French novelist Colette sitting in armchair
/ © Condé Nast Archive/Corbis.

Proust

When Marcel Proust began offering his manuscript of *Swann's Way* to French publishing houses in 1911, editors were frightened by the sheer size of the book and by its interminable, page-long sentences. Proust's stream of consciousness was so uninterrupted that he initially wanted to publish the first two volumes of his sixteen-volume masterpiece as a single paragraph.

Two years later, Proust finally persuaded Bernard Grasset to publish *Swann* – at the author's expense. Throughout the First World War he continued working on *À la recherche du temps perdu*, known in English as *Remembrance of Things Past*, but better translated as *Search for Lost Time*.

One of the editors who rejected Swann was the writer André Gide at the *Nouvelle Revue Française*. Gide soon realised his error. He lured Proust back to the NRF, which brought out a new edition of *Swann* and published all subsequent volumes of *Remembrance*. Proust's literary reputation was established. He received France's highest literary award, the Prix Goncourt, in 1919. The following year he was made a *Chevalier de la Légion d'Honneur*. The green and gold medal rests in a glass case at the family home in Illiers-Combray, the tiny village 120 kilometres southwest of Paris, which Proust immortalised.

Over 4,500 people – more than the population of Illiers-Combray – make the pilgrimage each year to the home where Proust spent his childhood holidays. Thousands more visit the writer's black granite tomb in Père Lachaise Cemetery. And every Thursday, the bank which now owns the flat at 102 boulevard Haussmann where Proust wrote most of *Remembrance* opens his empty former bedroom to the public.

Every year more books are added to the mountains of Proust lore. Recent editions include a collection of Proust's childish but humorous drawings, prefaced by the novelist Philippe Sollers, and a charming comic-strip version of *Remembrance*. Although the comic book is painstakingly faithful to the original, it shocked some Proust purists: 'They're murdering Marcel!' a headline in *Le Figaro* said.

If few French people have read all four thousand pages of *Remembrance*, virtually every French man or woman with more than a primary school education knows its first line – said to be the most beautiful in the French language: *'Longtemps, je me suis couché de bonne heure.'* The English, 'For a long time I went to bed early', sadly lacks its music.

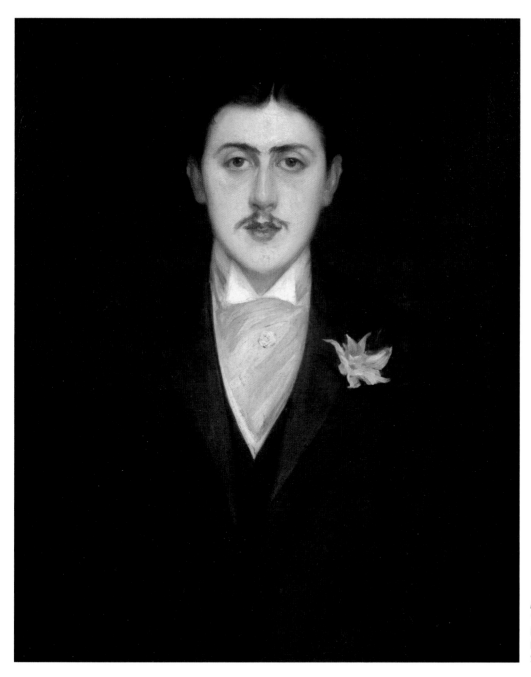

Portrait de Marcel Proust,
1892 © Jacques-Emile
Blanche/IVARO 2011.
Photo: © White Images/
Scala, Florence.

Remembrance is an exploration of the mechanism of recollection, which Proust divided into 'voluntary' and 'involuntary' memory. The latter, he wrote, is hidden beyond our reach 'in some material object ... where we do not suspect it'. We encounter the objects that unlock our past purely by chance.

In the most famous passage of *Remembrance*, the adult narrator's mother forces him to drink tea on a cold winter day. 'She sent for one of those short and plump little cakes called *Petites Madeleines* which seem to have been moulded in the fluted valve of a scallop shell. ... I brought to my lips a spoonful of tea in which I had soaked a piece of the Madeleine. But at the very moment when the liquid mixed with crumbs from the cake touched my palate, I trembled, aware of the extraordinary thing taking place within me. I was filled with a delicious pleasure'

A page later, the narrator discovers the secret of this serendipitous moment. As a child in Combray, he would enter the room of his bed-ridden Tante Léonie on Sunday mornings before going to Mass. The old woman would give him a piece of a Madeleine soaked in her linden tea. That taste, rediscovered by chance many years later, brings his entire childhood back to the author. He finds Combray in a cup of tea, and the experience launches him on the narrative of a lifetime, a vast panorama of provincial and Belle Époque France, an almost anthropological study of the upper middle classes and the moribund aristocracy.

Tante Léonie, watching the comings and goings of Combray through her bedroom window, prefigures the invalid Proust writing in his bed. Visiting her home is strangely touching: there is the little 'oriental salon', furnished with Algerian pottery, paintings and furniture brought back from the colonies by Proust's uncle. In the main sitting room hang portraits of Proust's father, the famous medical doctor Adrien Proust, and his mother Jeanne Weil Proust, the daughter of a cultivated and wealthy Parisian Jewish family.

Her initials, 'J.W.', are engraved on the writing case in the salon, which Proust is believed to have used to write *Remembrance*. The dark, wood-panelled dining room smells of damp, dust and furniture polish. It was here that the narrator's parents stayed up late talking with Charles Swann while the little boy pined for his mother's kisses upstairs. Proust's bedroom is exactly as he described it, with its view of the garden and the path to Swann's house, the sleigh bed in the alcove, a *prie-dieu* and an engraving of Eugène de Beauharnais.

On the winter weekday when I visited Illiers-Combray, I was joined on the house tour by an American trial lawyer from Chicago and his estate agent wife. They had travelled from London on the Eurostar for the day just to visit a Proust exhibition at the Bibliothèque Nationale and the house in Combray. The lawyer had started *Remembrance* for the same reason he read Joyce's *Ulysses*, he said: for the challenge. 'At the beginning it was daunting, but then I began to understand his revelations.'

The fourth member of our group was an Iranian grandmother who had lived for many years in London. Over the past two decades, she read the entire four-thousand-page novel three times. This was her second pilgrimage to Combray. 'Proust invaded my life,' she told me. 'The first time I came was in June, and there were red poppies in the wheat fields, just as Proust said. I want to come back in April, to see the hawthorn hedges blooming.'

Irène Goujon has seen all manner of Proust fanatics in the fifteen years she has sold entry tickets, books and postcards in Tante Léonie's house. 'Once a Brazilian woman burst into tears the moment she crossed the threshold. Another time a Canadian woman from Montreal came straight from the airport. She didn't go to her hotel or eat anything. After the tour she asked to go

back to Proust's bedroom. We found her kneeling on his *prie-dieu*, in ecstasy.'

In 1971, to mark the centenary of Proust's birth, the mayor and local lycée director had Illiers's name changed to Illiers-Combray, in honour of Proust's novel. The dreary village has altered little since Proust stayed here in the 1870s. After twenty-two years in Illiers, Mme Goujon says the local farmers and shopkeepers consider her a blow-in. 'Your family has to be here for two or three generations before you belong here. They couldn't care less about Tante Léonie's house; if anything, it annoys them. They think Proust is for Parisians.'

Mercifully, Illiers is not a Proust Disneyland. On the sloping square outside the fifteenth-century church where the awestruck narrator first saw the Duchesse de Guermantes, no hotel or café bears Proust's name. Aside from Tante Léonie's house, Illiers-Combray's only concessions to its great writer are the little plastic bags full of Madeleine cakes sold in village bakeries.

Marie-Céline Fossard, the guide at Tante Léonie's house, suspects that old-fashioned bigotry may account for Illiers's indifference to its famous son. The Prousts lived here as bourgeois merchants from the sixteenth century. A street was named after Marcel's father, the medical professor, many decades before the lycée was given Marcel's name. Is it because he was a homosexual? In Proust's day, homosexuality was considered an illness. Proust himself called homosexuals 'inverts' and said that they, along with Jews, belonged to a 'race of the damned'. He never denied that he was half Jewish, but he tried to hide his homosexuality.

Remembrance contains many allusions to male and female homosexuality, from the composer Vinteuil's lesbian daughter to the love affairs of at least three of the novel's male protagonists. Yet when fictionalising his own great passion for his driver, Alfred Agostinelli, Proust transforms Alfred into a female character called

Albertine. His description of Albertine sleeping ('Looking at her, I had the impression of possessing her completely, which I did not have when she was awake . . .') is one of the most beautiful in the novel.

Devastated by his mother's death in 1905 and suffering from severe asthma, Proust increasingly withdrew from society. On the advice of the poet Countess Anna de Noailles, he lined the walls of his over-heated bedroom with cork in 1910. For more than a decade, until his death from pneumonia at the age of fifty-one, he worked mostly in bed, writing on his knees or dictating to his secretary Céleste Albaret.

From time to time, Proust would host a midnight dinner at the Ritz Hotel, where he seduced three of his last male companions from among the staff. The soirées at the Ritz helped Proust gather dialogue and costume details for his novels. But when word of such parties reached soldiers in First World War trenches, it prompted some to mutiny.

Zola

Experiments of a Naturalist

Émile Zola was twenty-six years old when he wrote *Thérèse Raquin*. The novel was his first masterpiece, and in a pattern that was to be repeated throughout his life, it shocked the bourgeoisie and inspired the scorn of high-minded critics. Louis Ulbach, the newspaper editor who nonetheless hired Zola as a columnist, called it 'putrid literature'.

The first stage adaptation of *Thérèse Raquin*, written by Zola himself, ran for only nine performances in 1873. 'It created a scandal because the characters are playthings of their instincts and sexual urges,' says Henri Mitterand, a professor at Columbia University in New York and the world's most renowned Zola expert.

'Adultery was presented not as something to be condemned but as the result of a physiological attraction. The prudish, puritan morality of the time could not accept this; the taboo against sex could not be broken.'

Despite its initial snubbing, more than a dozen versions of *Thérèse Raquin* have been staged, including a late-nineteenth-century Italian translation starring the great Eleonora Duse. But it is Marcel Carné's 1953 film version, with Simone Signoret as Thérèse, which most French people remember.

Thérèse Raquin portrays the same trio – bored wife, dull husband, passionate lover – as Gustave Flaubert's *Madame Bovary*. But Zola took the realism of Balzac, Stendhal and Flaubert further, treating his fictional characters as if they were laboratory animals under scientific study. Their fate is the brutal result of physical determinism. Zola called this literary school 'naturalism'.

'He worked on the principle that every character had a specific temperament,' Professor Mitterand explains. 'Camille, the husband, is sluggish; Thérèse is high-strung; Laurent hot-blooded. It was a chemistry experiment.'

Like other novelists of his time, Zola often set his stories in the stifling world of the petite bourgeoisie. The lovers are forced to work in the mother-in-law's shop and lie about their relationship. They feel they have no choice but to get rid of the husband. 'Zola's stroke of genius, his invention, was to imagine that after they kill the husband, they can no longer satisfy their passion,' Professor Mitterand says. 'This inhibition is a modern form of remorse. They become impotent. Little by little, they begin to hate one another. It's like a Greek tragedy – characters are punished in the flesh for their crime, and sink into madness.'

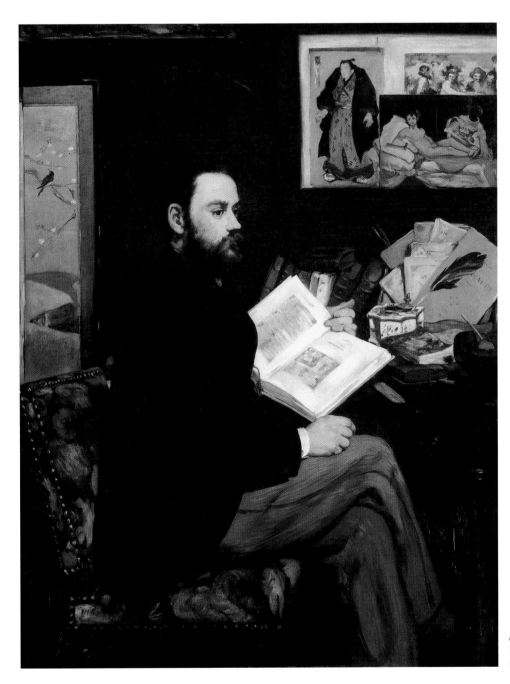

Portrait of Émile Zola,
Edouard Manet.
Photo: © Scala, Florence.

Zola's sad childhood may have predisposed him to writing about hardship and decline. His father, an immigrant Italian engineer, died when Émile was seven years old. His mother, Émilie, was harassed by Francesco Zola's creditors, and the downward progression began. The young Zola twice failed his baccaulaureat and gave up formal schooling. A rebellious streak and several years doing menial jobs were his basic training for journalism.

French intellectuals in the second half of the nineteenth century were fascinated by medical science and nervous disorders. Industrialisation was drawing the rural poor into the cities, creating an urban proletariat.

In 1865, the Goncourt brothers, Jules and Edmond – friends and rivals of Zola – published *Germinie Lacerteux*, the story of a neurotic, alcoholic servant girl. Zola expanded on their pathological vision of the mind and body. 'He believed that his generation was in decline, exhausted by unfulfilled aspirations,' Professor Mitterand explains.

Yet Zola brought incredible discipline and energy to his work, publishing some forty volumes in thirty-six years, in addition to hundreds of newspaper articles. He described his twenty-volume saga, *Les Rougon-Macquart*, published between 1871 and 1893, as 'the natural and social history of a family under the Second Empire'. Across four generations, the reader follows the legitimate branch, the Rougons, and the bastard Macquarts, through every strata of French society. The Rougons are tainted by mental illness, the Macquarts by alcoholism.

Zola's oeuvre helped to free the fin-de-siècle French public of its nineteenth-century prudishness. When his 1884 novel *Lourdes* was banned by the Catholic Church for denouncing the hold of superstition over believers, Zola went on to investigate corruption at the Vatican and published the equally devastating *Rome*. His understanding of the subconscious, and of instinct and sexual urges, prefigured Freud.

Flaubert and Zola were skilled technicians whose ability to shift scenes and sequences was later repeated in the cinema. Zola had a profound influence on the twentieth-century novel, especially in the US, where John Steinbeck and Theodore Dreiser took up his crusade on behalf of the losers in modern society.

Investigative journalism was the foundation of Zola's fiction. An agnostic, he attended Mass and studied confession manuals before writing *La Faute de l'Abbé Mouret* in 1876.

For *Au Bonheur des Dames* (1883), which takes place in a Paris department store, Zola interviewed staff at Le Bon Marché and asked his wife to collect catalogues. The book is still studied in marketing courses.

Germinal, the story of a miners' strike published in 1885, is Zola's greatest novel. In February 1884, he spent eight days among 12,000 striking miners at Anzin. Zola was the only writer to crawl through a dark miners' tunnel, just as five years later, when preparing his railway classic, *La Bête Humaine*, he would travel in a locomotive cabin.

'He was the first novelist to give a dynamic, sympathetic vision of the working classes,' Professor Mitterand says. 'The workers in Balzac, Stendhal and Flaubert are mere silhouettes. *Germinal* was the first book to pose the problem of the place of the working class in modern society.'

Zola is the undisputed master of the crowd scene, having understood that crowds were living creatures. Before the police open fire on the strikers in *Germinal*, the workers destroy equipment at the mines, then rush towards the homes and offices of their bosses, crying: 'Bread! Bread! Bread!'. Thirty-two years before the Bolshevik Revolution, Zola described 'this beautiful horror' witnessed by the mine-owners and their families: 'It was the red vision of revolution that would inevitably carry them all away, one bloody, fin-de-siècle evening. Yes,

one evening, the people let loose, unleashed, would run thus down the roads; the blood of the bourgeois would flow, they would parade heads, scatter the gold from gutted safes.'

Zola's novels were best-sellers, and he might have settled comfortably into his Paris townhouse and country home at Medan, but in 1888, his personal drama began. The forty-eight-year-old writer fell in love with Jeanne Rozerot, a twenty-one-year-old laundress hired by his wife, Alexandrine. The following year, their daughter Denise was born and, in 1891, a son, Jacques. The childless Madame Zola went through years of weeping and emotional crisis, but eventually accepted the arrangement, becoming fond of her husband's illegitimate children.

While his private life was in turmoil, Zola continued his lifelong battle against the establishment. Paradoxically, he sought the recognition he believed he was entitled to. Zola was the most famous literary figure in France, but was so controversial that the Académie Française rejected his application more than a dozen times. Like his friends, the Impressionist painters Cézanne and Manet, who were excluded from the official salon, Zola was a brilliant outcast. During the Dreyfus Affair, which divided France from 1894 until 1906, he was even stripped of his Légion d'Honneur.

At a time of intense anti-Semitism, Alfred Dreyfus, a Jewish army captain, was unjustly accused and convicted of giving military secrets to Germany and condemned to forced labour on Devil's Island. Zola took up Captain Dreyfus's cause, publishing an open letter to the president of France under the banner headline 'J'accuse . . . !'

'My duty is to speak out,' Zola wrote. 'I do not want to be an accomplice. My nights would be haunted by the spectre of the innocent man who far away, in the most horrible torment, is paying for a crime he did not commit.'

Zola was tried for defamation and condemned to prison. He fled to London, where his wife, mistress and children visited him during his year of exile. Zola returned to Paris in 1899, after Dreyfus was acquitted. He died in 1902 of carbon monoxide poisoning from a coal fire in his Paris townhouse. A roofer had blocked the chimney.

The hatred raised by the Dreyfus affair was so bitter that suspicion still lingers that Zola's death at the age of sixty-two may not have been accidental. At his funeral, the writer Anatole France delivered the famous epitaph: 'He was a moment in the conscience of mankind.' A group of miners joined the cortege of 20,000, chanting, *'Germinal! Germinal!'* Six years later, Zola's ashes were taken to the Panthéon – not because he was a great writer, but because he had willingly risked his reputation and livelihood to fight injustice in the Dreyfus affair.

I wrote this article for the Irish Times *in February 2001, to coincide with the Gate Theatre's production of Zola's* Thérèse Raquin.

Victor Hugo Victorious

On the eve of 26 February 2002, then Prime Minister Lionel Jospin launched France's year-long celebration of the two hundredth anniversary of the birth of France's favourite writer, in Besançon, the eastern town where Victor Hugo was born.

Hugo might have relished being used as a prop for a Socialist's presidential campaign. 'His political behaviour was strongly poetic, and his poetry is political,' said Professor Jacques Seebacher, who had just supervised a new edition of the complete works of Hugo.

Jospin unveiled a plaque outside the house where Hugo was born at 140 Grande-Rue, then joined 350 prominent political and cultural figures who had travelled in a specially chartered TGV train with the Socialist culture minister, Catherine Tasca, for an evening of music and readings at Besançon's Nouveau Théâtre.

Although the festivities were devoted to the theme of childhood, the Socialists highlighted Hugo's political vision in a year of presidential and legislative elections. Hugo's life spanned most of the nineteenth century, and he was a tireless campaigner for equality, universal suffrage, freedom of the press, women's rights, free and compulsory education, European integration and an end to the death penalty. In old age, he pleaded for European intervention in the Balkans and amnesty for the Paris *communards*.

Radio France devoted hours of programming to Hugo on the twenty-sixth. The President of the French Senate, Christian Poncelet, and orators from the main political groupings 'rendered solemn homage' to his oeuvre and personality. Hugo was a royal appointee to the Senate for three years in the 1840s, and returned as an elected member in 1876. In the interim, he spent nearly twenty years in exile in the Channel Islands, in opposition to the reign of Napoleon III.

The Académie Française also devoted a session to remembering Hugo. (He was finally admitted to 'the immortal ones' on his fifth attempt, in June 1841.)

Bicentennial organisers quoted Hugo regarding the 1848 revolution. 'Let us never forget memorable anniversaries. When the night tries to return, we must light up great dates, as one lights torches.'

But would Hugo have approved of the profusion of commemorations for his 200th birthday? 'I dislike events without spontaneity, pre-planned ceremonies that found a sort of religion with annual feasts and transform the republic into a soporific pontificate,' he said.

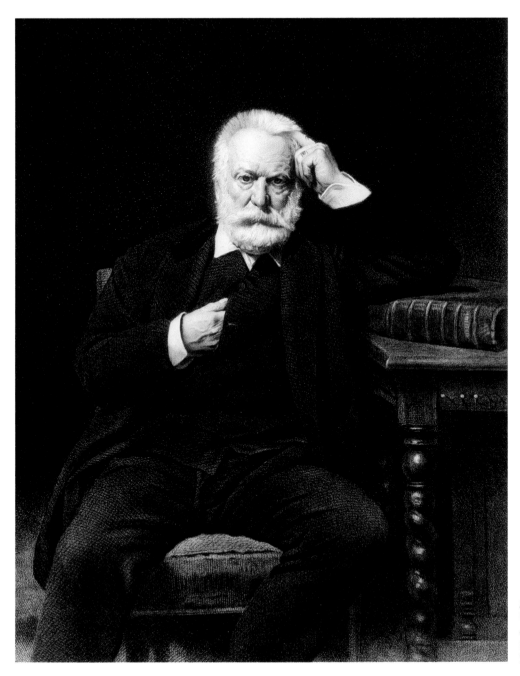

Portrait de l'ecrivain francais
Victor Hugo (1802 - 1885)
en 1879, Massard.
Photo: © White Images/
Scala, Florence.

All over the planet – in Bucharest, Sofia, and Athens, Jerusalem, Bamako and Taipei – Francophiles fêted two hundred years of Victor Hugo. 'From the smallest towns, from the entire world, have sprung forth by the hundreds, books, readings, expositions, reviews,' Bertrand Poirot-Delpech, academician and President of the National Committee for the Bicentennial of Victor Hugo, wrote. This Hugo-mania, he continued, 'shows a spontaneous desire, a need, a gluttonous appetite for Hugo'.

The celebrations had a lot in common with France's most famous writer: monumental, inspired, sometimes plodding, impressive by their sheer volume. The calendar of events, available on the culture ministry's website, ran to nine pages and was far from complete.

Poor Alexandre Dumas and Émile Zola, also great nineteenth-century writers. Dumas was born in 1802, and Zola died in 1902. But with the deification of Victor Hugo, they barely get a look-in.

Hugo was the son of an officer in Napoleon's army. Modesty was not one of his virtues. In 1829, he asked, 'Why should there not now be a poet who would be to Shakespeare what Napoleon was to Charlemagne?' Although he never learned English – a sign of entrenched Anglophobia – Hugo saw himself as Shakespeare's literary descendant. His contemporaries – Balzac, Lamartine and Baudelaire – often ridiculed him. 'They were all jealous,' said Nicole Savy, the head of the cultural department at the Musée d'Orsay, and a Hugo scholar. 'He earned an enormous amount of money, much of which he gave away. He was adored and detested.'

André Gide summed up the ambivalent attitude of many French intellectuals to the popular writer. Asked who was the greatest author of the nineteenth century, Gide responded, 'Victor Hugo, hélas.'

The English were more indulgent towards the French writer's massive ego. Swinburne called him the greatest writer since Shakespeare and the greatest Frenchman of all time. Alluding to his immense production of plays, novels, poetry and political tracts, Lytton Strachey said, 'Words flowed from Victor Hugo like light from the sun.'

Savy wrote her doctoral thesis on *Les Misérables*, the ten-volume indictment of society wherein an abandoned girl named Cosette and the former convict Jean Valjean attain a form of salvation. When *Les Misérables* was published in 1862, it was the Harry Potter of its day. Crowds formed outside bookshops, whose stocks were quickly exhausted.

A large bas-relief medallion of Hugo adorns the wall of Savy's office. In 2002, she lectured about her hero in France and Japan. 'He's the man of my life,' the white-haired museum executive said with a tender smile. 'Experts in all fields – politics, the conservation of historic monuments, law – if you show them a text by Victor Hugo, they marvel at it. He had a prodigious understanding of history, and of what was going to happen.'

As Savy noted, Hugo made no distinction between politics and literature. But his first feat – the overnight destruction of classical French theatre – was literary. On 25 February 1830, his play *Hernani*, set in sixteenth-century Spain, opened at the Comédie Française. The first romantic drama, it did away with the classic unities of time and place.

Dona Sol's line, 'You are my lion, superb and generous', brought the house down. 'Corneille could never have written that!' the historian Jean-Noel Jeanneney explained. The evening entered French history as 'The Battle of Hernani', during which the poet Théophile Gautier and a band of young romantics pelted the stuffy, bourgeois theatre-goers they called *genoux* (knees) from the balconies. In April 2002, 180 French lycée students re-enacted the Battle.

When she launched the commemorations, the Socialist culture minister Catherine Tasca said, 'We

recognise in Victor Hugo the values that founded our Republic'. The Socialist education minister Jack Lang ordered a Hugo poem recited in every school in France on 7 January.

The French Left considered the Hugo bicentennial a godsend in an election year. Max Gallo, the best-selling writer and adviser to the renegade leftist presidential candidate Jean-Pierre Chevènement, published a two-volume biography of Hugo, to whom Chevènement compared himself.

Although he opposed the death penalty from his youth, Hugo was a monarchist until middle age. The 1848 revolution – and General Cavaignac's suppression of the June insurrection, in which five thousand people died – began to change the writer. 'He evolved,' Savy said. 'He became more and more "red", all the while abhorring violence.'

Louis Napoleon Bonaparte staged a coup d'état on 2 December 1851. 'Napoleon wanted Hugo killed,' Savy continued. 'He fled, and he became someone else – the great Victor Hugo of exile.'

From Belgium, Hugo, his wife, mistress and four children went on to Jersey and then Guernsey. For nearly twenty years of exile, until the Second Empire collapsed with the Franco-Prussian War, Hugo was a virulent critic of the ruler he called a murderer, a monkey, and 'little Napoleon'. In 1859, he refused the emperor's offer of amnesty, writing in a famous poem, 'And if there is only one left [to resist Napoleon III], I will be that one!'

From Hauteville House in Guernsey, Hugo continued his life-long battle against the death penalty, which would not end in France until 1981. When Hugo's appeal for the life of the US abolitionist John Brown was ignored, he said it was 'something worse than Cain killing Abel; it is Washington killing Spartacus'.

But Hugo succeeded with a plea for the lives of six Fenians sentenced to death by the English in 1867. The Irishmen's wives wrote to him in Guernsey and he responded with an open letter, 'To England', in which he said it would dishonour Britain to hang a man 'because he has a political or national faith, because he has fought for this faith, because he has been conquered'

The English did not realise 'the ravage that a drop of shame makes in glory,' Hugo continued. 'Before these gallows worthy of the madness of George III, the continent would not recognise the august Great Britain of progress.'

Hugo passionately defended France's move to universal suffrage for men in 1848, on the grounds that it did away with the need for violent revolution. Nearly a century before French women gained the right to vote, he campaigned for them. 'He said their citizenship had to be recognised,' Professor Jeanneney explained. 'He spoke of the equality of human souls, the necessity of identical civil rights.'

Hugo also pleaded for freedom of the press, obligatory education for all children, and separation of Church and State'. The first two would be enshrined in law in his lifetime; the third, twenty years after his death.

And it was Hugo who first spoke of a United States of Europe. 'The continent would be a single people; the nationalities would live their own lives within a community,' he predicted in 1855. 'A continental currency having all Europe's capital as a base . . . would replace the absurd monetary varieties of today, effigies of princes, miserable figures.'

For all his political vision, Hugo was deeply human. Early in their marriage, he was hurt by his wife Adèle's love for his best friend, the literary critic Charles-Augustin Sainte-Beuve. The actress Juliette Drouet became Hugo's devoted mistress for the next half-century. That did not stop him having many affairs. In 1845, he was caught *in flagrante* with Léonie Biard, a painter's wife. Hugo's status protected him, but Léonie went to prison,

and then a convent. Out of spite, she later sent the love letters Hugo had written to her to Juliette Drouet.

When Hugo's favourite, eldest daughter Léopoldine drowned in a boating accident with her husband of seven months and unborn child in 1843, the writer was inconsolable. He devoted his finest book of poetry, *Les Contemplations*, to her, dividing the volume into 'times past', before Léopoldine's death, and 'today'. 'Tomorrow, at Dawn', his short account of a visit to her grave, is one of the most moving poems in the French language.

Hugo's brother Eugène and his younger daughter Adèle both ended up in insane asylums, and the writer lived in terror of losing his mind. His wife, mistress and sons all pre-deceased him. 'I refuse the orations of all churches,' he wrote in his last testament. 'I ask a prayer of every soul. I believe in God.'

Hugo's sympathy for the poor, whom he defended in political speeches and romanticised in his novels, earned him the lasting affection of the French. When he died in 1885, he was carried in a pauper's hearse from the Arc de Triomphe to the Panthéon. Two million people followed the funeral procession.

The Revenge of Alexandre Dumas

It is a historical and literary revenge worthy of his best-known character, the Count of Monte Cristo. Two hundred years after his birth, and 132 years after he died, Alexandre Dumas *père* received the veneration of the French establishment. By decree of President Jacques Chirac, his remains were transferred from the small town where he was born in Picardy on 24 July 1802 to the Panthéon, burial place of great Frenchmen.

Dumas's *The Count of Monte Cristo* and *The Three Musketeers* are probably the best-known French novels in the world. Lenin said that the tale of Edmond Dantès was his favourite book. The former president of China, Jiang Zemin, called the story of a man imprisoned in the Château d'If on false charges of conspiracy, who escapes, finds hidden treasure and devotes years to the pursuit of revenge, 'the absolute novel'.

Douglas Fairbanks, Jean Marais, Michael York, Gérard Philippe and Jean-Paul Belmondo are a few of the sixty-five actors who have played D'Artagnan, the nobleman who sets off for Paris in the early seventeenth century, joins King Louis XIII's musketeers and forges a virile friendship with Athos, Portos and Aramis after duelling with them. Brandishing toy swords, children all over the world have cried 'One for all, all for one', without knowing that the motto was devised by Alexandre Dumas.

The Sorbonne professor Claude Aziza counts 312 feature films adapted from Dumas novels, including eighty-five silent movies. These include thirty-three *Musketeers* and twenty-one *Monte Cristos*. In recent years, Patrice Chéreau directed Isabelle Adjani in Dumas's *La Reine Margot*, and Leonardo DiCaprio starred in *The Man in the Iron Mask*, which Dumas based on the mystery of a man held prisoner for more than forty years by Louis XIV. Another US version of *Monte Cristo* was released in 2002. Michael Jackson wanted to produce and act in *Wolfed*, also based on a Dumas novel.

But Dumas was snubbed in his lifetime; in the nineteenth century, mixed race was a social handicap. Critics mocked his curly hair and prolific output – 1,200 books by his count, between six hundred and seven hundred according to experts, often written with the help of ghostwriters called *nègres*. Dumas's biographer Daniel Zimmermann credits him with creating 37,267 human characters.

As the tabloid *France-Soir*, puts it, Dumas's blood was 'black and blue': black through his grandmother, a slave on the Caribbean island of Santo Domingo; blue through his father's noble family, the Davy de la Pailleterie. The name Dumas is an allusion to his grandmother's origin, a contraction of the words *du mas*, or 'from the farmhouse'. The writer Gonzague Saint Bris says Dumas 'carried in

his veins all the contradictions of society, black blood and white blood, aristocratic and servile origins'.

Dumas was 'a bankrupt millionaire, in love with women and unfaithful to them all, a friend of princes and workers, immensely hard-working and lazy'

In our time, Dumas's sin is being a 'popular' writer. He appears in few literary anthologies, and is not taught in French lycées. 'People admitted that his books made enjoyable reading,' says Alain Decaux of the Académie Française, who is the honorary president of the Association of Friends of Dumas. 'But then they put their noses up: he has been read by too many people.'

On the 200th anniversary of Dumas's birth, writing in *Le Figaro*, François Taillandier called him 'the French people's first history professor'. Dumas's father, a Napoleonic general, fought in the Egyptian and Italian campaigns. General Thomas-Alexandre Davy de la Pailleterie was imprisoned by the Bourbon King Ferdinand in Naples in 1799. The king's agents destroyed his stomach by trying to kill him with rat poison.

The general died when Alexandre was only four years old. Some sixty years later, the writer took revenge against the Bourbons by buying rifles for Giuseppe Garibaldi's forces and joining in their invasion of Sicily and Naples.

The orphaned Dumas became a notary's clerk at the age of fourteen, then went to Paris at twenty-one, to work as a secretary to the Duc d'Orléans, the future King Louis-Philippe. His son, Alexandre, the first of many illegitimate Dumas children and the future author of the tear-jerking classic *La Dame Aux Camélias*, was born when Alexandre *père* was twenty-two; it would take him seven years to acknowledge paternity. Of his vast consumption of women, Dumas *père* said, 'It is out of humanity that I have mistresses. If I had but one, she would die in eight days'.

Dumas *père*'s first huge success was also the first play of the romantic period, *Henri III and his Court*, first staged in

1829. Dumas invited Victor Hugo to the première, and the two became lifelong friends. The following year, Dumas's *Antony* consolidated his fame. Its last line – 'She resisted me, so I killed her' – was the most famous sentence of the 1830s.

In his memoirs, Dumas recounted how twenty-five dinner guests complained that another play, *Christine*, fell flat. After midnight, Victor Hugo and the poet Alfred de Vigny told Dumas to go to bed, then rewrote the manuscript while he slept, slipping the polished work under his pillow in the early hours of the morning.

Dumas shifted from theatre to novels with *The Three Musketeers* in 1844. In the burst of energy sparked by its triumph, he produced thirteen books over the following year. Dumas's swashbuckling adventures familiarised generations of French people with factually flawed versions of seventeenth- and eighteenth-century France. 'Historical truth is a girl you can rape, as long as you give her beautiful children,' Dumas said.

Like other nineteenth-century greats – Dickens, Balzac, Hugo – the sheer volume of Dumas's writing was astounding. Dumas was also a journalist, founding eight publications in the course of his lifetime. He often worked on three or four manuscripts at a time, and, like Balzac, staved off creditors. Both men wrote serialised fiction for newspapers; in 1844, Balzac – the better writer – underwent the humiliation of seeing his series cancelled so that he could be replaced by Dumas.

Long before cinema or television, Dumas knew how to hold the reader's attention with dialogue, action, brief descriptions and un-nuanced characters. Every chapter ended in suspense, with the words, 'to be continued'.

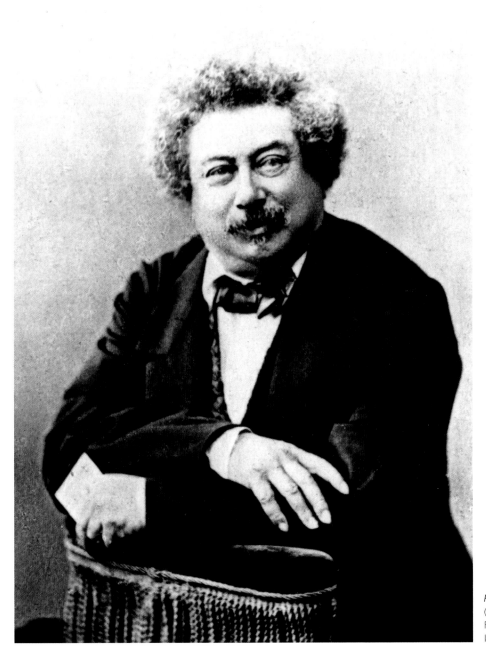

Portrait d'Alexandre Dumas père,
(1802-1870), écrivain français.
Fin 19ème siècle. Photo: © White
Images/Scala, Florence.

Dumas enjoyed a reputation as a generous man who loved animals, women and food. He gave up trying to stay slim from the age of forty, and his last book, *Dictionary of Cuisine*, includes descriptions of the dishes he sampled in travels to North Africa and Central Asia.

Dumas's death from a type of anthrax went almost unnoticed because it coincided with the Prussian invasion of France in 1870. 'Deep down in your heart, do you believe that anything will remain of me?' he asked his adored son Alexandre on his deathbed.

Victor Hugo paid a moving tribute to Dumas, calling him 'the most popular man of the century' and praising him as 'more than French … European; more than European … universal'. Dumas 'sowed civilisation' and was 'a great, good soul', Hugo said.

Although celebrations of Hugo's bicentennial overshadowed commemorations of Dumas, Dumas's wish was finally fulfilled when his remains were placed alongside Hugo's in the Panthéon in a grandiose ceremony. Dumas was the seventieth person to be 'Pantheonised' and only the sixth writer, after Voltaire, Rousseau, Hugo, Zola and Malraux.

Then President Jacques Chirac decided to honour Dumas in March 2002, but waited until the unstable election season was over to schedule the ceremony. Perhaps not by coincidence, it took place on 30 November 2002, the day after Chirac's seventieth birthday.

'Alexandre Dumas, with you it is childhood; hours of reading savoured in secret; emotion, passion and panache that enter the Panthéon,' Chirac said, standing on the steps of the Panthéon with the blue, white and red tricolour projected on the giant pillars behind him. The 1789 Revolution transformed the unfinished church into a mausoleum with the words 'To Great Men, the Gratitude of the Country' inscribed on its pediment.

Chirac said Dumas was 'a builder of French identity' and portrayed him as a symbol of French egalitarianism.

'Alexandre Dumas … knew that the Republic alone can open the future to all those who, like him, have only their work, their talent and their merit to obtain their just place in French society.'

Dumas's 'Panthéonisation' made front-page headlines, and *Le Figaro*'s editorial went so far as to compare Chirac to the writer. 'Dumas resembles Chirac,' Jean-Marie Rouart of the Académie Française wrote. 'These two affable, overgrown teenagers, fond of virile friendship, real feelings, adventure and brotherhood share their fondness for a light, heroic France of the good life, unpolluted by dried-up intellectualism.'

Sadly, Dumas did not find his 'just place in French society' during his lifetime. His grandfather, the Marquis Antoine Davy de La Pailleterie, was a colonist in eighteenth-century Santo Domingo – today's Haiti.

He had four children with an illiterate African slave named Cesette, but when the marquis decided to return to France, he sold Cesette and their offspring to a neighbour to pay his passage. Dumas's father, also called Alexandre, arrived at Le Havre in 1776 – not unlike the thousands of Kurds and Afghans who crowd into Calais today, *Le Monde* noted. After serving as one of Louis XVI's dragoons, the former slave became a general in Napoleon's army, only to be betrayed by the emperor. In 1802, Napoleon expelled officers 'of colour' from his army, then banned 'blacks and people of colour' from French territory. The following year, mixed marriages were forbidden.

Dumas the writer was reproached for his prodigious output and the use of ghostwriters. His own mixed race was never far from the minds of critics, like Eugène de Mirecourt, who wrote of Dumas's 'big lips, African nose, fuzzy hair, brown face'. Mirecourt said Dumas's origins were even more marked in his character than his physique: 'Scratch the surface of Monsieur Dumas and you will find the savage.'

Dumas would doubtless have loved the pomp and pageantry of his 'Panthéonisation'. After his coffin was exhumed in his native village of Villers-Cotterêts, he was taken to spend a last night at Monte Cristo castle, whose construction bankrupted Dumas in 1850.

The Republican Guard escorted his remains to Paris, where the minister of culture and speaker of the Senate presided over a ceremony at the Palais du Luxembourg. The designer Jean-Charles de Castelbajac – like the musketeer d'Artagnan, a native of Gascony – embroidered the musketeers' motto 'One for all; all for one' in silver thread on the blue velvet cloth draped over the casket. As night fell, pall-bearers accompanied by four musketeers with plumed hats on horseback carried Dumas up the rue Soufflot. Before them, 130 actors in period costume played a few of the 37,267 characters created by Dumas. 'Here you are at last, Alexandre!' the academician Alain Decaux said. 'In your person, we receive the most-read French writer in the world, but also – and especially – the most illustrious dispenser of wonderment who ever was.'

George Sand

A Great Republican

It took three strands of French history – the pre-revolution aristocracy, Napoleon's empire, and a mother from the common people – to create the extraordinary 'social métis' (her own expression) who was George Sand.

Born in 1804, Aurore Dupin de Francueil adopted the name George Sand when she published her first novel, *Indiana*, at the age of twenty-seven.

In 2004, France paid homage to the early Socialist and *écrivain engagé* who published nearly a hundred novels, wrote 20,000 letters and had tempestuous love affairs with the poet Alfred de Musset and the composer Frédéric Chopin.

The Ministry of Culture declared 2004 'The Year of George Sand'. In February, she was fêted in the Senate and National Assembly. In March, a commemorative stamp was issued in her honour.

Some 40,000 tourists, double the usual number, visited Sand's home region of Le Berry, in central France, and her beloved château at Nohant that year.

The George Sand Bicentennial Association held the main celebrations on 3 July, in and around Nohant, though the writer was born on 1 July. Dignitaries from Paris attended the official ceremony in late morning. Not since Victor Hugo wrote her funeral oration in June 1876, and Gustave Flaubert and Alexandre Dumas *fils* (who called her *Maman*) travelled to Nohant for her burial,

have so many people gathered to remember Sand. 'Others are great men,' Hugo wrote. 'She is *the* great woman.'

In the evening, a giant picnic was held in the gardens of the Château d'Ars, near Nohant, in memory of the *soirées champêtres* that Sand organised for her house guests. Musicians, dancers and actors representing Sand's best-known characters performed among the picnickers. A sound-and-light show accompanied by an actress, narrator and pianist was intended to convey the essence of Sand's life and oeuvre.

There were at least six George Sand exhibitions in Le Berry and her château at Nohant, where you can see the dining table set for de Musset, Liszt and Flaubert, in 2004. The year closed with a colloquium on 'George Sand: Literature and Politics' at the French Senate in December.

Sand's father, Maurice, died when she was four years old. She was raised at Nohant by her paternal grandmother, Marie-Aurore Dupin de Francueil, who, despite being the illegitimate daughter of the Maréchal de Saxe, married an aristocrat from the *ancien régime*. It was to escape the notice of the revolution that Mme Dupin de Francueil purchased the modest but graceful château. For little Aurore, too, Nohant would always be a refuge.

Aurore's father supported the revolution, joined the Napoleonic army and married a seamstress.

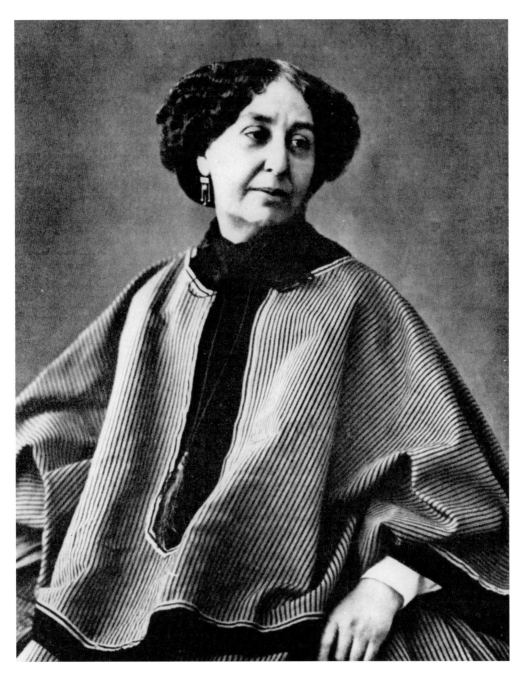

George Sand, 1865, Felix Nadar. Photo: © White Images/Scala, Florence.

Though the future George Sand had little contact with her mother, she attributed her sense of equality and compassion for the poor to her mother's origins.

Sand became a disciple of Pierre Leroux, who wanted to make a religion of humanism, ban privilege and liberate women. It was Leroux who coined the French word *socialisme*. Sand was an active supporter of the 1848 revolution, whose leaders met in her Paris apartment. When it failed, she went into internal exile at Nohant.

After studies at a convent school in Paris, Aurore had married Baron Casimir Dudevant when she was eighteen. She bore him a son, Maurice, then a daughter, Solange, though there are doubts about the paternity of Solange.

Like a true country gentleman, Casimir was interested only in hunting, drinking and chasing local servant girls. In her boredom, Aurore became friendly with young people in the nearby town of La Châtre. Among them was Jules Sandeau, a student seven years her junior, with whom she fell in love.

All of Sand's lovers would be considerably younger than she was.

When Casimir discovered the affair, Aurore declared, 'I want a pension and I shall go to Paris'. She and Jules Sandeau rented a garret on the quai des Grands-Augustins. Aurore spent hours in literary and political discussions, and began writing articles for *Le Figaro*, which was then a small, opposition newspaper. 'Living! How sweet!' she wrote of her newfound freedom. 'How good it is – despite heartbreak, husbands, boredom, debt and relatives!' It was during this period that Aurore wore men's clothing, though biographers differ as to whether it was to avoid attracting attention in student cafés and theatre stalls or, on the advice of her mother, to save laundry money.

The change of name was also for practical reasons. The editor of *La Revue de Paris* detested women and refused to publish their writing, so Aurore Dudevant submitted her articles under the name George Sand. George was a typical first name in the Le Berry region, and Sand was a shortened, English-sounding version of her lover's name.

To avoid being categorised as a female writer, Sand kept the name when she started writing novels.

For the rest of her life, she would use both names. De Musset called her George. So did her son, Maurice. But Chopin, her lover for nine years, called her Aurore.

Sand's affair with de Musset lasted only eighteen months, but with its stormy break-ups, tearful reunions and long stay in Venice, it came to symbolise love in the romantic era. De Musset was unfaithful and a drunkard. Yet when Sand eventually left him, she was so bereft that she cut her long hair and sent it to him. De Musset, his brother and Sand all wrote novels about his broken heart, making it one of the best-documented in literary history.

Throughout their passion, Sand showed an amazing aptitude for work, producing three novels in less than five months. Her dissolute lover complained: 'I worked all day, and in the evening I wrote ten lines and drank a bottle of brandy; she drank a half-litre of milk and wrote half a volume'.

Sand mothered all her lovers, most of all Chopin. The Polish composer was 'a fragile, extremely ambiguous figure, who found a maternal figure in Sand', the pianist Piotr Anderszewski told *Le Figaro Littéraire*. 'She protected him, gave him a sense of security that allowed him to concentrate on his art.' Chopin composed some of his best works at Nohant.

Sand supporters and Chopin fans continue to dispute the real cause of their separation. The former say Sand suspected Chopin was secretly in love with her daughter Solange; the latter accuse Sand of crassly abandoning the composer when he was dying of tuberculosis.

Sand was amazed to find love again in middle age, with the engraver Alexandre Manceau, a friend of her son, Maurice. 'I love him, I love him with all my heart,'

she wrote. 'I am forty-six years old, I have white hair, but it doesn't matter. Men love old women more than the young ones; I know that now.' Only Manceau's death from cancer fifteen years later would separate them.

In her lifetime, Sand was as famous as Hugo, Balzac and Dumas. Though her novels about hard-working, suffering peasants seem dated now, the themes of love, politics, society, feminism, art, friendship and nature are timeless.

'I can't stand the clichés about her,' said Jacqueline Majorel, director of the tourism office in La Châtre. 'She is either portrayed as 'the good lady of Nohant' because she helped the local peasants, or as the debauched mistress, or as a regional writer. People want to stick labels on her, and it's unfair because she was very complex.'

Annick Dussault of the Bicentennial Association said George Sand was still relevant. 'The French Republic decided to honour her because, above all, she was a great republican,' she explained. 'In her life and in her writing, she went to extreme lengths to defend the values we still believe in: freedom of the press and thought, the right to vote.'

Honoré de Balzac

Gargantuan Appetites on the rue Basse

Honoré de Balzac was the first writer to describe in minute detail the importance of money in French society. His surviving Paris home, in the stylish neighbourhood of Passy, is a reminder of the central, unhappy role that the lack of money played in Balzac's own life. Debts envenomed the writer's relationship with his mother, complicated his love affairs and led him to work himself to death. He died on 18 August 1850, at the age of fifty-one, devastated that he had not completed the task he set himself as 'historian of the human heart'.

When Balzac moved to the rue Basse (now the rue Raynouard) in 1840, he chose the location for its inaccessibility to creditors and bailiffs and for its escape route. Until 1937 another, much higher building rose in front of the three-level, cream-coloured stucco house with pale green shutters where the great writer lived for seven years. The house on the street obscured the one below it, where Balzac rented five rooms under his housekeeper's name – again to give the lie to creditors. His friends, including Victor Hugo, knew the passwords for the concierge: 'One enters like wine into bottles.'

If by mischance a bailiff got through these barriers, Balzac raced down the communal staircase to the courtyard below and out the gate into the rue Berton. Turning left, he could reach the banks of the Seine and catch the ferry into central Paris. The path to the right led to open fields and countryside. It is a wonder that Balzac, with his wide girth, could get down the narrow wooden steps at all. The charming rue Berton, with its street lamps, cobblestones and tree-shaded wall, has not changed since the mid-nineteenth century. You cannot reach it from the Balzac museum and library, but it's worth the detour past Turkish embassy guards to see it.

The most surprising thing about the apartment where Balzac shut himself away to map out the *Comédie humaine* – and where he wrote, among other volumes, *A Dark Affair*, *Splendours and Miseries of Courtesans* and *Cousine Bette*, to give them their English titles – is its modesty. You can't help being surprised how a man of such gargantuan appetite and talent fitted into these small rooms. How could the pantry, now the ticket office, have held food enough to satisfy him? One dinner purchased by Balzac's publisher consisted of a hundred oysters, twelve lamb chops, a duck, two partridges, a sole and twelve pears, most of it consumed by the writer.

Balzac was a spendthrift who liked brightly coloured, hand-tailored clothes as well as lavish meals. He called his compulsion for buying antiques he could not afford 'bric-à-brac-omania'. Traces of it remain in the Passy house – his gold- and turquoise-encrusted cane, to which

his contemporaries mockingly attributed magical powers;
a framed gold crucifix that he bought for the Polish Countess, Eve Hanska.

Balzac's sitting room is devoted to mementos of Hanska, whom he married five months before his death. Their sixteen-year courtship began when the bored noblewoman sent Balzac anonymous, adoring reader's letters from her estate in Ukraine.

In the seventeen-volume *Comédie humaine*, Balzac created a universe of more than two thousand named characters. To produce an average of two thousand pages annually over a nineteen-year period, he rose at midnight, brewed very strong black coffee, wrote until 8 AM, breakfasted, and then resumed work until five every evening. His white porcelain coffee pot, emblazoned with the initials 'H.B.', can be seen in Balzac's red velvet-lined office.

Martine Contensou, a curator, says she feels his presence in the study, which has been painstakingly decorated following his descriptions of it in letters. 'We are working to promote his oeuvre, and it's very much alive,' Contensou says. 'He was interested in everything, he took part in everything. You still feel his energy.'

The most powerfully evocative object is Balzac's original desk and armchair. He wrote to Hanska of the simple, dark-wood Henri II table that it was 'witness to my anguish, my misery, my distress, my joy, everything My arm has almost worn it away, moving over it as I write.'

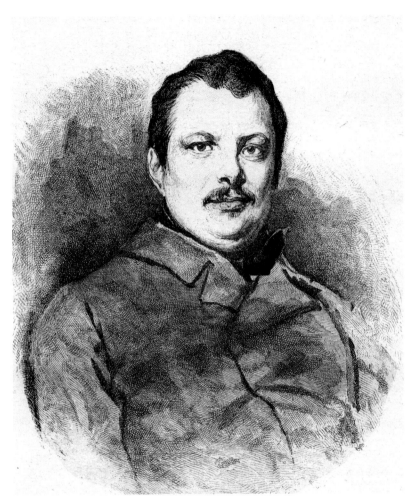

Honore Balzac © Leemage/Universal Images Group/Getty Images.

VII Irish Connections

'It was pure snobbery, because you couldn't join in dinner party conversation if you hadn't seen it. People spent hours discussing whether Godot was meant to be God.'

Actor Jean Martin, who played Lucky, on the success of the first production of Beckett's *Waiting for Godot* in 1953

Samuel Beckett

Yeats and Wilde died in France. Joyce stayed for twenty years between the wars, and Ulysses was printed in Dijon. But Samuel Beckett was the only Irish writer who joined the Resistance during the Nazi occupation, made the French language his own and settled permanently in France, where his works are taught as the oeuvre of a Frenchman. The following five articles, written between 1998 and 2007, provide a glimpse of how Beckett was commemorated in Paris, and how he was remembered there by three close friends.

A Stately, Snowy Mulligan Begins Centenary Tributes to Beckett

A man in a black coat and hat stands over a slab in a snowstorm, declaiming. Green rubbish bins are lined up in the lane, a few feet from the heather that fringes the grave. A crow caws in the naked tree, and the monolith of the Tour Montparnasse looms in the background.

When Irishman Peter Mulligan singlehandedly opened the Beckett centenary in Montparnasse cemetery with a poetry reading in sub-zero temperatures on 27 December 2005, it felt for all the world like a scene from a Beckett play.

'Suzanne Beckett, née Deschevaux-Dumesnil, 1900-1989, Samuel Beckett, 1906-1989' are the only words on the tombstone. Beckett died on 22 December. 'We should have been here on that date,' Mulligan says. 'We are late – again.'

'We' meant Mulligan, his Iranian-born wife Golnar and their son Reza, a threesome as oddly matched as Vladimir and Estragon. Golnar, a tax accountant, is elegant and shelters from the snow under an umbrella. Reza, a lawyer with a US law firm in Paris, reads French versions of the poems.

Mulligan was born in Dún Laoghaire in 1939 and emigrated to Britain at age eighteen. Now a retired banker, he heads the Northampton Connolly Association.

In 1985 Mulligan wrote to Beckett to ask his permission to include a poem in a collection of poetry from the Irish diaspora, *Beyond the Shore: The Irish Within Us*.

Beckett sent a note saying that Mulligan could choose any poem he liked from his *Collected Poems in English and French*, published by John Calder.

The snow stung our faces as Mulligan read the Beckett poem that Golnar chose twenty years earlier, a devastating description of a failed relationship, entitled *Cascando*: 'saying again/ if you do not teach me I shall not learn/ saying again there is a last/even of last times/ last times of begging/ last times of loving/ of knowing not knowing pretending/ a last even of last times of saying/ if you do not love me I shall not be loved/ if I do not love you I shall not love'

Every year on Bloomsday the Connolly Association holds a ceremony at Lucia Joyce's grave in Northampton.

'Beckett was James Joyce's secretary,' Mulligan explains later in a café at the edge of the cemetery. His daughter Lucia spent the last thirty-one years of her life at St Andrews mental hospital in Northampton.

'After Joyce died, Beckett visited her every year, and he attended her funeral,' Mulligan continues.

Mulligan brought a small jar of earth from Lucia Joyce's final resting place, which he sprinkled beside the Becketts. The jar was refilled with a handful of earth from Montparnasse, to be scattered at Lucia's grave on Bloomsday.

Breakfast on Beckett's 100th Birthday

Samuel Beckett might have felt uncomfortable at the Irish ambassador's breakfast on 13 April 2006. The gilded eighteenth-century mouldings in the residence were not in tune with the great writer's 'stripped-back minimalism', Ambassador Anne Anderson noted.

But Beckett 'remained Irish in his blood and bones', she added. It was unlikely he would have been up in time for the 8.30AM meal, but he would have appreciated the rashers.

'He always told friends travelling from Ireland, "Bring me back some rashers",' Anderson said.

Though he lived in France for the last fifty-two years of his life, Beckett kept his Irish passport current, and on one trip to the embassy emptied his pockets to help a down-and-out visitor who was looking for consular assistance.

Ambassador Anderson invited French and Irish writers, artists and musicians who've been influenced by Beckett. Among the guests were the French academician Jean-François Deniau, senator Jacqueline Gourault, who heads the France-Ireland friendship committee in the senate, and Isabelle Maeght, whose family owns a famous art gallery, and who knew Beckett as a child.

The Irish poet Cathal McCabe and the French actor Alain Paris read from Beckett's work. McCabe's text described May Beckett's long labour, a hundred years earlier, concluding: 'It was over at last.'

Some of the breakfast guests went on to Montparnasse cemetery, where two dozen people held an improvised and atmospheric ceremony over Beckett's grave at noon.

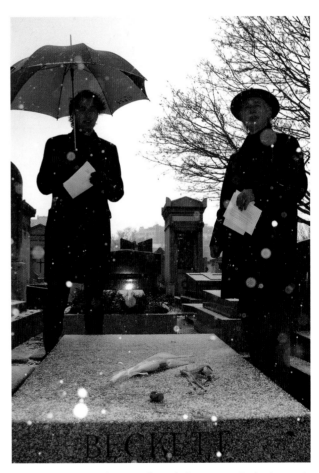

Reza and Peter Mulligan declaiming over Beckett's grave in Montparnasse cemetery, December 2005. Photo: Lara Marlowe.

Peter Mulligan, the head of the Northampton Connolly Association and the instigator of the cemetery event, sprinkled earth from the Wicklow mountains, where Beckett walked with his father Bill as a child, on the grey granite tombstone. Mulligan and Alain Paris read from his works. Ambassador Anderson and the poet Derry O'Sullivan – who knew Beckett – spoke about him.

Centenary events concluded with the Booker Prize-winner John Banville discussing Beckett's influence on him at the Centre Culturel Irlandais.

The Thin Man with the Eagle Eye

One night in 1953, the French actor Jean Martin saw a tall, thin man in the second row of the Babylone theatre, where he was rehearsing in the first production of *Waiting for Godot.*

'Do you want me to tell you how it came about?' Martin asked with a twinkle in his eye. The actor was seventy-six when I interviewed him in 1998. 'Anyway, you have to believe me – because the rest of us are all dead.'

Martin played Lucky, the slave-porter who plods through life at the end of a rope and colludes with his master in his own mistreatment. The man with the eagle eye in the second row was Samuel Beckett, then forty-six. 'He had incredible presence, but he was very, very reserved,' Martin recalled. 'He didn't say a word. When you saw him, you were fascinated.'

Beckett and his companion, Suzanne Deschevaux-Dumesnil, would become close friends of Jean Martin. Suzanne, ten years older than Beckett, bullied publishers to read his work and cooked and cleaned for the writer. They would marry in old age, not long before Suzanne's death. 'She was completely different from him,' Martin said. 'She never drank a drop. Sam was very driven – her not at all. It created a kind of balance.'

It was Suzanne who took the manuscript of *Godot* to the theatre director and actor Roger Blin. For six months,

he scrabbled for money, and a location to produce the play. When another actor quit two weeks before the opening, Blin asked Martin to play Lucky. At first, Martin thought it wasn't much of a part.

The character's only spoken sequence is a long, incomprehensible monologue when his tormentor Pozzo forces him to 'think out loud' to entertain Vladimir and Estragon.

'I didn't know what to do with Lucky,' Martin said. A doctor friend suggested he observe patients suffering from Parkinson's disease. Recounting it forty-six years later, Martin stood up and his right hand began to tremble. The shaking took over his whole body as he tried to force out the words. When Martin asked Beckett if he approved of the technique, the writer shrugged.

The last rehearsal of *Godot* was attended by the female dresser and her boyfriend, a rubbish collector who provided a cast-off suitcase as Lucky's main prop. 'They were the first ones in the world to see it, and they must have been bored to death,' Martin laughed. 'But when I arrived onstage she noticed I was shaking and that I was carrying the suitcase. At the end of the monologue she started to vomit. Sam said, 'If that's the effect it has, then that's the way you must play it'.

'In his life, Sam never saw one of his plays performed in front of an audience,' Martin said. 'Never. When you asked him why, he said "aghhhh" . . . and waved his hand. I think somehow it would have embarrassed him. He was fundamentally shy. And he knew there would be a gap between the way he imagined it and the way it happened.'

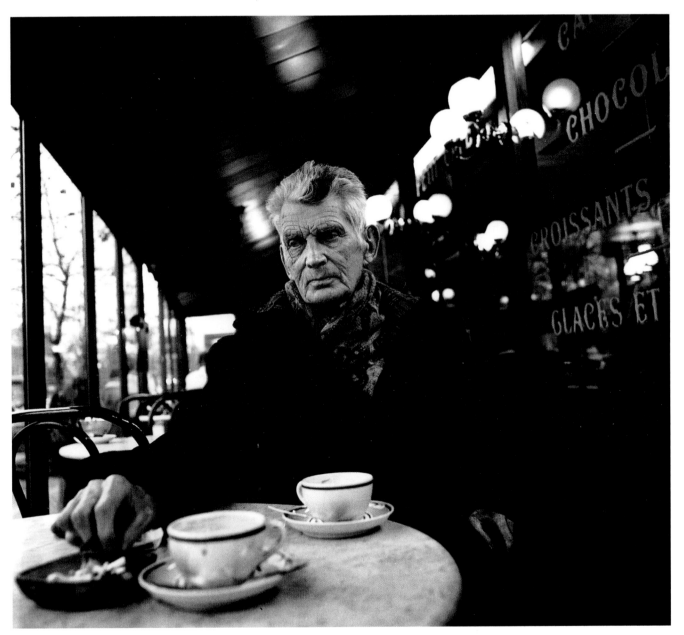

Samuel Beckett, Le Petit Café, Boulevard St.Jacques, Paris, 1985
© John Minihan. Image courtesy of the Kenny Gallery, Galway.

Le Figaro published a front-page opinion piece by the playwright Jean Anouilh entitled 'Pascal's *Pensées* played by the Fratellini' (a family of clowns) and hailing *Godot* as a masterpiece. Upper-middle-class Paris flocked to the tiny theatre, where Martin played Lucky 250 times. The audience was never quite sure how to react. 'At the end of the first act, some of them would yell "bravo, bravo". Others just looked at each other.'

Within six months, *Godot* was famous the world over. Its notoriety brought Beckett unexpected wealth, much of which he gave to friends and struggling artists. 'Several times in *Godot* the characters say, "We're bored", and the audience used to shout back, "Yeah, we are too!",' Martin laughed. So why was the play so successful? 'Before *Godot*, Blin and I acted in a half-dozen plays by Ionesco and Adamov, and no one came,' Martin said. 'I thought the public were stupid. But when we did *Godot*, I thought they were just as stupid. It was pure snobbery, because you couldn't join in dinner-party conversation if you hadn't seen it. People spent hours discussing whether Godot was meant to be God.'

After *Godot*, Beckett wrote *End Game* for Martin and Blin. 'We had the same problems as we did with *Godot*. People said, "It's a miracle that won't be repeated".'

Martin was banned from acting in France because he signed a petition against the war in Algeria. He went on to play the French paratroop commander Colonel Mathieu in Gillo Pontecorvo's dramatic, pro-Algerian film *The Battle of Algiers*, which 'didn't help the situation'. So he acted in Hollywood westerns with Henry Fonda before returning to France.

Through it all, Martin remained close to Samuel and Suzanne Beckett, visiting them at their home in the Marne Valley and accompanying them to Yugoslavia on holiday, to spend royalties that couldn't be taken out of the communist country. Martin kept a manuscript he wrote there, about his father's death. Beckett told him to leave the pages on the left blank, and each night the Nobel prize winner wrote his own version of Martin's text on the opposite page.

When Suzanne was ninety and growing senile, she could no longer look after Beckett. He stopped eating and had to be taken to an old people's home in Montparnasse. Two weeks before Beckett died, in December 1989, Martin visited him for the last time. 'He hated unexpected visitors – he wanted to be shaved and dressed – so I dropped a note off in the afternoon. When I arrived that evening, there was a bottle of Powers and two glasses on the table.'

Both men had fought in the French Resistance during the Second World War, but they never talked about it. 'He wasn't the type to tell his life story,' Martin said. 'We talked about people we'd seen, people we loved, what we read, painting. He was completely different from what people imagined – Sam was someone you had a good time with.'

Jean Martin died of cancer on 2 February 2009 at the age of eighty-six.

Direct from Beckett

It's not often that one has the opportunity to see a play directed by Samuel Beckett, seventeen and a half years after the writer's death. But 'directed' is the right word. The French actor Pierre Chabert performed *La Dernière Bande* (first written in English by Samuel Beckett as *Krapp's Last Tape*) as directed by Beckett in the Granary Theatre in Cork in May 2007.

Chabert met the great Irish writer and his French wife Suzanne in the early 1960s, when he was fresh out of drama school and sought permission to perform *Krapp's Last Tape*, a monologue in which a failed writer confronts his younger self.

Beckett agreed. Although he declined an invitation, saying he never watched his own plays, he sent Suzanne.

Chabert's first meeting with Beckett, for a drink at the Closerie des Lilas, helped determine the course of his life. 'I was absolutely dazzled by his physical presence, by the light that came from his eyes. It was the light of intelligence. It created a momentous impression, a real shock,' he recalled.

In 1972, Suzanne Beckett told Chabert she preferred his rendition of *Krapp's Last Tape* to all others. A few days later, he received a note from her which he still treasures: 'Dear Pierre, Would it interest you to play Krapp under Sam's direction?' Chabert went to the couple's apartment in the Boulevard Saint-Jacques. 'There was nothing on his work table, not a scrap of paper,' he recalled. For more than an hour, Chabert annotated his own copy of the play with explanations and instructions dictated by Beckett. In particular, Beckett dwelled on the 'farewell to love' scene, in which, after a revelation about his own destiny as a writer, Krapp abandons love.

'I hadn't really understood the link between the character and Beckett himself,' Chabert said. 'In the play, Krapp is at the end of a jetty when he has the vision. Beckett told me he had the vision in his mother's room. He explained that a writer's destiny was to say yes to his own darkness, to refuse nothing of his own failure, which is inside him.

'Beckett was the writer who played on introspection, who started from within himself,' Chabert adds. 'Unlike Joyce, he did not go towards the world, did not embrace it. On the contrary, Beckett starts with a sort of contraction. Everything must come out. There is no censorship on what he brings out of himself.'

To Chabert, Beckett explained subtleties of the play which are lost on the public; for example, how one can calculate that Krapp was twenty-four years old when he began recording the birthday tapes.

'There is a very precise complexity to it,' Chabert explained. 'Beckett had a very precise vision of his poetic art. He practised a sort of stylisation, of formalism.' An amateur pianist, Beckett was deeply influenced by music. 'His texts, especially the plays, are musical,' Chabert said. 'They are texts by a poet who counted every syllable. Take the names in *Godot*: Didi, Gogo, Pozzo, Lucky. Every name has two syllables, is fashioned by rhythm.'

As a favour to his close friend Robert Pinget, Beckett directed Chabert in Pinget's *Hypothèse* in the mid-1960s. 'I'll direct you, but we have to find a way to make it more theatrical,' Beckett said.

Like *Krapp's Last Tape*, *Hypothèse* is a monologue by a writer. The character thinks about throwing his manuscript in a well, but in the end burns it in a coal stove. Beckett had the idea of placing a huge manuscript on the table, which Chabert gradually scattered over the stage.

'At the end, the stage floor was covered with blank pages. When the character had no more manuscript, he picked up pages and clutched them to him – it was a physical relationship with the manuscript, and it was magnificent.'

Beckett was so pleased with the result that he sent Chabert to the Théâtre de l'Odéon, to meet the great actor and director Jean-Louis Barrault. Barrault produced a triple bill of Pinget's play, two short Beckett plays and two plays by Eugène Ionesco.

It was an incredible experience for the young Chabert. 'I was surrounded by stars – Michael Lonsdale, Jean-Louis Barrault, Madeleine Renaud' Barrault brought Chabert into his troupe. But the French culture minister André Malraux fired Barrault when he let the Odéon be used as a meeting place during the May 1968 student revolt. Chabert would rejoin the troupe a few years later at the Gare Orsay Theatre, then at the legendary Théâtre du Rond-Point des Champs-Élysées.

Chabert was one of a handful of actors – Roger Blin, Jean Martin, David Warrilow, Madeleine Renaud and Billie Whitelaw were the others – whom Beckett trusted to interpret his work. In the 1980s, Chabert directed rather than performed Beckett's plays, in particular for an eightieth-birthday retrospective in 1986. Chabert's were the only rehearsals that Beckett attended. Chabert repeated the experience as artistic director of the Festival Paris Beckett 2006-07. Close to 200,000 people attended 450 performances from Beckett's entire oeuvre.

Before he died, Beckett met Chabert in the PLM café near his flat in the Boulevard Saint-Jacques. 'He said, "These are for you. They're my last plays. I'm giving them to you, but you have to direct them alone."' The bundle contained *Berceuse*, *Catastrophe*, which was dedicated to the Czech writer Václav Havel, and *Ohio Impromptu*.

'I was blown away,' Chabert recalled. 'I never would have dared ask him. I directed all three plays at the Théâtre du Rond-Point.'

But *Krapp's Last Tape* remains the first Beckett play that Chabert discovered, and the only one in which Beckett directed him as an actor. 'I have travelled through life with this play,' he said.

'I acted in it when I was around twenty. Now I'm nearing the age of the character [sixty-nine], and this play is still with me. It certainly helped me to evolve, to overcome the painful things of life. I play it now with more openness, more distance. There is a lot of emotion, but there is humour, and acceptance.'

Chabert had no doubt that the torment of Krapp on his sixty-ninth birthday remained relevant today. 'These are timeless human situations,' he explained. 'They are archetypes. It is also a play about time, memory, ageing, and the fact that one gets to an age where one is forced to weigh up one's life. If people want material success, they can achieve it. But if they have an ideal – love, perfection – there is inevitably a degree of failure.' Chabert's career encompassed half a century of French theatre. The deaths of Beckett and Barrault were a terrible loss, but their legacy was a consolation. 'You have the texts that stay inside you and accompany you,' he said.

Pierre Chabert died of a cerebral haemorrhage on 11 February 2010 at the age of seventy

Devoted Friend, Defender and Publisher of Beckett

The publisher Jérôme Lindon's books were impounded, his apartment was bombed and he was repeatedly fined by French courts for opposing the 1954-62 Franco-Algerian war. 'I am Samuel Beckett's publisher,' he said in his own defence. 'When one has this chance and this honour . . . the least one can do is defend the conditions of freedom where they are threatened.'

Three days after he died on 9 April 2001 at the age of seventy-five, Jérôme Lindon was buried near Beckett in the Montparnasse cemetery.

The men were close friends for nearly forty years. Beckett's wife Suzanne submitted the Molloy trilogy to Lindon at Les Éditions de Minuit in 1950. The manuscript had been rejected by every major French publishing house, but as he began reading the text in the Métro, Lindon recalled later, 'Suddenly nothing else mattered. I couldn't understand how people could fail to be dazzled by such a meteor.'

Lindon often said Les Éditions de Minuit would not have existed without Beckett, but then Beckett might not have been published without Lindon. Both men served in the French Resistance. They were similar in character, disdaining social life but loyal in friendship, combining deep pessimism with energy and enthusiasm.

When Beckett won the Nobel Prize in 1969, Lindon sent a telegram to him on holiday in Tunisia. 'I advise you to hide yourself,' the publisher warned. He went

to Stockholm to receive the award on Beckett's behalf, speaking of the writer's 'absolute distress' at having been chosen. As Beckett's literary executor after his death in 1989, Lindon became famous for defending the writer's work against sloppy interpretation.

Jérôme Lindon was only twenty-three when his upper-middle-class family purchased the struggling Éditions de Minuit, where he already worked. The publishing house had started during the Nazi occupation when Jean Bruller printed *Le Silence de la Mer*, a haunting tale of a German officer billeted in a French home, under the pen-name Vercors. The underground publisher produced twenty-five books during the war, all at night – hence the name. Because Lindon ran Minuit for fifty-three years, he was often mistakenly described as its founder.

When Lindon published *Molloy* in 1951, Beckett remarked, 'He's terribly nice, this young chap, especially when I think he's facing bankruptcy because of me.' That same year Lindon moved the publishing house to a former bordello in the rue Bernard Palissy, near the Flore and Deux Magots literary cafés. The Molloy trilogy was a success, like the theatrical hit of 1953, *Waiting for Godot*, also published by Lindon.

Although his authors won two Nobel Prizes and three Prix Goncourt, Lindon never published more than twenty books a year, never hired more than nine staff and never moved from his tiny headquarters. He often spoke of the need to publish 'books that the public don't want'. He made the break with traditional aesthetics and political rebelliousness the hallmarks of Les Éditions de Minuit.

A literary critic at *Le Monde* first used the term *Nouveau Roman* to describe writers published by Lindon in the 1950s, including Marguerite Duras, Alain Robbe-Grillet, Claude Simon (who won the Nobel Prize in 1985), Michel Butor, Nathalie Saurraute and Robert Pinget, who became a close friend of Beckett. The group was

characterised by meticulous description and disregard for storyline. A generation later, Lindon would 'discover' some of France's most prominent present-day writers, including Jean Echenoz and Jean Rouaud, both of whom won the Goncourt. He also published the philosophers and sociologists Jacques Derrida, Karl Jaspers, Herbert Marcuse and Pierre Bourdieu.

Jérôme Lindon was the grand-nephew of the French car manufacturer André Citroën. His family was of Polish-Jewish origin, and he joined the Combat Resistance group in Provence in 1942, aged seventeen, ending the war in Germany in General de Lattre's First Army. Throughout his life, he took risks and showed moral courage – in publishing unknown or controversial authors, and in opposing the Algerian war. He fought the commercialisation of the publishing industry and ultimately prevented the French retail chain FNAC from selling books at cut prices.

But, most of all, Lindon is remembered as Samuel Beckett's publisher. The novelist Marie Ndiaye was seventeen years old when the publisher accepted her first manuscript. To reassure the young woman before she signed her contract, she told *Libération* newspaper, Lindon told her he had given her book to Beckett to read. 'He always talked about Beckett like a first love whom one never really gets over,' Ndiaye said.

Yeats in France

Like much of his life, William Butler Yeats's fascination with French culture 'was in a sense channelled through' his love for Maud Gonne, Roy Foster, professor of Irish history at Hertford College Oxford and the author of *W. B. Yeats: A Life* told a rapt audience at the Irish College in Paris in June 2009. Yeats was, Foster said, 'a great Irish European'.

Yeats began visiting Gonne in Paris in the late 1880s, when she was living with her married French lover, the right-wing parliamentary deputy Lucien Millevoye. The daughter of a wealthy British army colonel and an Englishwoman, Gonne ardently espoused Irish nationalism, and published a newsheet called *L'Irlande libre*. Yeats usually stayed at the Hotel Corneille near the Odéon, which had strong Irish connections. The old Fenian John O'Leary, who'd been one of Yeats's mentors, and John Millington Synge lodged there. So too would James Joyce.

Yeats believed that English Victorian literature was depleted, Foster explained. He and other young writers, including his London flatmate Arthur Symons, with whom he travelled to Paris, were inspired by the French symbolist movement.

Yeats tried (but failed) to meet the great French poet Stéphane Mallarmé. Yeats did find Paul Verlaine, who by that time had spent two years in a Belgian prison for shooting and wounding Arthur Rimbaud, became a devout Catholic, then lapsed into the bohemian life of an alcoholic in the Latin Quarter, gratefully accepting any offer of a glass of absinthe.

Yeats visited Verlaine 'at the top of a tenement house in the rue St Jacques', the Irish poet wrote in his autobiography, as quoted by Foster. Verlaine had taught school for three years in England, and the poets conversed in English, with Verlaine searching for the odd word in a dictionary. Verlaine told Yeats he 'lived in [Paris] like a fly in a pot of marmalade'.

An old man wearing ragged trousers, a rope for a belt and an opera hat joined their meeting. Verlaine called him Louis XI, because he allegedly resembled the French king.

At Verlaine's funeral a few months later, Yeats wrote, 'His mistress quarrelled with a publisher at the graveside as to who owned the sheet by which the body had been covered, and Louis XI stole fourteen umbrellas that he found leaning against a tree in the cemetery'.

Yeats was a passionate theatre-goer, and Maud Gonne graciously translated for him when they saw Villiers de l'Isle Adam's five-hour symbolist play *Axel*. Before the two principal characters commit suicide, Axel says, 'As for living, the servants will do that for us'. The quote stayed with Yeats for the rest of his life.

The premiere of Alfred Jarry's *Ubu roi* struck Yeats as 'evidence of a new, brutal culture', Foster said. It allegedly prompted Yeats to predict that after Mallarmé, Verlaine, Gustave Moreau, Puvis de Chavannes, and his own poetry, would come 'the Savage God'. Though he lived only seventy-four years, Yeats's life spanned the chasm between nineteenth- and twentieth-century Europe, from the romantic poetry of Verlaine to the rise of Nazism.

When Yeats co-founded the Irish Literary Theatre (subsequently the Abbey) in 1898, he was eager to import the stagecraft, lighting and symbolism he'd learned from French avant-garde theatre. But his Irish colleagues resisted these innovations from the Continent.

Yeats had attended art college at the beginning of his career. He spent many days wandering through the Louvre and the great museums of Italy. His own taste tended to the Italian Renaissance, especially Titian, and he had difficulty understanding the then revolutionary work of Manet. But Yeats believed that the new French painting should be seen in Ireland, and helped to organise an exhibition in Dublin in 1899 of paintings by Millet, Corot, Manet, Degas, Monet, Daumier and Puvis de Chavannes.

Yeats was also involved in Hugh Lane's undertaking to establish a modern art gallery in Dublin. But he was disheartened by opposition to the plan. What he regarded as Irish philistinism inspired the bitter poem 'September 1913', with its refrain: 'Romantic Ireland's dead and gone/ It's with O'Leary in the grave.'

Before the First World War, Maud Gonne lived in a small house with a garden in Passy, near the Trocadero. It was there, in 1908, that she and Yeats finally consummated their relationship, in their only night together.

During the war, Yeats often visited Gonne's country house at Colleville, later the Omaha Beach of the Normandy landings. It was here that Yeats fell in love with Iseult, the beautiful daughter Gonne had with Millevoye. But Iseult, like her mother before her, rejected Yeats's proposal of marriage.

There are many other chapters to Yeats's associations with France and the Continent, not least his support for the younger James Joyce, and his friendship with the American poet Ezra Pound, who settled in Italy.

It was appropriate that Yeats died in the Pension Idéal Séjour at Cap d'Ail, on the Côte d'Azur, Professor Foster concluded. Because 'part of the pattern of his life is a linkage between Irish identity and an intellectual and aesthetic affinity with Europe, particularly France'.

Remembering Oscar

The dandy in the purple velvet waistcoat and green silk scarf looked wistfully from the front page of the literary section of *Le Figaro*. On the hundredth anniversary of his death, all Paris seemed infused with Oscar Wilde's presence.

If Wilde's ghost was by his graveside at Père Lachaise cemetery, or in the glittering dining room of the Irish ambassador's residence, among the congregation at the memorial Mass at St Joseph's Church, or in the half-dozen theatres where he was celebrated, then the ghost must surely have worn a smile of derision.

Wilde might have seen in his rehabilitation - indeed glorification - the flip-side of the human folly that caused him such suffering in Victorian England. By the time he died on 30 November 1900 at the age of forty-six, poor, broken and alcoholic, even Wilde's friend André Gide shrank from being seen with him in public.

But a century later, the sting of scandal was gone. The familiarity of those with close connections to 'Oscar', 'Robbie' and 'Bosie' survived.

The Irish and British ambassadors raised champagne glasses to Wilde's genius. Referring to Wilde's deathbed conversion to Catholicism, Father Thomas Scanlon spoke of the prodigal son 'who was dead and is alive again, who was lost but now is found'.

The Taittinger champagne company, which financed one of several Wilde exhibitions in London, asked his grandson, Merlin Holland, if there was anything else they could do. When Holland said he needed a place to stay in Paris, Taittinger sent him to the Crillon, the most expensive hotel in Paris.

About twenty people waited outside the Père Lachaise gates and entered the cemetery with the dustmen at dawn. They included Holland, Ireland's Ambassador Patrick O'Connor and his wife Patricia, the British ambassador Sir Michael Jay, and Oliver Ross and Christabelle Ross de Marsangy, the nephew and grand-niece of Wilde's most loyal lover, Robbie Ross.

Sheila Colman, the executor of the estate of Wilde's other great love, Lord Alfred Douglas, was also there. So were the British actors Sir Donald Sinden and Steven Berkoff, and the playwright Sir David Hare.

Wilde was buried in a pauper's grave at Bagneux. But Robbie Ross purchased the Père Lachaise plot and had him moved there.

At Ross's request, his own ashes were later placed with Wilde. The Ross family remain loyal to Wilde after his death, just as their uncle cared for him and his family in life.

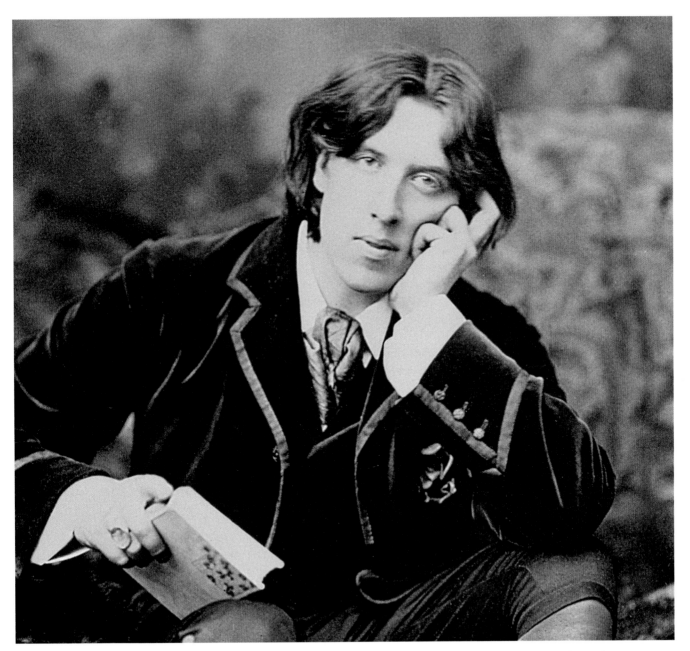

Oscar Wilde, 1882, Photo: © Scala Florence/Heritage Images.

Wilde's white Portland stone tomb was immaculately cleaned at Holland's expense for the centenary. Its lovely Assyrian angel, commissioned by Robbie Ross, and one of the earliest works of the sculptor Sir Jacob Epstein, was mutilated by two English women who castrated it with their umbrellas.

The tomb has long been a target of graffiti artists and has been constantly covered with scores of kissed-on, oily lipstick kisses. 'If you can write something that will result in people leaving it alone, I'd be very grateful,' Oliver Ross, a London solicitor, pleaded. 'There are other ways of showing respect.'

The Oscar Wilde Autumn School in Bray sent fifteen people to Paris for the commemorations. 'It's ironic that a man so ignored and vilified is now accepted as a national figure,' Carmen Cullen, the school's director, said.

Others become preoccupied with Wilde's life, but she preferred to concentrate on his work. 'There was a seedy side to him,' Cullen explained, alluding to the 'rent boys' Wilde once frequented. 'There is still a lot of ambivalence.'

Merlin Holland anticipated detractors in his remarks at the Irish embassy breakfast. When people criticised his grandfather, 'Part of me says, how dare you?' But then Holland remembers Wilde's aphorism: 'Praise makes me humble, but when I am abused I know I have touched the stars.'

The desecration of Wilde's tomb resumed soon after the centenary. In 2011, Sheila Pratsckhe, the director of the Irish College in Paris, appealed to the Irish government, which allocated funds for it to be cleaned again, and protected with a glass screen. The tomb was to be reopened on 30 November 2011, the 110th anniversary of Wilde's death, and one hundred years after the sculpture was created.

Eileen Gray

Two thousand and nine might be called 'the Year of Eileen Gray'. In February, the Dragon armchair made by the Anglo-Irish decorator, designer and architect in 1917 became the most costly chair in history, when it sold for €21.9 million at the auction of Yves Saint Laurent and Pierre Bergé's collection. The collector who bought it remains anonymous, but Cheska Vallois, the gallery owner who represented the buyer, said the astronomical sum was 'the price of desire'. No wonder the National Museum of Ireland, whose Collins Barracks branch maintains a permanent Gray exhibition, despairs of acquiring more pieces.

Also in 2009, the French government, local authorities and the cement company Lafarge joined forces to restore E-1027, the revolutionary but ill-fated villa (of which more later) that Gray designed and built at Roquebrune-Cap-Martin. 'This restoration is tardy, official recognition of Eileen Gray, who was neglected and forgotten,' said Pierre-Antoine Gatier, the chief architect on the restoration project.

Eileen Gray was more prone to self-doubt than to glorying in success. She was a notoriously shy person, who lived as a semi-recluse at 21 rue Bonaparte in Paris's sixth *arrondissement* for decades before her death in 1976 at the age of ninety-eight. Gray refused to attend the openings of exhibitions in her honour in Paris, London,

Los Angeles, Brussels, Vienna and New York in the 1970s, and sent a friend to receive the honorary title she was awarded by the Royal Institute of Architects in Ireland when she was ninety-four. Only three people attended her funeral in Père Lachaise cemetery, where she was buried in a simple grave numbered 17616.

Jean-Pierre Camard is the leading French expert on art nouveau and art deco, and the expert and auctioneer who has sold the largest number of pieces by Gray. In 1972, he was asked to assess the collection of the late high fashion designer Jacques Doucet, which had been in storage for decades. He immediately recognised a lacquered screen entitled *Le Destin*, on which Gray painted two Greco-Roman-style figures pursuing a ghost. 'It knocked me out,' Camard recalled. He valued the screen at 20,000 French francs. It sold for 170,000 francs – a phenomenal sum in 1972. 'It was a revelation for a lot of people who didn't know Gray's work,' Camard said.

The Doucet sale put art deco – and Eileen Gray – on the map. While he was organising the sale, a colleague suggested that Camard talk to Gray; he hadn't realised that she was still alive. When he telephoned her, Gray initially refused, then relented when he proposed breakfast at a café in the rue de Buci.

Camard had been warned that Gray was cantankerous. She wore mittens to their meeting, because her hands

were damaged by years of working with toxic lacquer resin, and she complained that she was losing her eyesight.

When Camard showed Gray a photograph of the Lotus table she had made for Doucet, which was about to be auctioned, the old woman reacted badly. 'I don't recognise it,' Gray said. 'It is shameful to have done that.' Camard thought Gray was accusing him of attempting to fob off a fake as one of her pieces. 'What do you mean, you don't recognise it?' he asked. It turned out she objected to the silk cords and amber baubles that Doucet had added to her table. 'I want you to destroy it,' she told Camard. The table sold for 61,000 francs. When Camard told Gray on the telephone, she replied: 'It doesn't mean it's good. It means it's expensive. That's all.'

In 2005, Camard auctioned six chairs that Gray made for one of her lovers, the French singer Damia, before the First World War. Gray called Damia her *Sirène*, or mermaid, because of the singer's voice. The chairs show a mermaid embracing a seahorse, and sold for an aggregate of €8.9 million, then a record.

When she met Damia, Gray cut her long auburn hair and began wearing elegantly tailored suits, as befitted a woman associated with the coterie of artistic Paris lesbians then known as the Amazons. Damia kept a pet panther, which the women walked on a leash in Paris. Gray overcame her shyness to accompany Damia to fashionable night clubs and restaurants.

Like the Mermaid chairs, the E-1027 villa was a labour of love by Gray, this time for a man. Jean Badovici, a Romanian architect fifteen years her junior, encouraged Gray to shift from furniture design to architecture. In the summer of 1924, she scoured the Côte d'Azur for an appropriate site, using a donkey to carry her luggage. Gray purchased a terrace on the cliffside above the Mediterranean, so inaccessible that building materials had to be carted in by wheelbarrow.

Gray spent three years building E-1027. She was extremely discreet about her private life, and it was typical that she chose a coded name for the villa, which she gave to Badovici. E was for Eileen, 10 for the J in Jean, 2 for the B in Badovici and 7 for the G in Gray.

The couple spent several summers together at E-1027, but Jean's drinking and womanising strained the relationship, and they parted amicably. The Franco-Swiss architect Le Corbusier stayed with them in the summer of 1937, praising Gray's 'rare spirit, which dictates all the organisation inside and out'.

Le Corbusier's return the following year was less happy. Without asking Gray's permission, the most famous architect of the twentieth century stripped naked to paint eight garish murals with black paint on the villa's blank walls. As Gray's biographer Paul Adam wrote, she considered it an act of vandalism: 'It was a rape. A fellow architect, a man she admired, had without her consent defaced her design.' In 1965, Le Corbusier died of a heart attack after swimming in the sea below the villa.

Italian and German soldiers occupied E-1027 during the Second World War. One of Le Corbusier's frescoes appears to have been used for target practice, or as the backdrop to an execution. Ironically, the existence of the frescoes Gray hated probably prevented the villa being razed. After Badovici's death in 1956, a friend of Le Corbusier's bought it. She willed it to her doctor, who allegedly used it for orgies with local boys. In 1996, the doctor was knifed to death by two vagrants whom he lodged in exchange for work in the garden.

Built on stilts above the sea, the white, ship-like structure of E-1027 is an icon of modern architecture. (The National Museum at Collins Barracks has Gray's original scale model.) Though classified as a historic monument since 1975, it remained derelict for decades. Curators have attempted to retrieve some of its original furnishings, and to replant the garden as it was in 1929. In

the summer of 2011, the 'Friends of E-1027' website said the villa would reopen in 2012.

The legacy of Eileen Gray, born in Enniscorthy, County Wexford, in 1878, now appears secure. Despite her aristocratic origins (her mother was a baroness), her privileged upbringing in Enniscorthy and Kensington, and the lack of material worries, Gray's life was not easy. None of her love affairs survived long. Badovici and Le Corbusier were mistakenly credited for her pioneering work at E-1027. The new house she built for herself after separating from Badovici, her apartment in Saint-Tropez and decades of work were destroyed in the Second World War.

'One must never look for happiness,' Gray once said. 'It passes you on your way, but always in the opposite direction. Sometimes I recognised it.'

Brian Maguire

In the Positive Spirit of Revenge

The Métro stations on the way to the Irish painter Brian Maguire's studio – Stalingrad, Crimea – conjure up images of hardship and war, which seems fitting for a painter whose biography on the Kerlin Gallery website notes: 'He has consistently brought his mordant wit and savage indignation to bear on the indignities inflicted on the oppressed individual.'

Maguire's habitat, in the far reaches of Paris's nineteenth *arrondissement*, is not, he jokes, 'a Gucci world'. Soviet-style concrete boxes line the boulevard de Flandres. Local residents are Asian, African and Arab, from all corners of France's former empire.

In our era of self-obsession and conspicuous consumption, Maguire is one of a dying breed: a genuine *artiste engagé*. He dismisses critics who believe that artists should be craftsmen tasked to create beauty. 'Picasso was attacked for being a member of the communist party, and he said: "What do you think we are? Monkeys who paint?" We are people. I have always been engaged in politics. Marxist criticism of society made sense.'

Maguire grew up in Bray, where his father was a chargehand in a shop. He became an artist because 'probably it was the only thing I was ever praised for'. He studied at the National College of Art and Design, where he became a professor and head of the faculty of fine art in 2000.

When I interviewed Maguire in 2008, he had spent the first half of a sabbatical from the NCAD producing eighteen paintings for exhibition at Dublin's Kerlin Gallery. He reserved the second half for working in Africa and teaching art in Ramallah, Palestine.

Even Maguire's decision to buy a studio in Paris was determined by international politics. He usually paints in the US every summer, in New York or Idaho. But in 2003, following the US invasion of Iraq, 'it was just the way America was going that year – I didn't want to spend money there, to tell you the truth'. So Maguire painted in Paris instead. He grew to like the working-class immigrant neighbourhood and purchased an airy studio above the print shop where the late Irish artist Michael Farrell made his lithographs.

'When I came to make this show, I was still wondering not so much about the events of Iraq, but about the debate that occurred and the Bush line that we're going to bring democracy to this country, which was never really challenged as hypocrisy,' Maguire said. 'So I began with two paintings: first [assassinated Chilean president Salvador] Allende and then [assassinated prime minister of Congo Patrice] Lumumba. These were two elected leaders of their countries, and American presidents ordered their removal from power and their executions . .

. . I felt that this information should have been part of the discussion, and it wasn't.'

Edvard Munch and Francis Bacon are the painters whom Maguire most admires. Both influences are clearly visible in his work. He considers himself an Expressionist, like the German painters of the 1930s.

In Maguire's mind, there is no break between the outrages of decades past and ongoing injustice. He has painted Tommie Smith, the black American gold medal winner who, with bronze medallist John Carlos, gave a black power salute on the podium at the 1968 Mexico Olympics. Both men were stripped of their medals and hounded by the FBI.

Maguire painted the banners of the Irish regiments who served with the British army, in Saint Patrick's Cathedral. 'It's as much a part of our history as anything, but it's lost. This is something that has become hidden. By painting it, I bring it out. If there's a logic behind my work, that's it,' he said.

Maguire called his show in the spring of 2008 'Hidden Islands: Notes from the War on the Poor'.

Maguire was scandalised by the gang war that had claimed the lives of thirteen young men in Crumlin in recent years. 'It came out of resentment over damage to a motorbike, for fuck's sake,' he said. 'The only response is a criminal justice response. There is no political response to this feud, no attempt at mediation, other than perhaps some priests. There's no use of the State apparatus.'

When Maguire represented Ireland at the 1998 São Paulo Biennale, he painted young criminals from headshots published in newspapers. The same method inspired his *Crumlin Youth*. Though Maguire has researched the Crumlin feud and knows 'who did what to whom', he made the face unrecognisable.

'I have tried to paint it in such a way that it shows what happened to him,' Maguire said. 'He's been wiped out. The painting is of a guy who's been erased.'

A triptych from Midleton, east Cork, was inspired by the town's former record as the world suicide capital. 'There is a walk where everyone who is buried killed himself,' Maguire said. 'When you enter, there's a dramatic national graveyard. As many people died fighting the British as those who died by their own hand one hundred years later. There's something in this All this work is an X. It's like making an X, making a mark and drawing attention to something.'

The father and brother of one of the suicide victims set up an organisation 'whose pride now rests in the fact that if they get a cry for help, they can have a counsellor with that person in seven minutes'. The suicide rate in Midleton fell from thirty-three to three over successive three-year periods.

But Maguire is still angry with the politicians. The hotline organisers in Midleton 'were going to push a coffin to Dublin to look for support', he recounted. 'They met the [then] prime minister, Bertie [Ahern], and he offered them €80,000. But they never got the money. I heard about it on a radio programme that follows up promises. They rang his unfortunate PR official, who hung up on them. The result was I went down to meet the guy. I was able to make a painting.'

An image resembling an infant in a pram was inspired by a prisoner Maguire saw strapped to a trolley and abandoned temporarily outside a police station in Brooklyn. 'I've worked in American prisons and I know how you become nothing,' he explained. 'You are just there to be ordered about, and you can be left on the side of the road.'

Guest Worker was inspired by the employment policies of Irish Ferries. It shows a man whose mouth is gagged, squatting on a weighing scale. 'The nature of being a guest worker is that you don't have a vote, you can't bring your family, and your value is in relation to your productivity – and this is why he's on a scales, with no

genitals and no voice,' Maguire said.

A large blue, green and grey canvas shows a supine figure being slotted into a brain scanner. Maguire became familiar with the machines when his own father suffered a stroke and, like many in Ireland, had to wait for a diagnosis.

But his anger over inadequate medical care in Ireland is tempered by outrage over conditions in Africa. 'They don't need it, because they're all dead at forty-one,' he said.

Brian Maguire in his Paris studio. Photo: Lara Marlowe.

'The average life expectancy is forty-one across central Africa, and it's eighty-two across northern Europe. It's a giant accusation, surely.'

I put it to Maguire that he is the last of the angry young men. He was fifty-seven at the time. 'I'm hardly young any more, for fuck's sake,' he said, laughing. 'For me, most art comes from a spirit of revenge, sometimes from a spirit of love, but not often.'

His own work comes 'mostly from the desire to say "this is happening", and that's seeking revenge for some kind of injustice.'

Yet the effect of Maguire's paintings is less bleak than you'd expect. 'If you say something with passion, if you are angry, in itself the thing is optimistic,' he says. He gestures to images of his paintings in a catalogue. There are bright oranges, turquoises, yellows. 'If you look at it from a distance, it is quite colourful.'

Maguire's work is represented in the collections of the Irish Museum of Modern Art and the Hugh Lane Gallery, as well as museums in Holland and Finland and private collections in the US and Germany.

'I've sold everything I've ever made,' he says. 'I don't know how this works, but it has worked. I have very little work in stock.'

One painting, of a classical French armchair, seemed out of character. 'The chair is like bourgeois life,' Maguire confessed. 'It was a gift, and it's quite comfortable. A lot of the deprivation and murder in the world happens so that people can have good suits, myself included. It's about power and wealth.'

Is a little luxury a bad thing, I asked. 'No,' he replies. 'I like the chair. I'm not a Calvinist. I didn't throw the chair out, and I'm not embarrassed by it. But I still see it has another meaning. I have as many contradictions as the next man.'

The Big House, 1990
© Brian Maguire. Image
courtesy of the Kerlin
Gallery, Dublin.

Mick O'Dea

Guests at an art-show opening usually glance at a few canvases, then concentrate on the more serious business of drinking and socialising. Not so the hundreds of people who came to see Mick O'Dea's *Un Salon* at the Irish College in Paris on 30 November 2006. Sixty people flew over from Dublin for the occasion. The walls of the gallery smiled, stared and frowned with something approaching real life. The crowd was mesmerised.

Many of the painter's three dozen sitters, of whom I was one, were present. Heads jerked back and forth, comparing the portraits to real-life models. O'Dea wanted to paint Irish people in Paris, and his selection included students, writers, actors, architects, a composer and a diplomat, as well as an ageing French couple who come to sit in the Irish College garden most afternoons.

Helen Carey, the college's then director, saw O'Dea's show 'Audience' at the Kevin Kavanagh Gallery in Dublin in 2004. To celebrate the tenth anniversary of his friend and agent's gallery, O'Dea had painted its patrons, whom he described as Celtic cubs. Carey and Kavanagh came up with the idea of a residency at the Irish College, to facilitate a similar undertaking in Paris. When he painted the 'Audience' series, O'Dea said, he wanted to capture the mood of the time, but without props such as mobile phones. So he painted everyone against a white wall, to suggest modern, well-lit interiors.

Even that concession to contemporary history slipped away in Paris. 'I absorbed a lot of lessons,' O'Dea said of his three-month stay. The day before he painted Cyril Brennan, the cultural attaché at the Irish embassy, O'Dea studied late eighteenth and early nineteenth century portraits at the Louvre. As a result, he painted Brennan against a dark background. A Titian exhibition at the Musée du Luxembourg confirmed O'Dea's shift to dark backdrops that bring out the face and hands. 'The portrait is a timeless thing,' he explained. The psychology of his subjects, not the century we live in, was what interested him in Paris.

Although it's not necessarily in his interest to do so, O'Dea works at incredible speed; he completed thirty-six paintings in just three months in Paris. 'There's a premium on hard-won paintings,' he said. 'People say, "So-and-so produces only a few paintings a year", and that makes them more valuable. Such thinking would have doomed Picasso. I am very prolific. I don't have a nine-to-five approach, but there are periods of high intensity and productivity, and this is one of them. When I have the bit between my teeth and I can't wait to go, I feel quite single-minded.'

*Thomas Jordan and
Catherine Lascroux* 2006
© Mick O'Dea. Image
courtesy of the Kevin
Kavanagh Gallery, Dublin.

O'Dea's portraits are a relief from contemporary art that often seems inaccessible, even incomprehensible. 'I really have a problem with art that makes people feel stupid,' he said. 'A lot of art does; I think maybe because the artists are stupid.' He isn't bothered by snobs who call portrait painters "mimetic" or "merely representational".

'The implication is: "Poor bastards; sad they don't have much of an imagination",' O'Dea said with a laugh. His paintings are often about the invisible threads between people: husband and wife, lovers, or more obscure ties of past relationships.

Marguerite Baratin, who is eighty-six, dropped by O'Dea's studio in the college to look at his work. 'She returned the next day and asked if I would paint her husband, Henry-Louis. I said I wanted to paint them both in their apartment.' The elderly couple didn't mind O'Dea dismantling their front door to bring in his easel, a huge contraption that can be hand-cranked up, down and sideways. They gave him lunch every day and talked about Irish literature and Henry-Louis's career at the United Nations. Baratin said O'Dea reminded her of her late brother-in-law, a painter whose canvases of her as a young beauty hang in their apartment. 'It was an opportunity for me to paint a French interior,' O'Dea said. 'The fireplace, panelling and mirror were important elements for me to get a sense of place that the other portraits don't have. It's a homage to Vuillard as well as Bonnard.'

The bonds between other couples painted by O'Dea – Loughlin Deegan, director of the Dublin Theatre Festival, and Denis Looby, an architect; the cabinet-maker Thomas Jordan and his wife, Catherine Lascroux, a picture restorer – were obvious. But every portrait contained a story within a story. O'Dea recalled Jordan's late mother, Peggy, once his neighbour in Rathgar, who persuaded him to hang bird feeders in his cherry tree so she could watch the birds from her bed.

The father of the diplomat Cyril Brennan, also called Cyril, was O'Dea's teacher when he was twelve. '"Michael is good at painting and should be encouraged", he wrote in my school report in Ennis,' O'Dea recalled. 'I met him in a supermarket fifteen years ago and told him how much that report meant to me. When I met Cyril two months ago he said: "You know my father." I had to paint him; I wanted to complete a circle.'

O'Dea's portrait of the architect Patrick Mellett captures Mellett's personality to perfection. For the first hour and a half of the sitting, O'Dea despaired as Mellett fidgeted. 'We scrapped it altogether, had a cup of coffee and started over,' he recounted. 'He got me into his focus, and I got him into mine. Suddenly the man who didn't have much time said: "Take your time." I didn't show it to him until it was completed, and it had the profound effect of something achieved through collaboration. I told him how remarkable I thought it was.'

Painter and subject jumped on their bicycles and cycled across Paris, looking for a bistro. They ended up at La Coupole, where Picasso, Modigliani and others traded paintings for drinks before the First World War. O'Dea ordered a bottle of Dom Perignon to celebrate their portrait. 'We did it in style,' he said. 'It was a great night; a real buzz.'

O'Dea is on the council of the Royal Hibernian Academy and has taught in more art schools, won more awards and exhibited in more galleries and museums than you can list. Is he an establishment painter? 'I suppose I am now,' he said, laughing. 'I never had a hankering to be starving. I am who I am. I feel comfortable with who I am.'

The Baratins, 2006 © Mick O'Dea. Image courtesy of the Kevin Kavanagh Gallery, Dublin.

At the same time O'Dea was boyish at age forty-eight, with a strong sense of fun and friendship. 'One of the beauties of being an artist is that you never quite grow up,' he said. 'Not much has changed for me since my student days.' O'Dea's father, also called Mick, used to quote George Bernard Shaw to him: 'Never let your schooling interfere with your education.' His mother, Margaret, née O'Brien, worked as a nurse in London during the war.

His parents met after his father returned to Ennis from Boston in 1939 and bought a farm and pub with his hard-earned dollars. 'Being brought up in a pub helped me become a painter,' O'Dea said. 'Behind the counter is almost like an easel. You have a job to do, but you're with people all the time.' One of his uncles is Martin Hayes, the well-known fiddler. 'East Clare fiddle playing is rolling and soft,' he said. 'When I hear it, I see the Clare landscape. The topography and people have influenced me, the same way they influence Clare musicians.'

Under Helen Carey and then Sheila Pratschke, the Irish College became a focal point of creative endeavour, not unlike Montparnasse in the early twentieth century. 'So many amazing people pass through the door, and it's easy for me to grab them and paint them,' O'Dea said. He met – and painted – the writer and director Gerry Stembridge, the dramatist Bryan Delaney, the French scholar Dr Angela Ryan of University College Cork, the composer Roger Doyle, the actor Michael Harding Delaney took O'Dea to French theatres. Although he couldn't always understand the language, his work was influenced by 'the physicality, the drama, the lighting'.

O'Dea painted the curator Jobst Graeve bare-chested, wearing a kilt designed by Jean Paul Gaultier. The effect is neo-classical and theatrical. So, too, is O'Dea's portrait of Jackie Blackman, a Beckett scholar from Trinity College Dublin, who appears in a red turban. Harding is portrayed as he played Jonathan Swift. 'It's something new for me to paint someone trying to occupy someone else's persona.'

I didn't take seriously enough O'Dea's warning that one must have courage to sit for a portrait. One rainy afternoon in November I stood still for six hours in O'Dea's studio. The result surprised us both: a canvas that was at the same time me and not me; well executed but not flattering, almost disturbing. Alone among the three dozen paintings, he labelled it a study, 'because I couldn't put your name down emphatically'.

Carey Clarke, a former president of the Royal Hibernian Academy who travelled to Paris for the show opening, said my portrait resembled a Kees van Dongen. There was something 'Goyaesque' about it, O'Dea said. It reminded Carey of the painting of Carlotta in Alfred Hitchcock's *Vertigo*. 'It's enigmatic, elusive. You can't quite get a grip on it,' she said, concluding: 'It's spooky.'

Anthony Palliser

Painting the Great and the Good

Anthony Palliser's love affair with Ireland began decades ago, with a chance encounter at a society wedding in Paris, on an island in the Bois de Boulogne.

'There was a punt to and from the island,' recalls Garech de Brún, a wealthy patron of Irish arts and traditional music. 'Anthony and I found the punt very agreeable, so we went backwards and forwards until the punters threw us off.' Palliser became a regular visitor at Luggala, the estate in the Wicklow mountains which de Brún inherited from his mother, Oonagh Guinness. There, the Anglo-Belgian painter met, befriended and painted other guests.

In 1981, when de Brún married an Indian princess, the daughter of a maharaja, Palliser was his best man.

In the early 1990s, de Brún and Palliser were drinking at the bar of the Ritz Hotel in Paris when they ran into Charlie Haughey and entourage. The taoiseach and his friends ended up in Palliser's studio, admiring his paintings. The architect Arthur Gibney invited Palliser to exhibit at the Royal Hibernian Academy, which he did in 1993.

The Mountains at Luggala, painted from a visit to de Brún's Irish home, is one of Palliser's finest landscapes. 'When I do landscapes, I fall in love with one specific place,' he explains. 'And I fell in love with this hawthorn tree, which is the only tree for miles. Garech told me with great solemnity that no one in Ireland cut hawthorns, because that's where the fairies live. It's been battered by the winds and the elements, but it still stands, in the surrounding magnificence of the mountains.'

De Brún owns several of Palliser's paintings, but he was most impressed with the series of *Thirteen Large Heads*, which the painter exhibited at the Ricard Foundation in Paris in 2005. 'Those huge portraits are absolutely extraordinary. I don't think I've seen anything quite like them,' de Brún says. 'When Anthony hung them in the Ricard exhibition, they were devastatingly impressive.' Palliser was despondent about the art market when he started the *Large Heads*, and told his American wife Diane, 'I am going to paint huge, unsellable pictures.'

If there has been a shadow over Palliser's charmed existence, it has been the struggle to pay the rent on the couple's ground-floor apartment in a leafy lane off the rue du Bac, and to fund the generous dinners they regale their many friends with.

The painter is the son of Sir Michael Palliser, long the permanent undersecretary of the British Foreign Office, and Marie Spaak, the daughter of Paul-Henri Spaak, the Belgian statesman who was one of the founders of what is now the European Union. One great-uncle was the

screenwriter for Jean Renoir's *La Grande Illusion*. Another was the writer who 'discovered' the painters Magritte and Delvaux.

But Palliser's distinguished family left him no material wealth; he describes himself as 'a starving artist on a diet' and is proud to have kept the artistic faith through hardship. 'The show at the Ricard Foundation changed things; I'm in the black for the first time since I was eighteen,' he says. He has since received commissions from two of France's wealthiest families, the Rothschilds and the Bouygues.

Bill Whelan, the Irish Grammy award-winning composer of *Riverdance*, tagged along to one of the Pallisers' dinner parties in the early 2000s. He purchased a sensual nude, and the men became friends. Palliser painted the view of *Twelve Pins* from the Whelans' home in Connemara, and Bill's wife Denise commissioned a drawing of her husband's face.

'Anthony's portraiture has a way of telling you something about the person,' says Bill Whelan. 'It's not just representative. He seems to be able to catch something essential. When my children saw the picture of me, they said, "Oh my God. That's you, Dad. And not in the same way a photograph is." I found it extremely unsettling. It wasn't like looking in a mirror. It was like looking at yourself.' Palliser has also painted Maurice Cassidy, a close friend of Whelan and the manager for *Riverdance*, and Paddy Moloney, with whom de Brún founded Claddagh Records.

'Garech is very much the pivot, the great introducer with everything Irish,' says Palliser. De Brún proposed that Palliser paint a series of Irish poets. 'Ireland is probably the only country where you could say, "Irish poets",' Palliser comments. 'If you said "French poets", you'd be rather stretched.'

Palliser had already painted the dramatist Brian Friel when he telephoned Seamus Heaney to ask for a sitting in 2010. 'Brother Friel speaks well of you,' Heaney told him. Upon leaving Heaney's home in Sandymount, Palliser says he was 'walking on air – that's what very gifted people do to you.'

Other Irish writers painted by Palliser include Nuala ní Dhomhnaill, Thomas Kinsella, Derek Mahon, John Montague and Colm Tóibín. 'I've been struck by how warmly they all speak of each other,' Palliser says. He has also painted the film directors John Boormann, Neil Jordan and Jim Sheridan.

'People were amazed that I got Thomas Kinsella to sit for me,' Palliser says. After de Brún gave Kinsella a copy of Palliser's book, the poet sent 'a perfectly adorable letter about how proud he'd be to be painted by me. This is unthinkable in any country but Ireland. How seriously people take themselves in England.'

Of John Montague, Palliser says, 'He has a very weathered face, and incredibly blue eyes, but usually the eyes are just slits and he constantly looks as if he's about to burst into fits of laughter.'

Something about Derek Mahon fascinated Palliser, who has drawn and painted the poet five times. 'He came out fairly tortured,' Palliser admits, looking at one painting. Palliser writes poetry himself, and says he was so impressed by Mahon's work that it inhibited him. 'The breadth of Derek's poetry was such that – a bit like the first time I saw a Goya painting – I was completely knocked off my horse and I said this to him and he looked at me very sweetly and said, "But Anthony, there are many ways of doing this".'

Mahon visited the Pallisers in Diane's home town of Savannah, Georgia, where they spend several months each year. Palliser was thrilled when Mahon included a poem dedicated to him and Diane, entitled 'Savannah Dock', in his volume of *Art Notes*, along with poems to Magritte, de Staël, Braque and other great painters.

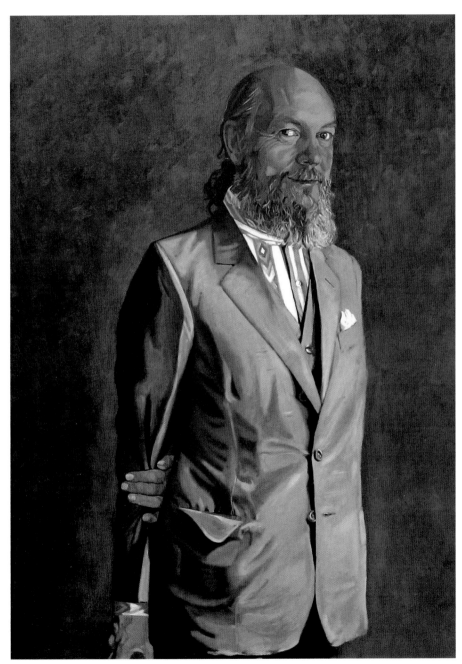

Garech Browne, 1993 ©
Anthony Palliser.

Mahon describes Diane in one of Palliser's paintings: 'There you are, coming from your wooden wharf/ as if in a photograph or a home movie./ Perhaps you've been for a swim, a lazy sail/ on the great river' The Irish poet understands the tranquillity that Diane has brought to the painter: 'Be life as gentle in your scented air/ and the art flourish that you nourish there/ in peace and quiet, far from the marketplace.'

Palliser loves the disregard for social class and absence of snobbery in Ireland. 'If I'm admired, it's for my work, not because I'm in the National [Portrait Gallery in London]. They don't like someone just because they're in a great gallery or something. The important thing is the work, and getting on with people.'

Palliser had to convince Graham Greene to allow himself to be painted for the National Portrait Gallery. 'The last thing in the world he wanted was to be painted,' he recalls. 'I persisted and he finally relented – I suspected because my father was then at the Foreign Office, and is a Catholic.'

Palliser went to Greene's home in Antibes every morning for five days. 'Around noon he'd say "opening time" and we'd go to the kitchen and make a dry martini, and then we'd go and have lunch [at] Chez Félix When he walked me to the station, he told me he thought it was going to be a nightmare, but it proved to be quite pleasant. As I waved goodbye from my train window, I thought, "I'll love this man forever". And indeed, every time he came to Paris, which was two or three times a year, we'd always meet up.'

The list of Palliser's friends and portrait subjects reads like a who's who of contemporary European culture. The actresses Charlotte Rampling, Kristin Scott Thomas and Helena Bonham Carter are among them, along with the late French philosopher Jean Baudrillard.

How does he know so many famous people, I ask him? 'It just happens. Literally,' Palliser replies. 'Fame in itself doesn't interest me, but a fair number of famous people are famous for a good reason.' He tells of his godfather, a learned Belgian diplomat named André de Staercke, who was a close friend of André Malraux and Brigitte Bardot. 'How do you know all these incredible people?' Palliser asked him. 'André said, "Once you know one of them, you know them all".'

Palliser's gift for friendship and conviviality is almost on a par with his artistic talent. His poem 'A Painter's Luck' conveys his delight in painting and joie de vivre: 'A sleeping city watching a girl/ A musician lost in noise/ An angry cat/ Friends that died/ Lovers married long ago/ Lucky me/ There I was/ And painted that.'

The Mountains of Luggala, 1995 © Anthony Palliser.

Olwen Fouéré

The Liberation of Paula Spencer

'Question me. Question me.' A raspy woman's voice, speaking French with a hint of an Irish accent, pierces the pitch-black theatre. 'Go ahead. He beat me with his fists, with his head, kicked me with his feet. For seventeen years' By the time the spotlight illuminates the face of the Franco-Irish actress Olwen Fouéré, the audience has been drawn into the life of Paula Spencer, former battered wife and alcoholic, mother of four, self-liberated cleaning woman.

For seventy minutes, Fouéré captivates, mesmerises. Alone on stage, she brings a cast of unseen, unheard characters to life: Charlo Spencer, the late, abusive husband; four children, sisters, a new male friend. As a French reviewer notes, Fouéré acts from her guts, 'gives this character presence, physicality and a dazzling voice'.

Fouéré's monologue has been adapted by the French director Michel Abécassis from two Roddy Doyle novels – *The Woman Who Walked into Doors* and *Paula Spencer* – to become *Paula Spencer: La Femme Qui se Cognait dans les Portes.*

The French embassy in Dublin chose Abécassis for a Franco-Irish 'tandem' project as part of France's 2008 EU presidency. Sheila Pratschke, the director of the Irish College in Paris, told him: 'If you want to produce something like that, you must work with Olwen Fouéré, who is one of Ireland's greatest actresses and who also speaks French.'

Fouéré told Abécassis: 'I'm not interested in going on stage and being a victim and wailing about what's happened. This woman has to be a survivor. She has to be full of life-force.'

Paula Spencer opened the 2008 autumn Irish cultural season in Paris. Fouéré and Abécassis then took it to eleven venues across France, and to the Project Arts Centre in Dublin, with English subtitles.

Fouéré started out at the Project with Jim and Peter Sheridan in the mid-1970s. That was a high point, along with other periods of creative collaboration, she says: with the visual artist James Coleman, the composer Roger Doyle (with whom she founded the Operating Theatre company), playwright Marina Carr and directors Selina Cartmell and Michael Keegan-Dolan.

Your average French actor might shrink from the raw language, violence and total absence of glamour in *Paula Spencer.* 'I don't find it humiliating,' Fouéré says. 'I wasn't conscious of being ugly or beautiful. I enjoy turning myself inside out and being something slightly disturbing. I like going to extremes, where you're crossing a boundary into some kind of disturbance of the waters in terms of your relationship with an audience.'

Fouéré long felt torn between experimental and mainstream theatre. Since 1976 she has done a phenomenal amount of both, working with virtually every leading Irish playwright and director, acting at the Abbey and the Gate, with the Royal Shakespeare Company, as well as avant-garde theatres.

Paula Spencer is not the most extreme role Fouéré has played. *Here Lies in film . . .*, the digital version of a live installation she performed at the Irish College in 2005, showed at the Temple Bar Gallery Studios in Dublin in the autumn of 2008. In it, Fouéré played the mad French writer and actor Antonin Artaud, who visited Ireland in 1937, carrying a cane he believed to be the staff of Saint Patrick.

'I was confined in a glass box for three to four hours. I had a three-hour make-up job for it,' Fouéré recalls. 'By the end of it, everything was peeling: my make-up, my latex, my wig, but me too. I came out of it in an altered state, every time.'

In 2005, Fouéré recorded French and English versions of the text for *Here Lies*, which visitors listened to on headsets. As she lay in the glass box – a replica of Artaud's room at the Imperial Hotel in Galway – she recited to herself the words of a letter that Artaud had written in an asylum, six months after his visit to Ireland, describing what happened to him.

At the age of three, Fouéré says, she had 'a linguistic identity crisis'. Her parents, who had emigrated from Brittany to Ireland, spoke French at home, but little Olwen refused to speak her mother tongue for years.

'I felt so different in both languages, and both were associated with completely different things,' she explains. 'French was the inside – home. English was outside, and that was what I wanted to belong to – that open landscape, all these people I met every day. I never felt integrated. It's only through my work in the theatre that I began to

experience a kind of assimilation and integration into Irish life.'

As a child, Fouéré was barely aware of the scandal that dogged her father, the Breton nationalist Yann Fouéré. For having served as a minor official during the German occupation, and for publishing a Breton newspaper during the same period, he was arrested and charged as a collaborator at the liberation. He served a year in prison, then went into hiding, fled to Wales and eventually settled at Aughrusbeg, near Cleggan in County Galway. He was sentenced in absentia to twenty years' hard labour, but all charges against him were dropped in 1955.

Yann Fouéré was ninety-eight years old when I interviewed Olwen. 'He never talked about it,' she said. 'He would go up to his study every night and continue writing articles and books, his political work. We weren't part of it. But we've inherited aspects of his work, in the sense that most of us have a radical, rebellious streak.'

The aftermath of the Second World War was particularly hard on Fouéré's mother, Marie-Madeleine, who was ninety-one when I met Olwen at the Irish College. The post-war period was a time of settling scores in France, when some ten thousand French people were killed, the majority in summary executions. 'She's very marked by it; it's part of her general anxiety,' the actress said. 'She had a hard time when my father was in prison. They put a sign on her door saying, 'This is the house of a collaborator'. They refused to serve her in a shop. She was a woman facing this alone, with two small children.'

Fouéré sees her father's work as 'a cultural struggle for the Breton language and minority cultures in Europe' as indicated by *Europe of 100 Flags*, the title of a book he wrote in the 1950s.

So in what way is Olwen Fouéré, *grande dame* of Irish theatre, a 'radical'? 'I would certainly see a lot of my work as a form of resistance,' she says. 'It's carving an alternative space. There's resistance to ideas that don't conform to

concepts of what theatre or art should be. I do not see my work as being about fitting in.' Aughrusbeg is the only place where she feels at home, Fouéré says. The house her family lends her in Ranelagh is just a base, 'where I leave my clothes and books'.

She often works at night, eats when she is hungry. There are two men in her life: one in a separate apartment in the same building, the other ten minutes away. 'They know each other. It's just something that happened and something valuable that I would hate to deny, but at the same time something I don't particularly want to talk about It's one of those situations you don't think is going to last, and it's been thirteen years now.'

In 2004, Fouéré was knocked down by a jeep on Camden Street in Dublin. She spent two months in hospital, yet she transformed what most people would regard as a horrific ordeal into 'a highly theatrical experience'. She turns our interview into a mini-performance, imitating Peter, the homeless man on the hospital trolley beside hers, an old woman who tried to leave the hospital in the middle of the night, another who sang 'Take these chains from my heart and set me free'.

Twice since she became an actress in 1976, Olwen Fouéré contemplated

stopping work: when she was pregnant in 1985, and again in 1991. Her daughter Morgane died two days after birth. Her son Jo-Jo was stillborn. Fouéré is determined to find something positive in pain. 'I feel blessed that I had the experience,' she says. 'I had an opportunity to experience motherhood, to experience the tragedy of loss, but also the positive energy that can come out of things you will never have again.'

The death of her babies meant Fouéré never had to choose between the stage, which she calls 'my life', and raising children. 'At the time, I wanted children, but I knew I couldn't combine the two things,' she says. 'My work is consummate; it takes up every moment. I cannot split myself. '

Olwen Fouéré Photo: Cyril Byrne/Irish Times.

Maud Cotter

Materials Girl

In a career spanning three decades, the Irish artist Maud Cotter has constantly changed materials and forms, each time reinventing contemporary sculpture.

A piece entitled *So far as it goes* is a clear glass coffee cup and saucer with a white substance that appears to be milk tilting diagonally inside. This is Maud Cotter at her usual game, upsetting our notions of reality, playfully defying the law of gravity.

The sculpture was used by the Irish College in Paris to publicise Cotter's residency for three months in 2008. Cotter traces the idea to its moment of origin: 'I ordered hot chocolate in Le Rostand café, by the Luxembourg Gardens,' she recalls. 'They tilted the chocolate to one side and the other. The gentility of the gesture and the spatial sophistication of the cup kept playing in my mind.'

Cotter made metal and glass shapes in the mid-1990s, and net-like structures in Lafarge model plaster around 2000. She has used cardboard, wax and PVC, turned to cast-off furniture endowed with 'emotional residue' to construct disturbing animal-mineral hybrids for her show *The cat's pyjamas* in 2004, and built towers from interlocking birch ply squares to explore the late architect and artist Frederick Kiesler's concept of infinite architecture in her 'More than anything' exhibition. Cotter has shown her work in galleries too numerous to list, across Ireland, Europe and the US, with poetic labels such as *My tender shell* and *In absence*.

Since that moment in Le Rostand café, Cotter has had a thing about cups and saucers: plain 1960s' ones 'if I'm weeding out the functionality of an object'; a short one with rose posies, discovered at the Porte de Vanves flea market, for a sculpture entitled *Slip of the tongue*. 'It was a mischievous little cup,' Cotter explains. 'It's so short, it's unambitious. It's a bit fuddy-duddy as well, because the roses are not exactly focused. I like objects that mimic objects. They're very modest. They're not very refined, but they mimic objects of refinement, ones that would be better made than themselves.'

Cotter piled Lafarge plaster into the rose posy cup 'in the way a child might play with their ice cream That was a kind of very oral feeling'. She added what might be interpreted as body parts: a bright yellow kidney or liver, a hot pink lipstick or nipple. 'It had that feeling of being intimately connected with some interiority of the body,' she admits.

Lafarge plaster, a stone composite that is twenty times harder than normal plaster, is one of Cotter's favourite sculpting materials. Sometimes it looks like melted candles. At other times it appears to have been moulded by hand. 'I don't actually touch it,' she explains. 'I get it to the right kind of temperament. Sometimes it's very flowing. Sometimes it gets a bit angry and fraught, or it wrinkles.

I can use it at the point that I like I pour it, and it hardens.'

Cotter's coffee cup period has not been dictated by Paris's status as café capital of the world, but by philosophical musings. 'I felt the cup was a territory of crisis,' she explains. 'Extrusions from the mouth, conversation and articulation are major arteries through which we communicate with the world. So I saw it as something deeply psychological.'

By filling her coffee cups with Lafarge plaster extrusions resembling ectoplasm (in the nineteenth century, emanations from the bodies of mediums), Cotter has, she says, 'imparted or implanted dysfunction and/or angst into the cup'.

Cotter has almost exhausted the cup cycle and is about to move on to 'another scale of engagement'. Yet, despite the ever-changing themes and styles, there is a continuity in her oeuvre. 'I see all my one-person shows as being connected with one quest, with one pursuit of the same problem in different ways: the whole question of our consciousness and material bodies in the material world, how those relationships play out,' she explains.

Without pretence, Cotter explains her work by quoting Vilém Flusser, Maurice Merleau-Ponty and Ludwig Wittgenstein, all European philosophers who died in the second half of the twentieth century.

Cotter was profoundly influenced by Merleau-Ponty's *The Primacy of Perception*. His description of 'the interior and the exterior world, and the internalisation of the exterior, and the transformation of information in the subconscious and the conscious mind, and how one processes it and how one is phenomenologically connected to everything' instantly rang true for her. 'This is a very important foundation to my work,' Cotter continues. 'This notion that one isn't exactly thick-skinned as much as thin-skinned, that one is in a state of interconnection with everything. Merleau-Ponty

describes our psychic, conscious relationship with the world as one of such depth and interconnection.'

Cotter's obsession with the boundaries – or lack thereof – between physicality and consciousness informs all her work. She wants, she says, to cast doubt on the world as we think we know it, and on our understanding of ourselves. Mirrors are a favourite theme 'because mirrors prompt one to consider another reality, another parallel world that runs alongside the real one'.

A prolific artist, Cotter says she was 'always in a hurry, a bit driven I think one of the more essential realities is material. I find discovering the nature of material and how it behaves spatially and how we interact with it is fundamental'. She worries that twenty or thirty more years may not be sufficient for her to explore all her ideas. She started early, as a child in Wexford, making 'Aladdin's boxes' from cheese containers, and frightening her family with a dressmaker's model she disguised and propped on a bed.

Though she is deeply attached to her home, husband and studio in Shandon, Cork, Cotter says an Arts Council travel grant to New York and the residency in the Irish College in Paris helped her. 'I can see that my work has reached certain points of clarity and then delved back down into a different layer of the problem,' she says.

In Paris, Cotter made frequent visits to the Louvre, where she filled a sketch book with details of masterpieces, always copying the part where she thought the energy was concentrated. 'Paris is interesting because of its historicity,' she says. 'I keep thinking of it as a pool that creates this sensation of a city that is quite liquid, but has packages woven together, private possession locked into systems. I like testing my ideas on a city like Paris, that has a very different sensory structure to New York.'

While 'trawling' through bric-à-brac shops in the rue d'Alésia, Cotter found a narrow, mirror-studded console table which she transformed into a work of art entitled

Console with objects that are no longer themselves.

'I lost a night's sleep over this one,' she says, laughing at her purchase of the table. 'It doesn't matter; I just had to have it. It's a reproduction. It's been a long time since I saw an object that displayed so arrogantly its lack of function, with such ambition. It's to hold things, but when you look in, it holds them on the thinnest of transparent glass. It promises something, and then there's a void at its centre.'

After haggling down the price in the French she learned at the Alliance Française, Cotter added Lafarge plaster extrusions from coffee cups to the top of the console. She discovered that 'what this one had to offer was its haunted shadow' and replicated one of the extrusions beneath the console in plaster. Its image, seen through the glass, mixes with the reflected images of other objects on top of the console. 'There's a cluster of things that exist and things that are shadows of things that exist,' Cotter explains.

For Cotter, *Console with objects* is a paradigm of the human condition. She says she's trying to show that 'things are not fixed within their boundaries. They harbour other energies. They are hosts to other growths and things. There's a kind of complex of parallel existences.'

Cotter made *Welcome to other forms of propagation* from a gold tea-set, Lafarge plaster, a mirrored table, and yellow plastic vertebrae from a dinosaur kit she bought in London. 'It is the most decorative piece,' she admits. 'I try to keep it more biomorphic than decorative. I try to avoid it, but obviously there's some point at which I just kind of enjoy it.'

Maud Cotter during her 2008 residency at the Irish College in Paris. Photo: Lara Marlowe.

Police Chief's Passion for Irish Music Resounds through the Century

How dignified Captain Francis O'Neill looks in the sepia portrait photograph, taken in 1901 and reproduced in the US Library of Congress's *American Folklife Center News*.

The Chicago police chief's visored cap is embroidered with the words 'Gen Superintendent' wreathed in laurels. The stars around his collar echo the larger star pinned on his chest. Gold buttons shine on his double-breasted jacket.

The greying temples suggest wisdom and authority; O'Neill would have been fifty-three at the time, but there's a far-away look in his eyes, the hint of an artist in the shaggy moustache.

O'Neill was by all accounts an exemplary police chief, whose passion for Irish music endeared him to the denizens of Chicago. Junior officers played music with him and joined in his quest for Irish tunes. The force's hierarchy broke down when lowly sergeants burst into O'Neill's office unannounced.

On one occasion, O'Neill was believed to be hot on the trail of a murder suspect. Engulfed by reporters on returning to headquarters, he announced he'd found a ninety-three-year-old Irishwoman who 'had a tune' he had never heard, *The Little Red Hen*.

Another time, O'Neill was rumoured to have been assassinated, but was eventually found playing music in the home of Sergeant James O'Neill (no relation), a fiddler who transcribed music for the superintendent.

Francis O'Neill was himself an accomplished flautist and player of the uilleann pipes. He collected more than 3,500 Irish tunes, said Nancy Groce, an ethnomusicologist at the Library of Congress's American Folklife Center. 'He is really legendary, one of the great folklore collectors of all time.'

Most collectors were not musicians, Groce said, so they sought lyrics only. Furthermore, 'unless you are a really good musician, transcribing Irish tunes is very difficult. They are fast, there are a lot of notes and nuances.'

O'Neill also recorded music played by the Irish Music Club of Chicago – over which he presided from 1901 – on dozens of wax cylinders. Thirty of the cylinders found their way to the music department at University College Cork, but the rest were believed lost until 2003.

David Dunn, a Milwaukee doctor, was rummaging in the attic for his grandfather Michael's fireman's coat and hat when he happened upon the treasure of thirty-two more cylinders. Michael and Francis had been friends and played music together.

The Dunn family donated the cylinders to the Ward Irish Music Archives in Milwaukee, who lent them to the Library of Congress for digitalisation. Today, they can be listened to or purchased on Milwaukee Irish Fest's website, *irishfest.com*.

'Francis O'Neill is one of the most powerful symbols of the role that Irish America plays in the history of Irish art and culture,' said Eugene Downes, the chief executive of Culture Ireland.

'The work he did at a time when there was not a culture of preservation, of transmission, was extraordinarily original and comprehensive. The fact that he combined this with the job of police chief in one of the toughest metropolises in America is amazing.'

The five books which O'Neill published 'not only were important in the US,' Dr Groce said. 'They went back to Ireland, where they have been used for the whole Irish traditional music renaissance.'

O'Neill's descendants from Chicago include the dancer and choreographer Michael Flatley, fiddle-player Liz Carroll and guitarist Dennis Cahill.

Cahill and Martin Hayes, the fiddle-player who emigrated from County Clare, figured prominently in Culture Ireland's 2011 Imagine Ireland season in the US.

Francis O'Neill was born in Skibbereen, County Cork in 1848. At the age of seventeen, he secured work as a ship's cabin boy and sailed around Africa, Asia, Europe and the Americas.

After his ship sank on a coral reef in the Pacific, indigenous sailors rescued the crew but put them on starvation rations. 'One of the Kanakas had a fine flute,' O'Neill wrote years later. He showed the sailor what could be done. 'My dusky brother musician cheerfully shared his "poi" and canned salmon with me thereafter.'

O'Neill appears to have owed his appointment as police chief to his musical talent as well.

He and Irish friends met to play at the home of Kate Doyle, a retired governess, on Sundays. The *Chicago Daily Tribune* recounted how Doyle called on Mayor Carter Harrison, whom she had helped to raise, in 1901. 'Carter, I'm going to ask a great favour of you,' Doyle reportedly said, 'but *gra machree*, I know you'll do it for Kate

What brought me here was to ask you if you would appoint my old friend, Francis O'Neill, chief.'

O'Neill's marvellous life was darkened by tragedy. He and his wife had ten children, six of whom died of illness. After their last son passed away in 1904, no music was ever played in their home again, out of respect for Mrs O'Neill in her mourning.

O'Neill continued to play elsewhere, but he distributed his phonograph and cylinders among friends.

Publicity photograph of Francis O'Neill as General Superintendent of Police, Chicago, ca. 1901.
Courtesy of Stephen Winick..

Recreating Joyce's 'The Dead' at American soirées

Stella O'Leary holds a dinner party every 6 January, based on James Joyce's masterpiece short story 'The Dead.' As Joyce wrote of the Misses Morkan's Feast of the Epiphany dinner, never once has the celebration fallen flat.

The evening is carefully choreographed. Every guest – gentlemen in dinner suits, ladies in period dresses – is a performer. O'Leary spends two weeks preparing the feast.

'It gives me the chance to renew friendships, to enjoy the camaraderie,' she says.

O'Leary shares an old house in Washington with her partner of nearly four decades, Tom Halton, a retired professor of Greek and Latin at the Catholic University. On this twelfth and last night of Christmas, garlands and fairy lights decorate the front porch. O'Leary welcomes guests in a white lace dress, circa 1915.

In the first act of dinner, guests stand before a table laden with white linen cloth, red glasses and food.

Michael Whelan, who in real life conducts seminars on business writing for the World Bank, reads from 'The Dead.'

Guests point to 'a fat brown goose . . . on a bed of creased paper strewn with sprigs of parsley . . . a great ham stripped of its outer skin and peppered over with crust crumbs, a neat paper frill round its shin and beside this, a round of spiced beef'. No detail of Joyce's description is forgotten.

Guests include three former priests, a full range of Irish and American accents and a strong contingent of members of the US Republican Party.

But Ireland's great writers, actors, and music – not politics – are the ties that bind us this evening. O'Leary is a committed Democrat who is close to the Clintons, but she is bipartisan in friendship. 'The common interest is Ireland and County Cavan,' she says.

O'Leary's partner, Halton, was born a few miles from Ballyjamesduff, so *Come Back Paddy Reilly* is sung for him.

In their years with the World Bank, Michael O'Farrell, also from Cavan, and his wife Catherine have hosted Cavan nights in India, Africa and the Balkans. Tom Corcoran left economic hardship in Cavan in 1958, at the age of thirteen, to become an aerospace executive in the US. He and Jack McDonnell, who sought his fortune in US telecommunications, are members of the Taoiseach's economic advisory board.

Angela Moore, an Irishwoman from Newry with a golden voice, joins McDonnell in singing *The Lass of Aughrim*. Gabriel Conroy's speech about 'the tradition of genuine warm-hearted courteous Irish hospitality' rings especially true.

The Irish in America are more likely to go to Florida than the monks at Mount Melleray to recover from holiday excesses, and iPhones are today's modern

innovation – the equivalent of galoshes in Joyce's story.

O'Leary recalls starting her Dead dinners the year John Huston's film came out. It takes Ambassador Michael Collins just a few seconds to find the year of Huston's film on his iPhone. O'Leary gasps and crosses herself, saying '87, 97 . . . so it's twenty-two years'. Guests sing the lyrics of Thomas Moore's 'Endearing Young Charms' from their iPhone screens.

As McDonnell reads Gabriel Conroy's closing speech, a website news photo of snowy Ireland is passed around the table on a phone.

On that January night in 2010, thoughts of the dead included Cardinal Cahal Daly, who died on 31 December 2009. Halton knew him decades ago at Maynooth and had just received a Christmas card signed by Daly in Belfast on 16 December.

In New York, then consul general Niall Burgess and his wife Marie also held an annual 'Dead' dinner. 'This year [2010] was particularly poignant, because we had invited Donal Donnelly, and we used the occasion to remember him,' Burgess said.

Donnelly, who played the endearing, sentimental drunk Freddie Malins in Huston's film, died on 4 January 2010, in Chicago.

O'Leary's guests were from the business and diplomatic community. New York is the capital of culture, though, and Burgess's friends included the novelist Colum McCann, who won the National Book Award in November 2009, the Tony award-winning actor Jim Norton, and Gabriel Byrne.

'Byrne spoke very movingly of all Donnelly's performances, said he should have won an Oscar for his role as Freddie Malins,' Burgess recounted.

'Just as the English have *A Christmas Carol* and the Welsh have *A Child's Christmas in Wales*, 'The Dead' is our Christmas story,' Burgess continued. 'The Dead' dinner he hosted with Marie gave him 'a sense of a great generation of actors passing; Donal McCann ten years ago, now Donal Donnelly.'

John Huston achieved the feat of bringing them together on a set in California to direct what Burgess calls 'one of the most authentic films ever made about Dublin'.

The illusion of being transported in time was strongest at the end of the evening.

As we piled on overcoats and scarves to leave the O'Leary-Halton party, one half-expected to step on to an icy Dublin quay. As in 'The Dead,' it was the coldest winter in thirty years, but there were no horse-drawn carriages, only cars parked amid drifts of frozen snow.

Index